INDEPENDENT FEMALE FILMMAKERS

Independent Female Filmmakers collects original and previously published essays, interviews, and manifestos from some of the most defining and groundbreaking independent female filmmakers of the last 40 years. Featuring material from the seminal magazine *The Independent Film & Video Monthly*—a leading publication for independent filmmakers for several decades—as well as new interviews conducted with the filmmakers, this book, edited by Michele Meek, presents a unique perspective into the ethnically and culturally diverse voices of women filmmakers whose films span narrative, documentary, and experimental genres and whose work remains integral to independent film history from the 1970s to the present.

Independent Female Filmmakers also includes a biographical profile of each filmmaker, as well as an online resource with links to additional interviews and a sample course syllabus.

The filmmakers in this book include:

- Lisa Cholodenko (*High Art*, *The Kids Are All Right*)
- Martha Coolidge (*Valley Girl*, *Real Genius*, *Introducing Dorothy Dandridge*)
- Cheryl Dunye (*The Watermelon Woman*, *Stranger Inside*)
- Miranda July (*The Future*, *Me And You And Everyone We Know*)
- Barbara Kopple (*Harlan County USA*, *Wild Man Blues*)
- Maria Maggenti (*The Incredibly True Adventures of Two Girls in Love*)
- Deepa Mehta (*Fire*, *Earth*, *Water*)
- Trinh T. Minh-ha (*Surname Viet, Given Name Nam*, *Night Passage*)

. . . and more!

Michele Meek is an Assistant Professor of Communication Studies at Bridgewater State University. She co-founded Independent Media Publications, which now publishes *The Independent*, and throughout her career has worked in film distribution, festivals, media journalism, and as an award-winning writer/director. Her recent essays have been published in *Literature/Film Quarterly* and *Girlhood Studies*. For more information about her, visit www.michelemeek.com.

INDEPENDENT FEMALE FILMMAKERS

A Chronicle Through Interviews, Profiles, and Manifestos

Edited by Michele Meek

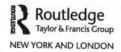
Routledge
Taylor & Francis Group

NEW YORK AND LONDON

First published 2019
by Routledge
52 Vanderbilt Avenue, New York, NY 10017

and by Routledge
2 Park Square, Milton Park, Abingdon, Oxon, OX14 4RN

Routledge is an imprint of the Taylor & Francis Group, an informa business

Library of Congress Cataloging-in-Publication Data
A catalog record for this book has been requested

ISBN: 978-0-8153-7303-2 (hbk)
ISBN: 978-0-8153-7304-9 (pbk)
ISBN: 978-1-351-24431-2 (ebk)

Typeset in Bembo
by Apex CoVantage, LLC

Visit the eResources: www.routledge.com/9780815373049

To Mirabelle and Amelia

CONTENTS

Contents

Contents

Contents

ACKNOWLEDGEMENTS

I am grateful to many people who have inspired, encouraged, and supported this project from its first inception through its publication. First, I am indebted to Erin Trahan who not only contributed three chapters to this book, but also has been an unwavering supporter of women filmmakers, independent film, and *The Independent*. Because of her perseverance and commitment, the archives of *The Independent Film & Video Monthly* have been perpetually preserved, both digitally and in print collections across the country, and they can now be read, shared, and analyzed by future filmmakers, scholars, and film fans at www.independent-magazine.org/archives.

I would like to thank Bridgewater State University's Center for the Advancement of Research and Scholarship (CARS) for their support of this project.

Thank you to all of the contributors and the filmmakers who collaborated on chapters that retain as much of the first-person voice of the filmmakers as possible. Thank you especially to Dr. Patricia White who provided the preface to this collection, and to Dr. Linda Williams who, in her emeritus status, nevertheless graciously agreed to her chapter on Annie Sprinkle and Beth Stephens.

I would like to thank Dr. Jean Walton at University of Rhode Island who offered early thoughts on the idea and publication of this project. Thank you also to Katherine Streeter for her commitment to working through the cover art together, to Haley Conger for her assistance with transcription, to Debra Zimmerman, Kristen Fitzpatrick, and Colleen O'Shea from Women Make Movies and Melissa Silverstein from Women and Hollywood for their help reaching filmmakers, and to Emily McCloskey for her initial interest in this book. I am also grateful to my fellow Mastermind Failure Club members Stephanie Alvarez Ewens, Moriah Harris, Margaret Owen, Betsy Stubblefield Loucks, Holly Wach, and Amy Walsh for their feedback and encouragement. Thank you also to Simon Jacobs, John Makowski, and their

colleagues at Routledge for their support and guidance during the completion of this project. I also am appreciative to my friends and fellow Independent board members Lizzy Donius and Amy Elliott as well as to Rachel Boccio for taking the helm as editor of *The Independent*.

Most importantly, I am grateful to my family—in particular to my grandmother Frances who showed me early on that being a woman did not mean relinquishing independence and authority; to my mother Laura who will always read and copyedit (and love) another draft of anything I write; to my husband and co-adventurer Geoff who always dreams big with me; and to my daughters, Amelia and Mirabelle, who make me confident that women will be at the forefront of our future.

ABOUT THE CONTRIBUTORS

Patricia Alvarez Astacio is an anthropologist and filmmaker whose scholarly research and creative practice develops in the folds between ethnography, critical theory, and the documentary arts. She is currently an Assistant Professor in the Department of Anthropology at Brandeis University.

Christina N. Baker is an Associate Professor of American Multicultural Studies at Sonoma State University. She is the author of *Contemporary Black Women Filmmakers and the Art of Resistance* (The Ohio State University Press, 2018), which is the first book-length analysis of representations of Black femaleness in the films of Black women filmmakers.

Lisa Dombrowski is an Associate Professor in the College of Film and the Moving Image at Wesleyan University. She is the author of *The Films of Samuel Fuller: If You Die, I'll Kill You!*, the editor of *Kazan Revisited*, and has written for *The New York Times, Film Comment, Film Quarterly, Film History*, and the Criterion Collection, among others. Dombrowski's research concerns the art and business of cinema, with an emphasis on post-WWII film form and modes of production. She is currently completing a book on Robert Altman and American independent cinema in the 1990s and 2000s.

Aviva Dove-Viebahn has a Ph.D. in Visual and Cultural Studies from the University of Rochester and an M.A. in Art History from the University of Virginia. She is currently a Senior Honors Faculty Fellow at Arizona State University, web content manager and *ex-officio* board member of the Society for Cinema and Media Studies, and contributing editor for *Ms.* Magazine's Scholar Writing Program. Her scholarly and popular writing focuses on the intersections of gender, race, and popular culture.

Cynthia Felando worked as an art house and film festival programmer after graduating with a Ph.D. in Critical Studies from the School of Theater, Film and Television at University of California, Los Angeles. She joined the faculty of the Film and Media Studies

Department at the University of California, Santa Barbara in 2000. Primary teaching and research interests include American film history, youth culture and media, women and film, contemporary trends in international cinema, and the history and criticism of short films. In addition to several journal and anthology publications, her book, *Discovering Short Films: The History and Style of Live-Action Fiction Shorts*, was published in 2015.

Amy Guth is a journalist, filmmaker, author, and talk radio host in Chicago. She is president of the Association for Women Journalists Chicago, founded and serves as Co-Executive Director of *Strangewaze*, a production company focusing on underrepresented voices, is author of the novel *Three Fallen Women*, and is currently producing and directing a documentary series about online harassment. Her work has appeared in WGN-TV, CLTV, WBEZ, WCIU-TV, *Los Angeles Review of Books, Chicago Tribune, Baltimore Sun, Orlando Sentinel, Hartford Courant, Sun-Sentinel*, The Nosher, Bookslut, and Jewcy, among others. Find her on social media platforms as @AmyGuth.

Michele Meek co-founded Independent Media Publications, the 501(c)(3) organization that acquired the assets of the Association of Independent Video and Filmmakers and *The Independent Film & Video Monthly* in 2007, and she has served as a board member ever since. She founded NewEnglandFilm.com in 1997 and throughout her career has worked in film distribution, festivals, and media journalism. She is also an award-winning writer and film director. Her most recent short film *Imagine Kolle 37*, about two girls who imagine their way to a Berlin adventure playground, has screened at festivals across the country, including the Independent Film Festival of Boston and Rhode Island International Film Festival. She has published both in peer-reviewed journals such as *Literature/Film Quarterly* and *Girlhood Studies*, as well as in industry publications such as indieWIRE and *Moviemaker Magazine*. She is an Assistant Professor of Communication Studies at Bridgewater State University. Her scholarly and creative interests focus on girlhood, women filmmakers, and sexuality studies. More information is on her website at www.michelemeek.com.

Anna Sarkissian is an independent filmmaker and anthropologist from Montreal, Canada. She studied film production at Concordia University's Mel Hoppenheim School of Cinema in Montreal and completed a master's in social anthropology at the University of Oxford. Her feature documentary, *With This Ring* (2016), is a portrait of unknown world champion women boxers from India and was made over the course of 10 years. She is currently pursuing doctoral studies in anthropology at Oxford, focusing on the experiences of women directors in Hollywood.

Benjamin Schultz-Figueroa is a Ph.D. candidate in Film and Digital Media at The University of California, Santa Cruz. His work focuses on the history of film's use to study animals in laboratory settings.

Sarah E. S. Sinwell is an Assistant Professor in the Department of Film and Media Arts at the University of Utah. She has published essays on Kickstarter, *Green Porno*, and *Mysterious Skin* in *A Companion to American Indie Film, Women's Studies Quarterly* and

Asexualities: Feminist and Queer Perspectives. Through analyses of such topics as YouTube, web series, art house cinemas, and queer and female independent filmmaking, her research investigates the intersections between contemporary American independent cinema and new media platforms. Sarah teaches both undergraduate and graduate courses in film history, film theory, women directors, independent media, and convergence cultures.

Erin Trahan served as the editor of *The Independent* from 2009 to 2016, where she oversaw the publication of two books on film distribution and spearheaded the preservation of the Association of Independent Video & Filmmakers' organizational archive and digitation of its print magazine, *The Independent Film & Video Monthly.* She has written about movies for *The Boston Globe, MovieMaker Magazine, Women's Review of Books,* among others and is currently a contributor to WBUR and on faculty at Emerson College. She holds a B.A. from the University of Notre Dame and an M.F.A. in poetry from Bennington College.

Emily Watlington is a 2018–2019 Fulbright Scholar. Previously, she was the curatorial research assistant at the MIT List Visual Arts Center, where she contributed to the exhibition catalogs *Before Projection: Video Sculpture 1974–1995* (2018) and *An Inventory of Shimmers: Objects of Intimacy in Contemporary Art* (2017). She holds a Master's in the History, Theory, and Criticism of Architecture and Art from MIT. Her art criticism has appeared in numerous publications including *Frieze, Mousse, Art Review, The Brooklyn Rail* and *Art Papers,* and in 2017, she received the Vera List Writing Prize for Visual Arts.

Patricia White is Eugene Lang Research Professor and Chair of Film and Media Studies at Swarthmore College. She is the author of *Women's Cinema/World Cinema: Projecting Contemporary Feminisms* (Duke University Press, 2015) and *Uninvited: Classical Hollywood Cinema and Lesbian Representability* (Indiana University Press, 1999) and co-author with Timothy Corrigan of *The Film Experience* (Bedford St. Martins, 5th ed., 2017). White serves on the board of the nonprofit feminist media arts organization Women Make Movies and the editorial collective of the feminist film journal *Camera Obscura.*

Linda Williams is Chancellor's Professor Emerita in the departments of Rhetoric and Film and Media at the University of California Berkeley. She is the author of *Hard Core: Power, Pleasure and the "Frenzy of the Visible"* (1989/99), *Porn Studies* (2004), and *Screening Sex* (2008). She also writes about the significance of melodrama as a mode of popular culture in *Playing the Race Card: Melodramas of Black and White from Uncle Tom to O.J. Simpson* (2001) and in the anthology edited with Christine Gledhill, *Melodrama Unbound* (Columbia University Press, 2018).

Holly Willis is a Research Professor in the School of Cinematic Arts at the University of Southern California, and the founding Chair of the Division of Media Arts + Practice. She is the author of *Fast Forward: The Future(s) of the Cinematic Arts* and *New Digital Cinema: Reinventing the Moving Image,* as well the editor of *The New Ecology of Things,* a collection of essays about ubiquitous computing. She is also the co-founder of *Filmmaker Magazine* dedicated to independent film and she writes frequently for diverse publications about experimental film, video, and new media.

PREFACE

Feminist Independents

This book goes to press during an upswing of cautious optimism about film-making opportunities for women in the US. Bubbling up from simmering rage fueled by Trump's election, #MeToo and #TimesUp highlighted structural problems of sexual harassment and discrimination in filmmaking and other industries, effectively deploying the social media and celebrity-branding tactics that increasingly characterize contemporary social justice activism. Harvey Weinstein, a veritable symbol of Indiewood in the Sundance/Miramax era, was disgraced; the Equal Employment Opportunity Commission reportedly found the studios guilty of discriminatory employment practices and began settlement talks; and taste-makers in corporate media and the prestige economy—from showrunner Ryan Murphy to Cannes Film Festival director Thierry Frémaux—made gender equity announcements.[1]

Unlike most other countries, the US does not subsidize filmmaking, trusting a free market—dominated by media conglomerates—to meet everyone's needs. Despite this lack of support, there are thousands of women and gender-noncon-forming people in this country making films, part of a 100-plus-year history of independent filmmaking. Has their time come? It's hard to say; the liberal feminist dialogue on women and cinema skirts the realities of what we might call non-indus-trial filmmaking, the realm historically served by *The Independent* and the Association of Independent Video and Filmmakers, the New York-based organization that published the magazine until closing up shop in 2006. Growing out of Michele Meek's commitment to preserving the contents and mission of *The Independent*, this book tracks the journeys of key women filmmakers from its pages to the present.[2] Some of them work within the industry; others have maintained careers outside of commercial film and television. These first-hand stories of women's work and influence

as cultural producers help us frame the current moment as one of gains and losses, continuity and rupture, new openings, and new obstructions.

The infrastructure of independent filmmaking in mid-20th century New York City was shaped by women like Maya Deren and Shirley Clarke, who lectured, published, and set up fellowships and exhibitions while making their legendary films.[3] Since then, as new technologies, new issues, and new subjectivities have transformed the mediascape, women have continued to play a central role in organizing the independent sector at every juncture—as producers, distributors, curators, nonprofit staffers, and program officers. I met—and was awed by—some of them in the early 1990s, while supplementing my job at the New York-based feminist distributor Women Make Movies with a stint as editorial assistant for *The Independent* under editor-in-chief Martha Gever and managing editor Patricia Thomson. As you can read in back issues of *The Independent*, women were key to the AIDS activist camcorder revolution, public access and public television activism, the multicultural and "accented cinema" of the 1980s, the New Queer Cinema of the 1990s, and the ever-expanding world of documentary. They continue to run institutes and foundation initiatives, give workshops, sit on boards and grant panels, write, blog, and teach. Such work happens in the background and interstices of what came to be known as Indiewood, the more commercially oriented, auteur-driven feature film sector that lured Hollywood studios to set up specialty divisions to feed at festivals like Sundance from the early 1990s until the Great Recession, when economic factors and technological changes put on the brakes. The less-hyped sector of independent cinema is itself dependent on public and foundation support and has historically circulated in media arts centers, academia, and the art world. Within it, documentary addresses topics and constituencies, and experimental work engages formal languages and formats, that corporate interests pass over. Such work is often made from explicitly feminist perspectives—intersectional, transnational, and oriented to collective social change.

The careers and passions of most of the women represented here have been shaped by this kind of independence and decisively informed by second-wave feminist politics as well as subsequent queer and intersectional challenges. Martha Coolidge, Yvonne Rainer, Lizzie Borden, Su Friedrich, and Ericka Beckman stepped into the New York avant-garde scene that Deren and Clarke had helped shape, and their feminist peers taught Lisa Cholodenko and Cheryl Dunye in film and art school. Sex-positive feminism and the video revolution enabled Annie Sprinkle's career as a postpunk porn filmmaker. Deepa Mehta worked in the context of Canadian policies of support for the arts and multiculturalism. Barbara Kopple, Trinh T. Minh-ha, and Jennifer Fox offered unique perspectives within a political documentary tradition whose most celebrated representatives were male. Julie Dash's aesthetic was forged in the crucible of the LA Rebellion of Black independent filmmakers, and Miranda July (born in 1972, the youngest filmmaker profiled) comes from the DIY ethics and the outspoken 3rd wave feminism of West Coast riot grrrl. These media artists set their sights wider than narrative feature filmmaking and industry inclusion, engaging public television, experimental forms, community-based media,

and theoretical projects that do not necessarily play on the red carpet. Some are downright radical.

Thus, this volume serves as a dynamic history of both convergences and disconnects among projects and eras of independent women's media making. As one of the few women to bring a feminist perspective to Hollywood feature filmmaking in the 1980s, Martha Coolidge fought to make room for others in her role as DGA president and leader in finding career opportunities in premium cable. The rise of Sundance and the mini-majors afforded openings for queer filmmakers emerging in the 1990s, including Cholodenko and Dunye, even as the kinds of filmmaking and relations of production represented by Friedrich and Rainer were disincentivized by a preference for narrative production with crossover appeal. Today low-cost, high-quality digital production tools; proliferating cable, streaming, and transmedia outlets; and peer-to-peer communication networks promise access to filmmaking for all. But without the public support of the arts that exists in countries like Sweden, Australia, and Canada, which have instituted gender parity policies—there is no guarantee of access and sustainability.[4] Let's not forget: the EEOC has been investigating the Hollywood industry for gender discrimination since 1969; the unregulated market has not produced equity.[5] That is why it remains so important to tap diverse histories and cultures of both cinema and feminist critique in assessing the signs of change.

Technological democratization has opened doors and minds to alternative media perspectives and to the critical vocabularies about identity and representation that inform them. Young feminist filmmakers like Lena Dunham, Desiree Akhavan, and Issa Rae are following different paths than the predecessors featured here, moving from web series to HBO shows and features. Leading film schools report enrolling 50 percent women, and even talent agencies are striving for parity, hoping to level the playing field for entering an industry long run by patronage.[6] But reserves of trained and talented women filmmakers ready to bridge the dismal statistical gaps revealed by well-publicized studies of employment in the film and television industries are not coming out of nowhere. The 2018 Tribeca Film Festival programmed nearly 50 percent films by women—including Jennifer Fox's *The Tale*. Tribeca is a sprawling, celebrity-graced affair that arose post-9/11 and marks a new era in the downtown New York film scene after the advocacy fights of AIVF in the 1990s. Chanel hosted a luncheon, entitled Through Her Lens: The Tribeca Chanel Women's Filmmaker Program, to celebrate this inclusivity. Still, Executive Director of New York Women in Film and Television Terry Lawler, at a party hosted by Women Make Movies, mentioned that neither organization had been part of planning the event. Overlooking feminist legacy non-profits is symptomatic of both the historical amnesia and limited vision around the meaning of independent cinema that too often characterize the post #MeToo conversation. The networks and institutions that women have helped build over decades—*The Independent* and *Filmmaker Magazine*, the Independent Film Project, the feature film and documentary programs of the Sundance Institute, and the Independent Television Service—are a critical context for this emergence, and feminist criticism needs to tell this story.

This book restores that history and that definition largely through filmmakers' own words. It reminds us that the issue is not just individual opportunity but structural change—in labor practices, government funding, arts policy, and more. Its focus on true independents helps counter the scarcity myth around women directors; it also belies the progress myth, in which benevolent market forces fix systemic problems. The women featured in its pages speak to their individual and aesthetic visions, but perhaps the most valuable testimony is to the very sustainability of what they do. It comes down to how independence is defined, and declared.

<div align="right">Patricia White</div>

Notes

1. Jodi Kantor and Megan Twohey, "Harvey Weinstein Paid Off Sexual Harassment Accusers for Decades," *New York Time* (October 5, 2017). Peter Biskind, *Down and Dirty Pictures: Miramax, Sundance, and the Rise of Independent Film* (New York: Simon and Schuster, 2004). David Robb, "EEOC: Major Studios Failed to Hire Female Directors; Lawsuit Looms" (February 15, 2017), https://deadline.com/2017/02/hollywood-studios-female-directors-eeoc-investigation-1201912590/amp/. Leslie Goldberg, "Ryan Murphy's Push for TV Directing Equality Making Big strides," *Hollywood Reporter* (August 9, 2017), www.hollywoodreporter.com/live-feed/ryan-murphys-push-tv-directing-equality-making-big-strides-first-year-1027979. Zach Sharf, "Cannes Film Festival Directors Sign Pledge Vowing to Increase Gender Equality at Festival," *Indiewire* (May 14, 2018), www.indiewire.com/2018/05/cannes-signs-pledge-gender-equality-1201964189/
2. See Erin Trahan's essay in this volume. *The Independent* print archive is available at http://independent-magazine.org/archives/
3. See Lauren Rabinovitz, *Points of Resistance: Women, Power & Politics in the New York Avant-Garde* (Bloomington: University of Illinois Press, 2003).
4. Anna Serner, CEO of the Swedish Film Institute is widely regarded as a leader in this movement, Svenska Filminstitutet, "Looking Back and Moving Forward: Gender Equality Report 2017," http://193.10.144.150/globalassets/_dokument/rapporter/swedish-film-insitute-gender-equality-report_2017_eng.pdf; Screen Australia's Gender Matters Policy launched in 2015 www.screenaustralia.gov.au/sa/new-directions/gender-matters. Canadian agencies including Telefilm Canada and the National Film Board of Canada have made significant commitments to gender equity, prompted in part by the research of Women in View http://womeninview.ca/
5. California Advisory Committee to the U.S. Commission on Civil Rights, "Behind the Scenes: Equal Employment Opportunity in the Motion Picture Industry" (September 1978), www.law.umaryland.edu/marshall/usccr/documents/cr12em712.pdf
6. Shaunna Murphy reports that NYU and USC enroll nearly 50 percent women in "Half of Film School Grads Are Women—So Why Are Only 1.9% Directing Big Budget Films," *MTV* (May 13, 2015), www.mtv.com/news/2159771/female-directors-college/. Scholar Mary Celeste Kearney questions this finding in a November 17, 2017 guest post on the Women in Hollywood blog: "How Film Schools Lead to Pipelines full of Weinsteins," https://womenandhollywood.com/guest-post-how-film-schools-lead-to-pipelines-full-of-weinsteins-f49f4c69d78/
 Rebecca Sun, "ICM Partners Pledges to Reach 50–50 Gender Parity by 2020 (Exclusive)," *Hollywood Reporter* (December 6, 2017), www.hollywoodreporter.com/news/icm-partners-pledges-reach-50-50-gender-parity-by-2020-1064634

1

INTRODUCTION

Michele Meek

In January 1982, *The Independent Film & Video Monthly* featured a report from the second International Women Filmmakers Symposium at the Directors Guild of America (DGA) with the headline "Independent by Default—or by Choice." Writer Marion Cajori states, "With very few exceptions, women had turned to independent production as a way out of long and frustrating years of work without being given any opportunity within the Hollywood system." Yet, in the article, these same women filmmakers express that staying independent "offers more freedom and control over the quality of work, not to mention the possibility of actually practicing one's craft."

Therein lies the irony inherent in independent female filmmaking—it offers more "freedom" and creative "control," but the path to be independent is not always explicitly chosen. Major Hollywood studios—who greenlight and fund most popular films—have been accused of "systematic discrimination" against women and people of color who pursue directorial roles.[1] For the women filmmakers in this book, *Independent Female Filmmakers: A Chronicle through Interviews, Profiles, and Manifestos*, discrimination took various forms—Director Cheryl Dunye's landmark NEA-funded film *The Watermelon Woman* (1996) was lambasted by Republicans in the US Congress for its depiction of lesbian sexuality; and Director and former DGA President Martha Coolidge recalls how she was told she could not obtain a producing credit (which not only meant more prestige but also more money) on some projects simply because she was a woman. Many of the women in this compilation turned to television to continue earning their living as directors and writers, and several—some by choice and others by necessity—became authors, teachers, or professors while pursuing their directorial careers.

Institutional bias has had a direct impact on the budgets, genres, and scales of the projects that women direct, as evidenced by the interviews in this collection. When asked in her 1981 *Independent* interview (republished in this compilation) what she might do with more resources, filmmaker Ericka Beckman responds, "It's impossible

to say now, because the ideas are now coming up reduced, so the time seems to have passed."[2] Similarly, in a discussion of why independent female filmmakers stay independent or move to television, Coolidge states, "you're not offered [projects] like men."[3] Many women in this collection articulate that funding challenges kept them from directing features more steadily. Director Maria Maggenti states that it took her six years to fund her second film even after the success of her debut feature *The Incredibly True Adventures of Two Girls in Love* (1995). When women do make films, they also seem to be held to higher standards—several women in this compilation mention how hard it is for women to "fail." Maggenti states, "a woman who doesn't succeed at every attempt that she is making is rarely given another chance,"[4] while for men, as Coolidge states, just one success "would carry them through more okay movies. And, you know, another successful movie and that man would have a career."[5] When asked how racism and sexism affect her work, Filmmaker Julie Dash replies, "Simply by limiting the options available to me for the completion of my projects."[6]

By this point, the statistics of women in media are well documented and widely reported—thanks to the studies overseen by Dr. Martha Lauzen and the Center for the Study of Women in Television and Film, Dr. Stacy Smith and the Annenberg Inclusion Initiative at USC Annenberg, and the Geena Davis Institute. Their studies have demonstrated the paltry numbers of women both behind and in front of the camera. For example, Dr. Smith found that although women comprised nearly a third of the directors of short films featured at the top 10 worldwide film festivals in 2010–2014, their numbers drop substantially for features[7]—women directed only four percent of the top-grossing movies from 2007 to 2017.[8] Such numbers are equally troubling for people of color—of the 1,100 popular films in 2007–2017, only five percent of directors were Black and only three percent were Asian or Asian American.

These numbers are disturbing, and they have not changed much in the past several decades. Dr. Lauzen directs annual studies to measure the rates of women directors, writers, producers, editors, and cinematographers in both the top 500 grossing films as well as in the independent film industry. In her historical comparisons, she found that the number of women directors of independent features screened at major film festivals changed from 24 percent in 2008–2009 to 29 percent in 2017–2018.[9] In looking at Hollywood, Dr. Lauzen found that women directed only 18 percent of the top 250 grossing films, a statistic that has changed by only one percentage point in nearly two decades since 1998.[10]

Despite overwhelming odds against women's making movies, many have persisted, as demonstrated by this compilation. But as the wide-ranging impact of sexual harassment and gender and race imbalance in the industry comes to light,[11] we must ask ourselves—how many of these and other equally talented female filmmakers might have become as secured in their positions in the filmmaking canon as their male counterparts if it weren't for unchecked biases? As Filmmaker Lizzie Borden states in her interview, "I've seen amazing films by women around the world while traveling with *Born in Flames* and realized that nobody will see or even count them."[12]

Writer Lili Loofbourow in her article "The Male Glance" in the *Virginia Quarterly Review* details how film and television critics view and analyze male versus

female work, arguing that the "male glance" is "the narrative corollary to the male gaze"—the way media made by or about men/boys receives more attention and praise than media made by or about women/girls. She argues, "The effects are poisonous and cumulative and have resulted in an absolutely massive talent drain. We've been hemorrhaging great work for decades, partly because we were so bad at seeing it."[13] Maggenti, in her interview for this compilation, states how Loofbourow's essay resonated as "significant" to her, because, as she says,

> I recognized so profoundly the ways in which women who work in the art of storytelling are not paid attention to, and when you're not paid attention to and when you're not taken seriously, it is harder and harder to get your work done.[14]

In other words, it is not only Hollywood who should be called out for discriminating against female filmmakers.

At the time of this writing, the University of Mississippi Press's Conversations with Filmmakers series features books of interviews with 108 filmmakers—only seven of whom are women.[15] So not only have female filmmakers faced intense discrimination throughout their careers, but they also then continue to meet such obstacles in how their work is received and remembered—even by academic publishers. I believe that, as scholars and critics, we must de-emphasize "auteur" filmmaking, as traditionally represented by a collection of feature films. Many of the women featured in this compilation have had what one might call "eclectic" film careers spanning genres, lengths, and forms—documentary, narrative, "experimental," features, shorts, television, and web series. Their careers often include long gaps or several for-hire projects in between their own creative projects. Although today's market for television offers some women greater funding opportunities and creative control, it still does not come with the cachet of feature film directing. I see no reason to continue such a misperception of their work. If we think that these women filmmakers have worked "in the margins," it is we who have kept them there.

I believe it is on us as scholars, writers, teachers, and film fans, to contemplate, teach, write about, and promote the indisputable legacy of these women's films. Otherwise, we are further perpetuating deep-seated industry sexism and racism. These women's films, in other words, should be on our syllabi. They should be included in our research. Their films should be screened in our festivals and events. Their "lesser known" works should be distributed and widely available. Books and biographies should be written about them and with them. These women should be invited to speak at our universities and organizations, and they should be fairly compensated to do so.

In addition to highlighting women filmmakers, my aim in putting together this compilation is to highlight the archives of *The Independent Film & Video Monthly*. As a print publication from 1976 to 2006 and continued since then as an online publication at www.independent-magazine.org, *The Independent* has often focused on the alternative, activist, and grassroots filmmaker. Over the years, the publication has been instrumental in drawing attention to independent film—and it gave voice to

filmmakers like Coolidge, Rainer, and Minh-ha and prominent scholars like Judith Halberstam and Laura Marks early in their careers.

As a filmmaker, film entrepreneur, and film journalist in the late 1990s, I became a regular reader of *The Independent Film & Video Monthly* and then later a more active participant—an "Online Independents" article in the May 1998 issue highlighted my company NewEnglandFilm.com; I wrote for the magazine in the 2000s; and I was elected to the Board of its parent organization, the Association of Independent Video & Filmmakers (AIVF) where I served from 2004 to 2005. As you can read more about in Erin Trahan's chapter in this collection about the history of *The Independent*, in 2007, I formed a team to launch a new 501(c)(3) called Independent Media Publications when the AIVF folded, in order to acquire and preserve the archives of the magazine and continue its publication online. The print archives of *The Independent*, I knew then as I know now, constitute an absolutely integral historical record of independent filmmaking from the 1970s to the early 2000s. I encourage you to explore and reference those archives yourself at http://independent-magazine.org/archives/ thanks to our partnership with University of Massachusetts, Amherst Libraries and the Internet Archive.

Despite its focus on marginalized filmmaking, I discovered in preparing this book that *The Independent's* coverage still concentrated largely on white, male filmmakers, and women filmmakers were often periodically grouped together in shorter profile pieces.[16] Quite embarrassingly, I discovered that when *The Independent* interviewed me in 2002 about Boston-area filmmaking, I too highlighted only examples of white, male directors—Brad Anderson, David Mamet, and the Farrelly brothers. As perhaps with any publication, a look back through its archives presents some astonishing omissions—there were no long interviews with or profiles of some of the most indisputably important independent female filmmakers in recent history, such as Ava Marie DuVernay, Sophia Coppola, or Kimberly Peirce, among others.

Nonetheless, the list of trailblazing female filmmakers who were featured by *The Independent* is abundant and still represents too many to fit into a book-length project. In order to retain as much of a first-person perspective of the filmmakers as possible, I narrowed the list to filmmakers who had either a longer Q&A interview or their own first-person essay in the original publication, which left out filmmakers like Debra Granik, Allison Anders, Lynne Sachs, and others. Focusing solely on female directors also caused me to omit noteworthy women producers like Effie Brown and cinematographers like Jessie Maple. This compilation also features exclusively filmmakers working within North America, which omitted numerous European filmmakers who might (and perhaps will in the future) fill their own compilation, such as Monika Treut, Christine Van Assche, Emma Hedditch, and Margarethe von Trotta, to name a few. Nonetheless, the women filmmakers featured here include a diverse range of ethnicities and nationalities, and many of them produced films outside North America—such as Minh-ha, Fox, and Mehta—in addition to maintaining their deep connections to North American cinema. Finally, two filmmakers—Karyn Kusama and Mira Nair—were ultimately omitted because we were unable to reach them (despite calls and emails to agents

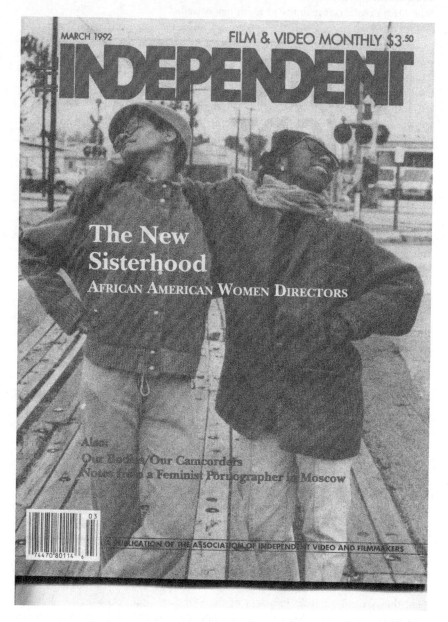

Figure 1.1 Cover stories in *The Independent* at times grouped women filmmakers together.

and managers) to conduct a current interview. However, I did retain the chapter on Julie Dash despite our inability to reach her as well.[17]

Of course, to suggest that the curation of this book was solely objective would be untrue. Rather, my goal was to assemble a group of women filmmakers whose work was not only influential at the time, but also continues to resonate today. The women in this compilation in many ways make unlikely companions—Coolidge's Hollywood films and leadership of the Director's Guild of America, Annie Sprinkle's sex-positive pornography, and Trinh T. Minh-ha's ethnographic documentaries. However, together they highlight the depth and breadth of independent female filmmakers' works, while also demonstrating how common themes often emerge through these disparate works. As Filmmaker Miranda July states in her essay in this book, it's "vitally important that new kinds of people put themselves in charge of what is collected, displayed and remembered."[18] Here is one such collection.

This book includes 15 filmmaker chapters, presented alphabetically by their last names. Preceding those, Erin Trahan's chapter *"The Independent* Revolution" provides a context and history of the AIVF, detailing how the organization originally conceived of the publication *The Independent Film & Video Monthly*, which was published in print from 1976 to 2006 and transformed into its online iteration in 2007.

Each of the filmmaker chapters includes a detailed biography, at least one historic interview, manifesto, or profile originally published in *The Independent Film & Video Monthly*, and, in nearly all cases, a current interview not previously published. All of the women filmmakers featured in this compilation can be considered "legendary" in that they broke gender, race, and sexuality barriers; influenced film movements; and presented some of the most innovative, unconventional, and even revolutionary films of their era. Borden made films about intersectionality before the term was coined, and Lisa Cholodenko depicted the fluidity of sexual desire at a time when sexuality was still largely viewed as binary. Filmmaker Annie Sprinkle became the first porn star to receive her Ph.D. and shifted the conversation about pornography, art, and sex positivity. Filmmakers Beckman and Yvonne Rainer broke the boundaries between art forms, integrating art and dance into their films. Minh-ha's films have impacted feminist and post-colonial theory and transformed the fields of documentary and anthropology. Dash's *Daughters of the Dust* (1991) became the first feature-length narrative film written and directed by an African American woman to receive a general theatrical release. Dunye became the first Black lesbian woman to direct a feature film with *The Watermelon Woman* (1996), and Maggenti wrote and directed one of the first same-sex teen comedies. Deepa Mehta's *Fire* (1996) became the first mainstream Indian film to feature a same-sex relationship. Coolidge not only broke into Hollywood filmmaking, but also served as the first (and thus far only) female President of the Directors Guild of America. July has challenged norms with her own films, while also assembling Joanie 4 Jackie, an archive of women-made videos between 1996 and 2007, now available through the Getty Institute. Barbara Kopple remains the only female director to win two Academy Awards for Best Feature Documentary—one for her film *Harlan County, USA* (1976) and another for *American Dream* (1990). In 2006, New York's Museum

of Modern Art held a retrospective of Su Friedrich's work, acquiring seven films for their permanent collection. Jennifer Fox recently made it "through the eye of a needle"[19] by, after decades of directing documentaries, shifting to writing and directing the Emmy Award-nominated narrative film *The Tale* (2018) starring Laura Dern. These women have been recognized for their pioneering work and have won awards for their films at the Emmys, Oscars, Sundance, and Cannes. They have directly impacted media history by challenging the status quo and making work that we should continue to watch, appreciate, support, and study. They are not only important *women* filmmakers, they are important filmmakers.

Many of the women in this book express the potential for increased opportunities and equal pay for women in the post-#MeToo era, but they also recognize the urgency to continue to advocate for equality, as Friedrich states, "The neglect and disparagement runs way too deep and does not change in six months."[20] But hope, we must, as Mehta says, "it's been a long time coming and I hope it sustains itself."[21] So do I.

Notes

1. Kate Erbland, "Major Hollywood Studios 'Systematically Discriminated' Against Female Directors, EEOC Finds—Report," *indieWIRE* (February 15, 2017), www.indiewire.com/2017/02/major-hollywood-studios-discriminated-female-directors-eeoc-1201783475/. According to the EEOC, "systematic discrimination" is partially defined as "a pattern or practice, policy, or class case where the alleged discrimination has a broad impact on an industry, profession, company or geographic area." More information is available on their website under "systematic discrimination" at www.eeoc.gov/eeoc/systemic/index.cfm

2. Ardele Lister and Bill Jones. "Ericka Beckman." *The Independent Film & Video Monthly*, Summer 1981.

3. Martha Coolidge. Interviewed by Michele Meek on March 2, 2018.

4. Maria Maggenti. Interviewed by Amy Guth on March 22, 2018.

5. Martha Coolidge. Interviewed by Michele Meek on March 2, 2018.

6. Kwasi Harris. "New Images: An Interview With Julie Dash and Alile Sharon Larkin." *The Independent Film & Video Monthly*, December 1986.

7. The reasons for these are multi-faceted, of course, as Smith's study shows, but the most significant obstacles declared by participants are work/life balance (64 percent) and finance (61 percent). See "Gender & Short Films: Emerging Female Filmmakers and the Barriers Surrounding their Careers" (October 5, 2015), https://annenberg.usc.edu/sites/default/files/2017/04/10/MDSCI_LUNAFEST_Report.pdf

8. Dr. Stacy L. Smith, Marc Choueiti, and Dr. Katherine Pieper, "Inclusion in the Director's Chair?" (January 2018), http://assets.uscannenberg.org/docs/inclusion-in-the-directors-chair-2007-2017.pdf

9. Dr. Martha M. Lauzen, "Indie Women: Behind the Scenes Employment of Women in Independent Film, 2017–2018," (2018), https://womenintvfilm.sdsu.edu/wp-content/uploads/2018/05/2017-18_Indie_Women_Report.pdf

10. Dr. Martha M. Lauzen, "The Celluloid Ceiling: Behind-the-Scenes Employment of Women on the Top 100, 250, and 500 Films of 2017," (2018), https://womenintvfilm.sdsu.edu/wp-content/uploads/2018/01/2017_Celluloid_Ceiling_Report.pdf

11. Over 94 percent of 843 women in the entertainment industry recount experiencing sexual harassment and/or assault, according to a study conducted by *USA Today*

(February 20, 2018), www.usatoday.com/story/life/people/2018/02/20/how-common-sexual-misconduct-hollywood/1083964001/

12. Lizzie Borden. Interviewed by Cynthia Felando on April 23, 2018.

13. Lili Loofbourow, "The Male Glance," *Virginia Quarterly Review* (Spring 2018), www.vqronline.org/essays-articles/2018/03/male-glance, accessed on June 19, 2018.

14. Maria Maggenti. Interviewed by Amy Guth on March 22, 2018.

15. "Conversations With Filmmakers Series," *University of Mississippi Press*, www.upress.state.ms.us/search/series/6, accessed on August 1, 2018.

16. "Film des Femmes: Women of the World" in December 1984; "Works by Women" in March 1985; "Speculations: Narrative Video by Women" in April 1985; Unofficial Stories: Documentaries by Latinas and Latin American Women" in May 1989; "Subject to Change: Program of Works by Women of Color Challenges the Status Quo" in July 1990; "No Faking: New Feminist Works on Spectatorship, Pleasure, and the Female Body" in July 1990; "A Mirage in the Desert? African Women Directors at FESPACO" in November 1991; "Calling the Shots: Black Women Directors Take the Helm" in March 1992; "Some Like It Hot: The New Sapphic Cinema" in November 1992; "Buffalo Gals: Women's Videomaking Flourishes in Upstate New York" in October 1993; "Reel Women" in April 1995; "Women, Women Everywhere" in January/February 1998; "The List: Inspiring Films by Women Filmmakers" in March 2003; "The Women Behind the Camera" in March 2003; "Women in Film" in March 2004; "The Girl Team" in March 2004; and "Women on the Verge" in March 2005.

17 Yvonne Rainer, also included in this book, declined to be interviewed, since she felt her writings and interviews with her from throughout her career provided enough information for the biography.

18. Miranda July, "Let's Walk Together: Miranda July's Hand in Yours," *The Independent Film & Video Monthly* (July–August 2002).

19. Jennifer Fox. Interviewed by Michele Meek on August 4, 2017.

20. Su Friedrich. Interviewed by Erin Trahan on May 13, 2018.

21. Deepa Mehta. Interviewed by Anna Sarkissian, June 2018.

2

AN INDEPENDENT REVOLUTION

A History of the Association of Independent Video & Filmmakers (AIVF) and *The Independent Film & Video Monthly*

Erin Trahan

Tear a page out of an old copy of *The Independent Film & Video Monthly* and you would find a rallying cry to storm Washington, festivals calling for your next project, or an article about who's making films in Pittsburgh. In the 1980s and 1990s, the magazine became the common bond of film and video makers who were not beholden to institutions as they pursued their independent projects—it was the only way to share such information. On an emotional level, *The Independent* made people feel less alone. Maybe that's why, for a group of predominantly liberal free thinkers, many called it their "bible."

While the Association of Independent Video & Filmmakers (AIVF) didn't start out as a magazine, nor was it ever intended to be solely defined by one, its story is perhaps more fully documented because of *The Independent*. But to get to the publication, we need to turn the clock back to the early 1970s when John Culkin was the director of New York University's Center for Understanding Media. According to Debra Goldman's thorough recounting of AIVF history from its inception through 1984, Culkin secured a grant in the early 1970s from the US Department of Education to "retrain workers displaced by the changing economy," and he gave cameraman Ed Lynch a small stipend to pull it off in New York City.[1]

By all accounts, Lynch was a dynamic personality, a son of a preacher, and when he started spreading the word to gather filmmakers in early 1974, more than 100 people showed up to an initial meeting. "Large, voluble assemblies devoted to a collective cause were familiar turf to the group, many of whom had come of age in the sixties," wrote Goldman. "Now they turned this activist energy to a cause of their own."[2] Words like commune frequently pop up to describe the weekly meetings

9

that formed committees on topics like self-distribution and planned screenings of members' work. They saw their advocacy on behalf of individuals in the field to create more opportunities for independent voices in public television and on cable, for example, as an extension of the interconnected social movements of the previous decade. The first board was formed and included Martha Coolidge, one of the filmmakers featured in this book. Energy was high, and ideas were free-flowing; there was much work to be done and no money.

An anecdote that Larry Loewinger included in a 20th anniversary history of AIVF sums up the ethos: someone proposed that an activity's organizer should get paid. The board laughed and recorded the laughter in the meeting notes.[3] The group included all types of media makers, but the active participants were predominantly social documentarians. Amalie Rothschild, an original board member, explained to Goldman that "ultimately it was the politically motivated people who had the most energy, passion, and commitment."[4] So while not explicitly political, an activist mindset dominated the group's initial priorities and that made an enduring mark on AIVF.

Indeed, over the decades, some of AIVF's most notable accomplishments were related to influencing policy. The first of many fruitful efforts was the group's testimony against creating a line item in the National Endowment of Arts' budget for the American Film Institute (AFI) in 1975. "If AFI succeeded, it would become the sole recipient of government media funds, an alarming prospect for hundreds of artists and dozens of incipient media institutions beyond the borders of Hollywood," wrote Goldman.[5] With that victory in hand, and a budding national reputation, AIVF was also on its way to serving a "community" beyond the borders of New York. Other stunning accomplishments included the 1977 legislation that required the Corporation for Public Broadcasting to reserve "substantial" program funds for independent producers.[6] In the Reagan years, AIVF's further advocacy for independent funding in public television ultimately culminated in the formation of the Independent Television Service (ITVS) in 1988. During the Clinton presidency, in which the arts backlash continued (Newt Gingrich was Speaker of the House), AIVF fought numerous battles for continued arts funding and freedom of creative expression. During this time, the magazine had become a central part of the organization.

By 1980, Lynch and all but one founding board member had left for other careers, the west coast, or for a much-needed break.[7] Meanwhile AIVF membership ranks had exploded in numbers and geography, the latter of which was a barrier for in-person participation. The zapping of that original hands-on vibe, as inevitable as it may have been, is much lamented in the organization's historical accounts.[8] One obvious way to connect the far-flung members was through some sort of communique. A single issue of *The Independent Gazette* was published in 1976—the result of a $4,000 grant to AIVF, inspired by member Tom McDonough's proposal for a publication called *Deep Truth*. Perhaps "too ambitious to sustain," *The Independent* returned to its mimeographed newsletter from 1976 to 1978.[9] In 1978, the board developed an executive director position, and Alan Jacobs came on for the first year and a half to transform AIVF from a "communal" to a "professional" organization. Lawrence

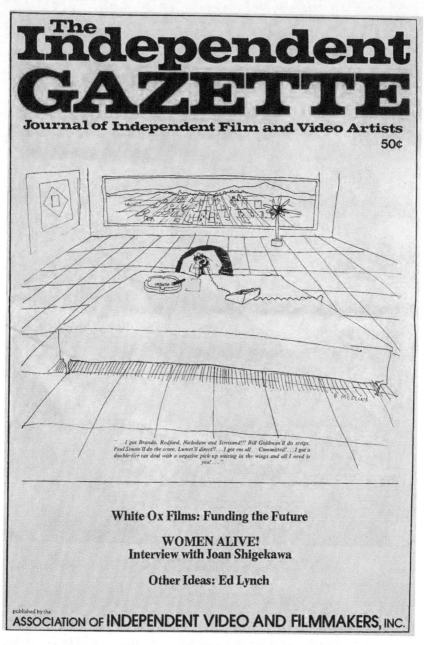

Figure 2.1 The initial concept for *The Independent* published as *The Independent Gazette*, but only lasted for a single issue before returning to the organization's regular newsletter for a few years.

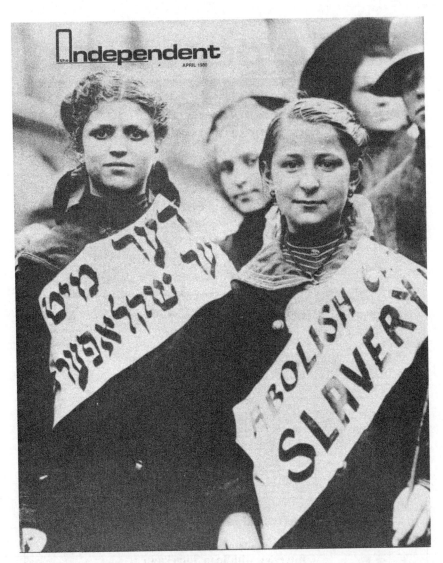

Figure 2.2 By 1980, AIVF had made a commitment to *The Independent* looking and reading more like a magazine.

Copyright of Independent Media Publications

Sapadin followed to build upon that foundation. At that point, *The Independent* became a concrete priority, and Sapadin aimed to change it "from a 'bland communicator' into a publication 'with an editorial thrust' that could 'influence the field as well as respond to it.'"[10] In 1980, *The Independent* took on the form of a magazine with 10 issues per year.

As AIVF entered the 1980s, it had formed its sister organization, Foundation for Independent Video and Filmmakers (FIVF), to raise and disburse money, and it had spun off ICAP (Independent Creative Artists and Producers). The late-1970s Comprehensive Employment Training Act (CETA) grant brought both clout and responsibility to the organization, which could now reallocate funds to individual artists. Loewinger wrote that CETA made AIVF "grow up" and "acquire the administrative skills necessary for handling large sums of money. Mostly, it raised serious questions about the racial, class, ethnic, and gender makeup of AIVF leadership and, to a lesser extent, membership," he added.[11]

Understanding and serving members' needs became the focus of the 1980s and 1990s, when AIVF streamlined itself from a collective into a professional association. In that stretch, AIVF undoubtedly struggled to balance its all-are-welcome ideal with the power dynamics endemic to a biased world—prejudices which were attached not just to social identities but also to film forms. But aside from philosophical differences or division among personalities, the biases that must have affected the organization are not abundantly documented. "I've heard complaints: 'Too much Third World stuff in *The Independent*,'" Sapadin told Goldman. But he argued, "That's where it's happening. The survival of minority production is essential to the survival of independent production."[12]

In this way, as a mouthpiece for AIVF, *The Independent* was often ahead of its time. The almost entirely female string of editors, starting with Ardele Lister (followed by Bill Jones, Kathleen Hauser, Martha Gever, Patricia Thomson, and others), made an effort to move marginalized populations, regions, and forms to the forefront of film conversations by putting those subjects on the magazine covers. When it came to women in charge, from 1991 to 2006 AIVF's top staff positions were overwhelmingly held by women. While a feminist lens was not exactly prioritized by the magazine, it routinely covered women filmmakers or feminist topics as evidenced by this book.

If the 1980s had been the suiting up years for AIVF, the 1990s might be seen as both its heyday and the beginning of the end. The entire field had become dizzy on "independent" film to the point that like any hot trend, the mainstream—or Hollywood—seemed to subsume it. (Granted, the trend was around feature-length fiction films.) Film festivals popped up everywhere as did articles and panels discussing what, exactly, made a film, or filmmaker, "independent." Because of the tone set by editors Gever (1984–1991) and Thomson (1991–2001),[13] *The Independent* was poised to facilitate this cultural dialogue.

As just one example, when critic B. Ruby Rich reflected on the state of independent media in 1994, she railed foremost against class barriers and more provocatively about how the marketplace stunts imagination. Her words then still ring true:

> For every filmmaker that succeeds . . . there are dozens—if not hundreds—forced into poverty by lack of subsidy, forced out of the field for lack of employment, or forced into bitterness by their inability to connect with audiences, funders, or critics.

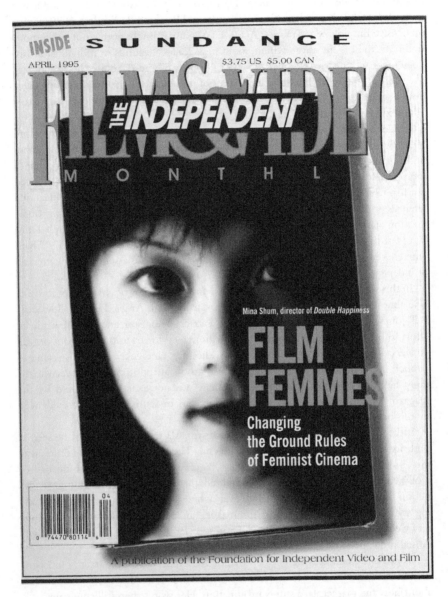

Figure 2.3 In its heyday, *The Independent* published 10 issues per year in a glossy magazine that was distributed in bookstores and mailed to members.

And even more prescient, she wrote, "The new technology talk is as exhilarating and as full of shit as ever. Computers are about to meet video and mate for real."[14] What AIVF could not do ultimately, it turned out, was mobilize fast enough. The print magazine reached an audience peak in its glossy newsstand version from 1994 to 2006.

We now know this "mating" has changed everything from how films are made, when and how they're watched, and how infrequently anyone reads printed material. This mating has radically shifted revenue streams and completely upended concepts of community. Access to money was always a struggle for AIVF, even in the flush years. But when its target community could go elsewhere? "AIVF never had the capital; it certainly had the will, but it never had the working capital to integrate itself into a digital environment," wrote James Schamus in the final printed issue of *The Independent*, July 2006.[15] The story of AIVF in the 2000s is one of an organization unable to reconcile its founding spirit with the pressures of economic change. In the early 2000s, AIVF had become an organization bringing in approximately a million dollars of grants, donations, and ad revenue per year, and the organization had stowed away hundreds of thousands of dollars in a "millennium fund" as a buffer. But economic crisis came on quickly when funding challenges compounded with poor financial reporting and a reluctance to make cuts. By the mid-2000s, the organization had used up its millennium fund and had limited options. The AIVF board wrote its last letter to its membership on July 2, 2006.

AIVF may not have led every possible policy charge but, as Schamus pointed out, in its absence there remains (even today) no clear organizational advocate for individual filmmakers.[16] There is no single advocacy group that represents that distinctive body's interests on topics such as net neutrality, fair use, licensing, etc. Or as one-time AIVF board president DeeDee Halleck wrote, "the real reason we need AIVF is to find each other . . . without this 'locator' we are nowhere."[17] At the endpoint in the organization's wonderfully winding evolution, the magazine was seen as its biggest asset.

In 2007, *The Independent* was handed off to a new nonprofit organization, Independent Media Publications (IMP), started by Michele Meek, the editor of this book.[18] Soon thereafter Meek and a small team launched a website that has continued the magazine online. One of the initial organizational priorities included preserving the archives of *The Independent*. I served as executive director of the organization and editor of the online magazine from 2009 to 2016. During that time, I worked to ensure that complete print collections of *The Independent* resided at Harvard College Library, Library of Congress, Pacific Film Archive, and the Margaret Herrick Library at The Academy of Motion Pictures Arts and Sciences. In addition, IMP partnered with University Massachusetts Amherst Library and the Internet Archive to digitize the entire 30-year archives of the print magazine, which can now be accessed for free at www.independent-magazine.org. This project was a labor of love, perhaps evidenced by the fact that I still house the remaining copies of the print magazines in my home office. Furthermore, keeping *The Independent* afloat, even in

its online form, has been extremely challenging in an era of crumbling support for journalism.

In many ways, this book is a culmination of a decade-long effort to preserve AIVF's role in the history of independent filmmaking in North America. The focus of this particular book is women filmmakers and their underrepresented stories. The hope is that access to the digital archive, and the array of social, political, artistic, and technological progress documented in the pages of *The Independent* and its subsequent website will inspire future generations of scrutiny and scholarship. There are many lenses through which to see this past. In the spirit of AIVF's roots, all are welcome.

Notes

1. Debra Goldman, "AIVF at 10: A History," *The Independent* (January/February 1985).
2. Ibid.
3. Larry Loewinger, "The Fab Formation (of a Media-Arts Organization)," *The Independent* (June 1994).
4. Debra Goldman, "AIVF at 10: A History," *The Independent* (January/February 1985).
5. Ibid.
6. See Lawrence Sapadin's timeline for additional milestones through 1994, including the related formation of ITVS in 1988.
7. Lawrence Sapadin, "Adventures in Advocacy," *The Independent* (June 1994).
8. Debra Goldman, "AIVF at 10: A History," *The Independent* (January/February 1985); Larry Loewinger, "The Fab Formation (of a Media-Arts Organization)," *The Independent* (June 1994); Elizabeth Angell, "The History and Legacy of AIVF," *The Independent* (July 2006).
9. Debra Goldman, "AIVF at 10: A History," *The Independent* (January/February 1985).
10. Ibid.
11. Larry Loewinger, "The Fab Formation (of a Media-Arts Organization)," *The Independent* (June 1994).
12. Debra Goldman, "AIVF at 10: A History," The Independent (January/February 1985).
13. Ardele Lister edited the first few editions of *The Independent*, followed by Bill Jones as freelance editor designer and layout until 1981. Kathleen Hulser was the first full-time paid editor in 1982, succeeded by Martha Gever in 1984 through 1991. Editors then included: Patricia Thomson, 1991–July 2001; Beth Pinsker, August/September 2001–January/February 2002; Elizabeth Peters acting editor March 2002–July/August 2002; Maud Kersnowski, September 2002–November 2003; Rebecca Carroll, December 2003–January/February 2006; and Shana Liebman, March 2006–July 2006.
14. B. Ruby Rich, "Field of Dreams," *The Independent* (June 1994).
15. James Schamus, "Love's Labor Lost," *The Independent* (July 2006).
16. Ibid.
17. DeeDee Halleck, "Why We (Still) Need AIVF," *The Independent* (July 2006).
18. Michele Meek was on one of the final boards of the AIVF, but "cut her board tenure short in the spring of 2005 after witnessing an increasingly bleak financial situation that was being overlooked" according to the article "After AIVF" that I wrote published in NewEnglandFilm.com in February 2007. She says, "I think the attitude was—AIVF had come through worse crises than this and survived. People couldn't really accept how bad the situation was."

3

ERICKA BECKMAN (1951–)

Emily Watlington

Ericka Beckman is an artist and filmmaker whose playful and rigorous films explore rules, structures, and social codes as they are encoded not only in human behavior, but also in structures such as games, architecture, and fairytales. Her earliest work from the 1970s sits at the intersection of film and performance and was completed largely in cost-effective, do-it-yourself Super 8mm film. In the 1980s and 1990s, she turned toward 16mm alongside more narrative work while conducting research on then-nascent virtual reality technologies. Most recently, she has trained her lens architecture, and has adapted her film work for installation in the gallery context, often expanding into multiple channels or incorporating her handmade sets and props into exhibition spaces.

Beckman was born on July 7, 1951 in Hempstead, New York. She received her BFA in 1974 from Washington University, St. Louis, and her MFA in 1976 from the California Institute of the Arts (CalArts), where she participated in John Baldessari's famed post-studio. There, she met colleagues and collaborators including artists Tony Oursler, Julia Heyward, and Mike Kelley. She also studied at the Whitney Museum's Independent Study Program in 1975.

Her work has been collected by numerous institutions, including the Whitney Museum of American Art, the Centre Pompidou, and the Metropolitan Museum of Art. Her solo exhibitions and screenings include the Hirschhorn Museum (1989), the Walker Art Center (2005), and the Tate Modern (2013). Her work has been funded by the National Endowment for the Arts, the New York Foundation for the Arts, and the Andy Warhol Foundation, among others. She is also Professor of Film and Video at Massachusetts College of Art and Design—the only state-funded freestanding art school in the US.

Art historians have largely associated her work with the Pictures Generation, particularly since her inclusion in the 2009 exhibition at the Metropolitan Museum: *The Pictures Generation, 1974–1984*. The group of artists includes figures

such as Cindy Sherman, Sherrie Levine, and Robert Longo whose work engages with images from mass media. This exhibition was a pivotal moment in Beckman's career; Geraldine Tedder aptly wrote that her inclusion in the Met exhibition, "rather than simply credit[ing her] as a pioneer in her field, embedded [her] in the current art discourse."[1] Tedder was commenting on the ways in which the art world seemed to, in a sense, "re-discover" Beckman's work around the 2010s. Her work, for some time, never quite fit comfortably in the world of independent cinema nor galleries and museums. Hence, for instance, her decision to recut her 1999 *Hiatus*—which was received with confusion at the time it was made—and turn it into a dual screen gallery installation in 2015.

The structural film movement also formed Beckman's work and anchors it historically. Structural filmmakers, such as Stan Brakhage and Tony Conrad, worked around the 1960s and explored the material and formal properties of the medium of celluloid. While Beckman borrowed formal maneuvers from this movement by, for instance, filming nearly all of her early work inside the black box, she always incorporated narrative and the body, prompting one critic to describe her work as "punk post-structuralism."[2] She regularly performed herself in her earliest work from the 1970s, but later began hiring actors and working behind the camera. Handmade props, often in primary colors, are another signature of her work, as are rhythmic soundtracks, and she typically involves herself in all aspects of production.

Beckman's work frequently addresses issues of agency and questions of how one makes decisions or can think freely in the face of deeply engrained rules and social norms. In *Cinderella* (1985), for instance, her protagonist, in a moment of epiphany, declares, "I'm just a product of all that I've been taught." This is especially evident in her work that centers around games, namely *You the Better* (1983), wherein games of strategy are turned into games of chance as the players in the film—led by artist Ashley Bickerton—battle the oppressive, omnipotent "House." Strategic efforts to accommodate their highly structured suburban games are thwarted by both chance and power—despite all the efforts of their built environments to foster predictability. In this game of chance, their actions become futile and their agency diminished. Throughout the film, the shapes of the suburban homes featured early in the film— a triangle atop a square—recur in games as bases, backboards, etc., visualizing how architecture is but one structure shaping human behavior.

Later works *Cinderella* and *Hiatus* (1999/2015) take on this question of agency by way of games and technology as a feminist critique. In the works, she employs video games as a structure to reveal gender as learned behavior. The films' female protagonists, who operate in virtual game spaces, are assigned desires, subject to consequences for breaking rules, limited to the functions of their console controllers, and unable to recode the game from scratch. Yet, as I have argued elsewhere, they are also granted some agency—within these limitations, they ultimately control their actions, and are licensed to ignore the rules and accept consequences.[3] A video game, as presented by Beckman, becomes the perfect analogy for being a woman: trying to contend with our own subjectivity in a world that is constantly trying to assign us desires, have us conform to images, and play by the rules.

In 2003, the artist left the black box that had come to characterize her work in order to film extant architectural structures for *Switch Center*. Previously, she had worked with architecture largely as models inside the black box for *You the Better*. *Switch Center*, shot in an abandoned water purification plant outside of Budapest, is a tribute to the durability of Soviet architecture, despite ironically being razed to make space for retail spaces. For *Tension Building* (2014), shot at the Harvard University Stadium, Beckman returns to the spectacle sports of *You the Better* in a timely critique of the spectacle of American culture. The piece takes up fixed seating from the perspective of the spectacle: Beckman uses a technique much like a surveyor's transit, which engineers use to fix their perspective on a single point and take measurements in 360 degrees. Rather than using celluloid as the determining structure as a structural filmmaker would have, Beckman allowed the architecture to quite literally structure her view and navigation of the space. Currently, Beckman is at work on a film about the history of Monopoly, which was originally designed by a woman to teach socialist economics, but has been since adapted by men at the Wharton School of Economics.

This chapter includes an interview with Beckman originally published in *The Independent Film & Video Monthly* in 1981, along with an original interview with Beckman from 2018.

Ericka Beckman

Ardele Lister and Bill Jones/Summer 1981

The Independent Film & Video Monthly

To this date, Ericka Beckman's major work has been in Super 8mm film. Due to her recent prominence, she has been cast as a major innovator in that medium, though Super 8mm for Beckman was an expedient short-stop in lieu of more sophisticated, more expensive visual technology. Still Beckman is a true innovator not only in Super 8mm, but also in larger filmic terms. Beckman is one of the few filmmakers or artists to extricate communicable ideas from age-old, and rather badly manhandled, storytelling devices. The proof of this feat is that when watching Ericka Beckman's films, one has the sense of specifically knowing what they are about even through one can't necessarily say what that is. Knowledge is imparted in a new way. The way itself is Beckman's own sense of meaning as residing in actions rather than codified objects. There is a language of movement, in which Beckman is most fluent.

The desire to perform a dissection of the conglomerate of form, function, content, and idea (what we think of as meaning) is not new. A great amount of cutting up has been done over the past 60 years, but little coherence in putting it back together. Usually form substitutes for all else, and we are left with nothing more than the knowledge that we have shared the same concept of space as the artist.

Through her films Ericka Beckman gives us a new way of perceiving reality as action and thus allows the viewer to codify and make meaning of the material in

relation to his or her own experience. Each person views the same film but sees it differently. This is what art is all about.

Bill Jones:	How do you make your films?
Ericka Beckman:	I start with drawings. This procedure began in 1974. I was painting from dream imagery, but I found painting terribly restrictive, because it was so minimal and formal. So I began to experiment by using video to essentially form still images of body parts in compositions. Then I photographed the video image.
Ardele Lister:	It was a very private use of video.
Beckman:	Yes, I was developing a personal language and forming meaning within it while performing these pieces privately, but always with the intent of composing images within the frame. I never showed these tapes, but I did photograph them and film them so I could edit in the camera. My work began to divide between photography and film. The photography dropped away, and the film stayed.
Lister:	Do you work directly from the drawings?
Beckman:	The drawings are very important to the way the films look. The style of the drawings changes with each film. They often depict the full narrative that I began with and then I cut back when shooting the film. In *Out of Hand*, for example, I began with a full story of a family in South America who is forced to move from house to house around the periphery of the city. They are never allowed into the central city by the military who keeps them out for political reasons. There is a young boy who sees all the moving around but realizes that things never get any better. Because of their position, he has to take things from the authorities who are not necessarily his friends, but he has no other source. Then he goes back to a house that once seemed to offer security and searches back through some of the old offerings.
Lister:	Why didn't you make that story as you describe it?
Beckman:	No money, no time. So I cut it back and simplified it in a way to fit my means. At first, I was only interested in the form the film took. I didn't think ahead to where they might be going. The ideas were small. Now they are large and complex, and I have to cut them back, which makes for the style of the films.
Jones:	What would you do if you had more resources?
Beckman:	It's impossible to say now, because the ideas are now coming up reduced, so the time seems to have passed.
Lister:	What's your next film about?
Beckman:	It's going to be an eight-minute film very tied to a musical soundtrack and based on a particular prop, a large wheel, which is something like a Ferris wheel. The story is that there is a factory worker on an assembly line who decides to leave and make

more of his life. The assembly line becomes a Ferris wheel, then the prop wheel with a pole at the center. He begins at the outside of the large wheel and through a number of game structures he passes to the center, mounts the pole and then becomes the pole. It is a simple metaphor for becoming more motivated, more directed, more aligned, through the playful quality of the games and the Ferris wheel. It's not intended to be a fantasy though; it's a physical film about his movement. Through movement and action, he transforms his spatial situation. It is a simple metaphor acted out, but for me the treatment of the metaphor in making the film is most important.

Lister: How do you relate to your recent critical acclaim?

Beckman: It's awful, haven't you read the things *they've* been saying? The whole thing about Super 8, like I'm a technical wizard. It makes it almost impossible for anyone to see what the films are all about. My reason for getting into Super 8 was because it was available to me with my limited finances.

Jones: What would you like people to see in your work that is not dealt with by critics?

Beckman: Nonlinear time, the formal aspects of the work. How it departs from a formal aesthetic. How it fits with the art of my contemporaries in painting and sculpture.

Lister: It's hard to find a writer who can deal with the filmic ideas as well as the formal and visual qualities more connected to painting and sculpture.

Jones: Also, your work is difficult to classify because it comes from more standard story forms, but changes the way they are told. I think most people think the story and the way it's told are the same thing, and that they are inseparable.

Beckman: It is difficult, because film seems to denote a certain kind of narrative based on the casual so viewers tend to restructure the work in relation to more standard narrative conventions.

Jones: I think your work deals with the splitting of narrative style from story or idea.

Beckman: Yes, but, in fact, it's about putting narrative in a subordinate stance to a conceptual stance with the material. There are ideas in the film I want to stand out above its narrative structure.

Jones: Could you talk further about the way you work with the camera and how important the drawings are to the film?

Beckman: The drawings are very important to the film. For example, I always know by the drawings how I want the set to look before I find it. They give me control of the image.

Jones: The film essentially looks like the drawings, especially because of the double exposures and mat techniques.

21

Beckman:	The techniques are not only to gain a visual quality like painting, but to investigate illusion and reality. In my earlier films, I used mistakes or chance montages of images and actions to jump off from, to build on. I let myself be surprised. My interest is in creating a cohesive whole out of musical and visual elements.
Lister:	You are more interested in the whole.
Beckman:	My position is that the story is subject matter; the treatment of the subject is art.
Lister:	You're not reconstructing reality with the camera.
Beckman:	Essentially, I deal with basic moral themes, stories about competition, the search, the chase, relationships, play and work, but told in a more personal filmic language. People may learn the language through the common themes and possibly a new way to experience these ideas.
Jones:	Most people relate the notion of reality to a set of stylistic conventions. Do you think it's possible to depict reality without these cues?
Beckman:	To me reality is a series of actions rather than a series of representations. I chose film because I wanted to build a language based on actions. I wanted to strip meaning of its object consciousness. That's why I don't use dialogue. I don't want to get caught up in a structuring of reality or a coding of objects. The verbal structure of the world was just more interesting to me than the object structure. Still when people see my films they often describe the films as full of props and objects, which isn't really true. They describe things they thought they saw that didn't really exist in the film, they are drawing things, inferring things from the physical actions, so I guess everyone sees, experiences the films differently.

A Conversation With Ericka Beckman

Emily Watlington/2018

Emily Watlington:	Since we last spoke, you've mounted a couple of solo exhibitions in Europe that look back to your work from the 1980s alongside more recent projects.[4] How has it been to look at these side by side?
Ericka Beckman:	I get excited to see older pieces talking to newer ones, and to discover the continuities between them—which I've only been able to see in these shows. That has made visible that I've actually been working on a lot of the same ideas that just keep on developing. Sometimes, you don't realize this in the process.
Watlington:	That's interesting to me because I've only seen your work in the last few years and so it's been easy to see the continuity looking back. You've also been turning some of your films into gallery installations—like *Hiatus* (1999/2015).

Beckman:	Yes. That was very important. And totally necessary to do.
Watlington:	Because it allowed you to transition from the cinema context to the museum context?
Beckman:	Right. *Hiatus* was first conceived very differently than it was actually edited. It was a kind of travelogue through an architectural space created by a capitalist entity, and it was a race forward to get back in time by a female protagonist. It was designed to have all of these modules that would be characters that are latent in game play—they may be online characters or doing other things. The film was going to be about negotiating space with a mission against all the material that you would have to navigate through. I shot all that. But once I began cutting—and it was originally cut for single screen—I realized I had to keep the narrative front and foremost, and cut all kinds of things that were distracting. I ended up with a film that portrayed one mission of the project. Luckily, the interest in my work being shown as an installation led me to recut the work as a double screen to bring out more of the material and to show a kind of displacement between the narrative and the environment of the film.
Watlington:	And the later interest in showing your work as an installation, is that from younger curators?
Beckman:	Yes. It started with Fabrice Stroun, who encouraged me to figure out how to show the work. He thought there was one film that warranted a screening in a traditional theatrical setting and said I should figure out how to make the rest of them work within his space [Kunsthalle Bern]. That was so exciting; I was able to really think back about how I always wanted to show the work.
Watlington:	And in the films themselves you're constructing spaces, so it makes sense to extend that into the gallery.
Beckman:	My first thing was to extend color. For *Hiatus*, I'm embedding LED lights in the floating screens themselves, and they're pulsing the colors that are on the screen. It's very subtle, sort of rhythmic . . . if you had a glass floor you would see the colors spreading in reflection. Instead of going from shot to shot to shot to shot, you're thinking about the things that are held together thematically, and bridges. Because certain colors stay on longer than others.
Watlington:	I can't wait to see this version installed!

We've spoken also about the delay in the deserved reception of your work, which reminds me of the Guerilla Girls line, that the advantages of being a woman artist include, "knowing your career might pick up after you're 80." Not that you're 80! But the point is a salient one.

In the earlier interview reproduced in this volume, you talk about how your critics in the early 1980s didn't seem to get your work and its merits; would you say this has changed, or is changing?

Beckman: Oh, it's changed. Definitely. There were a few people back then who got it—I mean really got it—but it wasn't in the art context.

Watlington: So in the cinema context?

Beckman: Exactly.

Watlington: There's a lot that has changed in the reception of your work, but also a lot that's changed both in audiovisual technology, and in feminism since you started working. Yet your work has retained a lot of continuity—both in terms of themes and aesthetics.

Beckman: That continuity generally stems from wanting to deal with certain issues of human rights, though not in a big social way. Usually I make a film about something that really disturbs me culturally, and I can see that showing up in my work—beginning with *You the Better, Cinderella, Hiatus* and all the way up to what I'm working on now. I've really been dealing with capitalism, and I guess feminist ideas as well. But I actually felt like the feminism of the 1980s was too focused on rebellion for me. I was more interested in looking deeper at some of the causes that are more inherent in our cultural assumptions.

Watlington: And in your work, the structural and social construction of gender but also of behavior in general.

Beckman: Yes. I knew *Cinderella* had a feminist sort of froth on it, but really trying to get to this position: when you start making decisions—what are your decisions based on? It's a very thick sort of tangled knot that you have to unthread to get a point where you can clearly think independently.

Watlington: Absolutely. I think the question of "how do you know what you want" versus what you're taught to want is so clear in that film, and this is definitely a gendered question but it is not *only* a gendered question.

I'm reminded that for every female filmmaker featured in this book—and women in any discipline—who finally do get their deserved recognition, there are at least a handful who haven't. So are there any female filmmakers you feel indebted to—either those who received visibility and served as role models, or those who didn't yet who you'd like to credit?

Beckman: Yes, role models would be Yvonne Rainer, as well as Lizzie Borden and VALIE EXPORT. There's also Julia Heyward, who is now starting to get more recognition. So are Mira Schor and Vivienne Dick.

Watlington:	I'm also wondering about how you see the role of male allies. A lot of your close friends and collaborators, especially early on, were male artists—and some of their work got formally recognized before yours did. I imagine they were also your supporters and collaborators. Can you talk about this?
Beckman:	I would say collaborators . . . in the sense not of collaborating on my work, but collaborating in dialogue about the development of our work. At CalArts there were many women who were strong makers, and my department was quite open. There was no sexism in the department at all. [John] Baldessari created a very open environment where everyone could succeed in what they were doing. The culture surrounding the work was more of critique and support rather than of professionalism.

There were many women who came to New York from the graduate program who stopped making work because of the prevalent sexism in the art world in the 1970s. There were more artists that I could talk and work with that were men once I arrived in New York. By then, my girlfriends were all pursuing other occupations—architecture, writing, publishing, fashion. There were a couple of strong women I was close to in the art world—Dara Birnbaum, Jenny Holzer, and later Barbara Kruger and Sherrie Levine. I was committed to staying and making films, but it was very hard. Everyone that I had come there to be with as a support group disappeared from New York or to other careers. Though they're successful: *Paper* magazine was created and published by my roommate at CalArts.

Watlington:	So, perhaps the New York world was more professionalized and competitive—and with that came some sexism?
Beckman:	Los Angeles in the 1970s was not an art world center. They had a few galleries and they were prized in their museum collections, but it wasn't a commercial center for art. Therefore all these alternative spaces popped up, allowing for more openness. I thought there was more going on in Los Angeles than in New York at the time.
Watlington:	Maybe more freedom for experimentation?
Beckman:	And also a lot more narrative—more personal work and performance work. New York had alternative spaces but a lot of them were self-programming, meaning the artists who created the space invited their friends and it was kind of locked up. This allowed people to take control of their own work and how they were going to exhibit it. It was great to see self-organizing, but those spaces seemed to be the only ones that were really open

	to women. Many organizers of those spaces included women, and so they made the place for themselves.
Watlington:	Which was not true of bigger museums and institutions.
Beckman:	Absolutely. More importantly, media was completely knocked out of the picture except in alternative spaces. Also, in New York almost everything was institutionalized in some way, except for these alternative spaces. So you're going to get the sexism in that situation.
Watlington:	And as your work points out, the structured sexism—so people started new structures and institutions.
Beckman:	Yes. That is what the women from CalArts that I mentioned were up against. And they just said, forget it. They saw no point in battling this because, it just took too much time and they wanted a career.

I felt the experimental film world was a little bit more open because the people were more liberal-minded and had more revolutionary practice backgrounds. That world was, I felt, much more open initially. That's where I ended up having to sort of accept being accepted.

Even before deciding to make film, I was part of the very rebellious student activist movement called SDS as a high schooler. We did a lot of things—revolutionary-type things around the Chicago convention. There was a lot of movement in political groups to use media after the Chicago convention. They drew to Portapaks, which became accessible. The opening of the cable television network to everything being fiber optic allowed communities that only had access to corporate television to produce their own programming. These movements allowed people who were thinking about media politically to help communities produce work to tell their own stories. This kind of spreading out of the platforms and centers of media production, as well as having devoted funds and people running those organizations who were very alternative—educators or media professionals—they were thinking about all kinds of ways to break the franchise on news and knowledge by corporate entities. That fed into my thinking in terms of being able to say, "I want to make media, I don't want to make art."

| *Watlington:* | So this moment informed your literal choice of medium. |

You were speaking a bit about being first accepted in the cinema/film festival world before the art world. And I wanted to bring up a story I've heard, but never in your words, of the rejection of *You the Better* when it co-premiered at the New York Film Festival with Jean-Luc Godard's *Passion*.

Beckman: That film really literally walked out of my studio and into the festival. There wasn't any test group or anything beforehand. I just had J. Hoberman come and watch it, and then next thing I knew he called me up and said, "It's in the festival."

That film was talking about what nobody was talking about. And now, it's like we're all talking about it. This is just another way of representing what's going on right now, and the dialogue that people are having.

So what happened there was that the film got maybe halfway through, which is when Ashley [Bickerton] begins confronting the audience in direct address. And the audience just broke down and from that point on, the film . . . they *had* to play it. But people were leaving. People were pelleting me with flyers. People were yelling and this kind of rumble came up so you couldn't even hear the film.

Watlington: Oh, that's terrible! But now it's in the collection of the Metropolitan Museum of Art. We talked about this a bit, but would you say the cinema/film world has been more or less welcoming of women than the art world? Or, maybe that's changed over time.

Beckman: As a young woman coming out of school, experiencing both of those worlds, there was a lot of resistance to women in the American avant-garde world at the time that I noticed first-hand. That turned me off to it so much early on that I didn't respect it for that reason. I really didn't.

People were always asking, why isn't Ulrike Rosenbach showing more? Why can't we see the works of the feminists in Germany more in the United States? Why can't we have more programming that represents what women are doing? And then why do we have women who felt they had to leave New York to have a career in Hollywood? It was definitely in the experimental world, the New York avant-garde scene, that really turned me off. I'm not the only one; there are other people who feel the exact same way.

Watlington: Well if you look at the history and the patterns, this absence is certainly discernable.

Beckman: This particular world was supposed to be a radical re-envisioning of what media is, but it was all male, and it was from the start. I did something called the Aspen Institute for Contemporary Art in 1969 right out of high school, and Ken Jacobs was there, Stan Brakhage was there, the whole group. They were scouting for their students to work with them, and even though

I thought the ideas were very interesting and exciting, I could just see how it played out socially and programmatically, and it just turned me off.

Watlington: This is evident in your work—you've borrowed from things like structural film coming out of the avant-garde, but have always incorporated narrative and the body. Some of this work reads—to me at least—as more explicitly feminist than others. For *Cinderella* and *Hiatus*, you were working with the idea of women creating their own space and own rules by way of video games. I recall that Player 33, or WANG in *Hiatus* was based on patronizing men you encountered at NASA Ames, who mocked your use of their advanced technology for mere art and games.

Beckman: There was a real excitement about art being connected to technology in the '70s, and institutionally supported collaborations that happened between artists and scientists. I thought that scientists and artists shared an ability to think very abstractly, and define models for that abstraction. I was very interested, when I started doing research in virtual reality, in the way it instantly connects with vision. Artists were the perfect people to beta test this stuff, because it dealt with stereoscopic vision. I thought it would be a great opportunity to talk to people working in that field as an artist.

After going to all these conferences—which I did in '89 here in Boston, and then Austin in '90, and I did the Cyberthon in '90—I found two groups of people to talk with. One was wide open and interested, and the other was very closed down. It was that relationship between the two kinds of conversations I was having that really formed that character. Yes, there was one scientist in particular at NASA that I had some trouble with, but it was more general than that. It was very prevalent.

There were things that other people couldn't even talk to me about within the institution of NASA Ames. We could go off and maybe grab a coffee and talk, but in the work place, it was impossible. The only way I got into that position to interview scientists within NASA Ames was because I had convinced a magazine editor that I knew in New York to do a story, and I came along to ask questions as a second reporter.

Watlington: They respected a reporter more than an artist.
Beckman: It was a business entrepreneurial private magazine.
Watlington: That's also interesting given the tension between the sort of structural or social versus the subjective and personal in your work— that as an institution they could speak with you in one way, versus as a person getting coffee.

Beckman: Jaron Lanier was the person who I felt most aligned with in terms of his attitude towards technology and its potential to create a new language for us. I feel this is definitely happening now and I wouldn't call it virtual reality any more. It's just the way media has pervaded our culture, and we're so dependent on it that it's affected the whole way we organize our thinking. That was what Jaron's idea was early on; that's why he worked in VR, because it was a new technology that at its birth could do something different. He was looking for ways that would open thinking, open synapses, and reformulate.

I was into what he was thinking about, because I thought of the relationship between VR and dance. VR used the body to create signals, and those signals would be the language to talk to the computer to change the environment. You could have a set of choreographed motions that would be learned that would do specific things in an environment. You could talk through your body and interact with not just an environment, but another person and collaborate on what your environment was.

Watlington: That makes a lot of sense; your work has long dealt with performance and film, but also choreography and learned but also encode-able behavior, things like this.

I'm wondering what's next for you. I read that you are working on a piece about how Monopoly was originally a socialist game created by women, and I'm so excited.

Beckman: I just finished a lot of shooting. I got very excited when I discovered that Monopoly had a precursor that was designed by a woman named Elizabeth Maggie in the early 1900s. She created a game that has a horrible title—the Landlords Game—and it taught a socialist economics theory. Games early on were very different than they're played now: they were patented, but people would modify the games themselves. That was part of her thing—it was basically about land tax reform, and tried to teach people to think about their relationship to land ownership and taxation.

She allowed the game board to be adaptive wherever it was played—mostly in liberal East Coast communities, and the Quaker community. It was played and modified by the Wharton School of Economics. They ended up speeding up the gameplay, and someone decided to refigure it. Then they went to Parker and got the patent on the refiguring, which became Monopoly.

She still had the patent on the precursor, and said she would sell her patent if they published the one version of the game that she

29

felt was really doing its job before it got sped up. At the time of the market collapse, this is what took place: a male from Wharton school published Monopoly, and her game came out after she sold her patent for about five hundred dollars. It came out as a mess of a game board—nobody would play it. It was ugly, confusing, downgraded.

I got very fascinated with this idea of two economic systems competing against each other, and how to visualize that. I made it visual with a lot of graphing, and through building architecture that is changing and representing the balance and imbalance of power, or the competition between the two games—like the score board. I figured out how to do a dual screen—I'm thinking about, for the first time, creating something for dual screen rather than modifying the dual screen. So that's where the film is going; it's bringing back performance, because it has to use players and it has game boards and real documentary situations, real locations that are important to where we sit now in capitalistic production. I've got demolished suburban sites, urban sites, and reconstruction sites as backgrounds for different parts of the game. There's different animation over more documentary kind of background stuff.

Watlington:	Have you gotten to play the original game? Is that accessible?
Beckman:	I have; I went to the Museum of Play in Rochester, near the Eastman House. It's a museum and research library devoted to games. I went there and did research; I played the game and looked at all the letters.

Earlier on you were asking a question about the reception of my work and why I feel like it's working better now than it was, and I think part of it is this awareness that we have been transformed since the Internet. We have developed finer tunings in the ability to recognize and differentiate visual pattern. When you're trained as an artist, specifically a painter, you train your eyes in a way to see color. And sometimes people think about color as mixture, like what would make that color, but if you're not a painter, you train your eyes to really be able to see things the way the normal eye doesn't see. I think that, now, we are able to see temporal patterns much better. I'm recognizing in myself that I am more fascinated by seeing movement and relationships of movement in space that I wouldn't be paying attention to normally. I'm also aware of being able to take something that's a type of pattern and select it and remove it from its context. This all has to do with, I think, the multiple screens

and the availably to configure them the way you want to. This is what people are now getting about my work. When I would say that—for instance, to the Whitney Program in the '90s—I would say, "I am very interested in what is called special effects." They would look at me like, "oh, forget it. This is really going nowhere." But for me, it was this idea that you could create new meaning through juxtaposition—not only just picture patterns but temporal patterns. Now this is what I think most people are getting—they're recognizing a new behavior we are perfecting.

Watlington: Your work was always future-looking. For instance, you were often working with technologies that maybe weren't even fully developed yet.

Beckman: But rather the ideas of those technologies. I can't say that I'm going to be analog forever, because it's just impossible. But at least with what I'm doing, I'm still not shooting completely digital. I'm using analog where I need to, because I'm understanding it better as a medium that is imperfect.

Watlington: So your new work is analog and digital?

Beckman: Yeah. Mostly, I'd say, 70 percent analog, but there's digital definitely in the process.

Notes

1. Geraldine Tedder, "Anthology of Critical Texts," in *Ericka Beckman*, ed. Lional Bovier, Fabrice Stroun, Geraldine Tedder (Zurich: JRP Ringer; Bern: Kunsthalle Bern, 2016), 127.
2. "Punk post-structuralism" was a phrase used by J. Hoberman to describe Ericka Beckman's work in the *Village Voice*, 1 January 1979.
3. Emily Watlington, "'A Woman Shouldn't Waste Her Talent on Such A Harsh Game': Female Agency Ericka Beckman's *Cinderella* and Hiatus," *Leonardo* (MIT Press, forthcoming) special issue on art and video games.
4. Emily Watlington, "Ericka Beckman: Game Mecahnics," *Mousse*, no. 58, 2017.

4

LIZZIE BORDEN (1958–)

Cynthia Felando

Lizzie Borden is a legendary filmmaker in more ways than one. On the leading edge of the 1980s New Wave in American independent filmmaking, she has been a true pioneer for women filmmakers and audiences longing to see real, multi-faceted women onscreen. Her work is a testament to her deeply independent artistic spirit and style. In 1983, Janet Maslin subtitled her review of Borden's *Born in Flames* (1983), "Radical Feminist Ideas."[1] Today, the description still fits. Perhaps even more.

Borden's first two independent feature films, *Born in Flames* and *Working Girls* (1986), are both key entries in at least three film canons—independent, feminist, and queer. They represent a fierce commitment to conveying women's perspectives and experiences and were among the first to demonstrate that films could successfully resist Hollywood's usual adoration of the "male gaze." She is a true auteur, in the sense that she conveys a personal vision that defies formal and thematic conventions. When they were released, *Born in Flames* and *Working Girls* were pivotal films whose stories and styles were welcome alternatives to commercial filmmaking. Simply, they enabled women to *see* differently and to realize what women-centered films could be. As the critic Teresa de Lauretis explained, "In short, what *Born in Flames* does for me, woman spectator, is exactly to allow me 'to see difference differently,' to look at women with eyes I've never had before." As Borden herself said, "It was about the notion of a woman's gaze. It's the whole idea of a woman's world that is made by women creating it, women doing it, and women seeing it."[2]

When she graduated from college, Borden moved to New York City where she was inspired by the array of experimental and international films. She also gained significant "on the ground training" by working as a film editor for downtown artists. Then she made a bold move: although she didn't have a classical film school education, she set her sights on becoming a filmmaker. Her experiences as a visual artist and film editor served her well as she sought to explore the possibilities of

movies to pose questions and to enable dialogue and collaboration among women, on- and off-screen, about their lives and realities.

Borden's first film was *Regrouping* (1976), an experimental documentary about a radical group of four young white women artists and intellectuals, and their efforts to find common ground and solidarity. The project began, as Borden explains in an intertitle, as "an agreement, an attempt at collusion" between herself and the four women but, in the end, "it became my film."[3] *Regrouping* screened at Edinburgh's International Film Festival in 1976, and its unorthodox storytelling strategies were harbingers of Borden's unique approach to filmmaking and to the unexpected twists and turns of low-budget independent filmmaking. *Regrouping* also established Borden as a force to be reckoned with in the realm of radical, independent feminist filmmakers whose goals were to create a "counter-cinema" that would defy Hollywood's representations and marginalization of women and to empower women's voices and visions.

In the late 1970s, Borden embarked on a long journey, spending five years shooting and editing her acclaimed, award-winning masterpiece, *Born in Flames*. It had an auspicious debut at the Berlin Film Festival, where it won several awards and captivated critics with its bravura style and radical possibilities.

Taking an artistic leap of faith, Borden started production on *Born in Flames* without a script and with an astonishingly low budget. Her plan was to develop story material in close collaboration with the women in the cast, whose roles often reflected their off-screen lives. The "script" emerged after shooting, during the painstaking, years-long editing process. As Borden explained:

> For me, it's more about the idea of questioning, and finding, and wanting more collaboration with the people I'm working with. The idea of a film being more than the sum of its parts is truly magical. I'm not a filmmaker who sees it all before I begin; I'm not interested in that.[4]

Born in Flames is an unabashed feminist allegory about sexism, racism, homophobia, and the enabling of those often overlapping oppressions by the media and government. Shot entirely on location in downtown New York City, it's set in a near future, 10 years after a socialist revolution has failed to change things in any meaningful way for women. Fed up, the women decide to take action. Their many objections to the current state of affairs for women include unfair labor practices, physical abuse and street harassment, media condescension, and the general pretense among politicians and the news media that the revolution has been successful for everyone. One of the many challenges the characters face is that they don't share the same ideas about how to enact or demand serious social change.

Born in Flames celebrates the diversity and strength of the women with a racially and ethnically inclusive cast of characters that represents the social and cultural gamut: straight and gay; old and young; and middle- and working-class. It also celebrates the professional and activist labor of women, with montages of working women that alternate with montages of street demonstrations and political discussions. The

most organized and active group, the Women's Army, delivers a satisfying blow to rapists and street harassers with its fantastic, super-heroic "bicycle brigade" that races cavalry-style to the rescue of endangered women. Adding to the subversive mix are the underground DJs, Honey at Phoenix Radio and Isabelle at Radio Regazza, who deliver spoken-word style calls to women to work together in the fight for a new revolution. *Born in Flames* also features the real-life activist, Florynce Kennedy, who mentors the Women's Army leader, Adelaide. While the various women advocate on behalf of collective action, their preferred methods differ and range from non-violent protests and interventions to violent ones. As Borden explains, women "speak of resistance in different voices," and, rather than being understood as antithetical, they should be "heard as a chorale."[5] In the end, after Adelaide dies in police custody, the coalitions of women come together to seize control of the media by interrupting a television broadcast to air their demands. And, although the women's issues and resistance in *Born in Flames* are deadly serious, there are many brilliantly realized comedic moments that add even more depth and texture.

Born in Flames has an equally inventive form with a fragmented narrative, breakneck speed editing, mobile camera work, and a combination of film styles and a dizzying assortment of fake newscasts, talk shows, FBI surveillance footage, as well as musical and spoken-word performances. In addition, there are several captured-on-the-fly documentary-style montages of street life in downtown New York City that punctuate the narrative sequences. The film's dynamic visual mix is further complemented by an intricate and driving soundtrack, with layers of music, including live and recorded songs, and often overlapping dialogue.

Just as Borden recognizes that feminist women don't speak with a single voice, she also recognizes the heterogeneity of women audiences. As a result, *Born in Flames* provides a range of possible identifications, which reflects Borden's aim to appeal to a broad audience that crosses race, ethnic, generational, and class lines. The result: critics praised it, women embraced it, and it quickly became a touchstone for a freewheeling and spirited style of independent filmmaking. As *The New Yorker's* film reviewer put it, Borden is "far more imaginative and farsighted . . . than many celebrated Hollywood figures, because she sees the plot from a wide range of perspectives and circumstances."[6]

Borden's next feature, *Working Girls*, reflects her abiding interest in women's labor with its day-in-the-life look at 10 prostitutes working in a middle-class brothel in New York. Inspired by her association with COYOTE, a coalition of feminist activists working to legalize prostitution, and her own visits to apartment-based brothels, Borden again sought to open a dialogue—this time about prostitution as labor, rather than as a moral or psychological issue. After the long, arduous, and sometimes overwhelming process of shooting and editing *Born in Flames*, Borden opted for a more focused and contained approach in *Working Girls*, by writing a script and limiting the shooting schedule to a few weeks. The result is a film that brilliantly demythologizes Hollywood's then (and perhaps still) conventional approach to prostitution, in which "working girls" are often tragic yet eroticized figures with little agency and fewer options. The film earned considerable praise

among critics for refusing the more familiar male-oriented fantasies of objectified women's bodies and mutual ecstasy.

Less oriented to plot than characterization, *Working Girls* offers a frank and nuanced view of prostitution with a "backstage" vantage point of the women as they perform for a procession of male clients and engage in the mundane and less than glamorous preparations for their brief sexual exchanges. The protagonist, Molly, is an Ivy-League graduate with dual degrees in English literature and art history, whose part-time yet lucrative job helps to support her aspirations to become a professional photographer as well as the quiet life she shares with her lesbian lover and child. Although Molly's co-workers are a fairly diverse bunch, most of whom have plans for other careers, they share a forthright attitude about their current choice of employment and its economic benefits. Further, as Molly and her colleagues casually chat between appointments, much is revealed about the differences between their non-working personas and their performances with clients, with whom they fake pleasure and emotional involvement. However, also importantly, Borden's depiction of the male clients is neither disparaging nor reductive, and viewers are not encouraged to identify with or to pity them. Like *Born in Flames*, *Working Girls* enjoyed another high-profile premiere, at the Cannes Film Festival; thereafter, it took the Special Jury Recognition Award at the 1987 Sundance Film Festival.

Most recently, since *Born in Flames'* restoration in 2016, Borden has traveled widely, both nationally and internationally, to prestigious festivals and special event screenings where the film has found new audiences and critical acclaim for its continuing resonance and astonishing prescience. She also remains committed to being a filmmaker and is currently in the process of developing several projects for film and television.

This chapter includes an interview with Borden originally published in *The Independent Film & Video Monthly* in 1983, along with an original interview with Borden from 2018.

"Everything Has to Fall Apart Before It Comes Together": An Interview With Filmmaker Lizzie Borden

Jan Oxenberg and Lucy Winer/November 1983

The Independent Film & Video Monthly

Lucy Winer: It's rumored that your film took approximately seven years to make. A lot of serious independent filmmakers can relate to that, especially given the very positive outcome of this process.

Lizzie Borden: Actually, it was closer to five years. I began *Born in Flames* differently than other people begin their films. I saw filmmakers I knew sitting with whole scripts, waiting two years, three years, for money and yet once they got the money they would do their film in a year. So, they say the film took one year, not four. I wanted to be

	working, so I jumped in with very little money, and had to keep making the film over a long period.
Jan Oxenberg:	Did you re-shoot a lot?
Borden:	Definitely. Very often the original shooting served as a script for what ended up being a secondary shooting. So, for example if I thought a progression of thought was A, B, and C, I would find that A and B was really A and L, so I had to fill in from B to L with other kinds of material or scenes.
Oxenberg:	Did you originally work from a script?
Borden:	Some parts were highly scripted—for example, all the newscasts and the FBI material. But those parts happened closer to the end of the movie. At the very start, there was the idea of making a film that took place after a socialist kind of revolution. I had been reading a lot of socialist women: Alexandra Kollentai, Rosa Luxemburg, and anarchist writings. I discovered more and more when it came to real creative social transformation that would completely put the desires of women in the forefront, it never happened. The idea of creating a situation where all that was pulled into the foreground was one of my initial premises. Another premise was that the death of a woman would serve as a catalyst for various groups to get together.

I worked with scripts with some of the actresses. For example, there was a script for the woman Adelaide Norris [Jeanne Satterfield] who is killed. But most of the people were drawn from who they were in real life: Adele Bertei played a very opportunistic, punky type; Honey came from an intuitively political background; Flo Kennedy is Flo Kennedy; Kathy [Bigelow], Becky [Johnston] and Pat [Murphy] were middle-class literary intellectual types [they play the editors of a Socialist Youth Review], sort of like the background I came from. But Jeanne Satterfield was not at all like the character she played. At first, I tried improvisation, but it didn't work. She worked better with a very very tight script. I worked differently with everyone until a way to work with each person evolved.

For me, a lot of the process of doing the film mirrored the process of co-existence I wanted to have with those people. One reason for doing the film came out of that sense of splitting the segments of feminism in different women's cultures. I was very distraught coming to New York and living here a long time and finding that this group of feminists didn't deal with that group of feminists. And how many Black women did I know? None. How many [Latina] women did I know? Class and race really did divide people, and just a *slightly* different political stance divided middle-class women. So, the film was really about creating a context and reason to work with very different kinds of women. That was what developed the script.

Oxenberg: Now that the film is done, there is a script.

Borden: Now there is a transcript!

Winer: Your film has a very marked style. It seems that what are tradition-ally considered negative telltale signs of low-budget filmmaking—for instance, grainy images and erratic camera style—have not only been used but used to stylistic advantage. The choices, the variations, seem very thoughtful.

Borden: My feeling was that if I really pulled these women from such different places, why should they all be represented in the same visual style? And I also wanted to make a style that looked shot-off-the-hip, like anyone could shoot it, so that it wouldn't be an alienated voyeuristic thing—beautifully posed shots with skin gleaming in the moonlight. In fact, it turns out that I couldn't use some really gorgeous shots: they were too pretty!

Also I was trying to construct a world that was a future world without having an expensive mise-en-scène or everybody running around in togas or driving 21st-century cars. I was going to use news stuff and fake news on video to represent the world. And I wanted to mingle styles and textures. It's all about trying to change what could be negative into virtues. Consider working with non-actors: if you let non-actors talk too long, it's going to fall apart real fast. So, I counted on short pieces. And I wanted the cutting to be very aggressive and very raw—to lead to ambivalence. I used the device of the newscasters constantly talking directly to the audience, and the underground radio station constantly talking to the audience, so that the question of *what* one is watching would be constantly thrown back. I don't know how successful the technique has been because some people still take the film too literally, as if I'm advocating urban guerilla warfare, which I'm *not*. I wanted to set up a dialectic in the film between the present and the future. Are these people real or are they actors? Are you seeing just the surface or are you seeing something to fall into as fictive space? And similarly, at the end: Is this a solution or is this not a solution? So that if one would say "NO!" really loud after the last shot of the movie, that's what I would want. Let's talk. Let's reopen the lines of communication.

Oxenberg: Although the film is very American in a lot of ways with the newscasts and so on, there seem to be a lot of European political references, specifi-cally: the jail suicide, the urban terrorist, and lesbian feminist groups. Is the film better received politically in Europe? Also, the political language of the film seems to be very much of the late sixties, early seventies. Do you feel *Born in Flames* is still politically relevant?

Borden: I made the film because it seemed that people now were either com-pletely cynical about the effectiveness of any kind of political process or burned out and caught without any kind of language. It seemed important to re-ask certain questions, and to re-ask them as mediated

through Europe, where the left is still a very vital force. If it relates to the sixties, it's only because that energy of the sixties was so good—not just here but in Europe too. Where has that all gone? Someone pointed out to me that the actual verbal language is very old-fashioned, although the images are not. How do you revive and reaffirm an old language and make it become something new?

Winer: Jan and I were talking before about how smart you were in not making those very trite choices about describing a future time: changes in dress or hairstyles, or colloquial language, cars or whatever, certain small details in the environment. How much more convincing your approach was in allowing the audience to accept that this was at some other time—whether it was a year away or 30 years was neither relevant nor that important. And why did it work (because not even the dungarees were different!)?

Borden: A lot of that was the devices, for example, a Black mayor named Zubrinski tells you it's 10 years after the revolution. You can't ever forget it because you are constantly reminded. Take the short scenes: you're still in one scene when the next happens, so the juxtaposition of the two helps create that feeling. Every time you don't believe it's the future, something else will turn around and cry: "No, no, no, this is the future." My biggest fear was that it would just not work, that people would say: "Oh come on, this is ridiculous." I'm glad that you say that the time warp works for you. As for the European response, New York is an exotic place to Europeans as opposed to New Yorkers or Americans, for whom New York is just a dirty place.

Oxenberg: It's exotic to me.

Borden: That's because you live in Brooklyn.

Winer: Do you consider *Born in Flames* a science fiction film?

Borden: There are two science fiction points in the film. One, it takes place in the future, and two, women work together across race lines quicker than they would work with men of their own racial background.

Oxenberg: At what point in the process of making the film did the device of the newscaster become the unifying element?

Borden: That's important—that and the FBI. The FBI is one element I would probably redo, either making it more prevalent or more sinister.

The newscaster was a device to let the viewer know something about the world and the groups within it. And it also relates to the film's small budget. It allowed me to show pieces of something happening so that we could believe this was not only how the world *was* but more important how it was being *interpreted*. The two radio stations represented the outlook of a whole group of people. The newscasters could talk directly to the audience almost like a Greek chorus. When important issues came up, either Adele or Honey could speak about one side on radio and the newscaster would relate another side.

Oxenberg: The style of the newscasts is totally of the present, and yet, the content is futuristic. I thought that worked really well—you felt not only the tension but the irony of these particular facts being reported to you in an incredibly shallow 1980s style.

Borden: A future just like the present always seems more chilling than a future that's different. A different future makes it easier for the audience to think "it will never be like that."

Winer: It worked. That was a very wise decision.

Oxenberg: How do you feel about the language of the political speeches?

Borden: It's not about the language—during those heavy speeches, I tried to offer something fun to look at, like lots of images or some music or whatever because I don't take the speeches too seriously, and in fact they critique themselves within the film. But, for me, it's revolutionary to show women like that working together, just presenting those images. In fact, there was a time Honey was living in my house, Adele was living in my house, another woman was. And that was great because I shot so much on the spur of the moment. I could just shoot immediately, and everyone did everything. What was interesting for me was that sense of them really learning to do everything and understanding how a film was constructed. So, everyone was involved in doing many different parts of the film. I was doing the soundtrack for most of the film. But when I was shooting, someone else would do sound, someone who had never done it before. But a lot of them were musicians, and that was fine, and some could handle it better than I could. It was fun, and it really changed my life.

Oxenberg: How?

Borden: The people I see every day at this point are different from the people I saw every day then. And the questions I ask myself about the function of film are very different. I am very aware that I would like the film to be seen outside of the film ghetto, outside of the downtown scene. It's important to me when I see some of the relatives of the Black women who were in the film liking the film because they wouldn't normally go to films like this. The most important things in life are the smallest: who you speak with every day.

Oxenberg: Why did the film take so long to make? One would assume it was strictly for practical reasons, fundraising and so on, but were there any creative reasons for taking so long?

Borden: They go hand in hand. At a certain point if I had received all the money I needed to finish, it would still have taken that long because once you start a process, it's a slow process. I can't just say, "Oh, I have the money, we can go shoot 50 scenes and finish the film." I had started a kind of organic process which had to evolve at its own rhythm to have a kind of complexity. If you shoot 50 scenes, they are all going to be a single piece—and it doesn't matter how brilliant you are. If you want things to occur in a different way, you can't operate like that. And I am also very slow. I feel more comfortable as an editor than as a director. The

wonderful thing about being an editor is you can take forever and do the stupidest things, and no one sees how stupid you were. And some of the stupid things end up being quite wonderful so you can keep them. But then others you can hide. For me, the editing process was very very long, and I worked constantly and really loved experimenting.

The other thing was that I knew what the subject was but I didn't know what the unifying or organizing elements were going to be until the last year or the last two years. So, at every moment I felt I had a mass of material which was going to fall apart before my very eyes and some people who saw it then thought: "Oh no, how is she going to do it, and why doesn't she work on something else for a while?" But maybe that's what it is always like: everything has to fall apart before it comes together. That happened to me. I couldn't have finished it faster even with all the money. It's a process I believe in, but I wouldn't want to do it again like that right now.

Winer: Were there ever moments or extended periods where you just felt like you couldn't do it, that you would never finish, or that it would be awful?

Borden: I can never conceive of not finishing something. I knew I would finish. I have always had the feeling, which is based on being a writer, that if you keep working on something, it will ultimately work out. But believe me, I got very depressed and freaked out. And I developed weird fears like the loft was going to burn down and destroy everything. But I feel that the loft *can* burn down, I can get run over and it doesn't matter because the film is done! I feel okay. It's wonderful. When I am in the middle of the next film, I think I will probably have the same phobias.

Oxenberg: On your next project would you work this way again? Is it worth it?

Borden: It's worth it, for sure, because, if I had only made four films in my life and they were films that really changed me, I would. Starting at ground zero with everything again would be hard. I would like to combine the two ways of working—some experience and some openness to exploring. The next project is on prostitution and a lot of it is based on an actual place, a very middle-class brothel with ordinary women and ordinary men. I have to shoot it at one time because it involves one place, but I want the liberty to crack it open, to go to other things. I won't be happy unless it has that kind of layering.

A Conversation With Lizzie Borden

Cynthia Felando/2018

Cynthia Felando: *Born in Flames* has had an active second life since the Anthology Film Archives restored it in 2016. What has been most memorable or striking about that experience?

Lizzie Borden: For a rag-tag film made for so little money, amazing. The Anthology restoration in 35mm was so rich, it felt like "real" film, it became another experience. So many people had seen it on VHS or pirated on a bad copy on YouTube. The re-release happened to coincide with a heightened political moment here—the election—so *Born in Flames* became relevant in a way I could never have anticipated. It began to be shown again in the months before the election, the days of rage echoing even more deeply than what I felt when I was inspired to make the film. Now it was echoed by women of my generation in the hundreds of thousands, among millennials, and the youngest, Gen Z. I have learned so much seeing new audiences watch the film and talking to them afterwards. In many ways, I don't see the film as "mine," but as an "entity" I follow around and observe. It has been so interesting to engage with audiences in Q&A sessions around the world. In some ways, it has been my form of activism because I'm really very shy. There are people who saw the film when it first came out, which is wonderful because they share my astonishment—why is the film still relevant? It shouldn't be. Things should have changed more for women since *Born in Flames*, but so much is worse, especially in areas like reproductive rights.

Felando: The conversations among the women in *Born in Flames* are fascinating because they're coming from several different perspectives—and the film encouraged a rich off-screen dialogue too among critics and audiences. Can you talk about that?

Borden: I was trying very hard to present many different kinds of thinking about feminism. Even at the time, the term alienated some groups of women, who preferred the word "womanism." Then, as now, any term used to characterize a group can stand in the way of women accomplishing change. My intention with all my films—*Regrouping, Born in Flames*, and *Working Girls*—is to ask questions, rather than to make statements. I'm always questioned about the last shot of *Born in Flames* when the World Trade Center explodes—what does it mean? It *is* really intended to be a question mark. What would happen after the shot? The film explores the nature and extremes of political resistance, from social protest to armed revolution. What is the right time, the right place, questions asked in particular by Zella Wylie (Florynce Kennedy), who mentors Adelaide Norris (Jeanne Satterfield). But it's not a linear narrative with one point of view: I wanted multiple voices, a chorale, because I didn't want every group of women in the film to merge into a dominant way of thinking. Then, as now, that can result in a failure to move in any direction. I don't personally believe in violence—it would, as one character says in the film, be

41

used against us. We need some kind of "underground railroad" to help people at risk. And although I'm an ardent feminist, I understand why some women don't like the term. We have to find ways to talk—and when to shut up and listen.

Felando: There are several compelling moments in *Born in Flames* that parallel recent events in the States, like the World Trade Center and 9/11, and the suspicious death of Sandra Bland, who was found hanged in her jail cell in Texas after being arrested in a traffic stop. Can you talk about those moments?

Borden: I think it was in the air. The World Trade Center was a phallic symbol that we loved and loved to hate. But I am bereft it is gone. Police violence was present, even then, but a young man commented in a Q&A recently that there isn't enough police violence in *Born in Flames*. I later realized that, in the last few years, there has been so much extreme police violence that the film must now seem tame. The news footage in *Born in Flames*, which shows a cop slamming a nightstick into a protester's head, used to provoke a gasp. These days, we see such scenes every night on the news. Another question everyone asks is whether I would make the film now. I always say the film couldn't have existed in the 1980s if there had been iPhones. Now everyone is a citizen journalist. They're making *Born in Flames* today. The women wouldn't have had to blow up the World Trade Center transmission tower to, as Pat Murphy says in the film, "take control of the language, take control of describing ourselves." The difficulty now is who is being heard in the cacophony of voices.

Felando: That relates to another question: an issue you've talked about with women's films is that it's not just a problem of parity in production but also a problem of very limited distribution, for domestic and international films made by women. Can you talk about that?

Borden: I've seen amazing films by women around the world while traveling with *Born in Flames* and realized that nobody will see or even count them. There have been major discussions in Hollywood about the lack of parity between women and men in film and TV, which is valid, but they're talking about parity within the existing system. And there are so many amazing women's films being made outside the States that will never be seen because they will never enter the distribution system. Even if they're on YouTube, Instagram, or other platforms, we don't know how to find them. We need alternative forms of distribution and financing. There seems to be somewhat of a contradiction between insisting on more of a "woman's gaze" in film and TV and the admission of more women filmmakers into the "Hollywood system" where, everyone insists, gender shouldn't matter in looking at a finished

product. There are only a few women who are trying to change the apparatus from inside—Jill Soloway, for one, in hiring practices and how rehearsals are structured. Parity is necessary, but it may not go far in achieving originality—there are too many voices to please. There is a lot of originality and uniqueness in films globally. Finding the means to bring them to audiences in the States would be groundbreaking.

Felando: *Born in Flames* seems very much like a musical with its many types and styles of performances and songs and music. Had you thought about it in those terms?

Borden: It was the way it came together in editing, as an alternation of montage sequences and more traditional scenes. A rhythm began to develop as I continued to edit which began to feel musical. I wanted the film to have a kind of drive, so I could appeal to people who weren't necessarily interested in listening to speeches. I wanted to give it a "beat" an audience could ride. In order to have the language in there, I built layers with other auditory elements—shouting, street sounds, a piece of a newscast. Ultimately, it was important to me for the film to have a kind of martial propulsion, for people to come out energized.

Felando: Can you talk about the comic moments in *Born in Flames*?

Borden: There has to be dark humor in everything I do. The only fallout is when *Born in Flames* is described as a straight comedy. Then people may be disappointed. Moments like Isabelle from Radio Ragazza entering a bar in a cowboy hat looking for "Honey" is meant to be funny, as is the montage with a shot of a woman wrapping chickens followed by a shot of a woman putting a condom on a penis. If you can make someone laugh, maybe you can seduce them into thinking about more serious concerns. For example, the idea of a bicycle brigade is both wonderful and crazy—where would all the women be hiding? So, I poked fun at it when Honey's roommate, Alexa, says, "the Women's Army isn't mature enough to hang out with me." But it would be so cool if there were brigades everywhere and one does exist—the Ovarian Psycos, on the East Side of Los Angeles.

Felando: *Born in Flames* has been called a science fiction film. Do you agree?

Borden: This is also where people can be disappointed: when *Born in Flames* has been labeled a sci-fi film on Netflix or Amazon, it was sometimes savaged. The film only has a science fiction premise—that it takes place in the future after a Social-Democratic cultural revolution. I wanted to explore what happens when the Marxist "woman question" is pushed to the side, and women are still considered second-class citizens. I think it has more fantasy elements. It has been strange to see the film over the years because it was

filmed against the backdrop of 1980s New York—those were our "film sets." Now *Born in Flames* looks more sci-fi, even dystopian, since so much has been gentrified.

Felando: Were there other films or filmmakers you were thinking about while making *Born in Flames*?

Borden: I'd studied art history and was trying to be a painter. I was writing art criticism, after being invited by Robert Pincus-Witten, when I was still a student, and I was thrown in the middle of the downtown art scene, so I met everyone, which was so heady. The work that interested me most was women's performance art, although the dominant art of the time was minimalist. Some of the artists—as well as the dancers and multi-media artists made experimental video, Super 8, 16mm pieces film and video—Richard Serra, Joan Jonas, Vito Acconci, Yvonne Rainer—mostly to be shown in galleries. There was an atmosphere of creativity—artists, musicians, performance artists, painters, sculptors, dancers. But I was increasingly influenced by feminism and I also felt alienated politically from punk filmmakers because many of them weren't political. I do remember being inspired by a retrospective of Jean-Luc Godard films—some were agitprop and narrative at the same time, some had direct address. I also liked the rambling messiness of John Cassavetes's films, like *The Killing of A Chinese Bookie*, and Gillo Pontecorvo's *The Battle of Algiers*. I borrow a shot from *The Battle of Algiers*—when Ron Vawter as the FBI agent draws the structure of the women's army—with the idea that, after all the women are arrested, another wave of activists will take their place. If I had gone to film school, *Born in Flames* wouldn't exist because I started with a premise but had no idea where it was going. I loved the idea of montage and was editing for some downtown artists and filmmakers at the time. I collaborated with my friends, Sheila McLaughlin, Bette Gordon, Becky Johnston, etc., and the longer I worked on *Born in Flames*, the more I tried to make it move more quickly since I didn't like long boring art films. I grew to love Chantal Akerman's film, *Jeanne Dielman*, but didn't appreciate it at the time.

Felando: One of the things that unifies *Born in Flames* is its celebration of women. The montages that show real-life women at work and responding to and smiling at the camera add a lot of depth and texture. How did you and your camera crew work to capture those moments?

Borden: I didn't always have a crew. I had a camera. And a car, illegally, which I parked in the street with a fake film permit. I took random shots when I drove around—like the girls dancing in a street, Honey hanging out with the drunk men on the corner—and

wove them into montages. Some of the dolly shots were made with me in a wheelchair being pushed through an office and the Grand Union grocery store. The women may have been smiling because it looked so absurd, and also because they were supposed to look happy because of the "Revolution." The montages were designed to contrast traditional women's work with what, in the film, Adelaide was fighting for—to do construction jobs. Sometimes my crew was me; sometimes me, a camera person and a sound person; sometimes five or six people for scenes like the jacking of the U-Haul trucks.

Felando: Can you talk about the importance of collaboration in your films?

Borden: *Born in Flames* wouldn't exist without collaboration behind and in front of the camera. It grew from the premise of "who could be most disadvantaged if women were pushed to the side after the 'Revolution'?" Black women, especially Black lesbians. The problem was that I didn't know any. Most women downtown, like me, were white and middle-class. So, I went to lesbian bars (The Duchess and Bonnie & Clydes), where I met Alexa. She wasn't interested, but Honey, her roommate, who described herself as a "singing evangelist," committed. I found Jeanne (Adelaide Norris) playing basketball at the McBurney YMCA. I knew Adele from the downtown music scene and Kathryn, Becky, and Pat from the art world. I can't remember who introduced me to Flo Kennedy or why she committed to this little film, but she became its godmother. The women who played leaders of the Women's Army came from various places—theater groups, artists' groups. It was especially hard finding straight Black women who would come down from Harlem.

I'm still grateful these phenomenal women stayed with it for so many years, but they put their words and hearts into the film. Honey interpreted her speeches as a kind of soft "rap," Adele wrote her passionate ones, and Flo was uniquely Flo—we never knew what she would say. Pat Murphy, who came from Northern Ireland, contributed her own political thoughts. At the end of the day, I sometimes reshot narrative sequences from improvised ones and wrote text for the FBI agents and the newscasters. The film isn't a documentary, although it does use some documentary techniques. I didn't know where it was going to end up. I was open to exploring where the premise led me.

Felando: Did you ever think it wouldn't come together?

Borden: Sometimes, even two years into the process. There were times I was filled with great anxiety. And there were financial problems. And there were breakthroughs. In the end, what made it work

was that I kept editing. The film was essentially "written" on the editing table. A few years ago, I had a battle with the Writers Guild, because they insisted the film wasn't "written" at all because there is no screenplay credit. I didn't feel it was right to give myself one because a script didn't exist before production started—it would have felt wrong taking credit for the amazing work Adele, Honey, Flo, Pat, Kathryn, Becky, Jeanne, Marty, Hillary, and others put into the film. Yet some scenes were written after they were improvised and reshot; the FBI and newscaster scenes I mentioned before. I feel that editing is a form of writing. *Born in Flames* is a strange hybrid.

Felando: How did you know when *Born in Flames* was finished?

Borden: I would have kept editing if Ulrich Gregor from the Berlin Film Festival hadn't seen it on the editing table and told me he'd include it in the next edition of the festival if I finished it, so I did. Otherwise, I might have kept going.

Felando: How did your work on *Born in Flames* inform what you did on *Working Girls*, for which you wrote a script?

Borden: I wanted to make a film that was more contained in time and scope. Working on something as open-ended again was too overwhelming. I wanted to make something I could control. I limited it to a day in story time and built a set in my loft.

Felando: With *Working Girls*, you avoided Hollywood's tendency to objectify women's bodies. Can you talk about that?

Borden: This brings up the idea of "the female gaze." *Working Girls* is a backstage story, so it's from the women's point of view of the men and is sometimes comedic. The view of their bodies is their own and from a woman's perspective. It was intended to be a kind of anti-pornography, anti-erotic. I am a pro-pornography feminist, but *Working Girls* is more about money and labor. I was lucky because I had some money to get started and then I found two amazing producers, Andi Gladstone and Margaret Smilow. I had women all around me—Judy Irola, the DP, and J. T. Takagi, who did sound. There were men on the crew as well, but they were cool. Even in this context, it can be difficult for actors to perform without clothes, so I'm really appreciative of Louise Smith—who played the lead role and was a theater actress who'd never done nudity before—and the other actors who were also nude in their scenes. The Screen Actors Guild looked at the script and said, "We don't handle this kind of script; it's pornography. You can do anything you want." That meant I was able to pay what I could afford: $75 a day. It was hard to find actors for all the parts, and some of the performers weren't professional actors; I found Asian actors from *Backstage*, for example. Ultimately, it's

about financing—there can be a struggle with producers if they want an "erotic" film and their idea of erotic is the traditional or "male" one; or, if a woman's idea of "the erotic" is derived from male-generated porn. We are in an interesting moment now with the #MeToo movement; and a potential over-reaction to pornography could lead to a backlash.

Felando: Seeing *Working Girls* enabled me to really understand what it was like to be outside the male "gaze," so it seems odd when reviewers describe *Working Girls* as a more "Hollywood" film.

Borden: I think the whole "Hollywood film" idea is such a misnomer because most films aren't financed that way anymore, even films with much larger budgets than *Working Girls*, which only cost about $200,000. It was a tiny festival indie, even though it was distributed by Miramax—one of Harvey Weinstein's early pick-ups from Cannes.

Felando: Can you address what you think has changed, or not, for women?

Borden: With *Born in Flames*, as I said, I'm angry that women's issues have regressed. And *Working Girls* has been shown in benefits against SESTA, the anti-sex trafficking law, because the law is so dangerous for sex workers. But it is easy to forget how much has evolved since the late 1980s, especially in terms of the fluidity of gender. I think some women in *Born in Flames* might have chosen a sex change if it had been more available at the time. I am often asked if I was thinking about "intersectionality" when I made the film. The term hadn't been coined yet, but I think the film in itself manifests the term. When *Born in Flames* was first shown, some audiences were shocked to see so many Black lesbians on screen. Now I'm sometimes criticized for not having enough Latinas and Asians in the film. That's progress! But I feel sometimes that intersectionality is such an academic concept. Within classrooms and in safe places in certain cities, the spectrum of otherness can be debated, written about, and lived. But I live in West Hollywood and a mile away, in Hollywood, close to where *Tangerine* was filmed, there is a trans beating or killing every few months. And the class aspect of intersectionality has hardly begun to be dealt with in "real life." I'm only aware of this because of *Born in Flames*, because of Jeanne, Adele, and especially Honey, who came from a poor family in Brownsville, N.Y. She was sometimes mistaken to be male and raped several times, both as a young girl and during the time I knew her, so I'm also hyper-aware of how women, who are not in a spotlight of attention, are treated when such things occur—and how far the #MeToo movement still has to reach.

Felando: Has *Born in Flames* reached the audiences you'd hoped it would?

Borden: Not enough people of color have seen *Born in Flames*. It has only been available to women of color on YouTube, in a pirated version. I will have to see what to do about that.

Felando: Which women filmmakers are you following these days?

Borden: The work I've loved since making *Working Girls* has all been from a definitive woman's point of view: everything from Jane Campion, to Andrea Arnold, Lynne Ramsay, and Jill Soloway. I don't mind being called a female filmmaker: it's a signal that you're going to see the world in another way.

Notes

1. Janet Maslin, "Film: 'Born in Flames,' Radical Feminist Ideas," *The New York Times* (November 10, 1983).
2. Teresa De Lauretis, "Aesthetic and Feminist Theory: Rethinking Women's Cinema," *New German Critique* (Winter 1985): 154–175.
3. Quotation from *Regrouping*: it's from the intertitle in the film itself.
4. Lizzie Borden. Interviewed by Cynthia Felando on April 23, 2018.
5. Ibid.
6. Richard Brody, "The Political Science Fiction of 'Born in Flames,'" *The New Yorker* (February 19, 2016).

5

LISA CHOLODENKO (1964–)

Holly Willis

Lisa Cholodenko was born in the San Fernando Valley, just north of Los Angeles, California, in 1964. She left Los Angeles to attend San Francisco State University (SFSU) as an undergraduate where she majored in Interdisciplinary Studies, which meant bringing together classes in gender and ethnic studies and anthropology to create a unique program of study. While at SFSU, she had the great fortune not only to take a class with writer and political activist Angela Davis, but to serve as her teaching assistant. Cholodenko graduated in 1987, and in 1990, she began to study film and enrolled in a summer immersion course at Stanford University.

After college, Cholodenko traveled internationally before returning to Los Angeles, where she worked as an apprentice editor on John Singleton's *Boyz n the Hood* (1991). Intrigued by filmmaking, in 1992, she applied to and was accepted by Columbia University, where she studied directing and screenwriting with mentors including James Schamus and Milos Forman. She graduated in 1997 with her MFA having made award-winning short films, including *Souvenir* (1994) and *Dinner Party* (1997), while also writing her first feature film, *High Art* (1998).

She went on to direct *High Art*, which became a landmark feature in the independent filmmaking scene of the 1990s. The film stars Ally Sheedy as Lucy, a once-celebrated photographer now living in a heroin-infused obscurity, and Radha Mitchell as Syd, an art magazine assistant who lives downstairs and becomes intrigued by Lucy. *High Art* earned numerous awards, including the Waldo Scott Screenwriting Award at the Sundance Film Festival, and garnered acclaim for Sheedy's angular performance. Described by Roger Ebert as "so perceptive and mature it makes similar films seem flippant,"[1] and as "essential viewing"[2] based on Sheedy's performance by Gavin Smith in *Film Comment, High Art* demonstrates Cholodenko's astute writing skill as she deftly captures the nuances of the relationship between Lucy and Syd, allowing for a kind of complexity rarely seen between women onscreen. The film's pale palette and subtle visual style at once set the emotional tone for the story while refusing the garish look one might associate with a story of New York sex and drugs.

Cholodenko followed *High Art* with *Laurel Canyon* in 2002, yet another complex character study that she both wrote and directed. The film chronicles the ups and downs of two relationships—Jane (Frances McDormand) and her boyfriend Ian (Alessandro Nivola) and Jane's son, Sam (Christian Bale) and his fiancé Alex (Kate Beckinsale)—who end up sharing a house in the Laurel Canyon area of Los Angeles. Jane and Ian are musicians recording an album together, while Sam and Alex are in the early stages of their respective medical careers. Lifestyles clash, couples begin to rethink the stability of their relationships, and, as in *High Art*, desire offers a pathway to self-discovery. Also, as in *High Art*, the film refuses to capitulate to any of the strictures of traditional story structure. *Laurel Canyon* retains a staunch commitment to conveying the messiness of relationships with honesty.

In 2004, Cholodenko made the Showtime feature *Cavedweller*, which is based on Dorothy Allison's second novel of the same name published in 1998. Set primarily in small town Georgia, the story follows Delia (Kyra Sedgwick) as she takes her 12-year-old daughter from Los Angeles back to the family she left a decade earlier. The film explores the emotional upheaval of the reconfigured family, which includes Delia's abusive husband (Aidan Quinn), now dying of cancer, as well as two other daughters, who fully resent their mother's surprising return. The project features the hallmarks of Cholodenko's work, with complex family dynamics, emotional storytelling, and an interest in uncovering a hard-won truth.

For her third feature film, *The Kids Are All Right* (2010), Cholodenko teamed up with screenwriter Stuart Blumberg to co-write the script for a film about a family headed by Jules (Julianne Moore) and Nic (Annette Bening) whose two children, conceived through artificial insemination, decided to find and get to know their biological father, Paul, played by Mark Ruffalo. Once again, a family's quotidian coherence is disrupted by an outsider, and the story unfolds in a way that swerves away from the politically correct to investigate the emotionally true.

During the writing of the film, Cholodenko herself got pregnant with her partner Wendy Melvoin, a musician and songwriter, through a sperm donor, and their son, Calder, was born in 2006; similarly, Blumberg had donated sperm while a college student, so the co-writers could draw on their own experiences and shared questions as they worked on the screenplay. The film, which was shot in 23 days on a budget of $4.5 million, was nominated for dozens of awards for the film, screenplay, and performances by both Bening and Moore. It won for Best Screenplay at the 2011 Film Independent Spirit Awards and was nominated for four Academy Awards in the categories for Best Picture, Best Performance (for Bening), Best Performance by an Actor in a Supporting Role (for Ruffalo), and Best Writing in an Original Screenplay.

Cholodenko's next large-scale project was the HBO miniseries *Olive Kitteridge*, which aired in the fall of 2014. An adaptation of the 2008 Pulitzer Prize-winning novel by Elizabeth Strout, the project chronicles the life of an acerbic school teacher, played by Frances McDormand, who lives in rural Maine with her husband, Henry (Richard Jenkins). Olive is cranky and depressed, as well as hilarious and feisty, with a sharp tongue and complex feelings, making the project perfect for Cholodenko, who attends fully to the shape of Olive's life as it twists and turns through grief and loss over 25 years.

While Olive may have been featured as a curious oddity on the sidelines in a traditional narrative featuring younger characters, Cholodenko recognizes and honors the pathos embodied by Olive as she struggles to understand who she is and why she is so unhappy. The four one-hour episodes were not written by Cholodenko—they were adapted by Jane Anderson—and Cholodenko attributes the success of the project to the combination of incredible source material, a great script, and a terrific cast. However, its power may also stem from the fact that Cholodenko approached the project like a film, working closely with cinematographer Frederick Elmes to achieve a specific visual style inspired by classic American paintings of the east coast while also attending to the full arc of the story across its four hours. The shoot lasted 60 days and involved having the main characters age across more than 25 years, but the project never feels choppy or disconnected. Instead, it boasts an elegant if cool coherence that is truly gripping. The show aired in the fall of 2014, two episodes each night for two nights in a row, and it subsequently earned more than 30 industry awards and nominations, including an Outstanding Directing Award from the Directors Guild of America for Cholodenko and an Outstanding Performance Award from the Screen Actors Guild for McDormand.

While *Olive Kitteridge* is cinematic and provided a unique filmmaking experience, Cholodenko has also worked in more traditional television, with a long list of directing credits for episodes of *Homicide: Live on the Street, Six Feet Under, The L Word, Hung, The Slap*, and *Here and Now*. She states that she approaches this work as a hired professional, spending a good amount of time on preparation and ensuring that she gets the job done on schedule.[3]

Although she has never wanted to focus specifically on identity politics in her films and television work, Cholodenko has nevertheless consistently showcased gay and lesbian characters, a fact that is perhaps only remarkable in an industry that for decades has marginalized them. Despite her reticence to be labeled in any particular way, Cholodenko was recognized and celebrated for her work in 2015 when she was awarded the Visionary Award at the Outfest Legacy Awards. In addition, *The Kids Are All Right* was recognized by GLAAD (Gay & Lesbian Alliance Against Defamation) Media Awards, earning an Outstanding Film award in 2011. At that time, GLAAD reported that *The Kids Are All Right* was the largest release for a film about a lesbian couple, which in turn sparked greater scrutiny of the story, with some being critical of the fluidity of desire among the characters. To her credit, Cholodenko defended her characters, noting that there can be a distinction between sexuality and sexual orientation.

Cholodenko is currently working with Stuart Blumberg on an English-language adaptation of the German film titled *Toni Erdmann*, which was originally directed by Maren Ade and nominated for the Best Foreign Language Film Academy Award in 2017. Cholodenko says she appreciates the eccentricity of the story, and notes, "There were a couple of years where I was underground, writing and catching my breath, and now I'm back."[4]

This chapter includes an interview with Cholodenko from 1998 originally published in *The Independent Film & Video Monthly*, along with an original interview with Cholodenko from 2018.

Lisa Cholodenko: High Art

Lawrence Ferber/June 1998

The Independent Film & Video Monthly

Jeremiah Bosgang's autobiographical *Good Money* cinematically recounts the tale of a successful TV network executive who ditched his comfortable LA life for the dream: existence on the other side of pitch meetings, creativity and, god willing, writing for *Saturday Night Live*. Bosgang's legend was considered unusual enough to win him an appearance on *Oprah*, but Lisa Cholodenko's story isn't too far removed. The raised-in-Encino daughter of a graphic designer and elementary school principal lucked into a position at the American Film Institute, which led to an interest in editing and eventually to assistant editor gigs on studio features, including *Boyz n the Hood* and *To Die For*.

It's here that life number one ends. Instead of settling into a potentially comfortable and lucrative career as studio editor, Cholodenko skipped coasts for Columbia University, determined to be an auteur herself.

"It was frightening to take on a bunch of debt to go to film school and move to New York and bag this thing," says the 33-year-old director. And now? "I feel like, hey, I showed them." Cholodenko laughs, then continues soberly. "Even though, you know what? I'm still penniless. I was better off in 1992 working as an assistant editor."

Then Cholodenko quickly volunteers, "I actually just signed with an agent I feel good about, Bart Walker at ICM. I think we're going to end up setting up some sort of situation where I can get paid to write the next script."

She hardly regrets her decision to go to film school. "For me it was a great idea. It gave me a lot of confidence. I hooked in with a [screenwriting] professor there, Brendan Ward—a great guy, really idiosyncratic—who I worked with for three years. . . . About directing, that's the sort of thing you learn by doing, and that's what film school gives you the opportunity to do. I probably worked on 20 projects." To boot, Cholodenko found herself under Milos Forman's wholly encouraging mentorship. "I respect him a lot, so I thought that was a good sign. I don't think he'd be telling me to waste my money if he thought [*High Art*'s script] was schlock. It was a good kick in the pants."

Though Cholodenko crafted two shorts of merit, *Souvenir* and *Dinner Party*, *High Art* marks her feature debut. Snagged by October Films at Sundance, *High Art* graces screens beginning this month. The lesbian love story involves Syd (Radha Mitchell), an assistant editor at *Frames* photography magazine, who lives a settled life with her boyfriend (Gabriel Mann) until meeting upstairs neighbor Lucy (an astoundingly grown-up Ally Sheedy). A prematurely retired photographer of renowned brilliance, Lucy is shacked up with her girlfriend Greta (the priceless Patricia Clarkson), a former Fassbinder crony and heroin addict. As the neighbors' friendship deepens, Lucy opens many doors for Syd—sexually, careerwise, and escapist. Inspired in part by Cholodenko's own introduction to New York's "heroin chic" scene in 1992, the

story initially revolved around Syd's near-ruthless careerism, yet eventually matured into a complex and compassionate character study (which netted the 1998 Sundance Festival's screenwriting award).

Cholodenko's script is not *High Art*'s sole impressive element. There's also its lustrous, pastel sheen—a polished look that belies low budgets and suggests skilled hands all round. Cholodenko praises Director of Photography (DP) Tami Reiker, whose glowing, silky work calls to mind DP Ellen Kuras. "A lot of the budget went to getting her the equipment she wanted," recalls Cholodenko. "We did something called flashing the film, which is to expose it one or two percent prior to shooting, which added a little bit of that blown-out Cassavetes look. We let coverage go in lieu of getting the right lighting conditions."

The film also boasts rising producer Dolly Hall among its three producers. Hall's *The Incredibly True Adventure of Two Girls in Love* ranks as Fine Line's highest grossing film of 1995, and its director, Maria Maggenti, was one of the links between Flail and Cholodenko, whose neighbor, Alex Sichel, directed Hall's *All Over Me*. Flail became serious about making *High Art* circa 1996, playing a heavy role in supervising the script's drafts and in casting. Jeff Levy-Hinte and Susan Stover also played not-to-be-underestimated roles as Cholodenko's producers. Thanks to their combined efforts, a crack crew (heavily female) was assembled. And the rest is history.

With *High Art* falling under the category of "lesbian film," sexuality comes up. Cholodenko is openly gay but has mixed feelings about being considered part of the New Queer Cinema movement.

"I think there are always going to be gay characters and themes in my work. [But] I don't want to be in a ghetto; it's time for us to transcend those borders," she says. "This New Queer Cinema thing was very specific and very important in a moment, [but] I'm not sure it's all that relevant now."

"I would really like to establish my own voice. I feel pretty passionate about writing. I guess the writer/director thing appeals to me, and we'll see how it goes and how long it takes me to crank these things out, since that's part of it too. It took me three years to get through *High Art*."

But some would say that time produces the finest wines.

A Conversation With Lisa Cholodenko

Holly Willis/2018

Holly Willis: You are well known for being a writer/director and someone who attends carefully to story. Could you start by talking about your writing process?

Lisa Cholodenko: Everything that I've written has been in different circumstances. The first two scripts are mine alone, and the third one, for *The Kids Are All Right*, was with Stuart Blumberg. I wrote *High Art* when I was a student at Columbia and it started out as a script assignment in a screenwriting class in my second year there. It was a very

cocooned environment, in a way, and I could write and get a lot of feedback. There wasn't so much of the inner critic lurking around then, so, in some ways, that was my most pleasurable writing experience. It felt much more fluid and less encumbered than other work that I've done as a professional. There was less at stake in a way.

When I was a student, there was more emphasis from teachers encouraging us to be with our subconscious and just write, or just "blurt." They told us, just lay it down and see what's on your mind and don't censor it; just work with the mess. That was the first style that I worked in, not knowing what the beginning, middle, and end are. But as it turned out, I did know the end of that story for *High Art*, and in a way, in retrospect, that's what made it such a pleasure to write.

As I moved on, I realized that I had to find a system. For me creatively and psychically to even endure the work, I had to have a container; I had to have some sense of a frame for the arc of the story. When I was newer at it and hadn't directed that much, I was fumbling around trying to figure out the best way to make that happen. I used to have a lot of legal pads and weird notes and lines where things would break. I really didn't consult a lot of manuals. I was winging it, which was a disservice to myself. I think I could have found more of a structured way earlier and I think it would have been helpful. So my second film, *Laurel Canyon*, was difficult for me to write in that sense because I just didn't have a lot of structural tools. I didn't get that at Columbia, for some reason, or I wasn't listening.

Willis: In writing *The Kids Are All Right*, you worked with a collaborator, Stuart Blumberg. How was it to go from writing alone to writing with someone else?

Cholodenko: It was very different with *The Kids Are All Right* and working with Stuart. First, I found that it was such a relief and a pleasure to work with another person and there was something very synergetic about that experience and birthing new ideas with him. I felt that this elevated my ideas, and that was an amazement. Before that I always felt that I needed to stick with the auteur model and direct what I've written. That was my path. And then when I opened myself up to writing with someone else who had a very different experience than I, it was a revelation. He had come out of the studio system and he was more outwardly comedic and broader, and I realized that there was a way to merge stuff that I was doing that was maybe a little more rarified and internal with his ideas and find something that appealed to me in the balance.

In terms of sensibility, that's what came out of that partnership. But, also in working with him, we together organically came to know what is my working style, which is cards. Rather than outline the whole story as a narrative in prose style, my style now seems to be talking out the story and the beats and the characters and getting a lot of dialogue going and feeling grounded in the world. And then once that feels like it has marinated, we get a stack of notecards and commit to beating out the movie scene by scene. Then we put it together, putting it up on a board and looking at how things track.

That was super helpful with *The Kids Are All Right* because it's an ensemble film and that can be a nightmare to do, tracking a lot of pieces, and I'm sure I would say the same about a film that has a lot of subplots or any project where there a lot of things to track. I know I'm late to the game. It sounds like most experienced writers know all of this, but somehow I came at this backward, so that was a revelation for me a few years into my career that this would be a very helpful way to structure the process without over-determining it in a sense.

With *The Kids Are All Right*, I had started the script on my own and had floundered around with the idea for a few months by myself. I had the characters and the scope of the thing, but the roadmap was completely obscure and I was overwhelmed by it. By the time I got with Stuart, he folded in and we were doing it in my old style and it seemed like we were doing ourselves a disservice. It took about a year into the process with him until we said, "Why don't we just write these scenes down on cards and look at it like that?" And once we stumbled into that process, it felt like getting a great haircut.

Willis: You shot that project very quickly, in 23 days on a budget of just $4.5 million. What was it like to go from the writing process, which took several years, to the production itself, which moved so quickly, and to make the film with limited financing?

Cholodenko: I was shocked and awed when I was told that that was all the financing we could get. It was a very painful moment—I will never forget when my agent called; it was so upsetting. I didn't think it would be so hard. I had actors—I had Julianne [Moore] and Annette [Bening] and I had some track record, so that was freaky. So we put this independent financing together and when he told me what we had, my first thought was, "Forget it. I don't want to do this. I don't want to squander all of the time we spent writing the script and feeling proud of it and then blow it by not having what I need to make a good film."

My agent said, "Look, don't walk away from this. You're going to figure it out. You're going to be inventive. You're going to find a way to do it." He reminded me that some people would feel that it was

a blessing to get that—$3 or $4 million. They would feel fortunate to have that. He said I would figure it out. And I felt like I got my marching orders. I had two actors. I had a script that I thought was really good, and I decided, I'm just going to do it. I don't know how, but I'm just going to figure it out with people who love the project and are down with figuring it out with me. And that was half the battle, I think, just pulling people in who felt passionate about it and wanted to do the best work that they could, even though there were such restrictions. So it was kind of a two-parter: finding those people to come on and support me, people who were ambitious and interested in partnering. And then also I really strongly believe that had we not worked on that script for so many years and knew it on a cellular level, that it wouldn't have gone that well.

Willis:	It must have been so gratifying to earn so many awards and accolades afterwards!
Cholodenko:	Yes, it was vindicating! After all that, right? It's weird sometimes. I was trying to get pregnant during that phase of the writing. We had cast it. We had written a draft that we felt that was pretty good. And we were trying to get financing. And it was a pretty solid cast. I had gotten pregnant, and I believed I could shoot it while I was pregnant. I got a call from my agent saying that Miramax, or the Weinstein Company—whatever they were at the time—wanted to do it. I just took a beat, and not with my agent on the phone, I had to do the internal check. I thought, "I can't make a movie with them and I can't make a movie with them especially pregnant. Life's too short for that." And on top of it, I realized that I didn't want to make this movie yet because I didn't think we had finished writing it. There's something not right about it. And I really believed that. I felt that we just hadn't quite nailed it. And it was the re-casting, with the Annette Bening character, and adding a character that had a comedic edge. That was the thing; that was what we needed. But it took a while to get there.

That's the hard part in making films, or the kinds of films that I make as a writer/director. It's not a science. So when do you say, "This is good. It works. It works for me"? It's weird when somebody calls and says it works for them, and they'll pay for it, and as the director, to have to be in the opposite position you are in and say, "I don't want to make this yet."

Willis:	When you say, "the kinds of films I make," what do you mean? What characterizes your work? Some directors want to entertain, some want to create political or social change, some want to investigate character. If you had to say what unites your body of work, what would you say?

Cholodenko: I think for me it's two-fold. My stuff is very character-driven so it's about the politics of relationships and emotional change. That is what I'm interested in but I never like to comment on something in a direct way, so I think it's getting the tone right in order to express the things that I want, and that tone is not earnest. It's more ironic. I've coined a term—traumedy. It means things that are really difficult and deep but delivered with an ironic or comedic subtext or edge. So yes, that's where I've been coming from in my own work.

Willis: That's a beautiful characterization. Your work isn't necessarily overtly a political form of filmmaking, and yet your exploration of relationships honors their complexity in a profound way.

Cholodenko: I'll just circle back and say that I'm driven to distill something in the end that is a truth of the human condition. I'll never forget first hearing of the idea of something being both surprising and inevitable, or an ending that is both surprising and yet inevitable. To me, when I watch films and you have that sense of, "Oh wow, I didn't expect that, but that's so correct in terms of where this story has gone." That's something that you might not articulate or say in real life. That's what actually got me into filmmaking and feeling like I wanted to be a director. You remember Jane Campion's film *Sweetie?*

Willis: Oh, yes, I do.

Cholodenko: I remember the end of it. I was alone in a theater watching the movie in my early 20s and I said, "Oh my god! Wow, I didn't expect that, but it makes so much sense." She exploded the myth of unconditional love! You're not allowed to do that! So that blew my mind. I thought, wow, filmmaking doesn't have to be overtly political or anything. You can drill down into these really specific emotional things or characters and come up with these truths that are kind of crazy and unexpected. That's what I love. I love getting really, really specific.

Willis: How does that desire carry over into thinking about visual style and things such as the cinematography, lighting, and so on? What do you focus on in order to express these truths?

Cholodenko: I take a lot of care with the visual design. Unfortunately—or maybe fortunately, I don't know—sometimes you don't have a lot of resources. It was interesting to me to go from *The Kids Are All Right* to *Olive Kitteridge* because that was the first time I could really take my time with a cinematographer [Frederick Elmes] and a production designer [Julie Berghoff]. We weren't just winging it or pulling it together and hoping for the best. Everything that I've done has been with real intention, but there has always been a real limitation to how much I could do and when you're shooting that fast because you don't have money and it's such a compressed schedule, you have to make different choices about how you're going to shoot it, what you're going to cover, and it all becomes a little bit of a math problem.

But I think with every film I look at where it's set, what it's about, and what the mood is. What the ineffable thing is. I try, such that I can, with the resources that I have to find the right people to come and know how to articulate that through their medium, whether it's production design or cinematography or something else. The casting of key people is super important to me. Who can I communicate with something that's really hard to communicate?

Willis: And how do you do that on the set, working in the language of emotion?

Cholodenko: I'll take this all the way back to my time at Columbia. I'm really grateful that I landed there because they have such an emphasis on screenwriting. They required us to do so much screenwriting and I still feel today that so much of this filmmaking work is in the screenplay. It dictates everything. Who you cast to help expedite what you want to feel, what you want to say. It should be in the writing, at least to me. For example, with *High Art*, I had very little resources. There was a DP, Tami Reiker, who really understood the film and lived in downtown New York. We came from similar worlds, she got it, and there were some movies that we both really loved and there was a treatment to the film, called flashing the film, that involves exposing some of the negative. It's a pretty high risk thing to do, but that's what we did. It helped create a mood that we were going after, which then related to how we were going to move the camera and what it would look like in that space, and certain juxtapositions, and how we were going to express this drugular world without being over-determined about it.

With other films, it's been a little frustrating to sit down with DPs and go through movies as references. To say, "I want it to look like that," but with a movie that someone else has made isn't as great. I realized this when I was working with Fred Elmes on *Olive Kitteridge*. We weren't working together in the same city until we got to Gloucester, Massachusetts, where we were going to shoot and he said, "When you come out, don't bring movies. Bring art. Let's look at art and other media." So I brought books of painting and photography, and we made a big wall of stuff that wasn't movies. For me it was a very poetic and freeing way to make the movie and feel that it wasn't derivative of another movie.

Willis: Did you consider the work of Andrew or Jamie Wyeth among the painters for *Olive Kitteridge?*

Cholodenko: Yes, for sure. I looked at all of that beautiful American painting. Edward Hopper did a whole bunch of painting in that area in New London. I love him, so that was a big inspiration.

Willis: What is your relationship to your cast members, especially with your main characters, as you prepare for production and then during production?

Cholodenko: I try, with as much time as I'm given, to go through the whole script with the principal actors, and if I'm lucky, many more times than that. And this is not to put it on its feet and perform it, but just to sit and read and talk through it. And then maybe a few times in, the actors can tell me what rings false, or what they don't understand, and then we can adjust it. Maybe I'll do some writing, very minimal, but maybe change some things. And then everybody feels like they know who their character is, and we've covered the bases so that's a big deal.

I still don't know in that moment where the magic will come from because we're not performing it. I wonder, do we really understand it? I learned this mostly from working on *The Kids Are All Right* because I was working with Julianne and Annette who have made many films. At that point, I could be an over-thinker and over-talker and try to get really analytical with the actors, which I know is a mistake. I learned along the way that less is more. It's better for me to hang back, trust the script, trust the prep work we've done, trust the actors I've cast, and see what they bring to it. Once they've laid the groundwork and I feel that they feel safe enough, and that they've found it on their own enough, then, after a few takes if I'm not seeing what I want, I'll come in and make an adjustment, but with very few words. It will be open-ended. I try to be really stealth and not get into their psychic moment. Usually, they are their own instruments and they know how to make adjustments. Maybe there's something wrong with the way it's written or it's beyond any of us. That has happened, and it's frustrating and people get irked. But I end up saying, "Let's just try it this way or that way," and we go through it a few times. It might feel counterintuitive, but you never know when you get into the cutting room. So sometimes I'll ask for a menu of options, and then we move on. And sometimes it doesn't work at all and you wake up in the middle of the night saying, "That did not work! That sucked!" Hopefully that doesn't happen very often.

Willis: Can you talk about your relationship to postproduction?

Cholodenko: It's a funny process and it takes a long time. It requires some faith. You put your movie together and an editor has been sitting there by himself and it's just footage and you want to see an assembly. I don't know about other people, but for me, it's always a painful experience. At first you look at it, and say, "Oh my god! What did I do? That sucks! It's bad! It's never going to amount to anything! It's so this, or that, or the other thing." And then it turns into, "I hate my editor! What an idiot." Then you catch your breath, you settle down, you have a great editor—I really love the guy I've worked with for the last few projects, Jeff Warner. He's super patient and down for it. He's not intimidated by me or frustrated. He's just ready to do the work to get the film to where it needs to be in a very big-spirited way. That's been helpful to me, to keep me

buoyant and to feel like I have support and he can really run with my ideas and not just implement them but augment them.

And this is another thought: casting is such an essential thing. It's also such an ephemeral thing. But it's like casting your partner in life, you know? Who do you gel with? Who gets you? So he's been great. And I think once you get past the trauma of "Oh my god, none of that works," you incrementally start going through it and to me, it just becomes really exciting, once I get past the place where I feel hopeless to where I feel hopeful. The more I understand the script, the more I feel confident about the performances, the more I understand what I want to achieve scene to scene, then I'm like, "Wow, I have it there. I have the tools. I can make myself feel that thing that I think I should be feeling in that scene." All the moving pieces start to come together, and it's hard work but it's really exciting.

Sometimes it's a fight to get more time in the cutting room. It can be the difference between having 12 weeks or 16 weeks, and you get a better film or show if you have the appropriate amount of time to work through the project and get each scene and sequence in the right balance. It's also about pace. And you evolve over time. You can say, "I like that scene, but I can cut, I can pace it up. I can do things that make this a different kind of movie. I can change it tonally." That happened with *The Kids Are All Right*. I had people come in and say, "It's a little slow," so I challenged myself. I said, "I am not going to get precious about this. This is a comedy. We have to pace it up. We have to cut." And it worked. For that kind of film, it worked.

Willis: You've done a lot of work in television as a director. Can you talk about the differences between your film directing and this work in TV?

Cholodenko: In TV, I'm a gun for hire. It's kind of a funny process. It's taken me a while to realize that it's just a different beast. TV for the most part— and I don't include *Olive Kitteridge* in this because they let me shoot that like a movie, and I feel like it was like a movie. It was shot on film, it was shot over a long period of time, we spent a lot of time in the cutting room, and HBO was more like a studio. So it was approached differently. But when I've done one-hour or half-hour episodic stuff, at first, when I started a long time ago—18 years ago or so—I really thought they were hiring me for my vision, and that I had to add something that was "Lisa Cholodenko," whatever that was. And over time, that's really not what they wanted. They were happy to have me, but it's really more about getting the episode done on time, making your day, getting the performances. It's someone else's vision, it's their show, and they've set the tone and they've created the visual template. So you want continuity. You want the arc of the story to unfold with

some uniformity. I also learned the painful way that I can't go at my own pace. The point is to get through each day and get the day's work done. I got in trouble a few times and it was painful. Even as a more experienced director, when I've tried to insert my own thing in a bigger way, it didn't really fly. If it's not your own show and you're coming in as a gun for hire, that's really what you're doing. You're in service to someone else's vision, and you play by those rules. So for me, that's the best way to approach directing for TV.

Willis: What is the most important thing you've learned directing TV?

Cholodenko: Preproduction is critical. In a way, this is true of features, but everything is so compressed on episodic that you have this very limited amount of time to prep your episode, to understand the scope of the show, the characters, what's come before, what's coming after. I think digging in as deeply as one can to that prep work not only in absorbing or assimilating the material but also making a game plan for how you're going to shoot it. I haven't had to do this with such meticulousness on a feature, which is why I love doing features. It allows for more spontaneity. But with TV, there are a lot of people looking at you. You have a lot of producers who are reporting to other people. So going in there and being able to say, "I've walked the set; I've made a floor-plan; I've made a shot list; I know how I'm going to get through this scene; I know that I can do it in this time frame." It's a lot! Some people think with episodic you can just roll in and do it, but it's stressful if you haven't done your prep. But if you have, and you know where to land, then you've got it. You have your vision for it; you know how to manage your time; you know what you can and can't do; you know how to deal with hierarchy; you know how to deal with producers and a lot of people who are breathing down your neck, with all due respect. It's a very diplomatic job and good for a diplomatic person. It's not the easiest job for me. I can do this to an extent, but then I want people to leave me alone and let me do what I can do.

Willis: You mentioned earlier that you shot *Olive Kitteridge* like a movie. Can you talk about this more?

Cholodenko: Yes, I was directing all four of the episodes, and we were block-shooting them and there were a lot of moving pieces. I had to really track what Frances was doing in the first episode when she's in her late 40s versus what she's doing in her 70s. Sometimes we'd have to do parts of that span in one day, so it was conceptually a really big deal. I had to keep my mind around all of it. To me, that's more like feature film territory.

And TV has changed. After *High Art* when I was offered a few television episodes, I personally thought it was kind of cool to do TV, but I don't know that it was seen that way by other directors. It was seen more as a way to make some money and keep working. The idea was that TV was TV and films were films. But I really love that that's changed. For me, as a filmmaker,

this change has opened up a lot of worlds I wouldn't have considered going into. I think it's helped create the kinds of movies and the kinds of stories that I am most drawn to: they're more in vogue, so that's very exciting.

Willis: What other changes have you seen that make you hopeful about the future?

Cholodenko: I think with #MeToo and what's happened over the last year, what might be coming down the road might be parity of pay, and a real effort to open up the system to minorities and women and people with alternative realities. It feels like it's not just tokenism; it feels like there is a shift happening. I could be wrong. It's unfortunate that it exists at all. In my early career, I found it a little bit annoying to always get that question: what does it mean to be a female filmmaker? How hard is it as a woman? And I felt like I really didn't know how to answer. But now that there's more transparency and accountability, it's much easier to reflect on that question without feeling like it marginalizes me, if that makes sense.

Willis: Yes, it does. I think the events of the last year have opened up the conversation. The question for women used to be, "How did you get in?" and now it's "How has everyone else been left out?"

Cholodenko: Yes. It shouldn't matter that I'm a woman. It's not that I make women's films. Fuck that! But I also feel like people would say that I made character dramas that are more emotional and more psychological, but they don't make money. And now that there's such a diversity of material and so many outlets and so much love for TV, things that women were doing in the past when funders would say, "We can't finance that," they're able to do. I always hated that dismissal. I thought it was bullshit. I don't want to be in this ghetto anymore.

There is another part of me, though, that says, "This is what it is." It's real. It's important. I support people speaking out about sexual violence or abuse, and I feel good about adding to the conversation, continuing to do good work, asking to be paid what's fair, believing that people will always love a good story well-told with some level of vision and just carrying on and not getting sidelined by the politics. So I guess I don't want to be too one-sided either way. But it has been frustrating to always get that question about what it means to be a woman making films.

Notes

1. Roger Ebert, "Review of *High Art*." RogerEbert.com (July 3, 1998), www.rogerebert.com/reviews/high-art-1998
2. Gavin Smith, "The Hard Way: Sundance 1998." *Film Comment* (March/April 1998), www.filmcomment.com/article/sundance-1998-the-hard-way/
3. Lisa Cholodenko. Interviewed by Holly Willis on April 24, 2018.
4. Ibid.

6

MARTHA COOLIDGE (1946–)

Michele Meek

Widely recognized as a female trailblazer, Director Martha Coolidge has built an impressive career highlighted by numerous film successes and landmark advocacy work on behalf of filmmakers. She is often celebrated for her popular films *Valley Girl* (1983) and *Real Genius* (1985), which launched the careers of Nicolas Cage and Val Kilmer, respectively, and she became one of the few independent female filmmakers of the 1980s to transition to directing Hollywood films. Coolidge's prolific directing career has spanned comedies, dramas, documentaries, and shorts, and she has worked on independent and Hollywood films and television episodes. She has garnered numerous awards for her films, such as *Rambling Rose* (1991), which included an Oscar-nominated performance by Laura Dern and won the Independent Spirit Awards for Best Feature, Best Director, and Best Supporting Female, and *Introducing Dorothy Dandridge* (1999), an HBO feature film that took home five Emmys including one for Halle Berry for Outstanding Lead Actress in a Miniseries or a Movie, as well as numerous other awards. In 1992, she won a Women in Film Crystal Award, and in 2016, Coolidge was a nominee for the Women Film Critics Circle Awards Lifetime Achievement Award.[1] Alongside her film and television career, Coolidge cultivated her groundbreaking work as a vocal advocate for filmmakers beginning in the 1970s with the Association of Independent Filmmakers (AIVF) and through the 1980s to the early 2000s through the Directors Guild of America (DGA), ultimately becoming the first and, thus far, only female President of the DGA.

Coolidge was born in New Haven, Connecticut in 1946. Her parents both worked as architects, and they represented both sides of the political extremes, as she recalls.[2] Although her father died when she was nine years old, he influenced her passion for filmmaking—together they made 8mm films. Growing up the eldest of several younger siblings with her mother, Coolidge recalls that after their father's death, they "had very little money" in those "rough" years.[3] Her experience of losing "social standing," she says, along with her drive enabled her to

"identify with outsiders,"[4] a viewpoint that helped her later in both her directing and advocacy work.

Coolidge became the first undergraduate film major at the Rhode Island School of Design (RISD), and she then completed her MFA in film at New York University (NYU) in 1971. Despite her early interest in fiction filmmaking, Coolidge actually began her formal film career in the early 1970s as a documentary filmmaker, due to budgetary constraints and limited resources. Although she had produced short films throughout the late 1960s and early 1970s as a student, her official directorial debut was the documentary *David: Off and On* (1972), a short film about her brother's life and addiction, that garnered her the American Film Festival's John Grierson Award. Her other early films, which she has called "portrait films, films about individuals, about my family,"[5] also were critical successes—she won American Film Festival awards for her subsequent short documentaries including *More than a School* (1973) and *Old Fashioned Woman* (1974).

Coolidge transitioned to directing longer narrative films with *Not a Pretty Picture* (1976), a fiction/documentary feature based on her own rape. Clearly ahead of its time, the film combines acted scenes alongside filmed conversations with the actors and Coolidge as director—a hybrid format that Coolidge says was not chosen to be "avant-garde," but rather intended as a way of avoiding "exploiting" the subject matter.[6] Coolidge details the making of the film in a personal essay, which originally ran in *The Independent* in 1976 and is republished in this chapter.

Coolidge makes no secret of her early struggle as a female director, noting that she made films for 18 years before anyone in Hollywood took an interest in her work. In the early1980s, she moved to Toronto where she shot the independent film *City Girl* (1984). When it ran out of money, she returned to Los Angeles where she was finally offered the film *Valley Girl* to direct. Even then, the budget was tight, and Coolidge was paid only $5,000 to direct the film.[7] Nonetheless, the film became an enormous success—grossing $17 million on its under half a million dollar budget[8]— and it remains a cult classic of 1980s cinema. She then embarked on the Paramount picture *Joy of Sex* (1984), before directing the quintessential teen comedy *Real Genius* (1985), which stars Kilmer as a counterculture genius who saves the world from a secret weapon being built by a university professor, and it is one of the only films of its genre during this era that featured a female genius, the character of Jordan Cochran played by Michelle Meyrink.

Despite her early critical and commercial Hollywood successes with *Valley Girl* and *Real Genius*, Coolidge found it difficult to find work directing feature films and throughout her career directed television. In the mid-1980s, she began directing several episodes of *The Twilight Zone* (1985–1987) and *CBS Summer Playhouse* (1988), as well as television movies *Bare Essentials* (1991) and *Crazy in Love* (1992). In between, she directed one of her most renowned independent features, *Rambling Rose*, which garnered over a dozen award nominations, including Golden Globes and Oscars, along with five Spirit Award nominations and three wins for Best Feature, Best Director, and Best Supporting Lead for Diane Ladd. The film, starring Laura Dern, is based on Calder Willingham's book about a sexually "wayward"

young woman's working for a family during the Depression and teaching them love. Coolidge then directed several features, among them *Lost in Yonkers* (1993), based on the Neil Simon play, and *Angie* (1994) starring Geena Davis and James Gandolfini. She remarks upon the pros and cons of being an independent versus a Hollywood filmmaker in an interview in 1994, when she states that as an independent director in New York and later, "I was my own person, my own producer. I dictated how I spent every dollar," while in Hollywood, "I'm definitely a cog in the giant Hollywood machine. My job is to maintain independentmindedness, to keep my soul on the material and not on the project size. That's a struggle."[9] In either case, what she emphasizes as her "mantra" and "truth" is a quote from the 1992 *Independent* interview republished here, where she states, "All work, if it's good work, is personal and autobiographical: it doesn't matter who wrote it. You pick material because it has themes that echo with your own."[10] In our 2018 interview, Coolidge expresses a delineation between her films that were micromanaged by studios versus ones where she had more creative control. In particular, she notes how films like *Joy of Sex*, *Angie*, and *Plain Clothes* (1987) had so much studio interference that she thought, "I can't even look at this movie," whereas "if you look at my best movies, I had the least interference by the studio"[11] One of these standout films is *Introducing Dorothy Dandridge* (1999), an HBO film starring Halle Berry about the first Black actress to win a Best Actress Oscar Nomination in 1954 for *Carmen Jones*. Berry owned the rights to the story, and HBO brought in Coolidge when Berry expressed her desire for a female director. Ultimately, the film and its stars won over 20 awards including several Emmys, Golden Globes, NAACP awards, SAG, and a DGA nomination for Martha Coolidge.

Coolidge was an early and vocal advocate for independent filmmakers, believing that "collectively artists have a voice"[12] and supporting directors' cuts of films.[13] In 1974, she became one of the founding board members of the Association of Independent Video and Filmmakers (AIVF), the organization that created *The Independent Film & Video Monthly*, and she wrote for the publication. During what she calls a "great time of energy" which included coalescing filmmakers and lobbying Washington, she also engaged in conversations that ultimately led to the formation of the Independent Feature Project (IFP) in 1979.[14] In the early 1980s in Los Angeles, she became increasingly active in the DGA at the encouragement of former DGA President Robert Wise, with whom she had interned through the American Film Institute (AFI). She served on numerous DGA committees, councils, and boards before being elected Vice President in 1997. She received the Robert B. Aldrich Achievement Award in 1998 for nearly two decades of service to the guild.[15] In 2002, she was elected to be the first (and still only) female President of the DGA. Coolidge has also served on numerous other boards, including the AFI, Women in Film (WIF), RISD, and NYU, and she is currently a professor in the Dodge College of Film and Media Arts at Chapman University.

Since the 2000s, Coolidge's directorial work has focused mostly on television for notable series including *Sex and the City* (2002) and *CSI: Crime Scene Investigation* (2006–2011). In 2000, she directed a segment of the film *If These Walls Could Talk*

2, 1972, a love story of two young women played by Michelle Williams and Chloe Sevigny, for HBO, and she received her second DGA nomination. In 2012, she also directed and produced the first long form, internet horror series for Crackle, *The Unknown*. She also continued directing features, including the HBO children's film *An American Girl: Chrissa Stands Strong* (2009), which garnered Coolidge a DGA Award nomination for Outstanding Directorial Achievement in Children's Programs, and *The Prince and Me* (2004), a romantic comedy for Paramount about an American college student (played by Julia Stiles) who falls in love with a prince from Denmark. Her most recent film *Music, Love and War*, a love story musical set during World War II, remains in post-production as the financial issues are resolved for the film's independent producer-financier, who is located in Poland. Coolidge is finishing editing and planning on the film's release, stating "if it was a lousy film, I wouldn't care. But it's a very good film, and it's important for people to get to see it."[16] After being such a strong advocate of directors' rights, Coolidge found herself in the position of seeking assistance from the DGA, who supported her rights as director of the project.

Coolidge once said that she sees herself more as a "humanistic filmmaker" rather than a "feminist" one.[17] She nonetheless recognizes the ways in which gender and race discrimination has guided the film industry, as she states in a 1999 interview, "Now that I'm older I realize that discrimination against women is absolutely everywhere and absolutely constant. But it can take subtle forms that you may not be aware of."[18] When asked about the "eclectic" nature of women's filmmaking careers—which often present as an array of shorts, features, and television—during our recent interview, she replies bluntly, "The reason is that you're not offered the same stuff like men."[19] Despite the obstacles she faced and early discouragement from men in the industry, Coolidge has successfully built a lifelong career as a talented working director. As she puts it, "I'm a leader."[20]

Included in this chapter is an essay by Coolidge published in 1976 in *The Independent Film & Video Monthly*, an interview with her from *The Independent* in 1992, and a third original interview based on a conversation with Coolidge from 2018.

Not a Pretty Picture: A Transition From Documentary to Low-Budget Fiction

Martha Coolidge/July 1976

The Independent Film & Video Monthly

Like many of us independent filmmakers, I have always wanted to make fiction films. The major deterrent was that the budget of a fiction film is prohibitively higher than that for a documentary. Distribution also posed a problem, as a non-feature-length fiction film must have a very specific purpose; i.e., a direct

Note: There have been minor edits and omissions made to this piece in collaboration with the author.

teaching film or an entertaining theatrical short. But in the last couple of years, I became frustrated with the limitations of the documentary portraits I was making because I wanted to look deeper into people's lives without invading their privacy. I then got an idea for a small, part fiction, semi-autobiographical film based on my own rape. I would have no privacy problem with myself, and the film would be fictionalized, using actors in an improvisational rehearsal setting as well as in straight fiction.

What began as a small film grew to feature-length, and I learned a lot about working under a very special condition: low-budget fiction. This is the single element that makes this a genre different from any other. The *low-budget* has very specific problems connected with it, particularly when it is a period film. This one was set in 1962.

To start with, a low-budget fiction film is often the director's and everyone else's first attempt. The problem, however, is that you don't have the experience which might make up for the lack of money in terms of fewer mistakes. In the case of *Not a Pretty Picture* (with eternal indebtedness to the people I met through AIVF), all the major positions on the crew were filled by professionals. In the positions particular to fiction films, such as props, makeup, sets, script, and PAs, we had more enthusiasm than professional experience. We were lucky in that the props and costumes of the period (which was no high point of fashion) could be found in our trunks, basements, and in thrift shops.

Casting

I hadn't made a fiction film since graduate school, and the bulk of my theater acting and directing experience had been in college. I was nervous and I wasn't quite sure where to start looking for actors. I had a very specific improvisational process in mind, and I called friends of mine with theater and acting connections and described to them who I needed. In this way I simply had to find the people I wanted.

Casting is a talent in itself, and certainly a major decision point for any motion picture. In this case I could not afford actors who had had a lot of film experience. I decided to look for the element which was the most risky in the film: the rehearsal improvisation and the use of the actors as themselves. As a documentary portrait-maker, this was an area I felt very sure of. I knew that the actors had to have certain qualities as themselves to work in the rehearsal scene. The most important roles were the woman who would play me and the rapist. I wanted a woman who had had a similar experience and who would have certain qualities in common with me. The actor had to be a nice guy himself and be able to play a jock rapist. Both of these actors would have to externalize the process in which they rehearsed, as that would be the essence of the rape scene.

Instead of having the actors read, I simply had long talks with them. The first quality I looked for was something filmic about them, which is the same in documentary or fiction. I also needed an "excitement" from them about the film's idea

which would show in the rehearsal and, for them, might make up for my lack of finances. They also had to be candid about their own lives on camera, which is especially difficult for actors who are by necessity conscious of their image.

I felt very lucky to find Michele Manenti and Jim Carrington. They had known and worked with each other before, which would help us in the rehearsal scene. It would be particularly helpful for Michele who had been raped under similar circumstances. I felt there was a great deal which could be released in Jim. This became more apparent in rehearsals. All the casting was dependent on how the rehearsals went, as I hadn't had anyone read—no one was replaced.

Probably the most controversial move I made in casting was putting my own roommate from school, Anne, in the film to play herself. This move was based on her impact as a documentary element of the film as well as on her character. I felt that the additional layer of reality this added would reinforce the others in the film. Also, her extraordinary personality and humor had saved me that year, and to find an actress who could play that would have been impossible. And her personal feelings about that year became an important element of the film, for she totally expressed the pain resulting from non-communication in adolescence.

I needed one SAG actor, an older man. I found SAG very cooperative, as the AFI (who gave me a grant for the film) has an understanding with them. The actor worked under the 150 percent deferral deal. What did become clear to me is the necessity for even more cooperation between low-budget filmmakers and SAG, as many kinds of low-budget productions are still difficult.

Script

To further make the film a combination of reality and fiction, the script was built out of the experiences of every member of the cast. All of us reminisced and improvised until the script was completely constructed. This expanded the script beyond simply my own experience. The greatest limitation on the script, aside from not being able to afford an established scriptwriter, was insufficient rehearsal time because I couldn't pay the actors. They were all holding down other jobs, and we had a terrible time getting together. For non-film-experienced actors and directors, rehearsal time is essential, and I'll never skimp on that again.

Production

The film never would have been launched if it weren't for Jan Saunders. An experienced production manager is absolutely central to a fiction production, and doubly so on a low-budget production. Everything must be planned. Because we were trying to save money, we found certain things took more time, and all of this had to be taken into consideration. The competency and commitment of the camera persons, Don Lenzer and Fred Murphy; sound person, Maryte Kavaliauskas; and gaffer, Nancy Schreiber, were also major factors in the success of production.

Shooting

One of the biggest problems and limitations of a low budget is not being able to have a set or moving cameras on dollies. The whole way of shooting the film is more limited. The scenes are broken down into shorter takes and often into closer shots. Now, even actors experienced in film would find this difficult, but they would have an easier time compensating for the resulting disruption of their performances. With inexperienced film actors, it only further inhibits and breaks up their concentration. This is the double burden on the actors and director in a low-budget film. The director bears the responsibility of seeing the consistency of the performances and maintaining the pace and flow. Also, an audience is used to seeing films with longer, fluid takes and more medium and long shots. Therefore, they experience a film shot under these conditions as uneven and more claustrophobic, and any jolt in a performance stands out even more.

Because the production of *Not a Pretty Picture* was so well organized, I was really directing for the first time. I had time to work with the actors on set and had time to deal with all of the last-minute details and specific acting problems that came up. The latter were usually a result of the actors' diverse working patterns or personality conflicts.

Low-budget films are usually shot on location and shooting at exterior locations is a real hassle; at different times we found ourselves surrounded by hundreds of people we weren't prepared to handle, like being in the middle of a knife fight and on a major bus route. Shooting was halted by the arrival of a number of fire engines, and at another time, by a Mr. Softee truck that wouldn't go away.

At first the waiting was very hard for all the actors. I had tried to prepare them for it. I also let them know the framing of the shots and why they had to move in certain ways. My feeling is that they are professionals and they need to know all the tools of the trade that they are working in. The cast and crew on this film were unusually close and very cooperative and respectful of each other.[21]

Editing

My final advice is that it is very important to try to have a sufficient budget for editing. We did, and that kept the final cost *down*, as the editing didn't drag on forever.

Finally, I would just like to say that despite the fact that low-budget films are limiting in many ways, they are also freeing. Many new things can be tried in a low-budget film that you would never dare do with more money riding on it. Many new directors and actors, technicians, and designers start this way. I think that when all of us, including critics, look at a film, we should consider its budget. Instead of looking at a film such as *Legacy* and saying it's not like a Hollywood feature, we should start by saying that it's new and interesting, and that it's phenomenal that it was ever made at all! Though a comparison between *Lipstick* and *Not a Pretty Picture* in terms of subject matter is obvious, they are films designed to fit completely different budget scales and to do completely different things. *Not a Pretty Picture* was intended to break new ground in terms of subject and work. For many of us, it did just that.

Rambling Martha Coolidge: From New York Independent to Hollywood Player

Ellen Levy/June 1992

The Independent Film & Video Monthly

Ellen Levy: In an early write up after you received the Grierson Award, you were quoted as saying you saw no real obstacles to women in the field. Was that an accurate representation of how you felt as an independent in New York, and do you still feel that way?

Martha Coolidge: I must say that I have no memory at all of saying this. I am shocked that I did. [Laughs] But it's nice to know that I, too, lived in the illusion of "you can do anything you want." It's very inaccurate, but it does accurately reflect two things: one, the image a young person starting out has of their potential in the business. That's very important. None of us would ever do what we try to do if we were aware of the obstacles that exist. The second thing is how younger women will talk about the obstacles they are facing and will deny they're there. There are many, many women in the business who say that there is no discrimination. I think that's completely ridiculous.

Levy: What are the obstacles?

Coolidge: Primarily preconceptions and discrimination. It's very hard for most people, still, to imagine a woman in a position of control and power. Certainly in terms of the film industry as it is run in Hollywood, the people I'm working with, the people they know, and the people they knew, particularly then, were men. That's who they all grew up with. It's an old boys' club bonded not just by masculinity but by their familiarity. Once you've made a successful picture with someone, they tend to want to make another with you. So the more successful women are, the more likely there will be repeats, and they will bond too, having brought mutual benefit to each other. That's how it works. But in the end in Hollywood, it comes down to what makes money. You're seeing this with women and with Black filmmakers. Money can overcome prejudice. Maybe not on a personal basis, but definitely studios will act against a prejudice if they think they can make money.

Levy: Does that put more pressure on women to compromise their vision in order to show that they can "do it as good as the boys," that they can make a "boy's film" that will sell?

Coolidge: First of all, Hollywood is not nearly as concerned with vision as we are. However, I feel that deep in their souls Hollywood does

know that vision is a critical part of being a good filmmaker. The success of Black filmmakers points this up in a very interesting way. Black filmmakers' vision is not as alien to the male establishment—it's just Black—as is the female vision. Women directors resent terribly being all lumped together in "You are women directors and women see things in a different way," but when it comes to a woman bringing their different visions, there's a very interesting point. You see women doing strictly Hollywood movies. But that's what everybody's offered. The movies that are made are movies the studios want to make. This is an industry, and it follows its own fads and vagaries. You try to find something in the material they want to make that has themes and subjects you're interested in. That's why everybody's always saying there are no good scripts; it's just very hard for each individual to find a script they love, that has really deep stuff they want to do—and that the other guys want to do.

Levy: Did you find fewer obstacles working as an independent in New York, or are the obstacles pretty much the same?

Coolidge: It depends what your character is, what you enjoy, and what is your bread and butter. In terms of following your own vision, there are many fewer obstacles in being an independent in New York. I enjoyed much more freedom. I mean, nobody sat there and discussed the content of the films I was making. They either decided to invest in them or not. Every single thing in Hollywood is a discussion and a compromise of some kind, to say nothing of the fact that they are usually giving you the story, modifying your story, or asking you to. Raising money as an independent is a very tough obstacle. The truth is, getting a movie set up in Hollywood is also a very tough obstacle, and in a certain sense you can't even say which is harder.

Levy: How and why did you make that transition from New York to LA?

Coolidge: I just couldn't figure out how to raise more money. Being a producer is not my real gift, and I did it out of necessity mostly. I wanted to make storyline, accessible movies. I'm not really an avant-gardist. I wanted bigger budgets. I wanted sets and costumes and people and actors, and you simply need a certain amount of money. I didn't know how to do it by myself. So I thought, "I'll go to Hollywood where they do it." But the fact is, they may do it, but it's just as difficult to get the movie.

Levy: Did you have an invitation from a studio to go out there?

Coolidge: No, no. It's always good to go out with something, so I applied for the American Film Institute Academy intern program and went out as an intern with Robert Wise on *Audrey Rose*. It was good;

I had something to do every day. At the same time, I made my calls to agents. I had movies to show, and I was talked about, even though they weren't hiring women at that time. But there was some buzz, some talk about women. And I did get an agent after three months. It was a lot of work, but I did. You can spend two years trying to get an agent.

Levy: By that time you had made three films?

Coolidge: No, I had more than three, but *Not a Pretty Picture* was really the one I showed the most.

Levy: What's it like working with a bigger budget?

Coolidge: I have yet to work with a big budget. The biggest I worked with was on *Real Genius*. That was the only movie I've made that wasn't totally squeezed budgetarily. *Rambling Rose* was a really low-budget picture.

Levy: What was the budget on that?

Coolidge: They don't want me to say.

Levy: On *Real Genius*?

Coolidge: 13 million. *Rambling Rose* was way below that and was made much later when money was worth less. *Real Genius* was a special effects picture, and we shot it in 64 days. That's a long time. *Rambling Rose* was shot in 42 days. But what's interesting, and what's important about coming out of independent film, is that you learn where to put your money. *Valley Girl* cost $325,000. Granted $325,000 was worth more than it is now, but the company that made it told the studios it cost three or four million. And the studios believed it. The point is you've got to figure out how to make the movie you want with the money you have.

Levy: Has the content of your films been influenced by being in Hollywood?

Coolidge: Oh, of course.

Levy: How?

Coolidge: This is where the concept of "your films" becomes problematic. *Valley Girl* was offered to me. I never would have written *Valley Girl*, developed *Valley Girl*, or said I wanted to do *Valley Girl* if I were left on my own. If I were a filmmaker in New York, it never would've crossed my mind. Put me in the atmosphere of Hollywood, deny me work for a very long time, and then show me *Valley Girl*, and it looked very good, y'know? [Laughs]. . . . I stayed very true to myself and made a movie I believed in.

Rambling Rose is the closest thing to an independent film that I've made in Hollywood. Six years ago I said, "I have to make this picture," just like I said about my independent pictures. No American would touch that [project] for 17 years. Critically, it

was extremely well received, but we know from testing the audience that there's always that little tiny section of the audience who is really offended at the idea of a 13-year-old boy being sexually interested in a woman. In England it was censored—their fear of children and sex is great.

Levy: It may have been an odd pairing to screen *Not a Pretty Picture* and *Rambling Rose* at the same time, but one of the things that struck me was—

Coolidge: There are similar themes.

Levy: Yes, but you said you self-consciously interrupted the narrative in *Not a Pretty Picture*—in what might be termed a Godardian or Brechtian way—in order to distance the audience from the film and not allow them to escape into fantasy, to force them to think about what they were seeing. I think you said it was to "avoid titillation." But in *Rambling Rose* the camera has an expressly voyeuristic gaze that is titillating. We see Rose having sex through a crack in the door, we see her on the street as a girlwatcher would see her—shot of ass, a shot of legs. Does this reflect a change in your sensibility and response to the material or a change in the conditions under which you were working?

Coolidge: I'm sure my sensibility hasn't changed. It's definitely my response to the material. It's very different trying to understand a girl's own sexuality and forcing an audience to participate in a rape. One of the things that I loved about Laura Dern, and one of the reasons that I thought of her for this part, was her performance in *Smooth Talk*. She so beautifully embodied the girl standing on the brink of sexuality, a girl who wants sex desperately and of course has no clue how dangerous the situation is that she's getting into—which I completely identified with. There's a touch of that desire in *Not a Pretty Picture*, but I was more frightened of the sexuality because of having been raped.

What's interesting about *Rambling Rose* is that female sexuality is the subject of the movie, not an object in the movie. She may be shot occasionally as if she were an object, okay: although, I must say that in terms of Hollywood's perception peeping through a door is the most reserved and realistic presentation of that scene. This is not a scene about the audience looking at a girl naked. It's about a specific boy looking through the door at his father. The boy is going to be not only interested and curious but horrified. I feel it's the least exploitative way I could've done the scene and still have one which I felt was really important because of the father's temptation.

Levy: Your early films came out of extremely personal experiences. What inspires your choices now, such as *Rambling Rose*?

Coolidge:	All work, if it's good work, is personal and autobiographical: it doesn't matter who wrote it. You pick material because it has themes that echo with your own. Of course, some movies are more jobs than others, but even in a job you try to find something you can really care about. Sometimes you'll take a movie just for one scene. Even in your own films, you're not going to feel the same way about every aspect of the picture. There are certain things you have to do because you're telling a story, and other things that are really what it's all about for you. I would say the themes in *Rambling Rose* are as close to me as the themes in anything I've ever done.
Levy:	Do you think it's important for filmmakers to be political?
Coolidge:	It's important for filmmakers to know who they are and what they believe in. It is death to think you can talk about things that are meaningless to you and to other people. Whatever it is, you've got to be trying to say something—and trying to learn something. Now some people aren't going to be really political in what they care about, some are going to be exploring a parent's lying to a child—though that could be political. But the fact is, it's human, and if it's important to them, then it's going to be important to somebody. I really believe that from the specific and from passion comes the universal.

A Conversation With Martha Coolidge

Michele Meek/2018

Meek:	I wanted to talk to you about the format of *Not a Pretty Picture*, because I think it's a film that is not easily categorized—
Coolidge:	This is not a feature.
Meek:	It's part documentary, part autobiography, part narrative.
Coolidge:	Yup.
Meek:	You include behind-the-scenes or making-of scenes. I know you wanted to move from documentaries to narratives, but did you see this as a hybrid film at the time, or how did it come about?
Coolidge:	I saw it really as what it had to be in order to do the subject properly—it didn't seem avant-garde or anything. Mitchell Block had just done [*No Lies* (1973)], which I felt when I saw it was good, but [was] three rapes—raping the audience, raping the girl in the movie, and the cameraman raping the actors. It was in one way exploitation, and in there as a theme. So I felt if I really wanted to avoid that, then I should do the "making of" rather than write it in sequence, because when you do actions as a sequence, there's a natural need of the audience to see it completed, to

see it come to an end. And I didn't want people cheering, you know, or looking excitedly at this rape.

In fact, I went to see *Liaisons Dangereuses*—I think it was the play—and when the guy rapes the girl in bed, the audience cheers. It's very disturbing. And I didn't understand it. But I did understand that when a star does something like that on stage, even if it is about morals and lack of them, the audience may cheer. It was very disturbing. And it's not that I'm some rigid feminist. I have a sense of humor in movies and entertainment. But that was very weird to be in that theater with people cheering for the rapist. And I was with another woman who felt the same way.

Meek: That reminds me of the scene in *American Beauty* where he's reclaiming his masculinity because he's "tortured" by his wife. And he throws a plate against the wall in this crescendo scene. It always struck me as a moment when you are on his side because he's breaking free of these family reigns. But at the same time, it's an act of domestic violence. And cheering him on at this moment always makes me really uncomfortable as a viewer.

Coolidge: Okay, so I go to see that movie with my husband. And when we got to the end, I had all kinds of disturbing feelings. My husband said, well that's a good movie, but I sure don't think I'd want to be a woman and see it. And that was very much how I felt. I didn't like the female characters—they made me very uncomfortable. . . . So, you're picking on another movie that hits this topic strangely. And I've certainly learned over the years that when it comes to discussing sexual roles or sexual harassment, at least according to the experts on the panels that I've seen, men and women do speak a different language, and that's why we sometimes have a very hard time understanding each other. It is true that that's happening—men will take a giggle from a woman as a plus, like "oh she's enjoying this," when, in fact, she may be giggling because she's so completely uncomfortable, and she doesn't know what to do, and she feels he's superior to her. So, it is a complete cross-communication that's gone wrong, and it happens all the time.

I think it's great that we're getting more real talk about what men have been doing for centuries. And I don't think it's only men; there are a few women who do it, and there are men who do it to men. So, we're not isolated. But it's the most common for men to do it to women. So, I think it's great to bring it up, and I hope to god something really lasts about it. . . . But it's something that most men haven't even thought about. And I hope it becomes more conscious.

I think that the things I've heard about education and schools and asking permission to touch somebody—that's not awkward. If everybody's

raised that way, it's not awkward. I've heard older men talk and say, well we can't hire women now, we don't know what they're going to say and get us in trouble. And I'll look at them, and I'll say, but that's not what the point of all this is at all.

Meek: Right.

Coolidge: So, you just have to keep going to change the new generation and change the language, change the behavior. I've been involved in some of my films in sexual harassment cases, and it's very awkward with people who've been behaving like that all their lives—

Meek: Are you talking about cases where you've brought up charges on someone or that have happened on your film sets?

Coolidge: In any feature or TV, if there is an incident, they come to the director usually or it could be to the producer. Actors have come to me; other crewmembers have come to me. And then I have to meet with the producer, the [assistant director] and myself, and then other involved persons. Then we talk to the person and tell them how it's going to be. Because of the new rules and because of sexual harassment, we have controls and rules about how to behave in the workplace. . . . We had one case where actresses were complaining about the clothes that were worn by one of the camera crewmembers. I was standing by the camera facing the actors, so I never saw the shirts . . . and they were really offensive shirts. And so, the cameraman had to make the crew member take the shirt off and put on a different shirt. And it made him really mad. The whole thing was, you know, a big to-do. We had another one with a high up member of the crew who was offending all the women, like the secretaries and assistants. . . . And the producer and I had to sit down and talk to him. And he just couldn't believe it. He said I've done this all the time. And we said, yeah but you can't behave like that anymore. It's wrong, it makes people uncomfortable, and you either stop it or you go.

Meek: One of the things that's coming out now is that many situations have been reported, but then nothing was done about it.

Coolidge: Well that's true.

Meek: So, it could be that this person had been doing it and people were even reporting it, but the director on a different movie might have said "whatever" and just ignored it.

Coolidge: Sure.

Meek: And you actually addressed him. That was the difference.

Coolidge: That's true. . . . And one of the problems is that in a TV show the creators, the writers, are looked at as the lords of the show, and in a feature it's often the director or the producer, usually the director. And then that person has their little fiefdom, you know. . . . They can say, "nobody will be over the age of 30 or 40 on this movie," I mean things that have nothing to do with anything except how they like it. Or "no women" or "no women in

high positions." I've had people say that to me. I had a production manager say that to me, and I was the director. I hope it gets better. I do.[22]

I directed *CSI*. I did one a year, and I loved doing it. I thought I'd get more shows. But instead, once the producers started directing, then *they* wanted the shows. And I understand. They wanted the money. But it was . . . it was interesting. One of them felt he had to put a block on my reputation, to have me not hired—I don't know what he thought. Honestly it really is a world that's difficult to understand, television. Not so logical.

Meek: One of the things that I've been thinking about with this book is that we really need to rethink how we define a body of work. Part of the problem with women's film careers is that they're often unusual in the sense that it's not feature film after feature film after feature film.

Coolidge: No.

Meek: And so, as an intellectual community, we don't know what to do with that, in terms of thinking of your body of work. What does it mean that you've done some documentaries, some feature, some television, some short films, some independent, some Hollywood? Like it's too like mind-blowing or something. [Laughs] And how can—

Coolidge: The reason is that you're not offered the same stuff like men.

Meek: Right.

Coolidge: Once they make a plateau—until they ruin their reputation in that area—they keep doing it. And generally, a couple of failures, that doesn't necessarily ruin them after a certain point.

Meek: For a male filmmaker, is that what you mean?

Coolidge: Yeah. You'd see five movies that were interesting, but not super successful. And then they'd make a successful movie, and that would carry them through more okay movies. And, you know, another successful movie and that man would have a career.

Now we're starting to see women are being given a big action picture. I hope it continues—that's all I can say. And it's very hard, some women hire women, but a lot of women don't, so I hope that changes. I'm looking forward to it. And the reason is obvious—because the women don't have the central power positions that men have.

I thought the UCLA article was brilliant because they followed the money. And what they found was that women who work in television a lot and other places, many don't have agents. Now, if you don't have an agent, then you're not submitted for television shows or features. You're kind of alone, and you're just lucky to get something. And so of course you don't make as much money. Then what happens is the agents don't want you because you don't make as much money. So those women don't have agents. And if you don't have an agent, you don't get the work. So, it's a chicken and egg problem. It's such a problem.

Meek: One of the things that I appreciate about your work is how you depict sexual assault in unconventional ways. In *Not A Pretty Picture,* you have the moment when Jim is talking about the confused feelings he experiences during the violent scenes. And the scene in *Rambling Rose* between Laura Dern's character and the boy is such an uncomfortable scene. And then of course in *Introducing Dorothy Dandridge,* there's the assault by her mother's lover. Can you talk about your creating those different moments in your films?

Coolidge: Well, [for *Introducing Dorothy Dandridge*], I forget if that scene was included because of Shonda [Rhimes] or me originally. It was included in Earl's book . . . but the point is we worked very closely on it finishing the script.

My mother told me there was no such thing as rape, which really messed me up. But the more I went around talking on the subject, the more young men I met who were raped. And the more different kinds of rape I heard about. And there was even verbal rape and abuse that's not, you know, overtly sexual but it affects you that way.

So, I feel that when you're making a movie, first of all, you need to show sex in a way that is revelatory about the characters. I mean you can show it just because it's a porno film, but I don't think of anything that way. So, to me if you learn something about the character and their abilities or inabilities and hang-ups, then that's a good thing.

And what's great in these sex scenes is they exist all over the place, but they're not put on screen. And I felt that they were riveting and very important to the character and to the story. So, I did them, and it was hard. But you know, everybody was very committed, and we had an excellent time doing it. You know in the rape scene in *Not A Pretty Picture* I show the actor and actress hugging at the end of the [rape scene] because doing good work is very pleasing. It's not the same as being raped.

Meek: What brought you to the film *Introducing Dorothy Dandridge?*

Coolidge: Well, you're only going to hear my side of it, because that's all I know. HBO had optioned this [project] from Halle Berry—she owned it and wanted to be in it. And they wanted her. So, they had approached from what I understand, every Black director you can think of. And oddly enough, most of them didn't want to do it, or she didn't want them.

At the end she had one Black director she was interested in, but she kept telling them she wanted to try a woman. She felt she needed a woman to do it. So, they came to me with the script and submitted it, and I went crazy—I wanted to do it really badly. So, I went in and met with them, and it was fascinating.

That was my first meeting where they said to me, well, you're mature and you know what you're doing, and we have a lot of people involved in this project, and we think that we need your level head. [Laughs]

I remember I was talking to the development person there and it came to me right there. I said, well what about this—what if we make the whole movie around the time of her death and she's making calls to friends because she can't find love. She's talking about her boyfriends and life and this and that. . . . I talked to Shonda, three weeks before we started shooting to come back to the rewrite, which was very late. But, I had outlined the whole thing . . . and then she wrote in order of shooting. So, we talked about the whole script and then she'd write it so it was done before we shot it.

We did a couple of weeks of rehearsal, which was great. We met with actors and tried out all these scenes, and she rewrote them, which was fantastic. She had the voice—that's the thing. She was the original writer, but they replaced her with a white guy, a really good writer . . . but what he didn't have was Dorothy's voice. He did not have a Black woman's voice. And so, she came back, and I was just so relieved. Because I just thought how can this movie be successful without a voice?

And Halle really was so committed—she and I did so much reading during this period and research. [We] went and met people and did things, and it was great. And luckily a lot of these friends of Dorothy's were still alive—we met them, we talked to them.

Meek: I've read that in your early career, when you said you wanted to be a woman director that was considered a preposterous idea—

Coolidge: Yeah, and the guys that gave me most advice told me, don't tell anyone that you want to be a director. You won't get the assistant's job. I mean, it depended who you were talking to. The other thing is that today the film schools even will say there aren't as many women because the women listen to the articles and the news and they realized that there aren't as many jobs and they don't think it's a good profession for them. Why would they fight a war when they could just do something and be more accepted? And I must say I think that was, I hope, truer two/three years ago than now. But you did see a sudden lack of women in our film school.

Meek: At one point, you had said something about how the industry got a little better for women in the '90s and then it got worse—is that what you meant?

Coolidge: Yes, well I did mean that . . . there was a male backlash—it was terrible. Women who were running TV shows were suddenly not running them. And, I mean it really went down and the percentage got really small. And yes, there were those of us who'd directed a lot of films and that was shocking—that we didn't expect.

Now, you're seeing more women. But if they just keep taking this 2 percent or something then all these new women that are getting jobs will get them, but there'll be nothing for us. So, I don't know.

I've been very lucky . . . my agent told me a long time ago, Martha, you're really good, you know what you're doing and you're going for it. Now, I haven't worked nearly as much as I'd like to work. But, I'm really proud of the work I've done. I've done really good work.

And I'm at this point where I realized all through this period men and women fall of the charts—they just get too old for the business and they don't update themselves. One thing that is good about women—we always have to update ourselves, always. We don't fit into a uniform pocket. And that's why the work is eclectic. You do all sorts of work because if it wasn't features this year, then it would be TV or a documentary . . . there are things you can say in docs that you can't say in other works. So, I think if you're really free to go anywhere it's great because, you know, each of these genres does different things.

Meek: Is the same true in Hollywood versus independent filmmaking? I know you've spoken about that a little bit in the past. Like what is the creative control that you have in different types of projects?

Coolidge: I think it varies, depending on who's producing. The thing is, I will say this—in the old days, I never ran across micromanaging like you see today—never. I wasn't doing TV—maybe that was one of the reasons. But now there are so many executives, and they all feel like they have to do something. Then you can get this kind of micromanaging that really, it fucks up your whole, I'm sorry—

Meek: It's all right. You can curse. I don't care.

Coolidge: It bungles up your natural flow, your creative flow of how you're going to do this. And you start thinking wrong. And when people start telling you over the phone, cut four inches out of this take and, you know, two frames of that. I always thought, isn't that what the editor and I do? I mean, why I am being told by an executive how many frames to cut out? How do they know? That's ridiculous, and so I got close—

Meek: So, that didn't come up until television? That wasn't something you'd experienced on Hollywood films as much?

Coolidge: Well, I'd say mostly television, but not all television. And it can be in features, I guess. Basically, if you look at my best movies, I had the least interference. I made the movie the way I said I would make the movie. And I went through all the trials and took notes from the producers, everybody. But, I didn't get messed around with. And then if you go to the movies that were most messed around like, well *Joy of Sex*.

Meek: I have not seen that because I can't get a hold of it.

Coolidge: Don't. Because, don't . . . it's okay. But it has [some scenes] like putting a diaphragm in that were ahead of its time.

Meek: I read about that scene actually.

Coolidge: There are other films like *Angie* and *Plain Clothes* where the studio interfered so much. So much is cut out of the movie that I, at that time,

thought I can't even look at this movie—what are they doing? But if you end up looking at the movie, I mean the problem with *Angie* always was that it was sort of funny, and then it became very serious. And the guy, one of the producers, the one who was on hand most of the time thought it was all a comedy, which is troubling. Can it be a comedy if the mother of a deformed child runs and leaves it?

Meek: Which are your films that were least interfered with?

Coolidge: Oh, *Rambling Rose, Valley Girl, Dorothy Dandridge*—these are really strong movies. And nobody messed around with them, you know. *Real Genius* and *The Prince and Me* were messed around with just a little, and it's okay—it didn't change the structure of the movies. And, *Lost in Yonkers* wasn't messed around with much.

You know with the *Prince and Me*, the only thing that was really too bad is when I shot the ending, I felt it had not been written right and I needed to re-shoot it. And I told them that. I was prepared to do it in post. And they wouldn't let me. And so it just has this ending, and it's fine but it isn't as big as I wanted it to be or as satisfying. But it's a really good movie and it certainly made its money and people liked it.

But some of those movies were fights down the line every day. Lifetime was actually very difficult. But I'm sure it's completely different now. But oh man, it was two frames, cut a foot there—my editor and I just couldn't believe it. I'd never heard anything like that. It was amazing.

Meek: So, when you're talking about working with television, you're talking about even directing a film for television.

Coolidge: Yes, but the HBO movies were very different. They were much more like real movies. And then in the features with studios, it just depended where and who was on them and all of that.

Meek: I wanted to talk about your role as the first, and still only woman President of the DGA.

Coolidge: It was suggested to me by some of the men there. And I realized I maybe could become first female president of DGA, and it would be important to the DGA, to the industry and to women to do that. So, I went for it . . . even though, it wasn't my be all end all ambition in life. I must say, it's a great guild. But then every time I was ready to run, some guy would come in and say "no, I guess I'll run." This happened for years.

And at some point, I got so frustrated that I started saying, no I really want to be the president. And so, I finally did get elected. [Initially], Jack Shea wouldn't step down because he was doing the contract—like I couldn't do that. But then, a couple of months later they had a board election, and I won the presidency.

It was incredible because once you become the president, you see things in a different way than anyone else. You're told things about global

business and the global effect of the industry on the DGA. What's incredible is, unlike a director, you're seeing things in a larger context. And it's extremely educational. And I'm actually incredibly thankful that I had that position, even though it was one of the most educational and painful experiences.

I have to be careful a little, because there were a few people, and I mean only a few, who were not excited about me being the president—I mean like four or five. I was a very popular president—in terms of popular vote, I was told at one point, I was the highest vote getter they'd ever had. And it made me feel good, because I wanted to represent the members. And people came up to me and hugged me and said, thank god you're there, I can't tell you what this means to me. I thought that was pretty extraordinary.

Then when these guys [said], well it's time for you to go now . . . and my problem was that I was in Europe and Canada making a movie. I couldn't even spend time on [my] campaign, even though you're not supposed to campaign.

And so, in the end, after my first term, I decided to not run because the five men had gotten a man to say he would run against me. . . . I didn't blame him. So I just didn't run. And yes, I, by acclamation, was elected vice president. And that was good. And then, you know, the rest is sort of of history. I think it was political, [a] gender thing. They weren't quite ready really.

I'm very, very thankful for it, but I also saw—and this is important for a filmmaker—I saw how—no other way to put this—I saw how corruption or evil sneaks into people's lives. You know what I'm saying? And in the guild, we were all supporting each other. But, there are people who don't want to give up their power. Okay, I see. So, I'm still on committees and things, but I walked away. Partly to prove they don't own me. They're quite used to hanging onto people forever. But I gave 20 years of my life—a huge amount of time to the guild.

Meek: Did it change your perspective on being a woman in the industry specifically?

Coolidge: Well, it did. And I met women who'd been at other guilds or organizations; they had said they had similar experiences. That was interesting. I was told what to wear and where to sit, what to say, and I wondered, do they really tell the guys what to wear? I mean, I spoke to women lawyers and judges, and they were interesting. Because they were women judges in the country, and they had all the same complaints—there were over 600 of them at this convention. Where would you ever find 600 women directors?

Meek: As the gender discrimination and sexual harassment in the industry has been exposed, I can't help but wonder about how independent female

directors have not gotten the types of films that they deserve to direct. When I look at something like the situation with Harvey Weinstein who made so many male directors' careers, I can't help but wonder, how many female directors did he "ignore" or not discover because he was really just a misogynist individual?

Coolidge: I don't know. He tried to buy a film from me, one of my films he thought could really make a lot of money with. It was a Turner film, and I decided not to because *Rambling Rose* was coming out and I didn't want another one of my movies competing with *Rambling Rose* when *Rambling Rose* was such a standalone. . . . But he didn't make a pass at me.

But it is true. I mean, I always looked at all these guy directors and thought, "how come I don't get chances like them. I've done as many movies. I've been made a fuss of, I've gotten the reviews. Why aren't I getting these chances?" And my agent said, "We can't get you a producer credit. The men get it, but we can't get it for you." And it's a huge monetary difference. You actually earn less, you become a different person than they are. And that's a problem.

I do think that that does exist; it's been a problem with every studio. I think that we have a gender prejudice, and we just think women aren't as strong or whatever, which is silly. And some women are not as interested in the big pictures, some aren't. But some men aren't either. Some men who aren't interested are actually doing them because they're men. . . . I wanted to make *Lawrence of Arabia*. I didn't go into this business to do women who have breast cancer in their kitchens. I mean, I wanted to get out there and do movies like the guys do and not necessarily the same subject, that's hard to say but, you know, you start thinking that's really unfair.

But I have had luck in television, and I've gotten some other features that were very different. So, I have a very eclectic career, very eclectic list of films. And I feel blessed that I've done the work I've done.

Notes

1. According to IMDB and the Women in Film Critics Circle website, the other nominees for this award in 2016 were predominantly actresses, such as winner Annette Bening and other nominees Viola Davis and Julie Andrews. In fact, few female directors have won the award—they include Margarethe von Trotta in 2004 and Barbara Kopple in 2006.
2. Lorna Fitzsimmons, "Respecting Difference: An Interview With Martha Coolidge," *Literature/Film Quarterly*, 27, no. 2 (1999).
3. Ibid., 151–152.
4. Ibid., 152.
5. B. J. Sigesmund, "Martha Coolidge: Feature Filmmaker," *The Independent* (June 1994): 23–24.

6. Martha Coolidge. Interviewed by Michele Meek on March 2, 2018.
7. Christopher Bell, "Nic Cage Totally Went Method Plus 7 Things We Learned From Kevin Smith Introducing 'Valley Girl,'" *indieWIRE* (June 13, 2011), www.indiewire.com/2011/06/nic-cage-totally-went-method-plus-7-things-we-learned-from-kevin-smith-introducing-valley-girl-118076/
8. "Valley Girl," *IMDB*, www.imdb.com/title/tt0086525
9. B. J. Sigesmund, "Martha Coolidge: Independent Filmmaker," *The Independent* (June 1994).
10. Coolidge noted in the process of editing this chapter that this quote represented "my mantra, my truth."
11. Martha Coolidge. Interviewed by Michele Meek on March 2, 2018.
12. B. J. Sigesmund, "Martha Coolidge: Independent Filmmaker," *The Independent* (June 1994).
13. Ibid.
14. Martha Coolidge. Interviewed by Michele Meek on March 2, 2018.
15. "Martha Coolidge," *Directors Guild of America*, www.dga.org/Craft/DGAQ/All-Articles/0604-Winter2006-07/Legends-Martha-Coolidge.aspx
16. Martha Coolidge. Interviewed by Michele Meek on March 2, 2018.
17. B. J. Sigesmund, "Martha Coolidge: Independent Filmmaker," *The Independent* (June 1994): 15.
18. Ibid., 154.
19. Martha Coolidge. Interviewed by Michele Meek on March 2, 2018.
20. Ibid.
21. In the original publication of this article, there is unrecovered text missing between the page break. The first page of the article ends with, "That made the production of" and its continuation begins, "ings on a shoot can ruin everyone's spirit and, after all, spirit is mostly what low-budget films are made of."
22. In a cut section at a later point in this interview, Coolidge states, "men talk to me and they love to gossip, you know, and they'd say well these and these executives want to go over to foreign countries and have women, so they don't want a woman, an older woman around watching them—meaning a director. . . . I mean, there are a lot of reason why they don't hire women directors that are more than just the reasons you're thinking of."

7

JULIE DASH (1952–)

Christina N. Baker

"I wanted Black women first. . . . That's who I was trying to privilege with this film."[1] With that remarkable objective in mind, Julie Dash spent 10 years completing research for her first feature film, *Daughters of the Dust* (1991)[2]—a film that illuminates an under-examined part of the history of African American people in the US and radiates the beauty and complexity of Black womanhood. Dash's *Daughters of the Dust* became the first feature-length narrative film written and directed by an African American woman to receive a general theatrical release. Dash will forever hold a significant place in the hearts and minds of filmmakers, film historians, and film enthusiasts for her visionary approach to filmmaking. In 2004 *Daughters of the Dust* was placed in the National Film Registry by The Library of Congress, which reflects its historical and cultural significance, and in 2016 musical and cultural icon Beyoncé drew inspiration from *Daughters of the Dust* for her visual album *Lemonade*.[3]

Dash privileges Black women in her films because she is aware that others do not. This choice to put Black women first cannot be separated from her identity as a Black woman filmmaker. As she unwaveringly says, "I am certainly Black, and a woman, and a filmmaker."[4] However, this is only the tip of the iceberg. As a Black woman, Dash brings to her filmmaking lived experiences that have allowed her to gain knowledge and insight to which others are not privy. The outsider-within perspective, which explains that Black women's marginality provides them with a distinct angle of vision, is reflected in her approach to filmmaking and stems from her experiences as a Black woman in a society that has denigrated Black femaleness.[5] When Dash describes the occasion in which she was pushed aside by a news photographer who chose to take pictures of "two white girls who were spectators," instead of herself and the group of girls of color who were participants in the event that the photographer was documenting,[6] she does so with an insight into racialized and gendered cultural constructions. These types of experiences, combined with

her recognition that in film and television Black women are "invisible at best" or portrayed as distorted unidimensional caricatures at worst,[7] provide the basis for the unique knowledge that is reflected in Dash's filmmaking.

Dash's involvement in film began at a relatively young age—she received extensive training in film during high school, college, and graduate school. Early on, her work deliberately challenged the marginalization of Black women in society and in the film industry. She says, "When I first became involved with film, I was interested in correcting certain distortions about Black people, distortions that I had been bombarded with by the media since my childhood."[8] Documentary film is where she began addressing her concern about misrepresentations of Blackness. However, she soon became interested in narrative film because she felt that was the most effective way to reach the majority of Black audiences. This led Dash to take the leap of moving from her home in New York to Los Angeles in the 1970s in order to pursue narrative film as a way to express her ideas and create social change.

In LA, she attended film school at UCLA and became part of a revolutionary group of Black film students who have since been referred to as the LA Rebellion. The work of those who were part of this group was influenced by the social activism and the emphasis on Black pride of the 1960s. During this time, Dash created three short films that were the precursors for her first feature film, *Daughters of the Dust*. *Four Women* (1974) was her first narrative short film, which explores the preservation of African American stories through dance. It is based on a ballad that tells a story of four archetypal Black women as projected by the external larger society. *The Diary of an African Nun* (1977) was inspired by a short story by Alice Walker and won a student award from the Directors Guild of America. *Illusions* (1982), which explores the experiences of Black women in Hollywood from the perspectives of two Black women characters, won the Jury Prize for Best Film of the Decade awarded by the Black Filmmakers Foundation. Film scholar Manthia Diawara notes four themes of these films: women's perspective, women's validation of women, shared space, and attention to female iconography.[9] These themes, which emphasize Black womanhood, are present in *Daughters of the Dust*, as well.

As Dash's most recognizable and lauded film, *Daughters of the Dust* tells the story of three generations of Gullah women living on an island off South Carolina at the turn of the 20th century. Dash's debut feature film highlights connections among Black women across time and space through its symbolic representations of the continuity of West African and African American cultures.[10] Although Dash completed 10 years of research on Gullah history and culture for the film, *Daughters of the Dust* is far from being a documentary. The film moves beyond reality or accuracy into a realm of the imagination.[11] For example, an unborn child and ancestors who have passed away become part of the present story. The voiceover at the beginning of the movie acknowledges, "I am the first and the last. I am the honored one and the scorned one. . . . I am the barren one and many are my daughters." These statements recognize the connection between the past, present, and future and problematize the unidimensional media images of Black womanhood that Dash sought to resist through her work. Not only is *Daughters of the Dust* unique in its complex depiction

of several Black women characters, but it was also innovative in its application of unique narrative devices. Film scholar Ed Guerrero compares the narrative structure of the film to the Latin American literary concept of magic realism.[12]

Perhaps Dash was ahead of her time, as contemporary filmmaker Ava DuVernay has stated.[13] In fact, despite the recognition that *Daughters of the Dust* would ultimately receive, film studio executives did not appreciate the value of Dash's counter-hegemonic portrayal of Black women. This rejection is an all too common experience for Black women filmmakers, who have often challenged the status quo.[14] For instance, Dash recalls Black woman filmmaker Kathleen Collins being told that her portrayal of a Black woman philosophy professor—the protagonist in Collins' feature film *Losing Ground* (1982)—did "not seem possible." This is indicative of the context in which Dash was (and to a large degree is still) working and the reactions to unconventional and non-stereotypical depictions of Black womanhood.[15]

In 1986, Dash declared, "we are developing more than just an audience; we are also developing new filmmakers."[16] As the success of contemporary filmmakers such as Kasi Lemmons, Gina Prince-Bythewood, Dee Rees, Tanya Hamilton, and DuVernay indicate, Dash's prediction was right. Because of Dash's persistence and ensuing accomplishments, she has inspired a new generation of Black women filmmakers, and DuVernay, who hired Dash to direct episodes of her television series *Queen Sugar* in 2017, referred to Dash as the "queen of it all."[17]

This chapter includes two interviews with Dash from 1986 and 1991 both originally published in *The Independent Film & Video Monthly*.

New Images: An Interview With Julie Dash and Alile Sharon Larkin

Kwasi Harris/December 1986

The Independent Film & Video Monthly

In the summer 1986 issue of *Black Film Review* bell hooks wrote:

> Black women residing collectively at the bottom of this society's social and economic hierarchy have struggled to make space wherein we can work creatively to develop fully our skills and talents. Sexism, racism, and class oppression have made that struggle arduous, though not impossible. To address the development of a Black female voice, we begin by examining the forces that have worked to oppress, exploit, and silence us. . . . Significantly, the second stage of such a discussion and examination (and a most important stage) is the focus on ways Black women artists have broken barriers, overcome obstacles, and found space to develop artistically. Understanding this process is especially necessary in any discussion of Afro-American women filmmakers and their work.
>
> *(from "Black Women Filmmakers Break the Silence")*

Two such filmmakers are Alile Sharon Larkin and Julie Dash. Both live in Los Angeles, home of what has been called the LA Rebellion, referring to the community of Black independent producers who work nearby, but separate from, the major Hollywood studios. Dash's work includes *Four Women, Diary of an African Nun*, and *Illusions*. Larkin directed *Your Children Come Back to You* and *A Different Image*. In this interview, they talk with Kwasi Harris about their experiences as filmmakers and their thoughts on contemporary Afro-American cinema.

Kwasi Harris: What was your first encounter with racism in a white, male-dominated society?

Julie Dash: When I was a kid, in the early 1960s, the Police Athletic League [PAL] sponsored summer programs in the Queensbridge Projects—that's where I grew up. We played games, did arts and crafts, made costumes, etc. And at the end of the summer, the PAL would hold a kind of gala or festival. Well, one summer when the big celebration rolled around, the local newspapers sent a photographer and a reporter to cover the event. The photographer lined us up; we were a group of Black and Puerto Rican girls dressed in little Hawaiian costumes. Then the photographer said, "Oh no. Wait a minute!" He pushed us off to the side and took two white girls who were spectators, put the costumes that we had made on them, and [he] took their pictures for the local newspaper. We said, "OOOeee . . . what's happening?" It took a while for that to sink in.

Harris: Would you say that Black women were invisible?

Dash: As far as commercial films and television are concerned, I would say invisible at best.

Harris: At best?

Dash: Yeah, better to be invisible than represented by the typical set of distortions we've become accustomed to—representations that bear little, if any, relationship to oneself or to the women we've known.

Larkin: The typical caricatures were the Black maid or the mammy, and she was always taking care of some glamorous white woman.

Dash: —and she could never figure out her own life. She was always confused.

Larkin: —and the victim, long suffering, sad. The first time I remember seeing a glamorous Black woman on television was when I saw Lena Horne in *Stormy Weather*. That tripped me out.

It's not only that Black women in the media are stereotypes, it's that our possibilities—for Black people in general—are really limited on the screen. People can't conceive of seeing Black people outside of the images that are on television or the way that they think that we look. All of a sudden, Sade is exotic. To me, she looks regular. All of a sudden, big lips are in, and we were taught to hold those kind of lips in. Now they have a definition of what a Black woman is; everything else is a deviation. They're defining our beauty again.

Harris: What about encounters with patriarchy or early relationships with male members of your family?

Dash: Everything that I remember reading as a child or seeing on television was a male perspective and sometimes a male perspective of a woman's life. That seemed strange. When I started reading a female perspective there was something warm there that I could touch.

Harris: Were you ever told that you couldn't do something because you were a woman?

Larkin: No, I was told that you had to go out there, that you were going to have to take care of yourself and you might have to take care of your family if you had one.

Dash: Well, no one ever said to me, "Don't do this" or "Don't do that." My mother always encouraged me to do whatever I wanted to do, especially film, which she found interesting.

Larkin: The only thing that I was discouraged from doing, come to think of it, was becoming an artist. You could be a school teacher or even a school principal, but artists were crazy.

My family was really headed by my mother, and she structured the family. I don't remember seeing my brothers wash a dish. I remember fighting with my younger brother over the TV, but I really should have been fighting with him over sharing the housework, cooking, and so on. My brothers weren't taught to be progressive men, in the sense of sharing housework and cooking.

Harris: When did you decide that you wanted to become an artist? Was it in high school, in college? When did you become interested in film?

Dash: I never really just sat down and said, "Ah, I'm going to be an artist." In high school I attended a film production workshop at the Studio Museum of Harlem. After that, I majored in film production at CCNY, in the Davis Center for the Performing Arts. But it wasn't until my fellowship at the American Film Institute that I began to treat film as an art form. Later, at UCLA as a graduate student, I acquired enough experience and flexibility to explore film as both a political tool and expressive medium.

Larkin: As I said, I was always discouraged from being an artist, although I drew and I had teachers who supported me. But I was told that artists were eccentric, and poor people didn't go into the arts. You need a practical career. It wasn't until college that I decided to switch from journalism into creative writing. Then in graduate school I studied film. But I didn't think of film as art, but as a very powerful creative medium— more a communications skill as opposed to an art. And I didn't think of myself as an artist.

Harris: When you began to gravitate towards film, were you conscious of wanting to change images? Were you self-conscious about becoming a filmmaker so that you could describe how you would like to see yourself?

Dash: When I first became involved with film, I was interested in correcting certain distortions about Black people, distortions that I had been bombarded with by the media since my childhood. I first became involved with film during the late sixties, and this was a very intense, very special time for Black people. What I saw and experienced in my community did not coincide at all with what was being shown on the nightly news. So, to that end, I decided to investigate various means of correcting what I viewed to be the intentional misrepresentation of what was happening. It seemed to me that film was the only medium capable of countering and invalidating the media-derived assumptions that much of the community had adopted. For example, I wanted to show newsreels in the streets of my community. I wanted to interview members of my community and then screen the results in other communities. Later, as I matured, I began to move towards dramatic films. I wanted to modify Black peoples' self-conceptions by utilizing dramatic forms. I still view the documentary form as a valid means of communicating ideas and issues, but it is not the most effective way of engaging the majority of Black people.

Larkin: I definitely went into film to help change images, partly as a reaction to the exploitation films that were being made. Film is very powerful, more powerful than literature. You can reach more people, and more Black people through film.

Harris: Did you encounter any difficulties in film school?

Dash: As an undergraduate in film school, I was the only female in my class. It wasn't difficult, but at times it was a bit awkward. Some people couldn't understand why I was there. They assumed I was interested in becoming an actress. Even now, when I tell people that I work in film, they automatically assume that I'm an actress rather than a filmmaker. For instance, I once had some optical work done on *Four Women*. While I was discussing the film with the timer, a guy working there asked me if I was the dancer performing in the film. I guess that's the only way he could understand my presence there.

Harris: What they're saying is that women are only supposed to be actresses, not behind the camera, but doing something for the camera. Julie, you mentioned one of your early films, *Four Women*. How did you choose the subject of four women?

Dash: I liked listening to an old slow ballad, and I wanted to visualize it—in a different way. It told about four archetypal Black women as projected by the external larger society.

Harris: And Alile, what were you interested in doing in your early work?

Larkin: I wanted to deal with assimilation, the different paths that Black folks take. I wanted to work from my Pan-African perspective and from different experiences that I had—not autobiographically, but as a source for ideas. I think that one of the problems with Black folks getting together is that we're told to conform and assimilate to a Eurocentric lifestyle.

Julie Dash (1952–)

Harris: This brings out an interesting thread in the work each of you do. Julie, you seem to focus on the relationship between Black people and white people without necessarily referring to Africa. Whereas, Alile, your work always suggests Africa as a reference point, maybe a way out of the relationship between Black and white people or a resolution of the problem.

Dash: That's not really correct. In *Diary of an African Nun*, which I adapted from a short story by Alice Walker, the protagonist struggles with the conflict that develops when her adopted Christian beliefs are intruded upon by the traditional African beliefs of her community. And in *Four Women*, I employ a circular structure to delineate four archetypal Black women, who together constitute a larger neo-African warrior/goddess. In fact, *Illusions* is the only film I've created that takes place in what I would call a non-African dramatic space. And even here I employ certain mimetic strategies that I've taken from Afro-American expressive traditions.

Larkin: Also, you have to consider the visual statements in Julie's *Four Women*. She starts with a homage to Africa and the Middle Passage. And the character with braids, she's the strongest character.

Dash: She's a compilation of all the other women.

Larkin: And her image is African. For me, she's a strong image of a neo-African woman.

Harris: How have critics received your films? Alile, how do you answer critics who see the longing for Africa in your work as a romantic escape: you are not African, no matter how much you relate to Africa?

Larkin: That's a question that often comes up with *A Different Image*. The film has been criticized negatively by women who consider themselves radical feminists, who say that I romanticize Africa. I think that comes from a lack of knowledge of African societies. I think that they should do some research and understand the roles of Black women in society from antiquity to colonization and European contact. Another criticism of A *Different Image*, I understand, had to do with the bright colors the character Alana wore. Again, that's part of our culture.

Dash: I think many people, both Black and white, are uneasy with the notion of making films about Africa. When films are set in Italy, Scotland, England, or Germany no one bats an eye. If a Black filmmaker creates a film about Africa, set in Africa, or from an African vantage point, it's reduced to a purely political act, not cultural, philosophical, spiritual, or even expressive.

Harris: Why do you think that is the case?

Larkin: Isn't that racism? And, as Julie said, an uneasiness. Why can't we connect with our beginnings? We see that in other films, the Wild West, Pilgrims, and all that. But if we go beyond the cotton fields, there's a problem.

Dash: Also, in touring with our films I've come across another phenomenon that occurs when critics view our works. This is especially true in France and England. If we depict a self-confident, self-reliant Black character who is

91

not miserable—who may choose to wear bright colors, or dress elegantly—then that character is said, by critics, to be leading a lush, unrealistic life. The three films I know that often face these kinds of superficial criticisms are *Losing Ground*, by Kathleen Collins, Alile's film *A Different Image*, and my film *Illusions*—all films made by women and depicting unconventional representations of Black women.

Larkin: We call that the "victim-misery syndrome," where Black people have to be miserable victims, waiting for a white savior to come along.

Dash: When Kathy's *Losing Ground* was screened in Europe, some of the critics couldn't accept the protagonist. They said things like, "She doesn't seem possible" ([meaning] a Black woman philosophy professor). They have such a narrow view of us. These critics seem more comfortable with our work if it fits properly into their preconceived ideas or if it coincides with what they have already seen before on film.

Harris: What has been the critical reception of your work, Julie?

Dash: Well, *Illusions* was almost totally ignored for two years after its release. It seemed to me that no one wanted to risk an opinion, until they read what someone else would say. *Illusions* poses as one thing, while in fact it's another. It intentionally mimics the form and conventions of Hollywood films of the thirties and forties. But by embedding certain foreign objects in the form—the protagonist Mignon, for example—I've attempted to throw the form into relief, hopefully making all of the sexist and racist assumptions of that form stick out.

Some people asked, "What's the point?" or "Why do you want to show a Black woman passing for white in the 1940s?" At the Amiens Festival (against racism in France) one Black woman—a filmmaker herself—stormed out of a screening proclaiming *Illusions* to be a throwback to *Pinky*. Perhaps because she was French-speaking, she failed to understand that there is more to the film than the protagonist's passing for white. In fact, I'd even toyed with the idea of having each and every character reveal themselves to be passing and/or in the closet by the film's end.

Larkin: I think that a very powerful statement in *Illusions* has to do with one of the most common stereotypes: the tragic mulatto. Julie redefined that. Her sister was not tragic. She was not passing out of shame. She was passing to help her people. The film redefined that stereotype.

Another reason I think *Illusions* is so powerful has to do with what we were talking about earlier, never seeing images of Black women. We'd see these glamorous white women singing songs up there on the screen, but the singers were really sisters. Our essence was up there but we weren't allowed to be shown. In that sense, *Illusions* is our story. Society would take what we created and make money from it, exploit it and us.

Harris: Do you think that the critics are really in tune with the emerging Black cinema? Do you think that their tools have to be redefined or sharpened?

Dash: There are very few critics, Black or white, who are well enough versed in Black culture in general and Black film specifically to comment intelligently on our work. Clyde Taylor, who's a professor at Tufts University, is one of the exceptions.

Criticism can give you something to strive for. It can identify aspects of the work that perhaps the maker wasn't consciously aware of. The best criticism doesn't just say, "I liked it" or "I didn't like it," but creatively engages the work. One could even say that the critic should creatively *misread* the work, which would allow the filmmaker the opportunity to reconsider the work from an unprivileged vantage point.

Larkin: The problem with most of the images of Blacks in film and TV is that we are always objects as opposed to subjects. We're writing stories or we want to tell stories about us, instead of always being the props in white folks' stories.

Harris: As an artist, how do you counterpose your idea of responsibility with the idea that an artist transcends social background and social responsibility?

Larkin: I think that's impossible.

Dash: The ancient African truism, "Art reflects light, and light reflects art" is certainly valid today. There are no imaginary muses. They are real. They're ancestral.

Harris: You seem to be defining a new cultural idiom and using film as a vehicle. How would you place your work in relation to capitalism and capitalist culture?

Dash: Contrary to what we're subject to one does not have to fill a film with sex and violence in order to sell it to the public. Hollywood and the television networks are conservatively run businesses. They place an ultimate value on the proven product. And for them Black films are "unproven." Hollywood is making films that were remakes in the thirties and forties. To make matters worse, the networks take those same old themes and story ideas, water them down, and run them on television. They are remaking sitcoms from the fifties and sixties—"bringing back the old favorites." How many renditions of *Death of a Salesman* must one see in one's lifetime? When do we get to see Toni Morrison's *Sula* or Zora Neale Hurston's *Their Eyes Are Watching God*? We've never seen anything close to that on TV or in the theaters.

Larkin: I agree, but racism plays into it, too. As independents, we don't have access to the market. We can't just go and take our films to the theaters and have them shown there. We don't have access to commercial television stations or PBS stations. I believe my product is commercial. Like Julie said, anything and everything can be commercial in this society. Yet there is something that is blocking my entrance into that market.

Harris: Do you think that critical cinema, cinema that uses different types of subject matter could actually be integrated into the system?

Larkin: I don't think that they will pick up or push our films. There's a problem in separating the different issues: sexism, capitalism, and racism. I don't think that you can separate them. And racism keeps certain folks in power. All of a sudden, there are lots of Black people on TV, maybe because of the success of *The Cosby Show*, but still with the same old images, nothing has really changed.

The Cosby Show is positive—in terms of casting—but it's a very safe show. They're an all-American family that made it in the United States. In terms of their politics, I would say they're liberal—a nice liberal Black family. It's not going to threaten anybody, although it might help people to have less limited ideas of Black folks.

Dash: The Cosby Show is a groundbreaking program, but not because it's confronting any major issues. There's a certain level of recognition of the characters as people I've known. That the characters are simply allowed grace, intelligence, and wit, as opposed to sheer minstrelsy, is an advance over the typical fare we have been offered.

Harris: You don't think *The Cosby Show* is colorless?

Larkin: I don't think that it's colorless at all, but I don't see anything revolutionary in terms of images of Black people. And I think it's racism when people say, "They don't seem like Black people." It's a well-made show, but those nuances of character and so on are also in Charlie Burnett's films, and I don't see him getting any support.

Harris: How about racism and sexism? How does that affect your work?

Dash: Simply by limiting the options available to me for the completion of my projects.

Harris: How about sexism, how does that figure in the whole stew?

Dash: It simply exists as another constraint placed on the realization of one's work.

Harris: Do you align your work with the feminist movement?

Dash: Feminism is still predominantly a white movement, and as such, unfortunately, still subject to racism.

Larkin: Black men have no power in this country. They're powerless. So how can I say that they are oppressing me? I can say that they possess sexist notions and behavior, but I can't align myself with the white women's movement and say that Black men are my enemies. There's been a rift between white women and women of color. If women only want to deal with sexism, and not with racism or capitalism, then they call themselves feminists. I think we have to deal with all those systems of oppression, because everything affects us. White women don't have to deal with everything, unless they choose to. In our work we try to deal with different images—in response to sexism, racism, economics—the same way that Black men do, or any people of color do, living in racist, sexist, capitalist America.

Harris: Some Black independent filmmakers would rather not be considered as Black independent filmmakers, but simply as "filmmakers." But in your work there seems to be a tension between subject matter—Black people—and a desire to be universal. How do you balance that subject matter and the demand to be accepted by society?

Dash: Well, I am certainly Black, and a woman, and a filmmaker.

Larkin: I think that those people are fooling themselves. That's a game they play with us: "If you write about Black people, it's not universal." If stuff made by white folks is considered universal, then our stuff has to be more universal, since we reflect the universe more; there's more of us. Is that what universal means?

Harris: Maybe, outside of America. . . . What's on the horizon? Where do you see yourselves going? Where do you see Black independent film going?

Dash: Hopefully, as Black films become "proven" as an exploitable commodity, financing will become easier to obtain. The films that we are making are getting better each year. It may take years between each film, but each generation of Black filmmakers will make better and better films, reach larger audiences, and hopefully those that come after us will not have to be as preoccupied with challenging distorted images of themselves. They'll just deal with all the great stories we have to tell and would like to share with the world.

Larkin: There's a lot of talent now. In terms of marketing, we know people with MBAs. There are journalists that are involved in independent Black filmmaking. I feel optimistic, especially with the home video market—that's going to really help us out a lot. One of the things that we have to do now is develop our audience, and we're willing to work on that.

Harris: How do you propose to develop an audience?

Dash: Every time we go on tour with films, at each film festival, with each screening, whether we are showing in a church, community center, museum, or whatever, the audience grows. They want to see more. Some people want to invest in our future projects. Some come up with tears in their eyes. They just want to say hello and tell you that they've had dreams or ideas just like what we've shown them on film—and they've never seen these images on film before. It gets very emotional at times.

What's most inspiring for me is that there's always someone in the audience who wants to become a filmmaker, but isn't sure they can do it, and, because of our presence, they make a decision to pursue a career. As filmmakers, we are able to share with them images and stories that they can identify with. We can offer them characters whom they can recognize and relate to. The last time I did a tour, last March—I went to Cincinnati—afterwards I received so many, many phone calls and letters of support. So I think we are developing more than just an audience; we are also developing new filmmakers.

Harris: And production? Do you find that there's more or less money available?

Larkin: Like you used to say, we have to get the technical thing together. We have the ability to make good products without million dollar budgets—or many thousand dollars budgets, too.

Dash: As independents, we've learned how to produce good films without million dollar budgets. The money is still as hard to get as ever, but that's part of being an independent filmmaker. Fundraising is very much a part of our lifestyle.

Harris: Mentors can be important in developing more sophisticated work as well as people more sophisticated about cinema. But there's almost a complete absence in our ranks.

Larkin: I really miss that. I've tried to find mentors in other fields. I don't have anyone who works in cinema, but I have a mentor who's a visual artist and another who's a dancer and songwriter. I wish that people in the commercial industry would get together with us, because they have a lot of skills and a lot of information that they could give us. This doesn't seem to be happening. Those Black folks that are working in the commercial industry are just trying to survive. I don't know of anyone who has a lot of energy for us. I don't think it has to be that way. I think there are many of us that are committed to building an independent movement who don't necessarily want to take their jobs. There are only so many token positions. We need them to give us some support, too, for what we're trying to do.

Dash: I'm reminded of Kierkegaard's maxim: "He who is willing to work gives birth to his own father." For years, I searched diligently for a mentor, but at a point I recognized that one must shape one's own development. There certainly exists a body of works created by Black filmmakers, Oscar Micheaux and Spencer Williams, for example, that every Black filmmaker should have studied in depth.

We should be working hard to establish . . . for want of a better word, I'd say, study groups. They could be local or regional, not necessarily institutional. But I think Black independent filmmakers have to come together, systematically and regularly, to discuss, develop, and implement our own film aesthetics. We need concrete discussions of each other's work, what was attempted, what was successful, what could have been better. We need a hot house context, in which works-in-progress can be screened for initiates, a context structured along the line of, say, the jam sessions held at Minton's Playhouse, which were so crucial to the development of BeBop. We should consciously begin to draw aesthetic conclusions from our work and that of our forebears.

I think the only time that I've come in contact with a number of independent filmmakers is at film festivals. But the schedule is so hectic that one doesn't have any time to really sit down and talk. What I'd like to see at

least once is a festival, or rather a seminar, that's just for filmmakers, where issues could be discussed in depth without having to digress to answer the questions of neophytes.

Larkin: I think the problem is that festivals are usually funded by public agencies, and as a condition of the funding the films have to reach a community audience. There haven't been funds for filmmakers to have our own forum.

Harris: What would you advise young Black creative people who want to get involved in the film industry?

Dash: If possible, attend a good film school. Also, contact as many filmmakers as possible; most aren't that inaccessible. Try to crew on independent productions. Read as many film books and journals as possible, especially in conjunction with screenings of the works discussed. If possible, acquire a video cassette recorder, camera, and editing unit. Record different things off the air or rent prerecorded tapes for study. If you can get a camera, begin taping images. If you can get an editing unit, experiment with restructuring the order of the footage you tape. Also, play with re-editing footage taken off the air. Try to do all of this in conjunction with at least one other person.

Harris: Do you think success in the market might undermine the possibilities for independent films that have something unique to say?

Dash: I think we have many important stories to tell. These stories are burning in our souls. These stories may or may not be what are considered "commercial products." Nevertheless, they must reach the screen. Eventually they will.

Larkin: I know someone who was working in the industry. They were making good money, and they said they had the contacts if they wanted to make a film. But, this person told me, they were afraid.

Dash: We're not afraid to make those films. It may be impossible for us to work inside the industry, but we don't know yet. There's no precedent. As independents, we maintain total control over what goes in the script, how the story is shot, and so on. I don't think that's possible within the industry.

Larkin: And, like Julie said, we've got stories to tell.

Geechee Girl Goes Home: Julie Dash on *Daughters of the Dust*

Deborah and Catherine Saalfield/July 1991

The Independent Film & Video Monthly

Although the work of Black women filmmakers has remained virtually unacknowledged, Julie Dash has consistently produced films that explore the struggles of Black women in the US. In each of her 10 projects, she introduces new models for representation of this perennially underrepresented group while reformulating modes of

narrative filmmaking. And her latest film, the feature-length *Daughters of the Dust*, may earn her the recognition she deserves.

Shot by A. J. Fielder, *Daughters* won first prize for Best Cinematography in a Dramatic Film at the Sundance Film Festival in Park City, Utah, last January. *Daughters* is the second segment of a projected four-part series on US Black women at key historical junctures. The series was initiated with Dash's 1983 film *Illusions*, which portrays the complicated issues of "passing" and gender in a story of a woman who works in a Hollywood studio during World War II. One of the series' two subsequent films will take place in the sixties, and the other will be a futuristic fiction occurring beyond the year 2000.

In contrast, the period setting of *Daughters of the Dust* is the turn of the 20th century on Ibo Landing, a former port of entry for newly enslaved Africans in the Sea Islands off the Georgia coast. Tension builds in the 113-minute film as the younger members of the extended Peazant family prepare for their migration "up North," leaving their difficult and isolated, but familiar and relatively autonomous rural life for the potential prosperity offered by the mainland's industrialized culture. Unlike *Illusions*, which intentionally mimics a forties Hollywood feature—black and white film stock, a linear script, and snappy dialogue—to elaborate and propel the storyline, *Daughters* borrows a traditional West African approach to recounting a tale. Dash asserts, "All stories don't need to be told in a Western way. We have the genres down pat. It's incumbent upon us to challenge and stretch the norm."

In *Daughters*, not only does Dash question formal conventions, but she also examines a community that was never considered an apt subject for feature filmmaking. Rather than take her cues from the mass media, however, she relied on her own ancestry in conceiving *Daughters*—specifically her father's family, which is from Charleston with roots in the Sea Islands. "But they didn't like to admit that they had relatives on the islands," Dash remembers. "For a long time, it was an insult to be Gullah or Geechee, because it was so closely associated with African ties. It meant you were ignorant, you had a strange accent, you practiced magic." Dash observes that her father's generation was "trying to assimilate." In making *Daughters*, then, Dash found means to "recollect, recall, and remember," words she ascribes to the film's narrator, the Unborn Child.

The story that unfolds in *Daughters* centers on the women of the Peazant family. Nana, the 88-year-old matriarch and the carrier of African heritage, resists the migration and fights to keep her children together, meeting hostile opposition from Hagar, who married into the family and now seeks to distance herself and her children from Sea Island customs. On the day of a farewell picnic, Nana's granddaughters Viola and Yellow Mary return front the mainland, bringing with them companions who represent aspects of modernity. Viola's friend, Mr. Snead, is one of the talented tenth, a citified anthropologist and photographer whom Viola has commissioned to document the family's last moments as a community on the island. Yellow Mary's companion seems a more enigmatic character, and the friendship between the two women suggests a romantic involvement. Meanwhile, another granddaughter, Eula, has been raped by a white landowner, and her husband Eli is

tormented by the possibility that the unborn child she carries is the rapist's and not his own. Ultimately, Eula's pregnancy serves as a metaphor for the larger issues of cultural rape and violation.

Dash sees the film as primarily concerning "the fear of going away from home and not being able to come back," the fear of abandoning one's culture and, there-fore, losing the foundation of one's identity. While the Christianized Viola uses her visit as an opportunity to extend her missionary work, trying to bestow her enlight-enment upon backward heathens, Mr. Snead finds himself more enlightened by the visit. In the process of his very serious and objective documentation of the Peazant family's migration, he gets entangled in what is perhaps his first personal contact with his own African roots. Yellow Mary, on the other hand, already "knows that the mainland is not all it's cracked up to be," says Dash. After having worked as a wet nurse and prostitute to support herself, she faces castigation from some of the women. "Her money and independence give her power which makes her danger-ous, disliked, and feared," she explains. "They're jealous because she travels—she knows more than they do." Unexpectedly, however, Yellow Mary chooses to stay with Nana when the boat shoves off with her companion on it. Whereas it appears that Yellow Mary has brought her lover home to meet the family, the woman is excluded from the explicit and acceptable bonds of blood and marriage. Further-more, Dash explains, "The companion needs to go home, too, to Nova Scotia."

By means of the characters' interwoven voices and the repetitious layering of images, Dash creates a collage of perspectives, "Because that's the way I think." This effect, supported by idiosyncratic, often lush photography as well as a conceptually varied score, allows *Daughters* to proceed at a contemplative pace. Without many stylistic precedents, Dash challenges her audience to sustain a level of engagement unusual in a culture where the pace of MTV and advertising set the standard. "I tell the story the way an African griot would tell a family history," she comments. Reacting to these techniques, reviewers have dubbed her an "anti-informationalist." Reluctant to appreciate this mode of expression, some critics have labeled the film "nonlinear." Dash replies, "I don't really see it that way, because these are all experi-ences that the characters have shared. Repetition is not necessarily repetitive. Black people like to say things one way, then another way, then another way. That's the way we worked [on *Daughters*], until we got to the end of what we wanted to say."

Originally, Dash conceived of *Daughters* as a silent movie. "I wanted a very visual film, memories recalled from the past, floating in a time continuum. You get more out of it once you leave the theater and it comes back to you than when you're waiting for it to connect." However, when she embarked on production, American Playhouse—the film's major funder—pressured Dash to include dialogue, "to make the film accessible to more people." Nevertheless, although Playhouse staff made suggestions after screening a series of rough cuts, Dash retained aesthetic and edito-rial control.

Although they provided $800,000—the bulk of production and postproduc-tion support necessary to complete the project—American Playhouse entered the picture after a long and difficult process familiar to most independent producers.

Two years ago, Geechee Girls Productions, Dash's company, marshaled a few small grants and a minimal crew to make an impressive trailer. The trailer then attracted funding from the Corporation for Public Broadcasting, the Rockefeller Foundation, and the National Black Programming Consortium, in addition to Playhouse. With the ambitious 35mm production now finished, distribution for *Daughters* still remains elusive, although American Playhouse will air the film in the future. Dash believes that her latest work may face some difficulties because of its emphasis on Black women's perspectives. "Most women tend to really like the film. Men have little, if any, patience with it because it has to do with women, first, and Black women, second. It's a double whammy." Given the obstacles that Dash has encountered, she remains optimistic about the success of her work and committed to the messages it imparts. Noting that, "there are so many other Black women filmmakers," Dash insists, "It's not important to me to be known or recognized as the flavor of the month. I'm thinking about the big picture, about history, and about making an impact in cinema, about making a statement that will last." Furthermore, Dash is clear not only about the difference between her work and the mainstream but about how her films differ from those of other African American directors. "What we've been exposed to is the work of Black men," she says, lamenting the underexposure of Black women filmmakers, especially in light of recent box office successes by Black men. But she takes pleasure in the attention her colleague Charles Burnett has received. "He's sensitive," she says, "not in a rush to be part of Hollywood cinema, not trying to entertain, but making his own kinds of films."

In refusing to conform to the expectations bred by Hollywood entertainments and insisting on making *her* own kind of film, Dash offers important reflections on cinematic representations of American history—and suggests new directions for the future. For example, in the final scene of *Daughters of the Dust*, Hagar's daughter Iona flees on a horse with her Native American lover just as the boat bearing her family departs for the mainland. In this sequence, Dash acknowledges the fact of mixed ancestry and, at the same time, invents imagery lacking in her own experience: "I always wanted to see a Black woman riding off into the sunset. Everyone else got to ride off into the sunset except Black women."

Notes

1. Julie Dash, *Daughters of the Dust: The Making of an African American Woman's Film* (New York: The New Press, 1992), 40.
2. Ibid.
3. Tre'vell Anderson, "25 Years Later, Writer-Director Julie Dash Looks Back on the Seminal 'Daughters of the Dust,'" *Los Angeles Times* (November 24, 2016), www.latimes.com/entertainment/movies/la-et-mn-daughters-of-the-dust-julie-dash-20161114-story.html; Tim Grierson, "'Daughters of the Dust': Why the Movie that Inspired 'Lemonade' Is Back," *Rolling Stone* (November 18, 2016), www.rollingstone.com/movies/features/why-we-need-indie-movie-daughters-of-the-dust-right-now-w450955
4. See 1986 interview with Kwasi Harris (originally published in *The Independent Film & Video Monthly*).

5. Patricia Hill Collins, *Black Feminist Thought: Knowledge, Consciousness, and the Politics of Empowerment*, Second edition (New York: Routledge, 2000).
6. See interview with Kwasi Harris (originally published in *The Independent Film & Video Monthly*).
7. Kwasi Harris, "New Images: An Interview With Julie Dash and Alile Sharon Larkin," *The Independent Film & Video Monthly*, summer 1986.
8. Kwasi Harris, "New Images: An Interview With Julie Dash and Alile Sharon Larkin," *The Independent Film & Video Monthly*, summer 1986.
9. Manthia Diawara, ed., *Black American Cinema* (New York: Routledge, 1993).
10. Sandra M. Grayson, *Symbolizing the Past: Reading Sankofa, Daughters of the Dust, & Eve's Bayou as Histories* (Lanham: University Press of America, 2000).
11. Julie Dash, *Daughters of the Dust: The Making of an African American Woman's Film* (New York: The New Press, 1992).
12. Ed Guerrero, *Framing Blackness: The African American Image in Film* (Philadelphia: Temple University Press, 1993).
13. Cara Buckley, "Julie Dash Made a Movie. Then Hollywood Shut Her Out," *New York Times* (November 18, 2016).
14. Jacqueline Bobo, ed., *Black Women Film and Video Artists* (New York: Routledge, 1998).
15. Kwasi Harris, "New Images: An Interview With Julie Dash and Alile Sharon Larkin," *The Independent Film & Video Monthly*, summer 1986.
16. Kwasi Harris, "New Images: An Interview With Julie Dash and Alile Sharon Larkin," *The Independent Film & Video Monthly*, summer 1986.
17. Cara Buckley, "Julie Dash Made a Movie. Then Hollywood Shut Her Out," *New York Times* (November 18, 2016).

8

CHERYL DUNYE (1966–)

Sarah E. S. Sinwell

Perhaps most famous for writing, starring in, and directing the first Black lesbian feature film, *The Watermelon Woman* (1995), Cheryl Dunye's filmmaking spans a number of genres including narrative, documentary, and memoir. Coining the term "Dunyementary," Dunye's films intertwine forms, genres, and styles that question contemporary understandings of gender, race, class, and sexuality via alternative modes of both fiction and documentary filmmaking.[1] Exploring the interconnections between postmodernism and personal identity, Dunye's intersectional approach to filmmaking also maps out the ways in which Black lesbian identities have been largely underrepresented within popular culture.

Dunye was born on May 13, 1966 in Liberia. Growing up in Philadelphia, she received her Bachelor's degree from Temple University and her Masters of Fine Arts from Rutgers University Mason Gross School of the Arts. When asked why she became a filmmaker, Dunye stated,

> I had been studying critical theory in Michigan State of all places and only survived two years there in the mid- to early-'80s. When I got back to Philly, the landscape had changed. It was activism. It was Reagan. And, the new sort of twist through the late '80s was media and politics—and the power that people could have using media and television and film. So, I really focused on using that methodology to promote the invisibility I felt around people that looked like me, you know, queer women, people of color.[2]

A student of feminist filmmaker Martha Rosler (*Semiotics of the Kitchen*, 1975), Dunye lists among her influences the works of filmmakers and artists such as Chantal Ackerman (*Jeanne Dielman*, 1975), Michelle Citron (*Daughter Rite*, 1980), Julie Dash (*Daughters of the Dust*, 1991), Michelle Parkerson (*But Then She's Betty Carter*,

1980), and Camille Billops (*Finding Christina*, 1991). In an interview, Dunye stated, "Cinema is my life, in a way, in all shapes and sizes from script to screen to film festivals, so it's very difficult to nail down what completely has influenced me."[3] She noted genres that influenced her early work, stating, "I really do like noir. I love Blaxploitation. And, I love stuff from the golden age of Hollywood—where there's lot of misrepresentation and looking at how marginal lives are represented."[4]

Like many other directors of New African American Cinema[5]—including Charles Burnett (*Killer of Sheep*, 1978), Spike Lee (*She's Gotta Have It*, 1986), Robert Townsend (*Hollywood Shuffle*, 1987), John Singleton (*Boyz n the Hood*, 1991), and Dash—Dunye's work focuses on the everyday experiences of Black Americans while at the same time questioning stereotypes about Blackness. Examining the intersections between Black, female, and lesbian identities, her films also address a variety of contemporary social issues including violence, class struggles, racism, and civil rights.

At the same time, Dunye's films can also be imagined in relation to B. Ruby Rich's concept of New Queer Cinema (a term she coined in *Sight and Sound* in 1992).[6] New Queer Cinema refers to films that are concerned with "appropriation and pastiche, irony, as well as a reworking of history with social constructionism very much in mind."[7] But, it wasn't until 1994, with the release of Rose Troche's *Go Fish*, that lesbian films became more popular in this movement as well. Along with films such as Marlon Riggs' *Tongues Untied* (1989), Isaac Julien's *Looking for Langston* (1989), Ang Lee's *The Wedding Banquet* (1993), and Maria Maggenti's *The Incredibly True Adventures of Two Girls in Love* (1995), Cheryl Dunye's *The Watermelon Woman* has been historically understood in terms of its examination of the invisibility of people of color within New Queer Cinema and a reexamination of alternative representations of non-white queer identities in film.

From her earliest work in filmmaking, Dunye investigated Black lesbian subjectivity via experimentation with film form, style, and montage. Based on the poem by the Black lesbian experimental poet Sapphire, Dunye made her first video called *Wild Thing* as a senior at Temple University. In her other short videos, *Janine* (1990), *She Don't Fade* (1991), and *The Potluck and the Passion* (1993), Dunye further explored these understandings of gender and sexuality, as well as familial and romantic relationships, by pushing the boundaries between documentary and fiction filmmaking. Combining archival photographs, Super 8 film, video, and 16mm filmmaking, these earlier works also served as a cultural study of the ways in which film had changed since the advent of the video camera. Putting herself at the center of her films, often in a starring role, enabled her to imagine how autobiography and her personal identity politics as a Black lesbian can be played out in the interstices between documentary and fictional filmmaking.

Dunye's first feature, *The Watermelon Woman*, is widely known as the first Black lesbian feature film. Winner of the Teddy Bear at the Berlin International Film Festival and Best Feature at Outfest and the Torino International Gay and Lesbian Film Festival, the film received much critical attention for its representation of Black lesbian identity. It wasn't until over 15 years later, with the release of films such as *Pariah* (Dee Rees, 2011) and *Girlhood* (Celine Sciamma, 2014), that films about

Black lesbians became more visible in the cultural imaginary. Written, starring, and directed by Dunye, the film was shot primarily on 16mm, had a budget of $300,000 and was distributed by First Run Features.

The Watermelon Woman is a self-reflexive hybrid of narrative and documentary filmmaking that addresses the complexity of Black lesbian identity by intertwining the story of Dunye herself with a fictional history of a Black actress from the 1930s, Fae Richards. By investigating archival, feminist, fictional, and filmic texts, the film also serves as a commentary on the invisibility of Black lesbian historiography. In this vein, the film also critiques the Mammy archetype within media and film culture and blurs the boundaries between truth and fiction. Examining the genre of queer Black documentary, the film is also a cultural critique of the erasure and omission of Black women from (film) history. Playing herself in the film, Dunye notes that "Sometimes you have to create your own history."[8]

In 1996, six days after its screening at the New York Lesbian and Gay Film Festival, *The Watermelon Woman* was attacked on the floor of the US House of Representatives "as an 'outrage' and became the latest pawn in the ongoing [National Endowment for the Arts (NEA)] debate."[9] Dunye had received a $30,500 grant for the film from the NEA. At this cultural and historical moment, the NEA was under attack for supporting such gay and lesbian directors as Riggs and such organizations as Women Make Movies, a nonprofit organization that supports the distribution of female (and lesbian) filmmakers. The film was accused of breaking Republican Senator Jesse Helms' clause in the 1996 NEA appropriations bill that "forbids funding work that denigrates religion or depicts sexual or excretory activities 'in a patently offensive way.'"[10] In fact, many of the critics of *The Watermelon Woman* hadn't seen the film, but, still objected to the rumors of "explicit sex" (a 90-second love scene) and "drug use" (the use of marijuana). As noted in a 1996 interview with *The Independent Film & Video Monthly*,

> Dunye believes the true source of the attack lies in making a film that blurs the lines between Black lesbians and straight women, and between real history and interpreted history. 'What we know as artists is that it's about the gray,' says Dunye. 'That's what's speaking here. You can be upset at the gray, or be angry at the gray, but the gray has to exist for the Black and white to exist.'[11]

Dunye's second feature, *Stranger Inside* (2002), garnered Dunye an Independent Spirit Award nomination for Best Director in 2002. A commentary on the gendered, raced, and classed system of incarceration, the film received Audience Awards at the Seattle Lesbian and Gay Film Festival, San Francisco International Film Festival, LA Outfest, and the Philadelphia Film Festival. Based on four years of research on the history of female imprisonment in the US,[12] *Stranger Inside* also includes references to Harriet Jacobs' slave narrative, *Incidents in the Life of a Slave Girl*.[13] At the age of 21, Treasure (played by Yolonda Ross), enters a women's state correctional facility in the hopes of reuniting with her long-lost mother Brownie (played by Davenia McFadden). As Treasure continues to be more and more involved with her prison family, the film also critiques other canonical women's prison films such as

Caged (John Cromwell, 1950) and *Caged Heat* (Jonathan Demme, 1974). Instead of skirting around the issue of Black lesbians in prison as many prior films had done, *Stranger Inside* places butch-femme culture at its center, as an intrinsic aspect of prison life. In addition, the film also critiques prison as an institution by refusing to justify the binaries between Black and white, innocence and criminality.

Quintessentially intersectional, Dunye's other features, *My Baby's Daddy* (2004), *The Owls* (2010), and *Mommy is Coming* (2012) continue to reconstruct representations of race, class, gender, and sexuality onscreen. Playing with genres such as the romantic comedy and the thriller, these films also push the boundaries of these genres by challenging normative ideas of Black and lesbian identity and questioning traditional tropes of fatherhood, motherhood, and the traditional romance.

Most recently, Dunye has also started to work on more episodic filmmaking with the television series *Queen Sugar* (Oprah Winfrey Network, 2017), *The Fosters* (Freeform, 2018), and *Claws* (TNT, 2018). In her work on these series, since she is not the showrunner, she looks to increase the representations of marginal identities and advocates for including more diversity via casting. She argues that by choosing to cast a lesbian, Black, Asian, transgender, or disabled actor, this provides a means of including marginal identities that otherwise might be erased or ignored. Dunye is now in preproduction on turning her 2014 short film *Black is Blue* into a feature. The story of a Black trans man in her short has now translated to "a story about a Black trans man, a Black trans woman, living in future Oakland, and the life they have within the context of gentrification, technology, and a relationship that they both have with an android."[14] Dunye is also currently an Assistant Professor in the Department of Cinema at San Francisco State University.

Included in this chapter are two interviews that explore Dunye's oeuvre—one published in The *Independent Film & Video Monthly* in 2001 and an interview based on two conversations with Dunye in 2018.

Breaking Out: Cheryl Dunye Nabs Big Audiences on the Small Screen With Her HBO Prison Feature *Stranger Inside*

Holly Willis/June 2001

The Independent Film & Video Monthly

Dunye returns to the screen with *Stranger Inside*, a gripping prison drama that traces 21-year-old inmate Treasure Lee (Yolanda Ross) as she tries to reconnect with her mother, Brownie (Davenia McFadden), who is in jail serving a life sentence. Once again, Dunye plays in the space between fact and fiction, creating a narrative that brings to light many of the unknown facts about women in prison. Among the startling figures gleaned by Dunye during her extensive research is that 90 percent of the 90,000 women in prison in the US are single mothers. Dunye also workshopped her script in 1999 at the Shakopee Women's Correctional Facility in Minnesota, where inmates offered their insights on life behind bars.

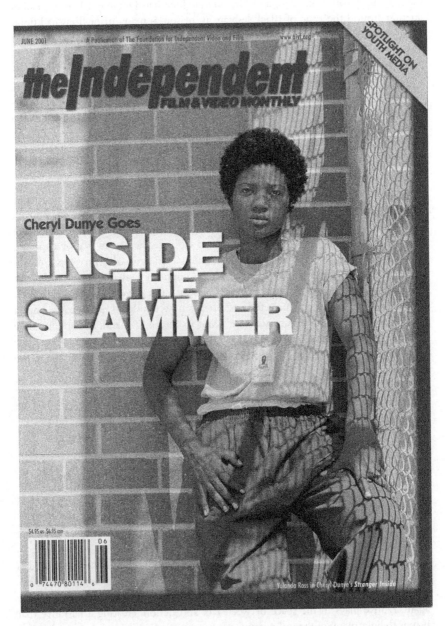

Figure 8.1 Dunye's film *Stranger Inside* was featured as the cover story in *The Independent* in June 2001.

Cheryl Dunye (1966–)

While the film certainly has its facts and figures, it's also Dunye's best straight ahead narrative project with strong performances all around and top-notch cinematography. Yolanda Ross, a relative newcomer to film, perfectly captures the mix of explosive anger and intense emotional need as she tries to deal with her mother, while Davenia McFadden embodies the hardened, violent inmate whose affection is hard earned. And instead of opting for the gritty realist style of so many prison narratives, Dunye, working with cinematographer Nancy Schreiber, instead chose to design the film with careful attention to color and framing. She used Sybil Brand, a former women's prison in East Los Angeles, where she was able to construct the two cells where Brownie and Treasure reside, while the rest of the facility offered a realistic milieu for other scenes in the story. The film's palette tends toward dark blues and grays, and there are several dream sequences for which Dunye chose a bleach bypass process, giving them an ethereal quality.

Although the film had a special screening at the Sundance Film Festival, Dunye's second feature was produced for television by HBO. In many ways, *Stranger Inside* is a culmination of Dunye's filmmaking so far, illustrating an adept directorial hand and strong visual sensibility. Here she talks about the genesis of the project, as well as her decision to make a film for the small screen.

Holly Willis: How did this project come about?

Cheryl Dunye: In part the story grew out of one book in particular, *Incidents in the Life of a Slave Girl*, a slave narrative about a woman who escapes slavery by hiding in an attic for seven years and watches her kids grow up there. Having become a mother myself, I was thinking about issues of motherhood and family, but began to really hone in on the issues for women in prison. I started doing extensive research, looking into places where theoretical issues around women in prison and social justice issues intersected. From that material I pulled together a script that was very rough. I also did a lot of film research, looking at women in prison films, which range from the Pam Grier spectacles to documentaries, most of which focus on the crimes committed.

Willis: The figures regarding the number of single mothers in prison are astonishing.

Dunye: It's the one thing regardless of race, color, creed, or circumstance that is a big factor for women in prison nationally and internationally. I wanted to use this idea, and because of my background, try to do this sort of this thing I call the Dunyementary, where I integrate documentary and fiction. But I needed to have access to a community to get the documentary aspects or to get to the truth of it. This search for truth comes from Godard in a sense. Luckily, I was able to connect with the Walker Arts Center in Minnesota, and the wonderful curators there—Dean Otto, Bruce Jenkins, and Sheryl Mosley—connected me with Shakopee Women's Correctional Facility, a women's prison just outside of Minneapolis. I was able to take the script inside and workshop it with women inmates.

Beyond the simple writing, I wanted to follow up with time to make sure that it was right with the people who know best.

There were two sets of mothers and daughters in the prison. That was groundbreaking for me. And I think in the past a lot of news journal TV people had come to them wanting to know about their crimes, the lurid details, or the spectacle of women in prison, which in my experience is really the only portrayal we've seen. Think of the Pam Grier films and the numerous documentaries on cable. I wanted my film to have a different flavor. Also, several documentaries have covered mothers, but no one had really talked to the daughters or addressed how families are created inside, or even how blood families fight to stay together when more than one member gets locked up.

Willis: I know that you took the script around to various DV production outfits, with little luck. How did the film finally get into production?

Dunye: My first goal was to get the script to a producer or production company because I did not want to produce the film. I knew I really wanted to give this a shot at being bigger than *The Watermelon Woman*, especially in terms of the audience that would see it. I think indie film today fails on that count. There's not much of an attempt to integrate new audiences. Anyway, along comes Jim McKay of C-100 and Maud Nadler, who was friends with Jim and had just joined HBO. She said she hoped that I'd consider HBO, and even though I wouldn't get a theatrical release I'd get to show the film to lots of people and communicate the message. They both were really behind it. It took me awhile—making your second feature, like all the boys, you want to make it big, broad, wide, and star-studded. But I'm not one of the boys, and the key for me was that the film was going to be seen by far more people on television and that my audience would dramatically change. And it all happened really quickly after that with the help of Effie Brown, Michael Stipe, my wonderful DP Nancy Schreiber, and in post, my editor Cecily Rhett, who all just understood the authenticity and the truth. Because of the strong script, a really good process went into making it.

Willis: One of the most striking things about your film is how beautiful it is, which is a stark contrast to the setting and characters who are very rough. Can you talk about your decision to shoot the film the way you did?

Dunye: Before I met Jim, I had gotten back to the real down-and-dirty idea of shooting it on my own, maybe on DV or Super 16mm. But I realized I didn't want to repeat that process, and when HBO stepped in with a budget, the choice of 35mm came up. I decided I really wanted to shoot on 35mm to make this . . . beautiful. I wanted to romanticize Treasure's passion, not necessarily her world,

but her passion and emotions, and this was very important for me to communicate. *Stranger Inside* is about the subjective as universal. My choosing 35mm helped make the film look a certain way. It helped me make particular set design choices with Candi Guterres, my art director, and Frank Helmer, my wardrobe/costume designer. We all worked together to bring Treasure's passion to life. All of this is very important to me—to make sure that the performances were strong, but also to make sure that it looked good.

Willis:
Some of your cast members were either brand new to acting or relatively new, including your lead, Yolanda Ross, who's terrific. What were the challenges you faced as a director in this sense, especially on a 24-day shoot?

Dunye:
Again, working with a budget opened up the possibility of exploring all of these things. As a sophomore filmmaker, you have to think about how to make it better than before. You either want to work with a large cast and bring in more talent that's recognizable, or you want to work with the truth of the project. In this case, the truth is about people that no one ever sees, these invisible women, so I went for the latter option. This film is about real people, which made it an easy choice for the production to bring to life but a challenging one for my casting director, Aisha Coley. Casting went on for several weeks and not one Treasure came in, so we had an open call both here and in New York, and bam, in walks the fabulous Yolanda. We flavored things up by combining actors you may know with ones that you might not—like Medusa, who is one of the inmates in the film and queen of the local rap scene here in LA. So mixing it up, I think, gave a fresh look to the film.

Willis:
You're often in your own films, but you're not in this one. How did you work with the actors, and how did you feel staying on one side of the camera?

Dunye:
It was good. I had reservations at first, but things shifted from *The Watermelon Woman* to *Stranger Inside.* I wanted to have more control. And taking a break from being on both sides made it easier to get what I wanted out of making *Stranger Inside.* But if you look real close, I'm in a scene in the film.

Willis:
How would you characterize your role as a director? What was a day on the set like?

Dunye:
In an average day we would integrate some of the stuff that we workshopped with the cast—some of the key scenes. I'd have a quick moment with my talent, and we'd go through how we had blocked the scene, then we'd make sure that we had a lot of extras— it is a prison, after all. A lot of the extras were former prison inmates, so there was some dialogue going on there. I wanted the film to feel authentic, so I made sure that people really felt at home. It was just a

hard-ass production. We worked hard on getting every scene from as many angles as we could, and at the end of the day, we'd try to do something that was different. There are several dream sequences, and time-passing moments, and a few extra-diegetic moments where, for example, characters are singing. We'd end the day with those scenes, so that everybody would leave with something different. In particular, the scene where the women are walking off to work camp surrounded by correctional officers and led by Leisha, played by Medusa, in full song. It's an amazing scene. It was something that had been pushed from day to day, and when we finally shot it everyone was so blown away. It reignited everyone's passion.

Willis: Were there scenes that were more difficult to shoot than others?

Dunye: The scenes when Treasure is in the group therapy sessions—that was really challenging. Those people are real. Some are former inmates and some are cast, but everything is unrehearsed. We'd get the two cameras and I'd say, "Okay, 20 minutes, this is the topic, go." It was amazing. There's a whole film there in just that footage. Incorporating the *real* real.

Willis: Those scenes look very different from the rest of the film in that they're a lot rougher and offer a good contrast to the more stylized scenes. They're also the only time we really sense Treasure's interior life. She doesn't speak much, but she doesn't seem to have the tough facade.

Dunye: I was very pleased that we were able to keep these scenes. And I'm amazed that this is the film I wrote, and that's what people are going to see! I don't think second time filmmakers, regardless of whether they're men or women, get to keep on challenging their creative process while they are on the set. As an aside, I don't know how many African-American women have made second features—very few—and I think I'm about the first lesbian African American to do that. So I feel blessed all around!

Willis: You told an amusing anecdote after the Sundance screening about how your casting call specifically noted that basketball playing skills were needed, but none of your actors actually knew how to play. How did you get around that?

Dunye: The original script had a much larger basketball component, but then we discovered that both Yolanda and Davenia didn't play well. We had a stunt coordinator who came and helped us get down some basic moves, and also find ways to integrate the fight scenes. And with those scenes we had two cameras going, and again, just tried to keep it real.

Willis: Knowing your body of work, this film seems to illustrate a flourishing of your storytelling skills. What was it like moving into a more traditional storytelling format?

Dunye: Speaking in general, Black filmmaking, indie filmmaking, queer filmmaking: none of it has really explored anything but the box office for a while, that drive to have numbers and be seen. But

what about exploring cinema and creating something different? I wanted to do that, but I also wanted to play with convention. So on the surface, this film has a message and a conventional story. There are a lot of strong things in the film, and there are things that I stayed true to as a filmmaker. I'm interested in mixing truth and fiction and really talking about storytelling that is fresh and expanding our notion of narrative and not just repeating it.

Willis: What were your thoughts about directing specifically for television?

Dunye: Well, I guess as a young artist I never wanted to see television, after my youth watching everything and anything. But it started to change for me in the late 1980s when ITVS and PBS started moving into the indie world. Then along came Sundance Channel and the Independent Film Channel, and we started to see indies get into the box. And I was comforted when I realized I was doing something different. Cable is not a bad place. And HBO is the cream of the crop. It's not your average television. For me, film-making sometimes has to happen by any means necessary.

Willis: Documentary filmmaking in general seems to be witnessing a tremendous cultural revival.

Dunye: We're still not seeing a variety of stories, but I think documentaries are changing the world. I'm so proud of all my documentary film-making brothers and sisters; they're making some of the best films.

Willis: As someone who's worked back and forth across the documentary/fiction line, what do you think is the cause for this interest?

Dunye: On a cynical side, I think it's because of the impending strike. But I also think [it's] the rise in yellow journalism and spectacles— feeling and seeing the real, seeing the fire, being in front of the gun. Documentary, because of its camera style, its fresh subjects, its real people, lends to that sensation that audiences feel reinvigorated by what they are watching and feeling. I still argue that [filmmakers] don't think about audience much. The way my film is constructed really lets you as an audience member participate. You can be entertained and learn and think at the time. That's exactly what one of my continuing passions is—the result is that you're left with something, not just a receipt for it. You're left with something you can use.

Willis: I think you're right, especially about the daring move you make at the end. There is the sense of narrative pleasure, but there's also the pleasure in seeing a world that we haven't seen before, and it's encouraging to know that someone is out there doing the work. Somehow in working between the two worlds you've found a great position. What's up next?

Dunye: I want to continue this kind of work. I think there are some wonderful scripts and stories out there, from the margins and the invisible people that we need to see. Give them to me!

Conversations With Cheryl Dunye

Sarah E. S. Sinwell/2018

This Q&A is the result of assembling and trimming two conversations with Dunye from January and May 2018.

Sinwell: Now that we have passed the 20th anniversary of *The Watermelon Woman*, what do you believe is its lasting impact?

Dunye: I think the lasting impact of a film like *The Watermelon Woman* is that it is one where individuals who need to believe, believe again. That people are given hope, that the sense of discovery, the sense of invention of who you are, is at your own hands. So through all the archival [footage] and the talking heads, the film ends on this note that—I just had to do this because I didn't exist. Everything is *The Watermelon Woman* . . . all these silent sides of who we are are *The Watermelon Woman*. All our invisibility is *The Watermelon Woman*. And that you can dip into all of your pictures—past, familial relations—to find the bit of yourself and share it with the world regardless of what it is.

Sinwell: Is it the film in your own body of work that you feel most connected to?

Dunye: To date that I've shot, I think *The Watermelon Woman* [features] so many people in my life including my mother, so I definitely feel very connected to that. It's one of the lasting images of her and my family.

But, I think cinematically, for me, *Stranger Inside* was something where from soup to nuts, [it represented] what I wanted to do cinematically, story-wise, content-wise. I was able to get it to a place where tons of eyes were looking at it (being HBO in the early 2000s). So, I feel like *Stranger Inside* is a lot, and it deals with subjects that I was feeling were very important in the early 2000s and continue to be important—women in prison, and how those relate to motherhood and parenthood and incarceration. Those are always pertinent. My ability to translate what I was reading, writing, thinking, and seeing in the numbers of folks incarcerated really came to fruition with that project.

Sinwell: When I teach your work, which I often get to do, I talk about your relationship to both New African American Cinema and New Queer Cinema and I am wondering, how do you see your relationship to these kinds of films and how do you see the ways in which these films impacted your work?

Dunye: I see my relationship to these films, these movements, as sort of filling the void because when New Queer Cinema came out there was no African American queer voice. There was Marlon Riggs who had been working in television and . . . a really hard spotlight was put on difference and multiculturalism in a new way. There were a lot of people that weren't being spoken about in either of these new spotlights that were being created on

New Black Cinema and African American New Queer Cinema. So, I was like, well, I guess I gotta do it. So, I consider my activism as well as my artistry . . . as filling the void. Putting myself in the picture when nobody else was going to do it.

Sinwell: One of the things I am interested in hearing more about is your awareness of the lack of visibility of Black identity and lesbian identity, how did Black and lesbian films and filmmakers of the time impact your use of narrative and style?

Dunye: Definitely. By the time I got to graduate school, professors like Leon Golub and mentor professors like Martha Rosler were definitely experimenting with documentary and narrative, and I just ate that up and really applied it.

I feel like not only do we have to change content-wise, meaning more stories that are about multiple identities and intersectionality, but, we also need to play with form because that might be another way to have power as cultural producers, and the artist is a producer, a creator of, not just the stories that are being told, but, *how* they are being told. So, definitely, it was for me to articulate that in my early shorter work with the talking heads, things led to what I call the Dunyementary, where you have a talking head, you have a vignette, you have a title card, or somebody talking—so those elements led to what I called changing form as well as creating stories and not about coming out stories, but stories about people who are living with intersectional lives, not just being Black, not just being queer, not just being a woman, but being all those things together.

Sinwell: Why do you think it was so important to combine fiction and documentary in your work?

Dunye: The reason I chose to combine them both is because I love the power, the effect, that both of them have on who I am as a person and the media that I like to consume. So, beyond being, going deeper into myself as Cheryl, trying to find my truth, then you know I try to find truth in documentaries. I try to see a grain of truth in narratives, and so this really just rolls them together, and it seems to work.

Sinwell: You include yourself in a lot of your films, including *The Watermelon Woman* and *The Owls*. Can you talk about that decision and what the idea of the self means in your films?

Dunye: Well, *The Watermelon Woman* came from putting myself in the picture because I couldn't find anybody to play Cheryl. But, then I realized the history of autobiography and slave narratives—part of it is just believing in the truth that is being presented. It's something I wanted to do.

I think a lot of filmmakers are playing with putting themselves in the picture [now] . . . even Issa Rae, *Insecure* to *Atlanta*. There's something about the self being seen that allows you to articulate what you are trying to say better.

Sinwell: So, do you think that the idea of autobiography or memoir or these self-told stories has changed since the '90s? Do you think that the idea of how we insert ourselves into the picture or the idea of how we see ourselves in relationship to those narratives has changed or do you think we've been able to extend it beyond the '90s?

Dunye: I think we've extended beyond the '90s completely. It's not just an art world thing. It's not just a thing that you see at film festivals. You're seeing it on television. And, then you are seeing it in the movement of media where people are using their iPhones and YouTubing. And, so the self has become such a canvas—of politics, of passion, of beauty, of absurdity, in different ways. It's had an effect; it has liberated. Everyone is using their cameras and their phones and media in ways to create themselves.

Sinwell: Do you think that television and episodic storytelling enable new ways of thinking about these narratives, and inserting the self into the narrative?

Dunye: Sure. I mean Hollywood is always looking for an episodic, in particular, they are looking for fresh new ways to tell stories, fresh new people to tell stories. Again, you look at Netflix—or even YouTube channels . . . Crunchyroll—there's enough content for *everyone*. So there needs to be more makers and more platforms for people to consume it. And that's where we're getting this younger generation—they identify beyond just race, class, and gender, but, in a different way.

Sinwell: How do you think of your filmmaking now compared to when you first started working in film?

Dunye: I think right now, as I dip into episodic, my filmmaking has changed quite a bit because I am able to use the tools of filmmaking on a regular basis. Normally, independent directors, writers, artists so rarely get to have access to the tools to make their work. You write a screenplay—that's a year. You go out and try to raise funds—that's a year, two years, three years. [Then] filmmakers get to make their work . . . if they are dealing with the feature film format, once every four years, maybe even five, maybe even six. And, if it never sells, it goes right to VOD or back in the box, [then] let's start again. So, right now, I have been able to have more access to the tools by switching to shorter form—which I did with *Black Is Blue*—and by doing episodic, which is shorter form filmmaking on someone else's story or show. But, I get to practice the craft. And, I feel like the works that are going to come out of my writer/director voice will be ones that are much more "cinematic."

Sinwell: Could you talk about why you are continuing to choose to make independent feature films? And maybe how episodic storytelling, or documentary storytelling, or web series, fit into that desire to make independent feature films?

Dunye: Well, [regarding] episodic storytelling for me right now, I am only directing episodes of other people's shows, so to me, it is just a job, and it's a way to articulate and play with the standard of what network television already

has out there. Independent films allow me to put all those things into my bigger ideas and make cinema for people like me who still love to go to a dark room, still love to go to a film festival. It's exciting to be able to have an audience.

Sinwell: What about *Queen Sugar*?

Dunye: Working on *Queen Sugar*, which is a powerful show about a lot of powerful things in African American history, and women, and so many things are going on so many levels, at least storywise. . . . producerial-wise, I feel like I definitely am looking at how to bring out the nuances of story content that are politically important. You don't get to choose your episode; an episode is assigned to you. So, therefore you have to dig into what's there and make sure you accentuate it.

There's already a look of the show, so I don't necessarily get to do my style or shtick, but . . . my ability to cast extras [relies] heavy on the side of intersectionality and diversity—meaning casting a trans person just to play any gender, nobody's going to know, having people of different abilities as extras. I mean, there are little things you can do. You can't really do too much. You definitely can "put your stink on" including marginal voices and representations within the show. So, that's really what I get to do. Much of it is already nailed down . . . so the little bits that I can do are in these places.

Sinwell: What do you see as the future of female independent filmmaking?

Dunye: I see the future of female independent filmmaking as female voices not alone, as directors, or characters, or stories, but, also in the sense of crews, as producers, as showrunners, camera operators, and writers. Not just in front of the camera, but behind the camera as well.

Sinwell: Do you think female filmmakers have more opportunities now than they had earlier in your career?

Dunye: I think people are more aware of female filmmakers. I think female film-makers are more aware of themselves. So, I think people are really stepping outside of their boxes and are able to put more media out there and get out there—Rose McGowan, Lena Waithe, and Issa Rae. People are able to put themselves in the picture the best way they can. I think social media has a lot to do with it. People are able to—in their own private ways—start to respond to things that they don't like. But, I definitely feel like it's changed a lot, where we can stand up for ourselves. We can coalition-build for ourselves. It doesn't necessarily say that the man above who holds the money is the one who is going to allow us to be in the picture, but, those things are starting to change with all these hashtag movements.

Sinwell: How do you see your role in that larger category of female filmmaking?

Dunye: As filmmakers, we are captains of our ships. We do have the ability to be advocates for something. And, I think we are starting to see a little bit more of that. Look at Ava DuVernay, I mean, she has done *Queen Sugar*. And, Issa Rae, she has set up a whole compound, a nonprofit, distributing films.

They have the ability to, especially the ones that have success stories, to set up more, to be ambassadors. I feel like I am an ambassador of cinema. I definitely feel like more people need to use their power in ways to make change. We need to become tsars of the city, taking civic responsibility.

Notes

1. Alexandra Juhasz, *Women of Vision: Histories in Feminist Film and Video* (Minneapolis: University of Minnesota Press, 1997), 291–304.
2. Cheryl Dunye. Interviewed by Sarah E. S. Sinwell on April 30, 2018.
3. Ibid.
4. Ibid.
5. New African American Cinema focuses on the everyday experiences of Black culture and identity, questions stereotypes about Blackness, and often addresses social issues such as violence, class, racism, civil rights, etc.
6. B. Ruby Rich, "New Queer Cinema," *Sight & Sound*, 2, no. 5 (September 1992): 30–34.
7. Ibid.
8. Cheryl Dunye, *The Watermelon Woman* (1996).
9. Mark J. Huisman, "Faux Pas de Deux: *The Watermelon Woman* is the Newest NEA Whipping Boy," *The Independent Film & Video Monthly* (October 1996).
10. Ibid.
11. Ibid.
12. Julia Bryan-Wilson and Cheryl Dunye, "Imaginary Archives: A Dialogue," *Art Journal*, 72, no. 2 (2013): 82–89.
13. Harriet A. Jacobs, Lydia M. Child, Jean F. Yellin, and John S. Jacobs, *Incidents in the Life of a Slave Girl: Written by Herself* (Cambridge, MA: Harvard University Press, 2000).
14. Cheryl Dunye. Interviewed by Sarah E. S. Sinwell on January 29, 2018.

9

JENNIFER FOX (1959–)

Michele Meek

Jennifer Fox's award-winning work as a filmmaker has spanned documentary, television series, and, most recently, narrative film. Fox has become well known for each of her documentaries having its own style, and she resists classifying her films as cinéma vérité, saying that projects such as *Beirut: The Last Home Movie* (1987), *An American Love Story* (1999), and *My Reincarnation* (2011) are more a "collusion" between her and her subjects who "accept" rather than "forget" the camera's presence.[1] In *Flying: Confessions of a Free Woman* (2006), she took this philosophy even further, developing a "pass the camera" technique that blurs the line between filmmaker and subject, as Fox filmed her friends and acquaintances, and they filmed her. After a 30-year career as a documentary filmmaker, in 2018, Fox made her debut as a narrative film writer and director with her film *The Tale* (2018), starring Laura Dern.

Fox was born into a Jewish family in Philadelphia in 1959, the second child from professional musician Gerry Fox and entrepreneur Dick Fox. Although Fox did not contemplate filmmaking until she attended college, she "always wrote" and credits her parents with helping her foster a love of the arts and a value for the risk-taking aspects of entrepreneurial endeavors. She says she often felt "invisible" amidst her five siblings, but that it also taught her to fight for what you want, saying she learned "if you don't fight, you don't eat."[2] Her grandmother and aunt both played foundational roles in her upbringing, since, as she says, they "would arrive 10 minutes after my dad left for work and left 10 minutes before he came home."[3] Growing up, she felt "enormous pressure as a girl," which, from an early age, she decided to resist. When confronted with a limited array of career choices for women as a secretary, nurse, or teacher, she began as early as kindergarten declaring that she wanted to be an archeologist. As a teenager, she considered several careers, even interning with a law firm to do a pilot study about bringing legal advocacy to the inmates of a mental hospital. After some exploration, she knew only that she wanted to "travel and write." She decided to challenge the belief that "girls can't travel alone," taking

her first solo trip to Israel at age 15. Her love of travel led her to an International Relations program at John Hopkins University, but she soon realized that it was "all business and math" and transferred to the writing program to study journalism and poetry. However, it was in an 8mm film class that she "found her métier." Through filmmaking, she felt she could encompass all aspects of herself—"the artist, the writer, the investigator, the fantasist, the person who loves music"—and unlike journalism, which she believed she could eventually "master," she thought at the time, "I will never be able to master film."[4]

She transferred to New York University to study film, although her studies there wound up cut short when she became inspired to make her first feature documentary. While still at work on her junior thesis film, Fox was moved by the story of her classmate Gaby Bustros, who was in the midst of packing to return to her family home in Beirut, Lebanon, during the civil war. The story of the Bustros family's reconnecting with each other in their aging family mansion amidst the bombings resonated deeply with Fox. In 1981, Fox dropped out of NYU and along with her cinematographer, fellow student Alex Nepomniaschy, went to Beirut to film what eventually became Fox's directorial debut *Beirut: The Last Home Movie*. Editing the film turned out to be a challenge since Fox's vision for the film conflicted directly with her editor John Mullen. As she describes it, "being young, I picked an editor who didn't agree with my thesis" that "being in the war actually liberated [Gaby] and her family emotionally and the people around them so they could feel more" and be "actually happier during the war."[5] On the other hand, she credits Mullen as "one of the most brilliant editors of montage I have ever seen in my life" who ultimately brought "some extraordinary editing" to the film.[6] With about 30 hours of film footage and about 120 hours of sound recorded, Fox dedicated the next year to working more intensely on crafting the story through editing until the film embodied her vision. Fox's determination also showed through in her adeptness at fundraising. As a first-time filmmaker, Fox received financing from WGBH and David Fanning, the founder of *Frontline*.

Beirut: The Last Home Movie ultimately screened in 1988 at the Berlin Film Festival, the London Film Festival, and it won numerous awards including both the Grand Jury Prize for Best Documentary and the Grand Prize for Best Cinematography at the Sundance Film Festival and Le Premier Prix for Best Documentary at the Paris Cinema Du Reel Festival. The film garnered critical praise, with *The New York Times* writer Caryn James calling it a "highly accomplished portrait,"[7] and *Los Angeles Times* reviewer Michael Wilmington crediting Fox with a "seemingly simple approach" that "becomes complex and many-layered."[8]

Fox went on the road to distribute the film for a year and says that afterwards she felt "burnt out" and unsure about making another film. So, she started teaching master classes in filmmaking and turned to Buddhist meditation, ultimately studying with Tibetan Buddhist Master Choegyal Namkhai Norbu Rinpoche and taking a job as his assistant in 1989. She initially started videotaping him, not with the explicit purpose of making a film, but rather because she thought it was so "precious to have such intimate access to a great Tibetan Buddhist Master."[9] Eventually, she

pondered how she might develop the footage into a film, and she saw an opportunity for a story through Rinpoche's son Yeshi. But that initially proved fruitless since Yeshi seemed neither interested in his father's practice nor moved by his father belief in Yeshi's past life as his father's uncle, a famous master, who died at the hands of the Chinese in Tibet.[10]

In 1992, Fox decided to pursue an hour-long film about interracial couples. Her own relationship with a Black man had raised her awareness of ongoing racism not only in American society, but also within her own family. Initially planning a traditional documentary profiling three interracial couples, Fox began shooting. However, after filming for several months, she realized that the access granted from one of the couples, Bill Sims and Karen Wilson, warranted a significant change in the project, and Fox started to see it as a documentary series profiling only them, their children, and extended family and friends. Fox filmed the Wilson-Sims family for nearly two years, often sleeping on the floor of their apartment and amassing 1,000 hours of footage. However, at the time, networks and producers did not recognize the commercial or critical potential of Fox's vision. Determined as ever, Fox rented an office, started transcribing the material, and created a trailer to pitch the series, which ultimately enabled her to raise funds from ITVS and the MacArthur Foundation, among others. Thus, Fox became one of the first female directors of a documentary series with *An American Love Story*. It broadcast on PBS during prime time nationally and screened as a special event at the Berlin Film Festival and at the Sundance Film Festival.

Her next project also started out as a traditional documentary, originally titled *Women & I*, but also eventually transformed into a series—in this case a six-part documentary series *Flying: Confessions of a Free Woman*. She shot from 2002 to 2006, traveling to 17 countries using a "pass the camera" technique where she filmed her friends and acquaintances, and they filmed her. Originally, funders and distributors were skeptical, saying, "real people can't shoot."[11] Not one to give up on her ideas, Fox partnered with a Danish producer who brought on an editor, and together they cut an eight-minute segment of the technique from six countries. It worked, as she states, "Once they saw the segment, that argument just fell apart."[12] The film became a Danish production with six other international television partners. Through her "pass the camera" technique, Fox created a more intimate space for women to share their thoughts about relationships, families, and careers, and the film which initially was meant to be about "sexuality and freedom and choices" delved into everything from female masturbation to sex trafficking to female genital mutilation to arranged marriages. For *Flying*, Fox specifically tried not to be "precious" with the videotape, filming over 2,300 hours of footage. *Flying* not only profiles women throughout the world, but it also charts Fox's own relationships with and revelations about her relatives, lovers, and friends and chronicles her ambivalence at leaving behind motherhood in her 40s through her pregnancy, miscarriage, and failed attempts with in-vitro fertilization. *Flying* received critical praise for its brash honesty and unique method of filming. "That the power is being shared creates a different conversation," Fox says. "Most of the time we don't capture real life, we ask people to act in their

real life. They are not being themselves. We notice it, but we don't articulate it."[13] The series premiered in its entirety at Sundance Film Festival, screened worldwide theatrically and aired on the Sundance Channel as well as through broadcasters around the world.

Fox then returned to the story of Namkhai Norbu Rinpoche, whom she had sporadically filmed from 1988 to 2009. When Rinpoche's son Yeshi decided to re-enter his father's world of Tibetan Buddhism after becoming disenchanted with his corporate job, it provided the much-needed storyline for the film—a moving portrait of a "prodigal son" who rejoins his father in a life of teaching and meditating, while rediscovering his past life as the famous spiritual master Khyentse Rinpoche. Fox received international financing for the project from the Dutch Buddhist Broadcasting Channel, ZDF-ARTE, among others, and the rights were sold to be the opening film of the PBS documentary series POV. She also oversaw a Kickstarter campaign to raise $50,000 in completion funds for the film in 2011—ultimately raising over $150,000 from over 500 supporters. The finished film *My Reincarnation* screened at International Documentary Film Festival Amsterdam (IDFA), Hot Docs Film Festival, and over a dozen festivals; aired on PBS and networks around the world; and was nominated for an Emmy in long-form documentary.

Fox has since made a shift into narrative filmmaking, which she likens to making it "through the eye of a needle."[14] In narrative filmmaking, financing often proves a more formidable obstacle, especially for women, but Fox says that it was not a matter of "if" she would raise the money, but simply "how."[15] She states that each of her projects has been financed in a different way, and the only consistent thread has been international funding, which she notes has been key to her success—that and being raised "at the knee of an entrepreneur."[16] For *The Tale*, Fox raised money through several funders, including Gamechanger Films, a company developed to equity finance narrative films directed by women. The idea for *The Tale* emerged during her production of *Flying* and is based on a story that Fox wrote at 13 years old about her sexual encounter with an adult male coach. The film shows the contradictions between what the 40-something Jennifer has come to believe is sexual assault and what the 13-year-old Jenny nevertheless insists: "I'm not the victim of this story. I'm the hero." The film is as much about memory as it is about sexual abuse, and it demonstrates the ways someone who has been assaulted protects herself by the tales she tells herself. *The Tale* received standing ovations at the 2018 Sundance Film Festival and 2018 Tribeca Film Festival, and it has generated abundant critical praise with the *LA Times* calling it "powerful yet nuanced and not in any sense sensational or exploitative"[17] and *Rolling Stones* declaring, "It's an artistic triumph in terms of the way stories—about women, trauma, and selfhood—are translated to the screen."[18] At Sundance, HBO acquired the film where it released on May 26, 2018. The film happened to emerge in the midst of the #MeToo era, where we have seen an unprecedented public reconciling with sexual assault. Fox says, "Our goal is nothing short of changing people's understanding of how and why abuse happens, how complex it is for all, and the function of memory to protect from trauma."[19]

Currently, Fox is exploring fiction again for her future projects. She says, "I don't make the big distinction that Hollywood does between documentary and fiction. But I do want to keep working in the narrative realm whether it be features or series going forward." As for whether she will remain independent or move into Hollywood, she says, "I have no idea. We will see."[20]

Included in this chapter are two interviews—one published in 2005 in *The Independent Film & Video Monthly* and an original interview based on conversations with Fox during 2017 and 2018.

Coming Out: Jennifer Fox Encourages Her Subjects to Let It All Hang Out

Holly Willis/December 2005

The Independent Film & Video Monthly

On a hot and sticky afternoon last summer, New York-based filmmaker Jennifer Fox climbed the stairs to the stage in a darkened auditorium on the Wells College campus in Aurora, New York, home to the Creative Capital artists' retreat. Each of this year's Creative Capital grantees had a mere 10 minutes to dazzle their colleagues and an assortment of advisors; the "right" presentation seamlessly merged a little background info, a quick sketch of the project, and a film clip showcasing the artist's talents. Fox, however, wanted her film to speak for itself. Cueing the projectionist, she stood back and waited. And waited. Nothing happened. Caught off guard, Fox abandoned her plan. She began to speak.

"I'm interested in presence," she said quietly, and within seconds, she was completely absorbed in describing her desire to capture the ineffable experience of screen magic, when a documentary subject becomes truly present in front of the camera.

Conjuring this kind of presence is one of the central ambitions of Fox's practice as a filmmaker, and as she spoke with hushed intensity, it was clear that Fox's camera could match forces with any person facing its lens. Fox, who has been making award-winning films for more than a decade, focuses on her subjects with singular conviction over long periods of time and with a commitment to create some sort of transformation, both onscreen and in the world.

Fox studied creative writing and journalism at Johns Hopkins University, and later studied filmmaking at New York University, but left in 1981 to make her first feature film, *Beirut: The Last Home Movie*—a chronicle of a family's struggle to exist in Lebanon during wartime. She says that it took her a little while to find filmmaking. "I asked myself, 'What could sustain my life?'" she recalls. "It had to be something I couldn't achieve. It may sound arrogant, but I thought of journalism as something I could master. Whether I would be good at it or not is another issue. But film? Film seemed un-masterable."

While she was at NYU, a classmate disappeared for several months and then reappeared telling horrors of life in Beirut. Fox was captivated. "I heard her story and

literally said, 'I want to make a film about your family,' and was in Beirut six weeks later," she says.

What interested her was life lived in extreme circumstances, and although she had never made a feature film, she quickly found a way to organize the project. "The key for me was my friend's older sister—before we started filming she said that destruction is more beautiful than construction, that going down has more emotion than going up. I felt that she could speak the heart of the story." Fox shot for three and a half months and then spent the next six years trying to put the film together. "I had no idea how to make a film," she says. "We constructed it three times, following different threads. I just didn't know how to tell a story, but either I was going to die, or I was going to make that film."

She did indeed make the film, and it was subsequently broadcast in 20 countries and won a long list of awards, including Best Documentary and Best Cinematography at the Sundance Film Festival in 1988.

While *Beirut* explores what Fox calls the seduction of living at the extremes, her 10-hour PBS series *An American Love Story* examines the stress of living every day. The film, which was shot over the course of 16 months in the late 1990s, profiles the interracial household of Karen Wilson, Bill Sims, and their two daughters. Fox says that she was in an interracial relationship herself and made the film in order to find out how people negotiated the social and familial challenges that arise when a white woman and a Black man share their lives. "First and foremost, my films are real journeys for me," explains Fox. She adds that she never intended to film for as long as she did but got caught up in the patterns and rhythms of the Wilson-Sims household and what was revealed there. "I didn't want to be there just for the high moments," she explains. "I wanted to see people over time, to see how race and love and family happen over time."

Love Story combines observational footage with voiceover fragments spoken by all four family members in a complex mesh of points of view. "We typically don't reveal our emotions when we go through our day—when we wash the dishes, for example," says Fox. "The drama in those episodes is so small. So, the layer constructed in voiceover was created in order to add in thoughts, to give the film a whole other narrative dimension." She liked the conflicts that were articulated in the voiceovers. "And I love interviewing—working through conversations where you and the subject are both surprised, where you both get to a place where there is a real moment."

Fox's latest project is *Flying: Confessions of a Free Woman*[21] an expansive and intense documentary investigation of the sexual lives of women around the world. Once again, Fox started with a question from her own life: "I couldn't find an image of myself," she says, explaining that being a woman without a husband or children made her feel invisible. "I couldn't see myself, so I had to make a film and say, 'See? There you are.'"

Fox gave herself several rules for making the film. "First, the camera had to be passed and everyone in the room had to be on camera." This rule is at the core of Fox's attempt to elicit real presence. "It creates this enormous intimacy onscreen,"

she says. "And my goal as a filmmaker has always been this—getting screen presence. When you see a great performance, it sparkles. But in documentary filmmaking we don't demand that because we're asking people to report on their lives rather than be present. What I want is for the camera to witness someone being alive. But the camera stops that process, because people become self-conscious. In passing the camera, other people get to be observers, and suddenly the camera is not an observer but a participant. It really affects the quality of the conversation and the scenes."

The second rule was that there was to be no sound person. "The reason I didn't bring a sound person is for the intimacy. If I had brought another person, I'd be more comfortable than the people I spoke with. But I didn't want to be comfortable. I wanted to need to make friends. The film is all about those friendships. If I had had someone traveling with me, I would have been much more secure, but I would have been a worse subject. And the subjects in front of me would have been less open."

Fox, who used a small Sony PDX10 camera, says that shooting the film alone was challenging. "It was difficult finding an aesthetic that didn't get in the way of my spontaneity," she says. "One of the principles of the project was not to be precious with videotape. As soon as you become precious, you start to control things, to make pretty shots. And if I did that I couldn't be myself. It's taken a while to find a balance between aesthetics and lightness."

Fox also worked on the way she approached her subjects, who were a mix of friends and strangers dispersed across 17 countries. "I am a naïve person, really, and I'm truly curious about other people, so I've used being open as a strategy to have other people be open. But in some cultures, being open isn't always positive. In Pakistan or Cambodia, for example, sharing may be seen as crossing boundaries. And as is always the case, talking about sexuality can either open doors or close doors. In Pakistan, with some women, my openness made them open, but in other cases, I appeared to be a crass Westerner. It's less culturally defined than personally defined, though. One of the premises of the film is that we're more alike than we think."

Fox discovered that not only are women across the world alike in many ways, but their lives aren't really being shown. "Whether we're single or married, we're living much more sexual, much more complicated lives than the stories would allow you to believe," says Fox, "and we need to come out."

For Fox, "coming out" can be facilitated by the sharing of the camera. "A camera can often be used to take away presence," she says. "But when you bring presence, people feel more alive, more aware. There are surprises, people learn things, and sometimes a camera catches something real, like when you say something that you've never said before. Then a person feels an ah-ha, and that process of learning about yourself is incredibly valuable."

These camera-inspired revelations constitute the core of a filmmaking practice aimed at nothing less than transformation. Says Fox: "I want to be living when I make films. I don't want to just be making them. I want to be transformed by the stories I'm filming."

Conversations With Jennifer Fox

Michele Meek/2017–2018

Michele Meek: In your past interview from *The Independent*, you talk about the idea of "presence" in your films, can you talk how this idea of presence is not just about making sure that the subject or actors are present, but that you're present in that moment as a filmmaker?

Fox: The person in front of you will never "show up" if you're absent. It's almost an oxymoron. So your job, your role as the director is to use your presence to invite others to be present. If I'm distracted, if I'm in my head, if I have an agenda that isn't what is before me, the other feels that and disappears as well. A good director's role is using themselves as their first tool. It is not the camera. It is oneself and one's presence.

Look, we live in a world where everything is about things that are, let's say, distracting, don't matter, or narcissistic, like making money, power, greed, and on and on, but the role of the artist throughout time is someone who's trying to reflect something real and true in society, and literally, we give up our lives for that. How we do it is we say we will stand here and feel what everyone else is running from. And by doing that we are then able to capture it or recreate it and provide a mirror for society to look at subjects, issues, stories, etc., and truth. I don't want to make [truth] big—comedy can have enormous truth in it.

Meek: So this idea about truth is so complex, especially with the Foucauldian idea of truth as produced and now living in an era where truth seems to be so elusive. I'm wondering how truth might relate to the way you've spoken about your being an auteur of your work or crafting your work. Is that something you still believe, and how does that factor into the kind of truth that you're producing?

Fox: We are absolutely always crafting, whether we're crafting documentary images or fiction images. For me, you're always in service of what is authentic and, therefore, what is true. I understand that truth in a Trumpian world is in the eyes of the beholder, but I think that when one gets quiet enough, when one gets present enough, truth is subtle and apparent. And also when I talk of truth, I don't always mean a big truth, I mean an authentic emotion, an authentic reaction, and a real telling of what was really happening to that person at that moment. So, for me, the big truth is made up of lot of little truths as a maker. I think that actors live with that all the time— what is an authentic performance that comes from an authentic place—but equally we can say that in documentary. When you have

a documentary subject that is really present in their life, as they are on film with you, you will have a subject that the audience can't take their eyes off of, because the souls of the audience respond to an authentic soul. We take knowledge from that. . . . I feel like I'm talking in such sweeping terms.

Meek: That's okay. I also think that this idea of presence connects directly to the themes in *My Reincarnation*. I know you spent many years not only making that film, but also studying meditation and fostering an interest in eastern philosophy. How does your filmmaking philosophy about presence perhaps connect to your personal philosophy?

Fox: I have studied Tibetan Buddhism since 1985, along with other meditation practices. But I have to say. . . . I think from very young I was always looking for how I can come back to what is me and what is true about me and to live authentically. I hope it doesn't sound pretentious that I keep using that word "authenticity." But I wanted to feel my own emotions, I wanted to know what *I* wanted, to perceive the world without so many filters, finally, even if it was feeling badly, I preferred to feel something. By the time I was in my early teens, I felt kind of spit out of society, family, and education as someone trained to be shut down. So, from an early age, I had the idea that I had to make a conscious effort and figure out ways to stay open to the world and the environment and to be able to see truly what is around me and to respond truly, rather than the way I was supposed to respond. I think that's been my life's work. It's always there, because just to live in society, you have to shut down quite a bit to function, so I'm always trying to stay open, present, be in touch in some way, and Buddhism and meditation have been part of that. It's a daily practice. And, you know, filmmaking itself is a daily practice. It's not like I am in a constant state of presence. No, I get up every day when I'm working, and I commit myself to trying to be present and not distracted and to try to meet what's in front of me in an open way so I can receive it, so I can translate it, so I can put it into film. Again, this sounds so esoteric, but I could give some examples.

Meek: Yes, let's talk about an example. And I realize you're in the headspace of fiction currently, so maybe talk about the shift from documentary to fiction and how you've transferred the abilities and talents you've developed in documentary to fiction?

Fox: There is a relationship working with actors and real people in that one point of presence—when I arrive at a meeting or rehearsal with Laura Dern, who's phenomenal in the moment, my role is to show up with as much presence as possible. In order to do that, I would consciously try to rid my mind of other thoughts about yesterday's work or the money I have to raise and really be with her in a really mindful way while we're working on the character. She's a

consummate talented actress who is always working with her presence. If I'm sort of half there or if I'm trying to bulldoze my preconceived notions with her, it never works. To be open to receive her ideas and still be authentic to what I might feel in the moment of the story about the character is my constant job. Ironically, it's no different than working with real people in documentary filmmaking.

The biggest problem as film people in an industry that's so popular and sensationalized, is getting ahead of ourselves about what will be thought about what we write, or how we will be judged, how famous it will be, or how successful it will be, and on and on. So one has to develop real muscles at blocking out all that chatter to sit down to connect with one's soul to write authentically or to research authentically. Again, it's always that same move. Later on, you come back with that critical self and critique what you've discovered through your presence. So, it's sort of a dialectic.

Meek: I read at one point that you don't think of your documentaries as cinéma vérité. Do you stand by that, or do you revise that? And does it matter?

Fox: First of all, it depends on what film. I don't know where you read it and I don't know which film I was talking about.

Meek: I think it was when you were on a panel discussion with one of the Maysles brothers—does that sound familiar? I think it was about *Beirut*. He was asking why you included the interviews, and you were standing by why that made sense for your film.

Fox: I think that [my] film that is the most cinéma vérité is *American Love Story* even though it has interviews in it. Where I have trouble with the notion of cinéma vérité is the "fly on the wall." For me, even when I'm in an observational mode as a cinematographer in a scene that I'm shooting, there is no forgetting the camera—ever. It's more working energetically with the subjects to include you in their lives and include the camera. So, for me, what people typically call cinéma vérité is actually not, because the camera is always affecting the moment. The camera can affect the moment in a good or bad way, and what we aim for is that the camera is affecting in a good way, that it's actually inspiring more authenticity, more honesty, more sense of being in one's life. But even when you take a 10-part series like *American Love Story* that I shot myself over two years with a family in Queens, what you see is that they were including and accepting me, Jennifer Fox, who *was* the camera, in their lives, but that meant that we were dancing together for two years, not that I was somehow hidden behind a camera, and they somehow forgot me. They never forgot me. They fought in front of me, they cried in front of me, there was drama in front of me, there was humor

in front of me or with me, but it was with the idea that we love Jennifer—and camera—we will include her in our lives and accept that this is the relationship we decided to have together. That's a very different concept from cinéma vérité.

And then if you take a film like *Flying*, it's absolutely not cinéma vérité. There are moments that look like vérité, but it's an autobiographical film, it's memoir, but it's also a survey film, and it's employing a lot of other cinema tactics.

My Reincarnation, I would also never say was vérité. There are moments that look like vérité, but it's the absolute collusion on all of our parts, meaning myself, Namkhai Norbu Rinpoche, his family, and his son. We are playing together with the camera, and they are accepting that there's this camera in their lives. They're not forgetting the camera. And the discussion Al Maysles and I always had. . . . You know, I'm a person who loves interviews in documentary. I even have fantasy interviews in my new fiction film, *The Tale*. . . . But there are different types of interviews. There are certainly interviews that are all about platforming a structure and talking about externals and events and lives, but the real piece I'm interested in is the type of interview that gets into the subtext and into the unspoken desires and feelings and fears of characters. Interview, at its best, goes beyond anything than can be seen. It breaks down walls into the inner lives of people that they don't talk about. And so, for me, when you're successful as a filmmaker and as an interviewer, both you and the subject drop into this place where you're both discovering something new about them and about life. So I love interviews, and will always love interviews. Frankly, as a human being, I'm not so interested in surface. I mean surface is about context, we need to give it, but my real interest as a filmmaker is in all the things that are never said, in the grays and the unspokens, in those deep rivers that move people backwards and forwards.

Meek: So your first film, *Beirut: The Last Home Movie* was an ambitious first project. I can only imagine how overwhelming that must have been as a new filmmaker. Did you have an enormous amount of footage when you returned from Lebanon?

Fox: Not by today's standards. We were shooting film. We had 30 hours of film and 120 hours of sound. . . . You shoot very differently with film—

I want to just back up. . . . Before I ever thought to make that film, I went to see the protagonist, Gaby Bustros, in New York, who had just come back from the war to get [her] things to move back to Lebanon. She invited me over, and she showed me photos of her

family home, which was a palace, and talked about living under the bombs. At that very moment sitting with her, I connected to her story quite deeply and suddenly. I had a very clear idea for a film. For me, her story was about how being in the war actually liberated her and her family emotionally and the people around them so they could actually feel more. It was about how they were actually happier during the war and felt more emotionally alive then before the war. . . . And I knew if I were there, I would feel what they felt. I felt how in extreme situations how much more alive I felt. So, I had a thesis about war actually giving on an emotional level that people never talk about. When I went to Lebanon to shoot the film, my point of view on their story was always through those eyes. So their story and hence the film wasn't just a whole lot of cans of footage. I was actually building a thesis that I felt the family and their life supported, which was about the strange thing that "war gives." I mean, we always talk about war taking, but war also gives something that one never talks about. It gives people purpose, identity, a sense of freedom in their emotional life because they can break through the rigid norms of society. So the film was very much about unpacking that, and that's a very difficult and complex argument, but that I felt was very true. And I felt when I went to Lebanon I found that the family actually supported my thesis, that it wasn't just something I was applying from outside. . . . I think it's important to say that as a filmmaker because it isn't just that you approach this really cool setting—a palace, a family, a war—with no point-of-view.

What was hard for me was that I had never edited a film before, let alone a two-hour feature of that complexity. And then, of course, being young, I made the mistake of picking an editor who didn't agree with my thesis at all. So, year one, basically, when I was out fundraising and he was working quite a bit alone, he came up with a film that I didn't agree with at all. Then year two, was—stop fundraising and sit with him. After year one, I basically stopped the whole production, went back to the drawing board, transcribed everything, and started to build my thesis properly, and then got in the trenches and battled with him frankly. And it took two more years off and on to achieve a film that was actually about my thesis. And what was so interesting about *Beirut* for me was that the older daughter in the film, the main character, Mouna, she actually says what I'd been thinking from so far away, she says it and articulates it. She says in the film that for her, the whole roller coaster of sinking down, down, down in destruction makes her feel more emotionally. And the film had to build to that, you had to understand it, though the audience doesn't have to know what my thesis is. The whole struggle in the editing was to get to that point.

Now while I can say John Mullen [the editor] didn't understand my thesis, he is one of the most brilliant editors of montage. So I was blessed with some really extraordinary editing despite the fact that what we fought each other on was the structure of the film. And despite my being very young—and he was in his 50s, I think—basically, one of my strengths of character is you cannot outlast me. You know, I was never going to let that film go until it said what it was supposed to say. It took a really long time, and by the time it was finished, I was just metaphorically on the floor bleeding. I mean, for your first film, you have no idea if what you've made is any good, if anyone will ever receive it, if you'll ever make another film again, if you even *want* to make a film again, because it was just so hard. . . . And then, I didn't know what to do with it. We had money from WGBH, and, actually, David Fanning, who was the creator of *Frontline*, put money in the film as one of the last films in a series called *World* that he was doing before *Frontline*. And we took so long to make it that *World* was long finished, and it ended up coming out as a *Frontline* special. It was the very beginning of the Independent Feature Project, and they had a market. I submitted the film to the market, knowing nothing, and they screened the film. And I literally was so upset that I went home—

Meek:	After the screening?
Fox:	Not after. They turned on the film to play it, and I left and went home and cried, because I thought it was the biggest piece of shit anyone had ever made on the planet. And then I got these phone calls directly after the screening: the film was invited to Sundance; it was invited to Berlin, to London Film Festival. . . . And then—
Meek:	Why do you think you felt that way when it started to screen?
Fox:	You know, I try to explain this, because it's not the only film that I felt this way about. When I make a film, I think that whether it's a good film or a bad film, I take it as far as I can in me and I go as far as I can to push it as far to what I feel or think is authentic or true and the film never measures up to my hopes, ever. For *Beirut*, every single screening for the first year, I sobbed afterward. I think the first film festival was London or Berlin and then Sundance—back then it was a different order—I just cried my way through those festivals. When it won the first two awards at Sundance that year, it really helped me understand and helped me stop crying, of course. I think it's really hard to talk about— just because we make work doesn't mean that . . . I don't know how to say it. I think that for young people working they say, you must be so happy, but my struggle isn't to be happy. . . . Yes I

want the world to receive it well, and I want it always to have the biggest audience possible because I'm making films for impact as well as art. I'm really asking and hoping to push both boundaries with every piece. But my hopes and dreams are very big, every time I put my shoulder to the cart to make a film. It's almost impossible to achieve my expectations. No one is more critical of my work than I am. You can trash my work; I can tell you, I've trashed it more. It's just the nature, there's so many things to talk about—there's art, there's impact, there's the audience, but first of all we are creators and that is kind of a life's work. We're grappling with how to show truth in form and time and space and with sound and music and we're grappling with things that are really difficult. That I cry when my films are finished because they don't measure up is just the way it is. I have a nephew going into the film business and he's been in shock at my reaction to my new film *The Tale*. And I have to tell him, hey you're looking for Hollywood, but Hollywood is not where I'm looking. I'm looking to create work that lasts forever. I'm looking for things that make impact and artistic impact that breaks boundaries. My expectations are bigger than yours. I don't know; it's so hard to talk about really. I hate the word artist because it sounds self-aggrandizing, but more and more I feel that's what we are. It's like being a carpenter. We're artists. It's like being a street cleaner. It's a job and it takes a certain tenacity and emotional volatility and openness and ability to feel. But the ability to feel doesn't always means you're feeling good all the time or happy or satisfied. If I didn't feel so strongly even about my own work, how could I make the work? If I didn't feel, how could I feel you to represent you? I think you are talking to me on a very philosophical day.

Meek: It makes sense. We are always the biggest critics of our own work. Maybe we're both our best fans and our worst critics.

Fox: Well, it also takes enormous ego. There I was 21, and I had the audacity to go to Beirut and make a film about a family in a very complex war and to try to get it right. To go to Beirut, I dropped out of film school. Every single professor, except for one, told me I was crazy. There was nothing in the world supporting this idea I had. I went and did it with an enormous amount of ego, but at the same time . . . at many moments you're standing out in the air without a parachute and that's your job because you see what other people can't see—and your job is to see what the other people can't see and to fight for it and build a ladder underneath until other people can actually get it. But being out there in the air without any parachute, or whatever metaphor we want to use, is incredibly scary, hard, difficult—and takes a lot of ego. We're always dancing between

ego—we think we know what we're doing—and our porousness to take in reality, to be present, to constantly be affected by truth. So, these things are another dialectic.

I teach filmmaking, and I've been around a lot of high school and college students lately who want to make films and their expectations are unreal and unfair to themselves. The journey of being a filmmaker is difficult, scary, frightening, fabulous, incredibly hard work, all sorts of things, but it isn't only one thing. And fear and self-doubt are components that are everlasting underneath it all. If you don't learn to live with fear and doubt, you won't be able to do it. Otherwise you'll just be making copies of what's already been done. And then, who the fuck cares? And being old, I really know what it means to say, "who the fuck cares?" because your life goes too quickly. How many films do any of us really have in us—so they better matter to us. If I'm going to make a copy of some other film, I could waste my life in a 100 better ways and make much more money. So it's also that fear, anxiety, doubt [that] are things we have to live with, not run away from, not think they are wrong.

Meek: Let's talk about your newest film *The Tale*. I know this film came out of a story you wrote at age 13, but when did you write the script?

Fox: *The Tale* really came about because of *Flying*. Just in a nutshell, *Flying* came out of me trying to investigate the predicament I found myself in in my early 40s, but was really thinking about even at the end of *American Love Story*. It was about sexuality and freedom and choices. What shocked me in the shooting of *Flying* was that, I swear to god, every second woman wherever I was—beyond race, class, and color—had a childhood sexual abuse or rape story. All of a sudden, my own story from when I was 13 years old that I had called "my first relationship" seemed to have the exact structure of every other story I was hearing. And there was a sudden click in my mind like a seismic shift: my story wasn't personal and special at all, it was universal. Suddenly I could no longer avoid the dark side of what had really happened. It was the first time I ever used the word "sexual abuse" on myself. I was probably 45 years old.

Meek: Did you ever consider the film as a documentary?

Fox: No, this film was always fiction to me, from the time I wrote *The Tale* as a kid of 13 through my 20s when I was thinking oh, I want to make a film about that experience. I always saw it as fiction, because there is no evidence. There's no one you can truly go to in real life who can stand up for the event. So, it is really, how do you represent it? But I always thought it had to be fictional. I didn't originally think it would be what it turned out to be, which is a film about memory and the construction of self. But once I realized in my 40s

that I was ready to tell the story when making *Flying*, I thought fiction. And also, in terms of craft, I felt it was a natural extension of my artistic practice to move into fiction, that I had kind of run out of what I wanted to do in documentary, and I wanted to expand my practice into new realms. That's the way you stay alive as an artist—you have to keep pushing the new as uncomfortable as that is, that's what we do. So, there are things that I definitely knew how to do from when I began the project and other things that I had no clue because fiction can be radically different. So, there are skills that I brought that a fiction filmmaker wouldn't have . . . a certain nimbleness . . . documentarians are nimble, but they're also incredibly tenacious at pursuing stories. I had those two things pretty much up my sleeve. Like when Laura Dern said, I can't shoot the film all in one go because my schedule's so bad . . . that did not frighten me. That was a no brainer to me. I said, no problem we can break up the shoot to fit your schedule. And in fact, it gave me time to breathe and think between each of the shoots and get on my feet rather than just belting it out. I mean the main shoot was still the first shoot, and we did shoot out 1973 but we only shot Laura Dern I think 10 days in the first shoot. And we ended up shooting her another six or seven days in two more shoots later. But that was easy, you know. Or the writing for me was very natural. I've always written. I love research. I love, you know, asking myself how to create new narratives. I love pursing the thread of my own curiosity about something, which is something I do in documentaries.

Working with actors was completely new for me. And that was one thing that I was at least aware of would be new. So, I started several years before we shot to start training. I was invited to a directing program in Amsterdam called the Binger Lab, which is much like Sundance, only it runs for three months. There, I primarily studied how to direct actors and also workshopped the script with actors. And that was just fantastic. And then I came back, and I continued to workshop this script with actors in New York, whoever I could find. But I continued to work with directing acting mentors like Judith Weston and Adrianne Weiss, which was wonderful. So, I was really conscious, like I don't know how to do this.

But that doesn't mean that I knew how to direct actors when I got on set. I just at least felt a little more comfortable. But, you know, when you make documentaries your whole muscles skillset is to become invisible and to blend in. And when you're a director on a big set, [like *The Tale*'s] 120 people on the crew in Louisiana, you are in the middle of a fishbowl and everybody's looking at your every breath. And I just had to kind of white knuckle it through that—you know

everybody would have an opinion, and I couldn't recede into the background. I knew nothing about production design. You know, we had a gorgeous, really fantastic production designer Debbie Devilla, and I think that times she just looked at me like who is this girl? I mean, I was shocked that you can actually decide in set design the color of the walls! I was just like, don't you just walk into a house and put your actors in it? Or costume design—Trisha Gray did costume, which was just a huge act of love and kindness for the production. The two of them worked like dogs. And again, you know, the costuming was unique, yet completely natural. So, in a way they kind of pulled me through.

But my real focus was acting frankly because that was the piece that felt like if everything else goes to hell, if we don't get the acting authentic in this story, this film will fail horribly. And frankly 90 percent of what happened on camera is kudos to the amazing skilled and talented actors we had. And about 10 percent is from me holding the line on what was truly authentic versus what somebody might think was authentic. I just had the most incredible cast.

So, the areas where the cast found it difficult that I didn't find difficult were the fantasy scenes. Each of them really struggled with the various fantasy scenes. Like, they would ask me: "who am I talking to?" "why am I saying this?" Because their touchstone is reality, and for me I was speaking from an inner reality that I was trying to uphold. Literally every single actor had small meltdowns around the fantasy scenes because they didn't know why or how to play it. And afterwards, you know, I think they're some of the best scenes in the film, because finally each gave in and committed with all their trust to play these special moments.

For example, little Isabelle Nélisse had no trouble doing anything and is just an absolute joy to work with because everything comes from an authentic place. Come to that walk in the hallway fantasy scene where she's speaking to the camera saying "I'm the hero," and we're on a dolly moving backwards and there's 50 kids in the hall—she had a breakdown. We sat in a side room for a while, and she started to cry. She said, "Jennifer what is this scene? Who am I speaking to? I don't know what you want me to do." And we talked and talked until finally she got up and gave this amazing performance. And yet she had no trouble doing anything else.

Meek: So, what did you tell her it? Because obviously it worked.

Fox: First of all, I was on the dolly moving backward. I told her, focus on me. I'm the one you're talking to. You're talking to you, you're talking to an adult. You're talking to a parent, you're talking to someone

who disbelieves you. And I said, forget about those kids—because they were really also destroying her concentration—and just look at me. And those are the things I remember. Frankly, this is where you know, again, and I can say this about each of the actors, this is where working with a great talent is all the difference in the world. I think she frankly just said, I'll just give it a try because you know, Jennifer wants me to and I'll just do my best. She is a consummate professional though she is young, and she's also tough, so she wasn't going to let the scene "beat her" so to speak. I also asked her to just to make it really naturalistic, like this is not extraordinary. I wanted those fantasy scenes to be very ordinary. I didn't want them to be gloomy or horror-y or dreamlike-y. For me, I was trying to make a story [that] represents that in the mind both your imagination and your memories are as real as the present. And so, the acting had to be real, the camera had to be real, the look had to be real. So, we were trying to make cuts from scene to scene as if it was all one time.

Meek: What usually happens in a story like this is the girl thinks of this story as one way, and her story is overtaken by the adult narrator in the present of the story. But in *The Tale*, that scene with her at the end where she's saying, I'm going to believe that this is the way it happened, and it

Figure 9.1 Fox includes interviews between the grown-up Jennifer (Laura Dern) and herself as the 13-year-old Jenny (Isabelle Nélisse) in her film *The Tale*.

doesn't matter how you see it, is so powerful and unique. Why was it important to include that voice in the film?

Fox: Well, first of all, I rediscovered her voice when I rediscovered *The Tale*. And the voice of my 13-year-old self is so strong and so clear. Even though [the original short story] was something fictionalized—it doesn't have graphic scenes in it—but it's very clear what happened and what I thought, that I broke up with them and I felt I was stronger than them. I mean the text in the film is straight from the real *Tale* I wrote at 13.

But in the investigation to write the script, I realized that I actually didn't know who I was at 13 anymore. I had crossed over and become an adult. And so, I developed the idea of a fantasy interview to reinvestigate her. But everywhere I turned . . . when I looked at diaries I had or letters my mother had saved that I sent her when I was at different places close to that time and my poetry—I mean this was a person, my 13-year-old self knew what she wanted, knew what she thought, was making choices even if they were bad choices, they were her choices. And she definitely had a sense of agency. And the adults around her from her 13-year-old point of view were incredibly inept or abusive.

But the point was that I wasn't stupid back then at all, I had enormous self-composure. It's just that I didn't have experience. And that's why I could be manipulated. What I hope at the end when you see little Jenny and big Jennifer sitting in the bathroom together is that you understand that both stories are true and both stories exist simultaneously. And we don't usually let our child's voice exist as adults; we have to squash the voice of our girl self or our boy self in order to assert our adulthood. In fact, it's dangerous to do that for our own development, because we're basically erasing who we were.

So, I'm really glad you asked the question. I'm glad you noticed, because some people don't. Because what I hate is that the adult story takes over and makes it the same old narrative: "you were an object," "you were used," "you're a victim," blah blah blah. Well shit. That is not how I felt. You know, I was doing my best to grow up and to embrace the world with, like I said, adults around me who were either unable to see what was going on or were manipulating me. But still I was navigating that even so. And that's a strong child. And that child created the adult who went to Beirut at age 21 to shoot a film in the war. You know, she created the adult who wasn't going to go down, the adult who wasn't going to become someone crying in the corner. And frankly, I have to tell you everywhere I turn people are coming out of the woodwork and telling me that

they were abused as children. And you will never know it because they are survivors just like I was. Because their child self also figured out how to get by even though they might not have had the support or the care they needed.

I think we have to celebrate that and not only look at the horror of it all. Like we have to celebrate the strength of the individual, not only how damaged they were and are. I mean I don't want to say that one doesn't deal with the damage. You're always dealing with the damage. And for some people that part is so overwhelming that they can't get on with their lives. Like that's there too and that's another parallel story, but it isn't the only story. And it's important to give survivors a narrative they can survive with and language they can survive with.

Notes

1. Jennifer Fox. Interviewed by Michele Meek on August 4, 2017.
2. Ibid.
3. Ibid.
4. Ibid.
5. Ibid.
6. Ibid.
7. Caryn James, "Review/Film; In Beirut, Struggle as a Way of Life," *The New York Times* (June 29, 1988), www.nytimes.com/1988/06/29/movies/review-film-in-beirut-struggle-as-way-of-life.html
8. Michael Wilmington, "Movie Review : A Look at Vanishing Aristocracy in 'Beirut: The Last Home Movie,'" *Los Angeles Times* (July 29, 1988), http://articles.latimes.com/1988-07-28/entertainment/ca-9771_1_home-movie
9. Jennifer Fox. Interviewed by Michele Meek on August 4, 2017.
10. Ibid.
11. Michele Meek, "To Shoot Flying, Jennifer Fox Gave Up Control of Her Camera," *The Independent* (May 2, 2008), http://independent-magazine.org/2008/05/shoot-flying-jennifer-fox-gave-control-her-camera/
12. Ibid.
13. Ibid.
14. Jennifer Fox. Interviewed by Michele Meek on August 4, 2017.
15. Ibid.
16. Ibid.
17. Robert Lloyd, "Director Jennifer Fox has Turned the Pain and Confusion of Childhood Sexual Abuse into 'The Tale,'" *LA Times* (May 25, 2018), www.latimes.com/entertainment/tv/la-et-st-the-tale-review-20180525-story.html
18. Phoebe Reilly, "Is 'The Tale' HBO's Most Controversial Movie Ever?" *Rolling Stone* (May 23, 2018), www.rollingstone.com/tv/features/the-tale-hbo-laura-dern-w520611
19. Jennifer Fox, "How My Struggle As A Survivor of Sexual Abuse Became 'The Tale,' A Movie I Hope Will Change The World—Guest Column," *Deadline* (May 26, 2018), https://deadline.com/2018/05/the-tale-jennifer-fox-hbo-op-ed-news-1202398382/
20. Jennifer Fox. Interviewed by Michele Meek on May 23, 2018.
21. In the original interview, the writer uses the original title of the project *Women & I* as opposed to its released name, *Flying: Confessions of a Free Woman*.

10

SU FRIEDRICH (1954–)

Erin Trahan

Su Friedrich is a thinking woman's filmmaker. Her work has been celebrated internationally and domestically by both festivals and museums, and it's well documented by academic and other highly regarded media. Her 23 films made over the course of four decades challenge conventions on multiple fronts. On a formal level, she avoids predictable narrative structure while still composing riveting stories, often about women's lives and relationships, and often about her own. That's why tropes like the male-centered hero's journey doesn't necessarily apply. It's not a relevant framework nor is its overused arc of interest to Friedrich and what she wants to express. For this reason, her films are singularly her own—unique, compelling, and imbued with structural and emotional daring.

Friedrich was born in 1954. Because her father was a professor, Friedrich's family moved several times in her youth, living in Michoacán in Mexico, Kerala in India, New Haven, Philadelphia, and finally Chicago in the US, all before the age of 10, when Friedrich's parents divorced. Her mother raised her and her siblings in Chicago, and they attended Catholic schools. While Friedrich says, "I stopped being Catholic in any way by my freshman year of high school,"[1] the cultural influence, rituals, and iconography of the Catholic Church are recurring themes in her films.

Friedrich's collage-style films often include moving images shot on 8mm film from the era of her childhood. Some of that footage looks like it could be of her family (and a tiny fraction is) but as a child she was more interested in still photography. She was "very proud and excited" to buy her first camera, and she pursued black and white photography as part of an independent study in college at Oberlin.[2] She liked working in the dark room, exposing and enlarging her own prints. After graduating and spending a year traveling, she hauled her gear to New York City in 1976, where she's lived ever since.

"I started getting frustrated with photography," she said of her first years in New York. "But I still couldn't imagine that I could make movies; I still only

knew about 'big movies.'"[3] All of that changed during a Super 8 workshop at Millennium Film Workshop (which, it turns out, would be her only formal film training to date). The first night, she could see herself as a filmmaker for the first time. It also helped to have access to something other than "big movies," films by Maya Deren or Chantal Akerman, for example, as well as to connect with a community that made and appreciated experimental film. "It gave me a lot of energy and courage to see that individuals, with very little money, were making films all by themselves," she said.[4]

Friedrich made her first four films between 1978 and 1980 while paying the bills doing paste-up work, part of book and magazine production. "Everyone I knew who had gone to art school got jobs being a type setter or a paste-up person, earning between $15 and 25 an hour; it was the gold mine for artists as a job. Then the computer came in, and it was the end of it," she recalled.[5] She organized group shows at galleries, churches, and women's centers, not just to have her own work seen, but "to feel that I was working with other filmmakers in some way."[6] Her 1981 silent, black and white 16mm film (as most of hers were to that point), *Gently Down the Stream*, was based on 14 dreams Friedrich recorded in her journal. It put her on the map, so to speak, garnering reviews in *The Nation, Art Forum*, and *The Millennium Film Journal*. It impressed reviewer Stuart Klawans though he confessed it could be described "about as easily as you can hold on to a handful of water."[7] Her inventive word use, such as "I/lie/in/a gutter/giving/birth/to/myself" hand-written directly onto emulsion, also made an impression on Scott MacDonald. He praised *Gently Down the Stream* for its "creepy power" and intensity.[8] "Its scratched texts seem to quiver with anxiety," he wrote in 1986.[9] MacDonald would go on to champion Friedrich's work and often feature it in his own film scholarship, including in *The Independent Film & Video Monthly*.

Because Friedrich's image and text combinations were so fresh and, at times, jarring, critics delved deep into their lexicons to name their own experience of it. "*But No One* (1982) is the slimiest film I've ever seen," wrote Barbara Kossy in *Artweek*.[10] "With its dim streets and crowds of shining, gape-mouthed fish, it threatens like an unlit alley."[11] In her next film, *The Ties That Bind* (1984), Friedrich pieces together her mother's experience living in Germany through World War II with a non-linear, non-traditional approach to documentary. "I felt that the story of the ordinary, non-Nazi (and non-Jewish) German hadn't been told," she said.[12] *Damned If You Don't* (1987) screened at the Flaherty Film Seminar and at several film festivals, including gay and lesbian festivals. The underlying story of a nun who falls in love with a woman, Friedrich said, caused her to be considered a "lesbian filmmaker," although she thought it was "boring" to be summed up as one thing.[13]

Her next film, *Sink or Swim* (1990), is perhaps her most-known work and is frequently taught in college courses. At the time, it was also her most meticulously constructed, at least in terms of scripts.[14] In 26-parts, one part per letter of the English alphabet, it tells a cumulative story about a young girl and her absent, abusive father. It's based on Friedrich's own experiences. She tried to write the narration

in first person but found that process "extremely difficult" and "too emotional."[15] She said that changing it to third person "gave me some mental distance, because I could imagine some other girl, not myself."[16] She cast a 13-year-old girl to perform the voiceover.

Just as *Sink or Swim* grants girlhood rare cinematic authority, so does Friedrich's only made-for-public-TV movie, *Hide and Seek* (1996). It delightfully bows to and critiques girl culture by throwing a lesbian crush into a slumber party and, like nearly all of her films, draws from an array of source material: mid-century fictional scenes are peppered with similar era archival science and health films. Plus, real, contemporary women discuss coming out. Friedrich said that getting three grants at the time of editing *Hide and Seek* "was huge. It was the only year I've had to work on a film without an outside job."[17] She didn't want to be a "hired gun."[18] She'd made 12 films at that point, and around 1999, she said she was "down to her last dime."[19] She did two editing jobs and said, "I just thought, 'I'd rather drive a truck or become a prostitute.' I love editing, but I don't love editing for someone else."[20] She took a teaching job at Princeton, where she's still on faculty, and continued making films.

In the early 2000s, with *The Odds of Recovery* (2002), she documented a series of pervasive health issues with vivid frankness, both in regard to her body and the emotional fallout from having it fail her. "While my particular story shapes the film," Friedrich told the *Bay Area Reporter*, "it's less important than the experience of the viewer, who should be free to remember his or her own stories, disapprove of, argue with, or identify with my experience."[21] Friedrich often finds unique strategies to put distance between self and viewer, which are actually meant to foster a connection. In *Seeing Red* (2005), for example, she shoots only her mid-section in some of the diary portions. Andrea Richards wrote that unlike what's found on YouTube, this tactic denies "the confessional form its usual casual identification by withholding the speaker's face. It's a simple, and paradoxical, device that shifts attention to what's being said instead of who is saying it."[22]

In 2006, New York's Museum of Modern Art held a retrospective of Friedrich's work and acquired seven films for their permanent collection. (She's had nearly two dozen retrospectives over her entire career.) The films made around that time also mark Friedrich's shift away from shooting on 16mm film. *The Head of a Pin* (2004) and *Seeing Red* were both shot on video, where, especially with *Red*, she said she found herself "accepting a looser approach in gathering material."[23] She shot when she felt like it and then tried to figure out its structure; because of the demands of editing 16mm on a flatbed, she previously had planned many things in advance when shooting. Something else turned for her at this time, maybe it was video, or getting older she told *make/shift*, "and maybe because of having done films a certain way for such a long time that at some point you have to challenge yourself—you have to stop doing Su Friedrich and see what happens."[24]

Two subsequent documentaries turned to external subjects: *From the Ground Up* (2008) traces coffee from bean to cup, and the more personal *Gut Renovation*

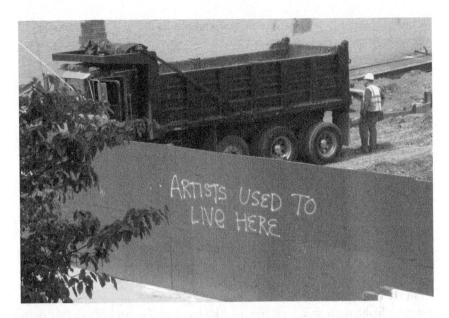

Figure 10.1 Su Friedrich's rage manifests in spraying the graffiti "artists used to live here" in her film *Gut Renovation.*

Copyright of Outcast Films

(2012) is about the gentrification of her Williamsburg neighborhood. The latter rallied locals (it received the Audience Award from the Brooklyn Film Festival) and prompted a lot of press coverage. *Filmmaker* called it "desperately angry and sidesplittingly funny," citing Friedrich's stealing a bottle of wine from a frou-frou party and scrawling graffiti like "artists used to live here" as favorite scenes.[25] "She may be trying, but she just can't pretend to be anything other than furious," wrote Sarah Goodyear in *The Atlantic.*[26] Friedrich's films can be counted on to reveal her immediate feelings and reflections on those feelings, sometimes moments or years later, sometimes imagined into the future. Her most recent film, the personal documentary *I Cannot Tell You How I Feel* (2016), is about the emotionally wrought process of moving her mother into assisted living. As in so many of her previous films, Friedrich says what others do not, and in fact admits, "I feel like this is something I shouldn't be saying . . . but none of us want to end up in a place like this."

As for what Friedrich still hopes to accomplish? She said she's working on a book about traveling through West Africa when she was 21.[27] Film-wise, in 2007 she said, "I don't really know what I'll do. Until I do it."

Included in this chapter is a 1990 *Independent Film & Video Monthly* interview with Friedrich by MacDonald and an interview with Friedrich in 2018.

Daddy Dearest: Su Friedrich Talks About Filmmaking, Family, and Feminism

Scott MacDonald/December 1990

The Independent Film & Video Monthly

Scott MacDonald: *Sink or Swim* is about your relationship with your father, but the way in which you present your struggle to come to grips with that relationship is very unusual. Probably of all your films, *Sink or Swim* has the most rigorously formal organization. The only other film I know that uses the alphabet as a central structural device is Frampton's *Zorns Lemma*. Obviously, your film deals more directly and openly with personal material than Frampton's did, but I wonder, is there any conscious reference to cinematic fathers, as well as to your biological father?

Su Friedrich: That's a hard question to answer. Offhand, I'd say I wasn't making a conscious reference to any other filmmakers, but that the structure was determined more by the fact of my father's being a linguist. I thought that using the alphabet was an obvious choice for the overall structure. I've certainly been influenced by many filmmakers, including some of the so-called structural filmmakers, like Frampton or Ernie Gehr, but my films are never meant to be a direct comment on or a reworking of ideas from other people's films.

I tend to think of the structural film school as avoiding the use of personal, revealing subject matter: I think they're more concerned with how film affects one's perception of time and space than with how it can present a narrative. Whenever I set out to make a film, my primary motive is to create an emotionally charged, or resonant, experience—to work with stories from my own life that I feel the need to examine closely, and that I think are shared by many people. With that as the initial motive, I then try to find a form which will not only make the material accessible, but which will also give the viewer a certain amount of cinematic pleasure. In that I feel somewhat akin to the structural filmmakers, since I do like to play with the frame, the surface, the rhythm, with layering and repetition and text, and all the other filmic elements that are precluded when one is trying to do something more purely narrative or documentary.

In the text in *Sink or Swim*, I had to make a decision about its form. I was using stories from my own life and began by writing

Note: This interview has been abridged from its original publication.

them in the first person, but I got tired of that very quickly. I sounded too self-indulgent, hearing myself always speaking about myself. Writing them over in the third person was quite liberating. The distance I got from speaking of "a girl" and "her father" gave me more courage, allowed me to say things I wouldn't dare say in the first person, and I think it also lets viewers identify more with the material, because they don't have to be constantly thinking of me while listening to the stories. Some people have told me afterwards that they weren't even aware that it was autobiographical, which I like. The point of the film is not to have people know about *me;* it's to have them think about what we all experience during childhood, in differing degrees.

On the other hand, it can sometimes be a problem to impose a structure on a story. I was happy to have thought about using the alphabet, but then that forced me to produce exactly 26 stories, no more, no less. I went into a panic at first, thinking that I had either 75 stories or only 10, and wasn't sure that I would be able to say all I wanted to say within the limits of the 26. But that became a good disciplinary device; it forced me to edit, to select carefully for maximum effect.

MacDonald: I think the irony is that Hollis, for example, really thought that his formal tactics were keeping his films from being personal (his use of Michael Snow to narrate *nostalgia* is similar to your use of the young girl to narrate the stories in *Sink or Swim*). When I talked with him about his films, he rarely mentioned any connection between what he made and his personal life—a conventionally "masculine" way of dealing with the personal in art. But from my point of view, his best films—*Zorns Lemma, nostalgia, Poetic Justice, Critical Mass, Gloria*—are always those in which the personal makes itself felt, despite his attempts to formally distance and control it.

Friedrich: The issue for me is to be more direct, or honest, about my experiences, but also to be analytical. I think there's always a problem in people seeing my films and immediately applying the word personal. *Sink or Swim is* personal, but it's also very analytical, or rigorously formal.

I don't like to generalize about anything, but I do think that it's often the case that the more a person pretends or insists that they're not dealing with their own feelings, the more those feelings come out in peculiar ways in their work. Historically, it's been the position of a lot of male artists to insist that they are speaking universally, that they're describing experiences outside of their own and thereby being transcendent. I think conversely

that you get to something that's universal by being very specific. Of course, I think you can extend beyond your own experience; you can speak about your own experience while also describing the experience of other people you're close to or decide to know. But I think you have to start at home.

MacDonald: Maybe these things are cyclical. I'm sure that generation of late sixties, early seventies filmmakers who avoided the personal—Frampton and Snow, Yvonne Rainer—were reacting against the sixties' demand that art, including film art, had to be personal. You bring two things together: the sixties' emphasis on the personal *and* the reaction against it and make the intersection into something that exploits the useful parts of both approaches.

Friedrich: I am a child of both worlds. When I was studying art history, I really responded to conceptual art, minimal art—those approaches which were very much about form and not about personal drama. But then, of course, I grew up through the women's movement and from the start really responded to the personal drama involved there. Not just that: I love fiction, I love to read about other people's lives, to learn about the choices people make and the ways in which they survive, or overcome, their personal histories. So I feel very much caught between the two approaches and feel that I learn from both.

As an artist, it's important to me to keep both issues alive: to remember that my responsibility is to speak honestly about how it feels to be alive, and that my pleasure is to use my medium to its greatest advantage. I wouldn't be happy if I only let film tell a story in a conventional form, but I would feel that the heart of the work was missing if I only worked with the film as a material, if I only investigated its formal properties. The film scene is in a constant state of flux, and I think that this effort to convey meaningful subject matter through unconventional form is one which occupies a lot of filmmakers today. Hopefully, the lines between narrative, experimental, and documentary will continue to be broken down, as they are all the time now.

MacDonald: Now that you've made a film about your father, as well as the film about your mother, it's probably inevitable that these two films will be paired a lot. When you made *The Ties That Bind*, did you already assume that, sooner or later, you'd come back to your history with your father?

Friedrich: I don't think I had it in mind then. I know some people always have three or four projects in mind, but I never know what I'm going to do next until I'm completely finished with my current

project. Certainly when I was interviewing my mother for *The Ties That Bind* and she got onto the subject of them getting divorced, it really struck a nerve and I thought it might be something to explore later.

One time a friend said it seemed like all of my films have been about my father—not really *about him*, exactly, but about reacting to his influence, or trying to get away from his influence, which is, in a larger sense, reacting to patriarchy. That was a pretty good observation, and I suspected that there was going to come a time when I would have to deal with the question of patriarchy more directly, to look at how it happened closest to home, not *out there* somewhere.

MacDonald: This film is clearly going to have a larger audience than some of the other films, just because it's in sync with the pervasive, contemporary issue of child abuse. What's interesting about *Sink or Swim* is its focus not on the most extreme types of child abuse, but on the situations men create because they feel that in order to *be* men, they have to act in a certain way. You uncover, firsthand, the brutality that's gendered into the family situation. On the other hand, as much as there are things your father did that you really dislike, even hate, the film suggests an ambivalence about him and about his influence on you.

Friedrich: Yes. I agree about what you said about gender, that abuse is more likely because of the inhuman situations that are intrinsic to a society that divides roles along gender lines. But *Sink or Swim* is also like *Mommie Dearest*: it's about the damage either parent can do when they're trying to shape their child in their own image. Most parents, either instinctively or consciously, try to instill their values in their child. They have a lot of ambitions themselves and, consequently, a lot of ambitions for their children. They force their children into activities or try to instill certain ideas in them that are not good, not natural for the child. I can see from watching the children of friends and relatives that part of who we are is formed by our parents and part of us is there from day one. If you have a kid who's not naturally ambitious or aggressive and you try to make him that, you're just going to bend him out of shape. On the other hand, if you have ambitious children and don't encourage them, you can be very destructive as a parent.

To answer the second half of your question—about my ambivalence about my father: people have said to me, "It can't be all that bad, because look where you are." or "You're not a

destroyed person; you're capable, you've made films, you've lived a relatively good life." I recognize that, and that's the source of my ambivalence. Certainly, I've learned to do things from him that have stood me in good stead over the years, just as I have from my mother.

Moreover, since the film is about how I've been affected by *my* childhood, it would have been grossly unfair not to acknowledge how my father was affected by his. I tried to speak to that by including the story about his younger sister drowning and showing how he spent many years afterward trying to overcome his guilt and loss. I put that story right before the one about him punishing my sister and me by holding our heads under water for too long, because I wanted to give a context to that punishment, to show that although we were devastated by his punishment, we were being punished by someone who had suffered his own childhood traumas.

One of the most painful things to realize in making the film was that we all inherit so much sorrow and hurt from our parents. We aren't the product of perfectly balanced adults; we are each created by people who have a legacy of their own, which goes back through each family line. On my good days, I try to believe that each generation rids itself of a bit of the violence of the prior generations, that with education and greater material well-being we wouldn't have such widespread abuse. But unfortunately I think the solutions are extremely complex, and I can see that simple notions like education are hardly an answer.

MacDonald: The most obvious example of your ambivalence is the source of the title, which refers to the incident of his throwing you into the pool for you to "sink or swim," since you wanted to learn to swim. At the end of that story, you admit you've remained an avid swimmer.

Friedrich: But swimming was fraught with all kinds of anxiety, which is why at the end of the film I tell the story about wanting to swim all the way across the lake and realizing that maybe I'm not physically capable of it, and am certainly very frightened at the thought of doing it, but feel compelled to do it anyway, because of him. It's at that moment that I finally say, "No, I don't have to do that. I can enjoy swimming, but on my terms, and I won't take on his standards for what makes a good swimmer or a brave swimmer," and then I swim back to shore.

MacDonald: I think in his generation there was this feeling that unless you were capable of terrorizing your kids a little, you weren't a

serious parent. Scaring them was almost a way of demonstrating how much you cared. As a young parent, I remember debating in many situations whether I was wimping out and doing my child damage by not being tough enough to do something that in the long run would be good, even if in the short run it was bad. And I think your father's generation felt this even more strongly. Did you talk with your siblings when you were making this film?

Friedrich: Yes. My sister is a year older than I, and my brother six years younger, so I was interested in their different memories of childhood. My sister and I shared a lot of the experiences I mention in this film, and we lived longer with my father, so she was able to confirm many of my stories. She had other stories which she wanted me to include in the film, but I stayed with those which had the most resonance for me. Since my brother was much younger and was only five years old when my parents got divorced, he didn't know about, or hadn't shared, some of the events in the film, but I valued his perspective a great deal. He has slightly more distance from my father and was concerned that the material be presented fairly, that it not function simply as vendetta, which was also a concern of mine. In fact, he had a funny reaction to my other "family film." I showed him *The Ties That Bind* when I was finished editing, and afterwards he said. "Jesus, I hope you never make a film about me!" I certainly can't blame him for that sentiment; it's a weird and suspect process to make films, to make art, based so openly on one's own family.

MacDonald: It seems inevitable that at some time your father will see the film. What do you think about that?

Friedrich: I dread it. When I first started working on the stories, I had a lot of anger, obviously—I even thought about sending a script to him. I had vengeful feelings. But the longer I worked on it, the less I wanted to punish him, and the more I felt I was not doing it so that *he* would finally acknowledge my experience, but so that I could acknowledge my experience.

The nuclear family is based on a relationship in which one person (the parent) has a lot more power and control than another (the child). Because of this, I think children are constantly having their feelings denied by their parents. If the child is unhappy and the parents can afford to acknowledge the unhappiness, they do it; but if the parents can't acknowledge the unhappiness because it reflects badly on them, they won't. For me, it was a matter of writing these stories so that I could finally say to myself. "This

did happen to me, and this is the effect it had on me," regardless of his experience. I'm sure he has a very different interpretation of a lot of the stories, which is understandable—everyone sees things from their own perspective, their own history. By the time I finished the film, I really felt that I was making it so that I could understand what had happened *and* so that other people who had the same experience could have that experience acknowledged. I don't think the sole purpose of art is to provide acknowledgment for people, but I think that's one of the things art can do. You can see a film or read a book that in some way corresponds to your experiences, good or bad, and you might feel stronger because you see yourself reflected in it. That's what being in the world is all about—having common experiences with other people. I hope that's the effect the film will have.

I've told my father that the film exists, but beyond that, it's up to him whether or not he sees it.

MacDonald: During the film's coda, we see a home movie image of you and hear you sing the ABC song. The last words of that song, and of the film, are, "Tell me what you think of me." Obviously, the song relates to the film in several ways, but is your use of it, on one level, a comment on the whole enterprise of making film? Do you mean that films are attempts to please whatever is left of the father in us and that the audience, which is now going to make a judgment of the film they've just seen, is an extension of patriarchy?

Friedrich: Well, in a way, but that was the joke end of it. When you make a film, you do it to get a response, and presumably most people want a good response. I surely can't imagine making a film and hoping everyone will *hate* it. The conclusion of *Sink or Swim* was more a way for me to acknowledge my absurd ambivalence. A lot of the stories in the film are about doing things to get my father's approval, and then at the end in the last story I decide that I'm not going to swim across the lake to please him. I've made a sort of grand gesture of turning back to shore, swimming back to my friends who will hopefully treat me differently than my father has treated me. But then in the epilogue I turn right around and sing the ABC song, which asks him what he thinks of me! I believe that, to a certain extent, we can transcend our childhood, but in some way we always remain the child looking for love and approval.

MacDonald: I would guess that whether or not men like this film is going to have a lot to do with their ideologies about family. I'm sure it will make many men uncomfortable; it will expose them.

Friedrich:	A surprising number of men have come up to me afterwards and talked about the film from the vantage point of being fathers. That wasn't foremost in my mind when I was making it, but their responses have been interesting: the film brings up a lot of fear in them, a lot of concern about how they're treating their own children. Many of them express a profound hope that they won't do major damage to their kids.
MacDonald:	Do you plan to tour with this film? I know you've been having some reservations about the usual way independent filmmakers present their work.
Friedrich:	In the case of the last two films, I did go around the country (and a little bit in Europe), showing the films and talking about them. With *The Ties That Bind*, I was eager to do it, since it was a big political issue: Nazi Germany and an individual's political responsibilities. For the most part, touring with that film was interesting for me. With *Damned If You Don't*, touring was a way to earn part of my living, and I was curious about the audience's response: since it was about a lesbian nun, I was curious to see whether people would be scandalized or amused, if a lot of lesbians would come to it, whatever.

But I got really worn out from the experience of having to speak after *Damned If You Don't*, and I approach the prospect of doing it with this film with a lot of dread, for two reasons. In the first place, the film is extremely emotional. It was difficult to make, and it's been hard sometimes to deal with people's response to it. Making a film which evokes such painful memories is risky; people sometimes look at me afterwards as if I have a solution to all the problems, as if I know some way to cope with the pain one feels. I'm afraid I don't really have any answers to give. All I know right now is the importance of acknowledging those childhood expectations.

The other reason is more general: I think the whole setup of having a personal appearance by the filmmaker after the screening is obsolete. . . . I think this whole structure grew in part out of a feeling in the sixties and seventies that, while there was an audience out there for avant-garde film, it wasn't big enough, and that one way to make the films more accessible was to have the filmmaker there. If people were frustrated or confused during the viewing of the film, they would be relieved of their frustrations afterwards by having the whole thing explained to them.

I certainly think that avant-garde film is in a period of crisis. Many independent filmmakers are moving into feature narratives,

and there's a feeling that the process of making "smaller" films is dying out. That might make some people think it's still important to go out and proselytize and educate, but I think that's a misguided response to the situation. The idea that I would go to a performance by John Zorn or whomever—some composer or musician—and he would have to get up afterwards and explain how to hear his music, as opposed to how to hear Schoenberg or Beethoven, is absurd. I think the film community is much too paranoid about the audience's alleged inability to understand avant-garde films.

My experience with *The Ties That Bind* proved this to me. Since it was about an older woman, I often had older people in the audience, people in their fifties and sixties who had never seen an experimental film. Sometimes they told me afterward that they were intimidated at the outset, but by the end of the film they were fine, they understood and enjoyed it. They're adults; they've got minds. There has to be more respect for the audience, and more trust.

I feel differently about visiting film classes, where you have young people who want to learn about film; I'm concerned about the discussion with general audiences. Half the people in a general audience are filmmakers or film buffs, and they already know what to expect. The other people might come because of the subject matter; they might feel insecure or confused, because of the form, but I think that's something they need to go away with and sort out at their own pace. Beyond that, I think it's almost impossible to formulate questions, to fix one's response, moments after seeing a film. It takes me a few hours or days to sort out my response to most films. I often feel guilty when I leap up after a screening and look out at a sea of bewildered, dreamy faces, at people who are just beginning to digest the experience, and say, "Any questions?"

MacDonald: To come back to *Sink or Swim:* I think probably the dimension that gets lost most easily in your films is the intricate network of connections between sound and image. In both *The Ties That Bind* and *Sink or Swim*, the subject is so compelling that the subtleties of your presentation can easily be overlooked—at least judging from the responses during discussion.

Friedrich: I think people might not be so articulate about that level of the films because, not being familiar with the field of avant-garde film, they might not have the language with which to describe those effects. But I do think there's an unconscious recognition of that level; that's why the film is working. If I wasn't editing well,

if I was putting stupid images up against those stories, the stories might have a certain impact (if you read them on paper they have a certain impact), but the images I use produce so many more meanings, and *that's* what people are really responding to, even if they think it's primarily the stories that are affecting them. If they come up afterwards and say, "That was really powerful," I think, "Well, it's powerful because it's the right shape, the right texture, and the right rhythm—all those things."

There was a period when I thought it was important to deny myself everything, including all kinds of film pleasure, in order to be politically correct and save the world, but I think if you do that, you deplete yourself and then have nothing to offer the rest of the world. If you want to engage people, if you want them to care about what you're doing, you have to give them something. Of course, that doesn't mean making a Hollywood musical. The discussion tends to be so polarized: some people think that if you introduce the slightest bit of pleasure, whether it's visual or aural or whatever, you're in the other camp. But I think that's changing.

MacDonald: There's always an implicit debate between the people who seem to want to get rid of cinema altogether, because of what it's meant in terms of gender politics, and the people who want to change the direction of cinema, to make it progressively vital, rather than invisible.

Friedrich: Sometimes it's a case of "the harder they come, the harder they fall." When people hold out against a position—against cinematic pleasure for example—the urge is still there in them. If they hold out too long, they end up doing something which is so much about cinematic pleasure that in effect they've gone over to the other side without really acknowledging how or why. I think that happens a lot, and it disturbs me. I really believe in film. I believe in its power. I think it's going to be around for a long time, and if people can't accept their responsibility for producing cinematic pleasure in an alternative form, well, that's their problem, and everyone's loss.

A Conversation With Su Friedrich

Erin Trahan/2018

Erin Trahan: Can you remember a film that made you think, "I can do that!"?

Su Friedrich: Seeing [Maya Deren's] *Meshes of The Afternoon*, which is probably everyone's answer. I rented a print from the Donnell Library and

watched it three times in a row. I was also really inspired by going to the Bleecker and seeing Fassbinder for the first time or Margarethe von Trotta. I felt a great affinity with a lot of the work I was seeing by European filmmakers. I was already making films, so it's not as if I thought it wasn't possible before then, but there was something about the spirit of Fassbinder's work, for one example among many, that made me feel that filmmaking was something I could be a part of.

Trahan: How old were you then? What else was going on in your life?

Friedrich: I got out of college in 1975 and traveled for six months throughout West Africa and then came to New York in the fall of 1976. I was doing photography, a kind of photojournalism for feminist magazines, working several publications including as a member of the collective that published *Heresies: A Feminist Journal on Art and Politics.*[28] In 1978, I did a three-night Super 8 filmmaking workshop at Millennium taught by David Lee, and I was totally hooked! I hate those mythical stories about the moment when one finds one's calling, but something serious changed for me in taking that class: I recognized who I should be. I had been really committed to photography. I loved it and imagined I was going to be a photographer, and at that time film was so remote, so far from what I thought I could do. It was really, truly that Super 8 class that made me think about selling my enlarger and dark room equipment.

Trahan: Were you making a lot of images in childhood?

Friedrich: In fourth grade I saved up my allowance, went down to the local pharmacy, and bought a Brownie Instamatic. I was so proud and excited to own a camera. Both of my parents were very passionate and knowledgeable about all aspects of culture. I was mostly raised in Chicago and spent a lot of time visiting the Art Institute, looking at great works of art and also being taken to the ballet and music events by my mother. But absorbing art is different than making it, and when I went to college, I didn't have any aspirations to become an artist; I was planning to be a math major. But I didn't do so well at college level math, so I switched my major to French, but discovered that the French department wasn't very good.

At Oberlin, Ellen Johnson taught the modernists. Her lectures were famous, and I was blown away by attending one at the encouragement of a friend who was taking a class of hers, so I switched over to be a combined major in art history and studio art. They had a strong art history program but the studio art was weak and didn't offer any photography courses, so I did photography as independent study and studied African art history also as an independent study with a professor from Ghana who taught political science. Between art history and photography, I had started learning the rudiments of how to compose

an image. (I don't think you can claim you know very much in college, or even a few years after college.) And then, of course, with film there's movement and sound, so after a few years of being committed to photography I discovered film, and how the huge, wonderful worlds of movement and sound could be added to image. That was the end of my photography.

Trahan: Your early film learning was on film—Super 8, 16mm, eventually, in 1994, with synch sound. Shooting on and editing those formats is very different from early video and certainly all of the digital formats now. It seems you've adapted well along with the times.

Friedrich: I didn't do it happily, but I did adapt. Back in 2002, I finished *The Odds of Recovery*. That was the first time I edited on a computer in Final Cut, instead of on a flatbed. The editing was in many ways easier, after editing the 20,000 feet of film I had when doing *Hide and Seek*. But then I did a matchback to film because I wanted to finish *Odds* on film. The process of doing a matchback was such a nightmare, and incredibly expensive. After six months of showing it on film at festivals, I realized that it would live on in VHS or Beta SP, and at that historical point, making prints for rentals and screenings had become somewhat obsolete.

I also couldn't really afford to shoot 16mm anymore. My partner gave me a simple video camera for my birthday and I made *The Head of a Pin* as a first attempt at working in video. Once I admitted I was shooting video, I got a good camera. In some ways I'm a perfectionist and in some ways really not. I'm a perfectionist when it comes to editing. That doesn't mean I do it perfectly; it means I aim for perfection in how it's constructed. With camera and audio, I've made do with what's at hand, so sometimes I just think, "Goddamit, I just need to record right now." And I use whatever is at hand. So some stuff is underexposed, shaky, or the audio isn't clean. If you're a commercial minded person, you might think, "Wow why didn't she shoot in 4k or use a better lens?" I recognize that, but not if you're worried more about the surface than what's inside, and if you can't afford a high-end surface, then you're really forced to deal with the interior, the meaning, rather than just "the look."

Trahan: That makes me think it's a good time to ask "the woman question." I say that somewhat jokingly and also dead seriously. How has being female impacted your filmmaking?

Friedrich: There are so many categories in which to apply that answer, it's hard. I could start with a few things. I am not an essentialist, I'm kind of the opposite. But I do think there are ways that we are raised and ways in which we're physically different than men, and that informs whatever

we do. The fact that I'm female plays a part of every aspect of my filmmaking, but I can't really name what that is, specifically. Back in the '70s people would talk about how women's work was more personal or wouldn't have as much action or was more inclined towards a happy ending. You know, really stereotypical notions of how being a woman comes through in one's art.

But think of Thelma Schoonmaker, the main editor of all of Martin Scorsese's films. Someone once asked her, "How can such a nice lady edit such violent films?" She rightly responded by saying, "They weren't violent until I edited them." And men can also make a heartfelt emotional scene, so I don't believe in those differences. But certainly for me, the fact that I'm a woman is a central aspect of my subject matter. I grew up thinking, "Fuck this world," so my world is going to point a finger at all of those things. It doesn't *just* do that but that's a part of the work.

Trahan: I'm not proud of this, but I had no interest in keeping up with the technology after studying filmmaking in college in the mid-'90s. At least not on my own, anyway.

Friedrich: I've been going to B&H for 30 years to get my photo and film equipment and the salesmen, who were all men, and would always treat me like a stupid little girl. Now I walk in and say, "Hi. Listen, you need to talk to me like I know what I'm doing," and they get all flustered and try to pull the usual bullshit but then they realize they can't. But everyone I encounter is going to assume I don't know enough, so I'm on my guard, being sure I *do* know what I'm talking about. Because—news flash—it isn't just about salesmen at B&H, it's throughout the film world, and the experimental film scene is no less sexist than any other part of American landscape.

Trahan: And how has the experimental scene treated you, or anyone who also fits an "other" category?

Friedrich: Well, also being a lesbian, back in the early '80s, it was a really fortunate thing that I made *Gently Down the Stream*, it really hit a nerve with people, and was really being recognized, but not as a "lesbian film." And then when I made *The Ties that Bind*, I got a full page review in *Village Voice* and that blew the top of my head off! I thought I was made in the shade! Amazing! But then came *Damned If You Don't*, and suddenly I was a "lesbian filmmaker." You make one film and suddenly you're *this* kind of filmmaker? How boring and reductive is that?

Sometimes I give a "clip talk," where I give some background about what went into the making of each film along with a five-minute sample clip from it. In the introduction, I list certain things I always

try to keep in mind when I work. One item is that my work should speak about the lives of women and my experiences as a woman. Because that's what men do in their work, isn't it? Men have always made things about men. (And if we're going to be fair, then we should call them "men" filmmakers, and "men's" film festivals when we're seeing programs without a single film by a woman.) Now we can talk about pre-#MeToo and post-#MeToo, but we are definitely not yet at a point where women don't have to be vigilant and proactive in respect to sexual harassment but also in regard to women's (lack of) inclusion in the film world. The neglect and disparagement runs way too deep and does not change in six months.

Trahan:	One of your other "categories" has been that of personal or first-person filmmaker. That sub-genre generates its own set of pre-formed judgments. Plus, women are again in the minority, and again, judged more narrowly than men. Have you gone through any major phases of feeling you shouldn't or couldn't make a certain film?
Friedrich:	Couldn't does happen very often. I'll think, "Oh my God, I'll never have another idea." But that's most of us. There's no telling when that will break, when some idea will walk through the door. I tend to make one film after another and people have said I'm prolific, but there are periods of a real sense of nothing being there. But *shouldn't* make films, I've never thought.

There is the worry about if something is too touchy. In *Damned If You Don't*, I was talking to a friend back home when I was living in Berlin, and was really drunk and said I want to make a film about girl who falls in love with a nun. The next morning, when I had sobered up, I realized, "Oh Jesus, I really can't do that," and turned it into an adult woman so I wasn't making something about a weird pedophile nun.

In *I Cannot Tell You How I Feel*, I wondered, "Should I be making film about my mother without her knowing about it?" And I decided I'll live with what history decides. I cannot resolve this conflict; I have to put it out in world. If somebody thinks I'm an asshole . . . well, when you get older, you think, "If I'm an asshole then I'm an asshole." There are ways, as a filmmaker or writer or painter, to think seriously of your subject matter and its impact on audience. I never take this lightly. Other people would have stopped short of the line. But some people don't have the same kind of access; it can take being in a fortunate situation. For *The Ties That Bind*, I had always wanted to make a film about my mother growing up in Nazi Germany and she didn't talk about it much when I was little, but she miraculously agreed to talk with me then, but it was because I lied to her and said I just wanted to record her stories for posterity, for the family. And for example, my partner

has said, "Don't you ever dare make a film about me." But there's *Rules of the Road* (1993); she couldn't stop me because we were broken up at the time. And my brother has said, "Don't make a film about me." But when he said that, I said, "If I did, it would be a love letter."

Trahan: What's it like to work with you on a film? Do you consider your subjects your collaborators?

Friedrich: If it weren't for the people who looked at my work while it was in progress, I swear to you it wouldn't exist. I learned that really early on. I've never called it collaboration; the other person is not an equal partner. I don't say, "Hey, let's develop it together." But when I start to think about something, let's say with *Sink or Swim*, I started to write all the stories but then I showed those stories to two, three, four people, and they gave me a lot of notes. I recently dug out all of my paper archives and I found a really fantastic page of notes from my friend Steve, "This is saccharine, this is maudlin." Sure, when I read it, I tore my hair out, I had been working on it for weeks and weeks and weeks, but he was right, and it was time to do some re-writing. I always ask people to read the script or look at an edit and be brutally honest. They're people I know well, who are really smart, and I keep going back, re-writing, re-editing, going back over and over and over. We are not good enough by ourselves.

Trahan: Has your work been understood? Interpreted in ways that satisfy you?

Friedrich: Yes. I've never had that question asked of me. It's such a weird question! The lesson I learned, watching the structural films, the system films, or films where maybe the filmmaker was really concerned with composition and tempo, is that cool things would happen, but they didn't seem to be concerned with engaging the viewer in an emotional way. I really want people to keep watching, to hook them. I want them to laugh, and cry, and be freaked out, and all those emotions that can be evoked when we watch something or read something. That's a big part of my drive—to have the films give you an emotional experience, an emotional ride, so I've gotten a lot of responses because people have been able to enter the work.

Even though, for example, I was in Dortmund for the Women's Film Festival with *Rules of the Road*. Germans think they speak English well but it still gets opaque at times. So I'm sitting out in the lobby, the theater door slams open, and in German a woman stalks away saying, "Cars, cars, cars, Godammit!" She's so upset about the film! It's true—it really is about cars, so I figure, "I didn't get you, did I?" But I have been very gratified by the extent to which people have been affected by my work, or moved by it. It has also been a long life lesson in how much people translate films. We all do this. If I read something about 16th century Algeria, I somehow "translate" it into something

recognizable to me. And it happened for the first time with me when I showed *Gently Down the Stream*, and afterwards a straight guy from Scotland told me, "I have the same dreams." I was like, "You do?"

Trahan: What's one of the most important things you teach your students at Princeton?

Friedrich: My experience teaching, for many years now, is that I feel more and more sorry every year for the students. It's exponential: my feeling sorry is getting bigger faster. I feel really guilty saying, "Wow, when I started making films, there was a place we could all go and hang out." But those places don't really exist now. So if they send somebody a file to watch, they think that's the same thing, and it's not. They're not being in the same space. They'll look at it for one minute and then check their email, get distracted. But how do they make spaces? You'd have to be really proactive as a maker. There's a great loss. On the one hand, ooh social media, it connects the world, but yeah, you haven't talked to somebody across a table from you in weeks.

Trahan: I know you were in New York most of the time that the Association of Independent Video and Filmmakers (AIVF) existed and published *The Independent Film & Video Monthly* (1976–2006). They were community catalysts, too, right?

Friedrich: I loved *The Independent*—that to me was *the* publication when I started making films. It was like my bible. I would read it cover to cover. The back had so much info about grants and the classifieds. Of course, those resources are now online which we didn't have then. But it was really wonderful and gave me such an understanding about how filmmakers were coping with both the technical and financial issues in trying to get their films made.

Trahan: And your films, and writing, frequently graced the pages of *The Independent*.[29] Switching gears, what do you still hope to accomplish as a filmmaker?

Friedrich: Please, that's a dumb question. I want you to put that part in there, how I said it's a dumb question. How the fuck does anybody know? I'm 63 and a half—it's horrifying to say that—but I suppose I'll just keep trying to make films and be good. It's not like now I want to make the really great film, or now I want to make the film that's seven hours long. I just want to keep interesting myself.

Trahan: Before we go, I have to ask about that moment when you're crying on the couch in *Seeing Red*, worrying that you'd become a housewife. Were you serious?

Friedrich: As you get older, you start living with people, and you have more responsibilities, like grocery shopping and doing the laundry, so you can live together. When I lived alone, I could ignore those things. One morning I opened the fridge and the only things in it were a bottle

of vodka and a pair of gym shoes. I must have been drunk when I undressed the night before. But then I started living in a collective loft situation with Cathy who really loves to cook. It grows on you. If you have kids, you really do have to do that domestic stuff, but even without kids, you have to put food on the table.

When I did *Seeing Red* I was in the middle of making *From the Ground Up*, and Cathy said, "You seem like you're in pain. Instead of making a movie about coffee, turn on your camera and do something more real." It was very real, that feeling of "I'm turning into a fucking housewife," because *From the Ground Up* was boring. So we distract ourselves. We make new pillows for the couch. I think I was doing a lot of that, so I stormed into my studio after she said that and had a tantrum on film. When I showed it for the first time at MOMA, everyone I knew was in the audience. I was sitting in the back with Cathy, imagining they would feel so sorry for me and my plight. But when I started crying on camera, they all started laughing instead in recognition. We all somehow turn into housewives.

Didn't I just tell you I have to go clean the basement?

Notes

1. Su Friedrich. Interviewed by Erin Trahan on May 13, 2018.
2. Ibid.
3. Su Friedrich. Interviewed by Katy Martin, *Art World Magazine* (2008), www.sufriedrich.com/PDFs/PDFS%20from%20GEN'L%20books%20%20+%20mags/GEN'L_ArtWorldMagazine_Martin_2008.pdf, accessed on June 20, 2018.
4. Ibid.
5. Su Friedrich. Interviewed by Erin Trahan on May 13, 2018.
6. Su Friedrich. Interviewed by Stephanie Beroes, *Cinematograph*, no. 2 (1986): 68–71, www.sufriedrich.com/PDFs/PDFS%20from%20GEN'L%20books%20%20+%20mags/GEN'L_Beroes_CINEMATOGRAPH_1986.pdf, accessed on June 20, 2018.
7. Stuart Klawans, "Films," *The Nation* (October 31, 1988), www.sufriedrich.com/PDFs/PDFs%20of%20single%20reviews/06%20GDTS%20reviews%20as%20PDFs/GDTS_Klawans_THE_NATION_1988.pdf, accessed on June 20, 2018.
8. Scott MacDonald, "Text As Image in Some Recent North American Avant-Garde Films," *Afterimage* (March 1986), www.sufriedrich.com/PDFs/PDFs%20of%20single%20reviews/06%20GDTS%20reviews%20as%20PDFs/GDTS_MacDonald_AFTERIMAGE_1986.pdf, accessed on June 20, 2018.
9. Ibid.
10. Barbara Kossy, "Speaking From the Inside," *Artweek* (July 28, 1984), accessed on June 20, 2018. http://sufriedrich.com/PDFs/PDFs%20of%20single%20reviews/01%20BNO%20reviews%20as%20PDFs/BNO_Kossy_ARTWEEK_84.pdf
11. Ibid.
12. Su Friedrich. Interviewed by Katy Martin, *Art World Magazine* (2008), www.sufriedrich.com/PDFs/PDFS%20from%20GEN'L%20books%20%20+%20mags/GEN'L_ArtWorldMagazine_Martin_2008.pdf, accessed on June 20, 2018.
13. Su Friedrich. Interviewed by Erin Trahan on May 13, 2018.

14. Friedrich has posted all of her scripts online including *Sink* in five languages. www. sufriedrich.com/content.php?sec=scripts

15. Su Friedrich. Interviewed by Katy Martin, *Art World Magazine* (2008), www. sufriedrich.com/PDFs/PDFS%20from%20GEN'L%20books%20%20+%20mags/ GEN'L_ArtWorldMagazine_Martin_2008.pdf, accessed on June 20, 2018.

16. Ibid.

17. Su Friedrich. Interviewed by Erin Trahan on May 13, 2018.

18. Erin Blackwell, "Framing Lesbian Angst," *Bay Area Reporter* (April 3, 1997), www. sufriedrich.com/PDFs/PDFs%20of%20single%20reviews/08%20H-S%20reviews%20 as%20PDFs/HS_Blackwell_BAY_AREA_REPORTER_1997.pdf, accessed on June 21, 2018.

19. Ibid.

20. Ibid.

21. Jenni Olson, "Friedrich Lays Odds," *Bay Area Reporter* (September 19, 2002, www. sufriedrich.com/PDFs/PDFs%20of%20single%20reviews/09%20OR%20reviews%20 as%20PDFs/OR_Olson_BAYAREAREPORTER_2002.pdf), accessed on June 25, 2018.

22. Andrea Richards, "Su Friedrich is Seeing Red." *make/shift* (Fall/Winter 2007–2008, www.sufriedrich.com/PDFs/PDFs%20of%20books%20for%20INDIV%20films/SR_ Richards_MAKESHIFT_2007.pdf), accessed on June 26, 2018.

23. Su Friedrich. Interviewed by Katy Martin, *Art World Magazine* (2008), www.sufried rich.com/PDFs/PDFS%20from%20GEN'L%20books%20%20+%20mags/GEN'L_ ArtWorldMagazine_Martin_2008.pdf, accessed on June 20, 2018.

24. Andrea Richards, "Su Friedrich is Seeing Red." *make/shift* (Fall/Winter 2007–2008, www.sufriedrich.com/PDFs/PDFs%20of%20books%20for%20INDIV%20films/SR_ Richards_MAKESHIFT_2007.pdf), accessed on June 26, 2018.

25. Brandon Harris, "Su Friedrich on Gut Renovation," *Filmmaker* (March 8, 2013), www. sufriedrich.com/PDFs/gutrenovation_reviews_pdfs/Filmmaker%20Magazine.pdf, accessed on June 26, 2018.

26. Sarah Goodyear, "Raw Anger Permeates a New Film About Gentrification in Williamsburg, Brooklyn," *The Atlantic* (March 6, 2013), www.sufriedrich.com/PDFs/gutrenovation_ reviews_pdfs/The%20Atlantic.pdf, accessed on June 26, 2018.

27. Su Friedrich. Interviewed by Erin Trahan on May 13, 2018.

28. A feminist publication on art and politics published by the Heresies Collective.

29. Some of *The Independent* articles that feature Friedrich include Martha Gever's "Girl Crazy: Lesbian Narratives in She Must Be Seeing Things and Damned If You Don't," in July 1988; "Some Like It Hot" by Judith Halberstam in November 1992; "Fit & Trim: A Foolproof Method for Storing Film Trims" in July 1999; and "A Message To The Future" in January/February 2000.

11

MIRANDA JULY (1974–)

Erin Trahan

Miranda July's artistic expression has taken many forms, from experimental videos to performance and fiction writing. As a filmmaker who produces, writes, acts, and directs, she's known for revealing otherworldly moments in ordinary lives—like how a break-up can feel as if it stopped time in *The Future* (2011), or how you can live a whole lifetime in one city block in *Me and You and Everyone We Know* (2005). Yet her films also often have an unsettling undercurrent, something between off-key humor and unflappable optimism. Her characters span and cross generations, and their relationships frequently play against conventions. Underlining their actions—and July's storytelling—is a generosity that can befuddle those more accustomed to brutality. Ultimately, her protagonists are people who want to share their strongest feelings and are met with grace for doing so.

July was born in Vermont in 1974 as Miranda Grossinger. An imaginative child who wrote and performed in her own plays, she adopted the pseudonym Miranda July as a teen (like Lady Bird before *Lady Bird*) and has used it since.

July and her older brother grew up in Vermont and California, where their parents modeled creativity and self-expression. Both writers, her poet mother and Ph.D. father founded a literary magazine in the 1960s that evolved into the still operating North Atlantic Books, which specializes in titles related to mind, body, spirit, and nature. They exposed July to independent and art film at a young age. She recalls being bored by Kenneth Anger and Stan Brakhage videos at age nine,[1] for example, and catching a spark from the short films of Jane Campion in high school.[2]

Her first professional production was a play she wrote in high school, *The Lifers*, which was based on a real-life correspondence she initiated with a prisoner. She presented the play in a punk club, though it wasn't a band, and already considered herself a filmmaker, though her movies were "live." The instinct to refuse classification has carried her through an unrivaled and wide-ranging artistic career.

Her early pursuit of film included film internships (including with the late documentary filmmaker Les Blank) in high school and an intent to study film at University of California Santa Cruz, where the coursework and mostly male film students left her uninspired. She dropped out and moved to Portland, Oregon. There, she went punk (or Riot Grrrl), hardly working "real jobs," and, at times, stole food to eat. She joined a band, started recording performance albums, and generally focused on finding her voice. "I was trying to be an artist," she told the PBS Makers' series, and to everyone else it seemed "so unlikely that it was going to work out."[3]

In the mid-1990s, she started making short videos, in part, because that format seemed "manageable."[4] They almost always featured herself as a character and hovered between performance art, independent film, gallery installation, and elevated vlog. In her first short, *Atlanta* (1996), July plays both a 12-year-old Olympic swimmer and her overbearing mom. *The Amateurist* (1997) toys with what July calls "predictable amalgamations of single types" of women, including a stripper.[5] While she again appears in this video and has shared life experiences with the characters, she wrote in its Video Data Bank description (her current distributor of early titles) that she chose "not to speak with an autobiographical voice, which would in itself be yet another cliché (the confessional)."[6]

With this comment, July is reacting to what women are often accused of in art, of being too "personal." Critics and viewers presume much of July's work is autobiographical and this leads them down an erroneous and limited understanding of her work (calling it "self-conscious" and "precious" or "twee,"[7] for example). July sees these interpretations as tied to her being a woman, and her work has undoubtedly been judged by different, often harsher, standards than male peers doing similar work. When male filmmakers make personal work, she told *The New York Times* in 2011, "it's not really questioned, whereas I or another woman is looked at as so self-obsessed. Men are just not being judged in the same way. They're never going to be annoying in the same way."[8]

The Amateurist slowly gained steam, starting with a Best Experimental and No Budget award from Cinematexas and broadening out to play venues in both North America and Europe. In 1999, she released *Nest of Tens*, four loosely linked stories, explorations of what happens when tacit boundaries are pushed or exposed. In *BOMB*, author Rachel Kushner asked July if any innocence was lost in some of the awkward, mixed age sexual situations (specifically when a man and woman expose themselves with a child nearby). July explained that the children in her films always know what's going on and she doesn't judge them for that. She dislikes pretending that children are not sexual beings living in an adult world. "In general, I'm trying to make a space where it's not clear, or maybe not even interesting, whether someone is good or bad or crossing a line."[9]

Breaking down the notions of what's measured as good or bad, regarding either critical acclaim or popularity, seeps into July's advocacy on behalf of other artists as well. While living in Portland, she started collecting women-made videos and re-circulating them as a kind of video chain letter called Joanie 4 Jackie (or J4J). Joanie 4 Jackie ran from 1996 to 2007 and helped July see herself as part of a larger

filmmaking community. She joyfully placed all of Joanie 4 Jackie's content in the hands of the Getty Institute in 2017, and many of the films and related materials are available online.[10]

July calls *Nest* a "turning point" in her filmmaking, and by 2002 it, along with her other shorts, including *Getting Stronger Every Day* (2001), were circulating among the most elite showcases for experimental films, though she acknowledges that her work leaned more narrative than experimental. The success of *Nest* culminated in an invitation to present at the 2002 Whitney Biennial. (Indeed, there would be subsequent invites from the Whitney and other galleries in an entire thread of her artistic career not discussed in detail in this chapter.) Her success also precipitated an invite from *The Independent Film & Video Monthly* to guest edit an insert on experimental film in July 2002, republished in this chapter. In that issue, she addresses the existential questions raised by curatorial choices and the inclusion or exclusion from archives. Meanwhile, (there are many meanwhiles with July), she was finding local and regional grants to support her work and visiting universities on both coasts as a guest lecturer. As the years went by, those guest spots turned into visiting artist and artist-in-residence stays.

Nest's 27-minute run-time opened another door, allowing July to imagine the possibility of making a feature-length film. So she developed her first feature, *Me and You and Everyone We Know*, with support from the Sundance Institute, and it went on to win the 2005 Sundance Special Jury Prize for Originality of Vision as well as the Camera d'Or at Cannes. In an *Art Forum* interview, July points out that only two of the 16 films eligible for jury prizes were made by women that year and thus, "When you come out of nowhere as a woman with a feature film, everyone wants an explanation. How could you have had the balls to do that?"[11]

Fast forward to 2011's *The Future*, which some critics would call the best film of the year, while later criticizing July for disappearing between movies, despite having written two books. July is not alone in this phenomenon. Lucrecia Martel and Debra Granik are just two of many examples of women filmmakers who have been called out for supposedly taking so long between projects, especially when written up with a list of male filmmakers more prolific within the same time frame.

Me and You and Everyone We Know struck a chord with audiences for what Roger Ebert summarized as "fragile magic."[12] The central narrative is about an aspiring artist (July) who pursues a romance with a shoe salesman (John Hawkes) and placement of her work at a contemporary art museum. She's orbited by similar seeking and longing, mostly among kids. The magic is in how she (or me and you and everyone we know) tries to enact her inner life. Ultimately, it's a risky business but necessary for an honest connection.

At the time, critics reacted to the improbability of the scenarios her characters find themselves in in *Me and You*. She told indieWire in 2005, "There are a handful of things in the film that are not believable, but . . . for what I lose in believability it is worth it for the feelings, which is what I care most about."[13] The idea that emotions reign supreme is one she often articulates when reflecting on her work.

On the tail of *Me and You's* success, many filmmakers would have inked deals to make star-studded sophomore features. July chose a different path. She signed with

a literary agent and published her first short story collection, *No One Belongs Here More Than You* (2007). (Because meanwhile, she'd been writing and publishing short fiction since 2002.) The author Lorrie Moore wrote of being on a panel with July in which she sang her portion: "I watched her redefine boundaries and hijack something destined to be inert and turn it into something uncomfortably alive, whether you wanted her to or not."[14] Around that same time, July had been performing an interactive stage show, *Things We Don't Understand and Are Definitely Not Going To Talk About*, and that story became the basis for her second feature, *The Future* (2011), which, like her first, she wrote, directed, and starred in.

The *Future* was not exactly a predictable follow-up to *Me and You*. It is a far soberer, almost grief-stricken story about a couple's break-up, set to a backdrop of doomsday climate change. The couple's inability to act on their plan to adopt a cat leads to a bitter end. And yet, somehow, there's a glimmer of buoyancy. The cat talks and the moon talks, illuminating a kind of bent faith that the world is working just as it should. When she was writing the script for *The Future* she wrote in *The New Yorker* that it seemed harder than the first, "with all the pressure, real and imagined . . . it's easy to feel that I have become less free with each successive work." But then she re-watched her first film, *Atlanta* and realized that it was "all about pressure . . . [the Olympic swimmer] has done nothing her whole life but train for this moment. What she doesn't realize is that this moment will come again, and again, and again."[15] Of course, here July aligns herself with her characters only so much that with each new one she concocts, she reveals a yet unspoken aspect of her own grappling.

July followed up *The Future* with her first novel, *The First Bad Man* (2015). Even though she told AV Club, "I can't imagine being invested in someone else's script" enough to direct it,[16] she did accept an acting role playing mom to a teenage daughter in Josephine Decker's 2018 drama, *Madeline's Madeline*. She also entered production on her third feature, untitled at press time but one she calls a "heist film," with a plan to release in 2019. "Miranda July is Back" trumpeted one headline.[17] Despite what both amateur and professional critics think and write, July has been unfathomably prolific and potent on several fronts. She shows no signs of letting up.

This chapter includes the piece that July wrote for *The Independent Film & Video Monthly* issue she guest-edited in July 2002 and an interview with July from 2018.

Let's Walk Together: Miranda July's Hand in Yours

Miranda July/July–August 2002

The Independent Film & Video Monthly

When I was about nine my dad said he wanted to show me some cartoons. I was excited to see them but suspicious. Were they "cartoons" in the same way that lima beans were "like ice cream"? Would they be funny? Would Mickey be in them? This was my first exposure to Kenneth Anger's *Lucifer Rising*, I was deeply,

profoundly bored. I was not receptive to the experimental nature of Anger's work. Next, he showed me a Stan Brakhage film densely layered with moth wings. Equally completely boring. Not impressed. This is the snobbery that the children of cultural pioneers can afford. It seemed obvious to me—moth wings, of course. My dad kept these experimental movies in a cardboard box with the other 8mm films, his home movies of me and brother. But it is the things we take for granted that affect us most. A roof over my head, of course, loving parents, of course, moth wings, of course. And these things taken for granted, which vary radically (between families, between countries, between eras in time) form the kind of impenetrable haze that is THE WAY THINGS ARE. Memory is very reluctant to open up and show us how it came to be this way. And more often than not, we don't ask this of memory because we are at its mercy—it has created us. It is, unfortunately, an elite position to stare back at memory. We are its creators, we built it and it is an ongoing project. Very very occasionally they will send us home from school with an awkward note telling us the bare minimum. It turns out slavery was not such a good idea but we fixed that. And we, the mothers and fathers of our past, pale with a moment of horror. There were things I didn't know? Asbestos?

But ladies and gentleman, I preach to the choir. THE WAY THINGS ARE is your cloth, you sew and gather and pleat with old memories strung thru the eye of your needle. So, I won't spend too much time describing your couture, your experimental movies and your mainstream movies and your indie-digi-whatever movies. Let's try instead to punch at the fabric. We will think about what is remembered and what is real and what is created in order to become remembered, that is, real.

First let's hear from Mike Kelly, an archivist at NYU's Fales Research Library and Special Collections. Part of this library's mandate is to archive the writing and artistic culture of the post 1975 "downtown" (NY) scene. Some of you were probably part of that scene. It's Mike's job to remember it; he is in a position to know how easily we forget. If he or his co-workers decide that something isn't important enough to save, it may be gone forever. The 10 people who were there that night will die. "What do you see when you imagine the 1970s?" asks the film scholar of his 10-year-old daughter. "I don't see anything." she replies [from Kerry Tribe's *Hera & Elsewhere*]. One wants to be able to take these things for granted so that we can move on. Honestly, we do not want another generation of boys scratching. And yet, I did not know about W.I.F.E. until last month. Seven years ago, I started a video distribution network for women called Joanie 4 Jackie; it sounds eerily similar to Cecile Starr's network. Hundreds of women participate in Joanie 4 Jackie today, and none of us, not one of us, has ever heard of W.I.F.E.

There are all different kinds of archives. Andy Warhol threw his daily detritus into boxes which now sit in the Andy Warhol Museum. Long before The Osbournes, he understood that we are suckers for this shit. For Real Pixar alone will keep the reality TV market alive, skin that sweats may soon gain retro chic. But do not forget this is just the aesthetic of real. *Real* real is watching four-hour diplomacy conferences on CSPAN2 instead of the news or FOX. It's very boring for most people. But luckily, for people like Mike Kelly and Rick Prelinger (an archivist of ephemeral media) it's

consuming. Before you read the interview between Rick and Robin (a landscape ecologist who also makes quasi-factual graphic stories inspired by his research), take a moment to think about that big huge photo at the bank (or city hall, or wherever you saw it). The one that shows the exact place you are standing only 100 years ago. Remember how you tripped out and tried to find the place where Walgreens was and quickly you were confused, because the land itself seemed different, bigger. And when you stepped outside into the daylight you had a dizzy moment of feeling it: that big land is under here. I am standing on it. This is the place Rick and Robin are coming from, that dizzy moment.

Let us talk now about Anne Frank because I think we have really missed the point with her. It's totally fine to make a movie and re-make it and make a play and an Anne Frank Festival, etc., but when are we gonna start handing out the fucking blank diaries to girls? If we love her bravery so much how come girl power had to be re-invented and sold to girls as makeup? Why aren't I one of many people collecting amateur videos made by young women (the Joanie 4 Jackie project)? My feeling is that maybe people are afraid of being BORED. Anne's diary was a page-turner, but how likely is it that a video made by a girl in some suburb is going to be as good? Look folks, there are whole channels devoted to *ads about stain removers*. You've already been to boring and back, you'll be able to handle it. Boring is deceptive, remember how bored I was by the moth wings. The things we take for granted affect us most. I want my (un-conceived) daughter to take Joanie 4 Jackie for granted, to roll her eyes at me before building some bizarre thing out of light. And "boring" changes, as what we take for granted changes. "A glass of water" will no longer describe something dull when wars are fought over water. Mike Kelly tells an anecdote from the Fales Library.

> We started collecting cookbooks to support the Food Studies program here. Most of the librarians reacted positively, but some were disgusted and puzzled that we were wasting our time on such crap. One such curmudgeon made a remark about 'what's next? are you going to start collecting Chinese takeout menus? I have a big stack I'd be happy to donate.' My answer is yes, and in fact someone has offered us a collection of Chinese menus going all the way back to the late 1800s. One Chinese menu from 1950 doesn't have a ton of research value, but a pile of menus from a 100-year period certainly does.

So you have to risk being bored, you have to distrust it and recognize that fear of boredom is often just fear of the unknown. You have to ask questions of people that have never been asked before. We move on now to UK-based artist Emma Hedditch. She started a European sister project to Joanie 4 Jackie. But like me, she found that many of the women she was most curious about were not making movies. She had to facilitate the production of these movies in order to archive them. So now we are talking about "amateurs" making archives, which is kind of a gray zone, especially if the amateur archivist is a professional artist. Let us not get hung

up on this, let's just say there can be many different kinds of archives depending on who is making the decisions. And it is vitally important that new kinds of people put themselves in charge of what is collected, displayed and remembered. After I had been collecting girl-made movies for a while, I started to collect collections of movies complied by girls. The Co Star tapes. This series aimed to explain the role of a curator in a way that kicked the academia out of it: If you know what you like, you have what it takes. That is, I asked them to think of themselves as curators, so that I might expand the collection and its usefulness to girls. Emma's collaborations with her audience could be seen as documentary or educational outreach except that she retains a kind of creative authorship that would be inappropriate for either of these fields, or for an archivist. But that's the trick, to find a personal reason for being interested in living. Like Robin identifying with the character of the photographer as he studied the photographs, we do better work when we are implicated. We are more dedicated. So don't feel like a pervert for getting off on something, it is all about getting off. It took me a long time to understand that what I loved most about the movies I collected through Joanie 4 Jackie was not always the content of the films themselves, but the personalities of the girls who sent them to me. Their letters and the way they thought of themselves was fodder for characters I later created in my own movies and performances This was how I used my "archive." There is not one way.

Robin and Mike would never be called exploitative. Mike doesn't consider the W.I.F.E. archive his art project and Grossinger is obsessed by images of *land* taken by *men*. (We don't yet recognize the slow almost pornographic violence of cartography.) Their titles and/or topics protect their interests. But let's remember that it won't always be so clear, the seemingly dry world of archives is actually pretty wet. *The Diary of Anne Frank* is after all a girl's diary, a very private thing. I want to suggest though, that the person who asks a brand new question has a unique relationship to the answer. Artist Harrell Fletcher asks John McKenzie, who is developmentally disabled, "Why are you interested in future generations?" McKenzie replies. "I don't like the Beatles because they were born in the '40s and they were stronger then. The people born in the '40s make me feel sad." While Harrell did not write this astute response, you would not be reading it if he had not asked the question and published it in a series of monographs devoted to disabled artists. Harrell considers this and other archive-like collections to be *his art*. He is renouncing creativity in a kind of blatant disregard for the tensions around authorship. I think we are lucky that he signs his name. No such luck with most of the people who have defined archives, and therefore history, memory, and THE WAY THINGS ARE.

This messy territory between creators and fact-organizers is actually a good place to stand if you are interested in Truth, which can't be extracted joylessly or without art. Just as Emma invites the audience to shoot her movie Harrell invites people to help him make his art. What they both have in common with the archivists is a desire to see images made by people who (unlike themselves) are not self-consciously creative. As Rick said to Robin: "One reason I'm interested in ephemeral material and trivial evidence from way back when is because you get a more complete picture

of how things were." And like Robin retracing the path of the aerial photographer, Kerry Tribe re-enacts documentary, distilling the truth with fiction. What did it feel like to be real, to be there when it happened? Was it more or less meaningful than the moments we can create with our retroactive understanding? The aerial photographer was just up there in the clouds flying around—there is nothing inherently accurate about that. Or about Godard and Miéville's documentary project, (which Kerry transforms in *Here & Elsewhere*). The accuracy comes when you cast your own shadow across the image. When you stare too intently at the photograph, or in the dark hall of the Natural History Museum, when you catch your own reflection in the glass around the wall exhibit. Come *alive*.

On a recent trip home my father brought out the box of experimental and home movies. When I was putting the box back in the attic I discovered a new collection I had never seen before. It was every note that everyone in my family has ever left for each other. These are the notes that are left on the kitchen table as children and husbands and wives move back and forth between the job/school and the house often missing each other only by minutes. Like the Chinese menus, one such note might not have a ton of research value but hundreds of them over a course of a lifetime certainly does. I read my mom's first sweet notes to my dad saying sorry for blowing up, with hearts doodles. And then 70 similar notes over the course of the next 20 years. I noticed that I began my own series of apologetic notes around age 11. My brother's messages were filled with ridiculous jokes until exactly age 14 when suddenly he could only afford "Back at 3" or just "Out." My dad didn't leave any notes, he just saved ours. I read long into the night, making myself almost sick with the dizzy feeling of Time. I knew where I was, I could feel the shape of the ground under the house, the slow fall into battle with good intentions, the steady insistence of love.

A Conversation With Miranda July

Erin Trahan/2018

Erin Trahan: Do you have an early film memory, one that made you think, "I could do that!"?

Miranda July: The films of Jane Campion I saw in high school. They were short and relatable to me as a young woman and kind of arty. Those were the first things where I thought, "those seem manageable to me."

Trahan: Do you have an early memory that made you think you couldn't make films?

July: It's funny, I want to say everything else in the world! It's good context, the Jane Campion thing. It was like a door opening up in a wall that seemed solid. All these things that should've made it seem accessible, like reading interviews with Steven Soderbergh and Spike Lee [how they'd say], "I charged this to a credit card," had nothing to do with the intimate level that I would have to start at. They presumed a level of entitlement that even I, a Berkeley girl and daughter

of writers, didn't have. I obviously had it enough to find my way, but I translated it to making plays, which was what I could do at that time, especially technologically, since there was no video camera. That evolved into filmmaking for me.

Trahan: Can you talk about your filmmaking in those earliest years?

July: This sometimes gets lost because I did so many other things. I had two film internships in high school. One was with Les Blank and Maureen, his wife. I filed trims. I essentially spliced them back in so they could be found again. Obviously the point is to have a context for what a filmmaker's life might look like. I just got reminded of this, in a documentary about Ram Dass. (That's such a Berkeley reference, my new age-y parents knew of these people. I didn't grow up in LA so they did their best with connections they knew of.)

I went to UC Santa Cruz with the intention of studying film even though they didn't have a proper film department. I remember editing my first short film on 8mm or Super 8 and thinking, "This is the feeling. This should be boring, this doesn't look flashy," and it felt very adult to me, like, "Oh maybe this is how people figure it out." Because it's hard, they want to keep at it. I worked hard on other things. . . . For a number of years, I was taking acting classes and I sensed that wasn't the right path. I felt like more of a storyteller than that.

Trahan: Then you left UC Santa Cruz before finishing your degree?

July: For some other person, you could find your people in a collegiate setting. I hadn't had great experiences being taught, was annoyed by my film classes, which were mostly boys. A lot of first projects had guns in them. If Jane Campion is your reference that was setting me up for Joanie 4 Jackie. I dropped out in the middle, after two years, but before declaring a major or anything. I had this revelation, "I'm free! I can do what I want!" I told my parents after the fact.

Trahan: And you moved to Portland, Oregon.

July: I figured, I'm just continuing my education up here. I took animation class at [Northwest] Film Center which was interesting, kind of artier stop motion animation. Then I actually dropped out of that to go on tour with my band.

Trahan: What do you think you needed to really dedicate yourself to filmmaking?

July: The early 20s are so much about: Who am I? Am I like these people? I'd fallen in with this crowd that was so cool and punk and I was learning a ton and inspired but I did have this sense, being in my first relationship, and writing in my journal, that secretly, this is not really me and something has gotten lost. I was sharing a room with my

girlfriend in a house with five other women with very little personal space. And I had a sense of "I have to get back to who I really am," which is a funny thing at 21.

The filmmaking thing was kind of like throwing the anchor way out in front and dragging yourself towards a future. It was very wishful, in the same way we may make political manifestos but talk about them in stark present terms.

Trahan: And you launched Joanie 4 Jackie, a kind of chain letter full of amateur videos by women. They'd send a video to you and you'd send them back a tape of theirs and nine others. What was your hope for it?

July: I hadn't been [in Portland] that long when I made my first Joanie 4 Jackie. I thought maybe I could have a cool scene just the way my girlfriend had music. It was very much like building a context for myself and then it seemed possible and easy—relatively easy.

[Joanie 4 Jackie] was political. It was based on the idea that women were good filmmakers and were good people to be filmmakers because of a degree of self-consciousness, how you're kind of always making a movie in your head. A lot of stuff I wrote then, theorizing about feminist filmmaking, was throwing out the idea of talent— that talent only mattered if you were measuring it against a male conception of what a movie should be. Even in experimental films there was no yardstick that you could measure these films by. Maybe she made it to save her life. Maybe if she hadn't, she would've killed herself on some level, literally or not. Why judge "good"? "Good" may be the exact thing she's fighting against. Like a traditional narrative. It was really important to include every movie submitted. That wouldn't work the same way now.

Trahan: Yes, now we have algorithms or celebrities pointing us to our content. But the priorities of curators and archivists is something you've always questioned, and you raised that in your essay in *The Independent Film & Video Monthly.*

July: The goal for so long after Joanie 4 Jackie faded out was to have it exist as an archive. [Inclusion in an archive] could decide this group of women is most famous and this group is not going to be famous. We were collecting tapes not just to share them with each other in the present tense but for the future. It's a great example of something that would be erased and therefore it just wouldn't exist.

Trahan: Did Joanie 4 Jackie influence your sense of yourself as a filmmaker?

July: It's an interesting thing when you're not ambitious on your own behalf. I was shameless! I would go to places again and again and again. . . . I had a very large sense of the mission and didn't feel self-conscious in ways that might stop one young woman. But I always

felt like I wasn't really doing enough, that I was barely holding it together, and wasn't achieving even modest goals. The way Joanie 4 Jackie served me was also how it served other people. It was a conceptual framework: This thing exists. Many, many women who have made films, they're part of this and whatever you wanted to attach to that or whatever you needed, [it was shown in a] fair number of [J4J] surveys that participating was what was meaningful. The modest thing of appearing on tape with nine other women at that time . . . just its existing was so much of its power when there was so little else. That you need that. That's the thing men have that we don't. For them, Hollywood could actually serve as that thing, they relate to the stories they've told.

Trahan: In 2017, you made sure that the work and ephemera would be preserved.

July: I talked with a lot of different archives. . . . I went into this meeting with Glen Phillips, who heads up Getty Research Institute, ready to sell him on me, "I'm an artist you've heard of, here's a project of mine." He surprised me by also having the same interest in preserving countercultural archives. I feel like while I didn't change the world in all the ways I often said I was going to in all my Joanie 4 Jackie pamphlets, I did make good on [the archive]. Having Joanie 4 Jackie finally have an institutional home is appropriate and inspiring. And it also does make it accessible. To know that is a real peace of mind.

Trahan: At that time, in the mid-1990s, did the short format film feel like the best fit for the stories you wanted to tell?

July: At first it was amazing to me that I made anything. After my first short movie, *Atlanta* (the next one was *The Amateurist* and I had seen more experimental stuff), I think I was a little unclear, should I make videos for galleries? My sense of showmanship kept me from it; I also thought that world was elitist, and I didn't understand it from a punk point of view. I was always trying to get women filmmakers who were successful in the art world to let me show and distribute their work and I was always in a tug of war, trying to respect them, and also to sell them on the benefits of more women knowing their work. Honestly, *Nest of Tens* was more ambitious. That was the tipping point. It was almost a half-hour long, had different locations, a cast of kids and adults. It really stretched me. I thought, "Wow, I just have to make two more of these in length to be a feature." That was the first thought of that. Then I started writing *Me and You and Everyone We Know*, with the same idea as that short film, with interconnected stories. I consciously did something I already knew.

Trahan: How did Sundance factor in to helping you get your first feature film made?

July: I applied three times [to the Sundance Lab] and didn't get in twice. At that point, I was like, I don't care, I'm ready to shoot this. I arrived at that Lab with a chip on my shoulder. It didn't occur to me, in a conscious way, that it was a little bit like getting a grant . . . the fact that I could get feedback, talk to other filmmakers, meet people who'd made feature films. It was kind of crazy since it was mostly men who were not that enlightened, but they'd clearly figured out what their use could be and they were so focused on helping. I made the film almost immediately out of there (they can push a movie forward into this IFP speed dating thing with financiers). I met my producer Gina Kwon there, she was someone who worked with one of my advisors, Miguel Arteta. I was good test case. I was already a self-starter and they really tipped the scales; what they had to give was a rocket.

Trahan: In fact, it went on to premiere at Sundance in 2005 and win a Special Jury Prize, and later the Camera d'Or at Cannes. What stands out for you, nearly 15 years later, as far as lessons learned from making it?

July: Really the biggest shock of the whole thing was the kind of schedule you work on when you do a movie in the normal way, where every second is money. I realize Sundance had tried to prepare us for that. It's like preparing someone for war essentially, or something more intense than most people do as work. Food, energy, sleep, the creative part . . .

I didn't prepare at all as an actress, it didn't occur to me. I thought, "I have all these other things to worry about." I did fight really hard, actually, against all the people who were trying to help me. My advisors, the Sundance people, they wanted me to get real, known actors. It was still a moment in indie film when that wasn't unthinkable, and maybe Maggie Gyllenhaal could play my part. But I had a very clear idea. This sounds so mercenary, understand I'd been doing Joanie 4 Jackie for 10 years, so I knew where I came from and it was unique. I could only do that once and I shouldn't try to look like this person or that person. It turned out to really be true. Almost too true. Stars are helpful, they give you credit even though you're doing the same hard work. It was also suggested many times in interviews, "What'd you do? Round up kids in the neighborhood and improvise?" People didn't understand that I'd written a script and stuck to it word for word.

Trahan: Clearly words are important to you. The literary world can be as impenetrable as the film world. How did you launch that part of your career?

July: At Sundance, it's all of these people's jobs to sort of discover the next indie film talent. All kinds of sort of amazing things were offered. First look deals with, I won't name names. . . . I turned

down everything that was offered. One hundred thousand for a first look at a next script? I had nothing. I had no dollars, and I was so hardcore I thought that was like buying on credit in a way that was imprisoning. But, I had these short stories I'd written, and thought, "Ok, now I can get an agent." She's still my agent, one of the best literary agents you can get.

To me the real dream, one of the big wins for me of making that first film, was that I got to sell my collection of short stories. I worked hard to widen that space that was given to me or that I'd created. (There's also this—there's writing, performance, I'm going to make art too. That would be really incredible if I could do that.) Getting to do a studio movie is another filmmaker's dream.

Trahan: In the DVD extras for your next feature film, *The Future*, you mention the difficulty of financing it. Can you talk about that and financing film projects in general?

July: I just have to be clear not to sound defensive. I'm not doing the other work because I can't be a filmmaker full time. I don't know many people who make a living [that way], even my husband [Mike Mills (*The Beginners, 20th Century Women*)]. Most people are also making ads, or they have some deal, they're producers on TV shows. The financing, it's kind of case by case. For that movie I went out right as the [2008] recession had started. People were dropping movies left and right. People were excited to meet with me based on my last movie, but once they saw the script, they saw this was not really a comedy, and it was going against the broadness of the first movie. I just had sadder themes to explore at that time in my life. (I will always think of filmmaking as really personal, not in an autobiographical sense, intuitive might be a better word.) There were no people in America who would finance the movie. So [to obtain German financing] we hired all German keys, editor, makeup artist, DP—it was bizarre, how many Germans we were housing. Germany continues to be a really good market for me with my books.

Trahan: Did the difficulty with financing *The Future* send you in a trajectory away from film?

July: Not at all. The pressure to write a novel was a hundred times more than to make a film. That book of short stories [*No One Belongs Here More Than You*] has made so much money. Financial success is real! I'm not just living on air here. Given it is deeply rewarding, and it's been really lucky for me, with great advances while I'm writing a book, that time is largely paid for. And because of that literary world participation, I do speaking engagements that don't exist in the film world.

I'm just alternating, that's all I'm doing. Writing a book, making a movie, they're informing each other. The hardest parts about coming

off *The Future* were things that seemed to be tied to me, Miranda. In a story sense, people thought it was less fictional than it was. And yet creatively, the more realistic seeming the world was, the less free I felt. I realized by the end that I feel most agile when I'm really in fiction and if I can get my own feelings into that intuitively or subconsciously, that's the best. I really felt so relieved that I was writing a novel, and no one had to look like me, and I didn't have to play any of these parts. I freed myself with that in the novel. There's no one like me.

Notes

1. Miranda July, "Let's Walk Together," *The Independent Film & Video Monthly* (July–August 2002).
2. Miranda July. Interviewed by Erin Trahan on January 5, 2018.
3. Ibid.
4. Miranda July. Interviewed by Erin Trahan on January 5, 2018.
5. "The Amateurist," *Trio A* | *Video Data Bank*, www.vdb.org/titles/amateurist, accessed on June 18, 2018.
6. Ibid.
7. Todd McCarthy's 2011 review calls The Future both "overly precious" and "twee" (www.hollywoodreporter.com/review/future-sundance-review-74658); Mick LaSalle's 2011 review in SFGate also calls attention to the film's "preciousness" (www.sfgate.com/movies/article/The-Future-review-Cat-complicates-life-2334637.php); Lou Lemenick's review of Me and You in the *New York Post* on June 17, 2005 calls the film "too precious" (https://nypost.com/2005/06/17/me-and-you-a-cutesy-crowd-pleaser/). "Movie Review: The Future," *Movie Nation* (January 10, 2003), https://rogersmovienation.com/2013/01/10/movie-review-the-future/. The review calls the film both "precious" and "twee"; and Roger Moore's review in *Orlando Sentinel* on July 29, 2005 states, "Here's a perfectly twee little romance all but smothered in a blanket of indie 'edge.'"
8. Katrina Onstad, "Miranda July Is Totally Not Kidding," *The New York Times* (July 14, 2011), www.nytimes.com/2011/07/17/magazine/the-make-believer.html.
9. https://bombmagazine.org/articles/miranda-july/
10. The website to access archived Joanie 4 Jackie is www.joanie4jackie.com/
11. Miranda July. Interviewed by Julia Bryan-Wilson, *Art Forum* (February 2017), www.artforum.com/print/201702/joanie-4-jackie-66054, accessed on June 19, 2018.
12. Roger Ebert, Review of *Me and You and Everyone We Know* (June 23, 2005), www.rogerebert.com/reviews/me-and-you-and-everyone-we-know-2005
13. Miranda July. Interviewed by Peter Knegt on December 17, 2009 (originally published in 2005), *indieWIRE*, www.indiewire.com/2009/12/decade-miranda-july-on-me-and-you-and-everyone-we-know-55585/
14. Lorrie Moore, "Our Date with Miranda," *The New York Review of Books* (March 5, 2015), www.nybooks.com/articles/2015/03/05/our-date-miranda-july/, accessed on June 19, 2018.
15. Miranda July, "Atlanta," *The New Yorker* (June 11, 2007), www.newyorker.com/magazine/2007/06/11/atlanta-2
16. Miranda July. Interviewed by Noel Murray, *AV/Film* (July 28, 2011), https://film.avclub.com/miranda-july-1798226725, accessed on June 19, 2018.
17. Kate Erbland, "Miranda July Is Back: Five Years After 'The Future,' She's Supporting A New Film," *indieWIRE* (June 10, 2016), www.indiewire.com/2016/06/miranda-july-new-film-interview-1201687466/, accessed on June 19, 2018.

12

BARBARA KOPPLE (1946–)

Lisa Dombrowski

With more than 30 films, two Academy Awards, and a picture listed on the National Film Registry, Barbara Kopple is one of the most accomplished documentary filmmakers in the history of American cinema. Emerging out of the American cinéma vérité movement, or Direct Cinema, under the tutelage of Albert Maysles and D. A. Pennebaker, Kopple embraced an approach to documentary filmmaking that prioritized intimacy, observation, and advocacy. As her career developed, she directed documentary shorts and features, both independently financed and commissioned, as well as fiction films, television episodes, and commercials. Her work is a roadmap of many of the political and social issues that have defined American life over the last 50 years, including labor battles, civil rights, gender issues, free speech, gun laws, mental health, homelessness, AIDS, and environmental crises. Throughout it all, she has aimed "to tell gripping stories about people in crisis, and show that sometimes people that you never hear of—unless somebody's there to tell their story—are the people who probably have the most important things to say."[1]

Kopple credits the example and support of her family for her decision to strike out into the world of socially committed filmmaking. Born in 1946 to Alfred Kopple, a textile businessman, and Marjorie Kopple, a homemaker, she grew up in Scarsdale, New York, an affluent suburb north of New York City. Her family instilled in her the story of her grandparents, who stood up for free speech when they publicly defended the right of the blacklisted activist and singer Paul Robeson to perform in the town of Peekskill. Her uncle, Murray Burnett, provided an artistic model, writing for radio and theater, including co-writing the play that inspired *Casablanca* (1942). After spending one year at West Virginia's Harvey College, Kopple enrolled at Northeastern University in Boston, where she became involved with the anti-Vietnam War protest movement. After making her first short movie for a class assignment, she found "everything clicked for me, and I just said, 'I want to work in film!'"[2] Kopple moved to New York City and enrolled in a cinéma vérité class at the

New School for Social Research, where she met a fellow student who introduced her to Direct Cinema filmmakers Albert and David Maysles.

In the early 1960s, the Maysles brothers were a part of the Drew Associates, the first major practitioners of Direct Cinema in America led by Robert Drew and including Richard Leacock, D. A. Pennebaker, and others. Drew's team utilized handheld cameras and wireless sync sound to create "behind-the-scenes" portraits of politicians and crisis situations that eschewed overt signs of formal manipulation in favor of an observational, "fly on the wall" approach. After the group splintered, its members advanced Direct Cinema techniques in their own projects, moving documentary form away from "voice of God" narration, talking head interviews, and emotion-laden scores and toward a more rough-hewn, real-time aesthetic that seemingly allowed subjects to shape their own presentation, suggesting spontaneity, authenticity, and an unmediated realism. "You never know what corner you're going to go around or who people really are or what's going to happen," Kopple explained. "That's what's so exciting, is that you're filming things unfolding and getting to go along with it and watch how people change."[3]

The Maysles brothers hired Kopple as an intern, where she proved herself by doing "all the things that nobody else wanted to do."[4] She worked as an assistant on their portrait of door-to-door bible salesmen, *Salesmen* (1969), and the Rolling Stones tour documentary *Gimme Shelter* (1970), learning about sound, editing, and cinematography. She subsequently recorded sound for the award-winning, yet controversial, anti-war documentaries *Winter Soldier* (1972) and *Hearts and Minds* (1974); shot footage at the 1972 Republican Party convention; and recorded sound at the same year's Democratic Party convention for *Year of the Woman* (1973), a portrait of the feminist National Woman's Political Caucus. Meanwhile, Kopple had learned about attempts to reform the United Mine Workers of America (UMWA) following the murders of union activist Joseph Yablonski and his family. She began raising funds to make her first feature about the union reform movement and shot some initial footage; then an emerging labor conflict steered her toward the mining community of Harlan County, Kentucky.

Harlan County, USA (1976) catapulted Kopple to international recognition, receiving festival and theatrical play, an Academy Award for Best Documentary Feature, and earning inclusion on the National Film Registry—only the second documentary to do so. The film focuses on the workers at the Brookside Mine in Harlan County who go out on strike after the mine's owners, the Eastover Mining Company, refuse to ratify their decision to join the UMWA. Kopple and her team shot and edited over a four-year period and lived with the Brookside miners over the 13 months of the strike. Earning their trust was a challenge, but as Kopple later revealed, "We were there for so long that people didn't recognize us a lot of times without our gear on. . . . They'd lose consciousness of us as filmmakers."[5] Alongside the strikers and female community members, Kopple and her team faced company officers and scabs on the picket line who doled out beatings and gunfire. "We were machine gunned with semi-automatic carbines with tracer bullets on the picket line," Kopple said. "You can hear me screaming in the film, 'Don't shoot!' at the top of my lungs."[6] Integrating you-are-there footage of picket line confrontations and

tense union meetings with self-reflexive hints of the filmmaking team, interviews, archival footage, and a distinctly regional score rooted in the bluegrass-steeped voices of Hazel Dickens and David Morris, *Harlan County, USA* advances beyond the strict observation of Direct Cinema to suggest the politics of the filmmakers and engage the audience in the emotions of the miners' struggle. Peter Biskind raved in *Jump Cut,*

> The film's power comes from Kopple's intimate involvement with the people she filmed, the risks she took, the places—jails, courtrooms, stockholder's meetings—into which she forced her camera. . . . The film's poetry is not one of image but of action, clarity, strength; its eloquence is of the people within it.[7]

Kopple's second theatrically released foray into labor issues, *American Dream* (1990), features similar formal strengths as *Harlan County, USA* but many more shades of gray. Begun well into the Reagan era when union membership was in decline and even profitable corporations were seeking wage and benefit concessions in exchange for keeping plants open, the film focuses on the 1985–1986 Hormel meatpackers strike in Austin, Minnesota and the difficult choices faced by workers threatened with the dissolution of their middle-class lifestyle. Kopple explained, "As one guy says, how do you reconcile your feelings as a breadwinner with your belief in union solidarity? Do I cross the picket line so I can feed my family or do I stay out for the things I believe in?"[8]

American Dream interweaves the differing perspectives of representatives of the national union, their local affiliate, and a dissident faction within the local, favoring neither those who upheld the ultimately unsuccessful strike nor those who crossed the picket line. The film earned Kopple her second Academy Award for Documentary Feature, a first for a female filmmaker. The *Variety* review predicted, "As a record of the decline of unions during the Reagan era, *American Dream* may one day be studied in history classes."[9]

From the bluegrass labor anthems of *Harlan County, USA* to the dazzling soul of *Miss Sharon Jones!* (2015), music and portraits of musicians have also played a pivotal role in Kopple's career. Kopple created a revealing exposé of Woody Allen's musical life and private life in *Wild Man Blues* (1997), shot during his 1996 European tour with his Dixieland jazz band. Kopple revealed, "He totally let his defenses down, and really allowed me into his world of being reclusive and wanting to play his instrument and go home, and not have to interact with people, and not have to go to strange places."[10]

In *Shut Up & Sing* (2006), Kopple and co-director Cecilia Peck depict the backlash against the country music trio the Dixie Chicks, then the American bestselling female band of all time, after lead singer Natalie Maines spoke out onstage in 2003 against President George W. Bush and the impending Iraq War. In its review, *Variety* highlighted how the filmmakers portray the band's response to the fracas and their reinvention: "'Shut Up' identifies the Dixie Chicks as

sincere and honest, a self-contained matriarchal community that doesn't back down and, per the doc's POV, deserves support for their integrity alone."[11] *Miss Sharon Jones!* chronicles the vibrant life of the titular soul singer, who came up singing in church and in wedding bands while holding down day jobs, toured the blues circuit for decades, and finally burst into stardom in her late 40s. The film depicts the triumph of Jones's return to the stage after a devastating cancer diagnosis. The triumph was short-lived; Jones succumbed to her illness five months after the film's theatrical release. Kopple explained, "Her life was about resilience and celebration. Every time she was on stage, it was a celebration. She didn't want to give that up." Though Kopple herself did not attend the Woodstock music festival in 1969, she later directed a trio of films about the festival and its anniversary celebrations: *Woodstock '94* (1998), *My Generation* (2000), and *Woodstock: Now & Then* (2009).

A common thread across five decades—and counting—of Kopple's documentary filmmaking is access. Whether revealing the lives of celebrities, as in *Fallen Champ: The Untold Story of Mike Tyson* (1993), *A Conversation with Gregory Peck* (1999), and *Running from Crazy* (2013) with Mariel Hemingway, or the lives of ordinary people coping with challenging circumstances, such as the children in *Friends for Life: Living with AIDS* (1998) or the homeless veterans of *Shelter* (2015), Barbara Kopple has always worked to develop access.

She summarized her strategy: "Being a woman helps, because you can be a lot more intimate. People aren't as intimidated by you and you can ask things that maybe a male would have a tougher time doing. Plus, I'm persistent. I can be a real pain in the neck."[12] Kopple further emphasized, "If you don't have that access, you're not going to make a film that is going to be true to who the people are and really get deep inside. That's the secret of documentary filmmaking, the access. Without that you don't have anything."[13]

This chapter includes an April 1998 interview with Kopple originally published in *The Independent Film & Video Monthly* and an original interview with Kopple in 2018.

Barbara Kopple's Lessons in Longevity

Patricia Thomson/April 1998

The Independent Film & Video Monthly

Note: This is a condensed and edited version of the original published interview.

Thomson: Let's discuss your longevity as an independent documentarian. Al Maysles makes commercials; [Frederick] Wiseman has some kind of long-term contract with PBS. How do you survive?

Kopple: I do everything. I do the films that I love and films for other people. This year I've done three commercials. But they're fun and they're easy. And I

do specials for network television. I do it all. If somebody asks me to do something, generally, if I can, I say yes.

Thomson: Do you have staff whose job it is to beat the bushes and raise money for your personal projects and/or look for commissions? Or do these walk in the door?

Kopple: A lot of times they walk in the door. I guess all the time. We've never gone and hunted projects.

Thomson: At what point did that start happening?

Kopple: Well, all along my career. Because not only do I produce and direct, but I also do sound and editing.

Thomson: For commercial projects as well as for other filmmakers?

Kopple: Both. I just worked in this craft in every single field I possibly could. It was good for me, because nobody could tell me that something couldn't be done. For example, I did a commercial just now for the AFL-CIO in San Antonio on a bilingual teacher and her class. She came from impoverished means and struggled and worked to become a teacher. It was a plea to her kids that they can make it, too, and how the union has helped her. For the sound, the way I work is I would put a wireless mic on her and then boom the kids. And [the sound man] was telling me, "You can't do that." I said, "Listen, I know that you know what you're doing. But I've done sound for 15 years. This is how I would do it. This is how I would like you to do it, please."

Thomson: Does "please" help?

Kopple: Oh, I always say please. But it just helps to know what can be done, so that somebody can't tell you that something can't be done.

Thomson: So how many projects are you juggling right now, for instance?

Kopple: I'm working on *Woodstock*. It's really come together as a film; we need money to finish it, desperately. I'm finishing a piece for Lifetime about women and human rights. I'm going to do my second *Homicide*. And I'm going to be directing a feature film in the spring, so we're working on the script. And I'm hoping to develop some other projects in the interim.

Thomson: Are you nervous at all about making the switch to fiction?

Kopple: Oh, no! Are you kidding? Doing *Homicide* was the most fun I've ever had. Working with actors is so great. Documentaries are so hard. They're like cerebral puzzles. They take forever, and you have to just trust fate and trust life that things are going to happen. Fiction is easy, because you can allow your fantasies to come into play.

Thomson: You've said that you're not a documentary purist, and your work does demonstrate a range of approaches. Have you ever been tempted by the personal diary form?

Kopple: No. It's never tempted me.

Thomson: What do you think of it?

Kopple: Personal diaries are really good because you can really get in deep and see and feel things. Somebody's giving something to an audience with all the passion they can, really giving over of themselves. I think it's wonderful.

I have people call me all the time about wanting to do documentaries. In fact, some young woman is coming today to talk about whether she should get into documentary. After I talk with them for a little bit, if you feel a spark, feel that passion, it's so great to encourage them, because you never know what's going to happen.

Thomson: Do you do a lot of this mentoring? You have the time?

Kopple: I make the time. I also taught once a week—graduate students at NYU.

Thomson: Getting back to documentary style: How much of it is determined by the content, by the story you're trying to tell, and how much of it is determined by the nature of the commission, if that applies?

Kopple: *American Dream* took quite a few years to make—four years. I had to struggle within an inch of my life to do it, but it was a film where I could just go and stay and film whatever I felt was important and relate to the people in the way that I wanted to relate to them, and them to me. I was all on my own, and nobody cared what happened to [the film] or even thought that it would ever amount to anything. It was the kind of thing that you do when you're in the field and you get sort of lonely out there, and people are shocked when you finally bring back whatever this entity is. That's the hardest kind of film to make. And now, with the cuts in funding to the National Endowment for the Humanities [NEH], the National Endowment for the Arts, and the New York State Council on the Arts—it's very difficult to even think of doing a film like this.

Thomson: What did those public agencies give *American Dream*?

Kopple: I got a lot of my money from them. A lot of other places, too—churches, wherever we could muster it up. But my initial money came from the NEH. If I hadn't gotten it, I don't know how I would have even started it. It's terrifying to think that filmmakers like me and the generations that follow will not be able to do the kinds of films they really want to do—not without this kind of funding. What it allows you to do is to take risks and not do something that's just mediocre. To really go out there and give it everything that you have and spend time. *Mike Tyson*, doing that was a gift. It was a very solid, good budget: $2.1 million.

Thomson: *Fallen Champ* was a NBC Movie of the Week?

Kopple: It was actually Columbia Tri-Star television division, with NBC. It was their first nonfiction film that became a Movie of the Week.

Thomson: I remember how exciting it was when it happened with NBC. It seemed like a big door was opening.

Kopple: Actually, it would have been. The next film I wanted to do was a film on Bill Graham. I was given the research money, then there was a shake-up within NBC. The new people that came in wouldn't hear of it.

But that was pretty wonderful, doing that film. I could do whatever I wanted. Since it wasn't in a news department, it was a Movie of the Week category, nobody knew quite how to deal with me, so they just left me alone. They'd say, "Can we see dailies?" I'd say, "Of course, but that doesn't mean you're going to know how I'm going to put it together." They said, "Well, what should we do?" And I said, "Why don't you let me go out there and film, and when I get a rough cut together, you can see it." So they said "Fine."

Thomson: How did you decide that you'd be doing extensive interviews and using archival footage, as opposed to, say, taking a vérité approach?

Kopple: Well, Tyson was in jail by then. Right at the very beginning, during the research, I knew the one thing that stands in all the work I do is a sense of intimacy and a sense of showing somebody something they haven't seen before. Those are the two things that are absolutes in whatever I try to do.

We found some footage taken when Mike Tyson was 12 years old by a German cameraman named Michael Martin. He was filming something else for German TV [about] this young white kid whose dream it was to become a boxer, but he was also filming stories of all the people at [boxing coach] Cus D'Amato's at that particular time, one of them being Mike Tyson. I figured, "Oh my goodness, this was so long ago; how am I ever going to find this guy?" We hired an investigator. He found Michael Martin for us. I wrote Michael, we met, and I paid him for all his footage. I knew I had a gold mine in having something that was intimate; something that was as if you were following Mike Tyson on his journey of life and seeing a side of him you didn't know, which was the vulnerable side, the fragile side, the side that wanted to please, that worked hard.

Thomson: It's a fascinating portrait. Now, *Wild Man Blues* is such a different kind of film—a vérité-style road movie. Would you possibly have been interested in doing something on Woody Allen that was a similarly in-depth biographical portrait? Allen is just as complex and just as controversial a personality as Tyson.

Kopple: I think I did, in a different way. What was wonderful was we were on a road trip, and that meant nothing would be predetermined, except that he would play venues in different cities. But even that—different cities, different people, different problems, different situations, different everything.

So it's not as if someone says, oh, Woody Allen, you're going to do a film about his directing, about his writing, about his acting. This was something totally different, something that nobody knew about. That

was one of my criteria. It's playing jazz; being on the road with Soon-Yi Previn; being on the road with Letty Aaronson, his sister, and all the people who are closest to him, who I guess he loves most in the world. Out of his domain of New York City into strange places. I couldn't have asked for anything better. It was hard, grueling work: 16-, 18-hour days. We were half-dead all the time. It was wonderful.

Thomson: What was the genesis of the project, and what parameters for access were set up?

Kopple: A theater producer named Jim Stern called me from Chicago. He said, "How would you like to go on a tour with Woody Allen?" I went, "Yeah, right." He said, "No, really. He's going away for 23 days, 18 different European cities, on a jazz tour." Letty, his sister, called me. I went over, and Woody and I talked about film, about a magician that we both knew, and things in general. At the end of the conversation, I said, "So, Woody, are you looking forward to doing this?" And he said, "I don't want to go." "What do you mean, you don't want to go?" He said, "I just thought it was going to be a few cities. This is just ridiculous. I don't want to be away for this long. I just don't want to go. They booked a year or two ago; I didn't think the time would come this quickly."

From that minute, I knew that it was going to be pretty special. I had no holds barred. Total access. I traveled everywhere and did whatever I wanted.

Thomson: Did they have to pull Woody Allen kicking and screaming into this project—into being filmed? He's reputedly a very private man.

Kopple: No. He was kicking and screaming about the tour, not about me. Maybe he did when I wasn't there, but not in front of me.

Thomson: Did he know your work?

Kopple: Yes. He had seen *Harlan County*. He had seen *Mike Tyson*; he's a big sports fan.

Thomson: Were you able to talk about filmmaking?

Kopple: A little bit.

Thomson: Did you give him any advice on using the handheld camera?

Kopple: No, no. It's funny. Woody doesn't do that with people. You don't get into giving each other advice. If you ask him something, he will answer it. You and I can go off in a million different directions. But with him, it's a little bit more formal. He has so many things inside that are happening. He's more fragile on the outside, as to how to communicate with people, in a certain way. He's like a man of steel, or seven feet tall on the inside, where his thoughts, his writing, and his ideas are all imploding.

Thomson: In watching *Wild Man Blues*, I always felt that even in the scenes with his lover and sister and producer—the people closest to him—he still seemed constrained and on guard.

Kopple: I didn't think that. I thought he just laid it out. Like the scene in the Bologna hotel, when all those people are standing around outside and he goes to the curtain, looks out. Lenny and Soon-Yi are saying, "You have to go say hello to them." And he says, "What if they're not there to see me; they're there to see Mick Jagger or somebody else?" And later on, they're sitting down on the couch, and you realize Soon-Yi hasn't read anything that he's written and hasn't even seen *Annie Hall*. And how boring she thought *Interiors* was. And he says, "I'm good at making European-like films that drone on and on." Then a little time goes by and you see him sitting there, and she says, "What's the matter?" And he says, "I'm feeling depressed."

I could name any number of scenes where he was real. That's really who he is and what he's about. There was no formality with him. The only time he was performing was when he was on stage. So I felt totally different. I felt that as a filmmaker, I was able to really see behind the scenes of Woody Allen: get into hotel rooms, get backstage, get him swimming, get him on treadmills, get him in social situations—all of that stuff you never see.

Thomson: You didn't go into his bathroom. There are so many great bathroom scenes in Allen's films, I was curious what his own would be like.

Kopple: Actually I did, but it didn't make the film. We had a hard time editing it down.

Thomson: How many hours of footage did you have?

Kopple: If you count all the concerts, 50.

Thomson: Did he have right of review? Did you show him the film in progress?

Kopple: I showed him the work around three hours, which I felt was too long, but he was very anxious to see it. He and Soon-Yi came over. They're sitting in the editing room right over here, and they're like two kids in a toy store. Soon-Yi was holding Woody's arm, and they were giggling. Woody had his finger over his mouth, chuckling. It wasn't as if they were looking at themselves; it was as if a character and a relationship was being defined, and that's how they were looking at it. When he got up to leave, he said, "So, how are you going to cut this down?" I said, "I don't know; it's going to be really hard, but I'll do it." He said, "It's very entertaining." He liked it. He had a few comments on the music. We listened to them, and they were good. We implemented them. And that was it; goodbye.

But this was also not his film. I remember having a discussion with him once, saying, "When you finish your films, do you go see them in a theater or with an audience?" He said, "I'll screen it with the cast and crew, but no, once I do it, I'm finished with it." I said, "I always do; that's the treat for me, the present at the end—to sit there with an audience

and be able to see where they laugh, or shrug in their seats. It just gives me a whole different look. I'm so happy to be able to do that. It's a full circle of completion for me." He said, "Well, your film I could do that with." I said, "Yeah, I know why. Because the burden is on me, right?" He said, "That's right."

Thomson: Did you do more interviews that didn't make it into the film, or consider it?

Kopple: No.

Thomson: Why?

Kopple: What would they tell me? To me, you use interviews when you absolutely need them. Or you use interviews when the person you're interviewing is so alive that it's like you're listening and can visualize what's happening. I had something of seeing him in action, seeing him move from place to place and moment to moment. I didn't need any interviews to stop the action and tell you what he was thinking or have somebody surmise why he was doing something. I had *him*. And nothing to me was more valuable.

Thomson: What was the budget?

Kopple: Not much. A million, maybe, or a little under.

Thomson: Let's move on to the Woodstock documentary, *My Generation.* I understand that the film started with the Woodstock organizers and eventually evolved into a "Barbara Kopple project."

Kopple: I started it in February 1994. *Woodstock* was August 1994. Michael Lang and Yanni Sighbatsson—who was then at Propaganda Films; it was owned by Polygram—called me up and said, "We're doing this festival, would you like to direct a film on it?" So I met with them, and told them how I might do it, and they said, "Fine, goodbye. Go do it."

Thomson: And did they say, "Here's the cash"?

Kopple: Oh, yeah, they had money. Then in March or April, Polygram, which was the company producing the festival, started getting cold feet about the festival and wanted to pull out. But they couldn't because they had an iron-clad contract with Woodstock Ventures, which was the three original guys who did Woodstock in '69. So the only thing they could stop, legally, was the film. They stopped it.

But I was too involved in it. I was having too much fun. So I just kept going. Right now, it's almost done. It runs about two hours. And it's really fun.

Thomson: Can you describe the content a bit, beyond the concert?

Kopple: It's totally within my style of shooting a bunch of different stories, yet trying to make it look very simple. It looks at the three original promoters who did Woodstock '69, and here they are, these guys in their 50s, still doing Woodstock. It looks inside Polygram—at who is taking

this risk to put on this festival, all the decisions that have to be made, like how many condoms will be sold, or who the sponsors are. Ben and Jerry's is out; Häagen Daz is in. Or what kids can bring in to eat. What if someone's mother gives them a turkey sandwich—can they bring that in through the fence? Dealing with security, with everything that happens. I had total access.

Thomson: Did you also document Polygram's relationship with the film?

Kopple: No, I never do anything that's connected to me. That's not what the story is.

Then I filmed the people of Saugerties, New York, who were totally petrified about having people come in. They take up guns and everything else, because they're afraid this generation is going to rape or rob them, or whatever. They're totally nuts. But tourism isn't doing well up there, and they need the money. They get a percentage of the tickets, and they go along with it. So there's that story.

Then there's the story of the so-called Generation X—who they are; what their dreams are. You get to see their irreverence or cynicism. They call themselves the generation of doubters, and that's not so terrible. It also looks at the Boomers, who are no longer on center stage, sort of the older generation; and at those in between. It also looks at who we are today and who we were 25 years ago; and that's not so different. We're still struggling for a sense of ritual and a sense of community.

And then, the groups. Any group that goes on, you know who they are as people, whether it's Porno for Pyros or Santana, Salt-N-Pepa or Metallica, Chili Peppers, whomever. Henry Rollins, for example, is hysterically funny; so is Trent Reznor from Nine Inch Nails. Rollins says, "Would I go to a concert like this? Are you crazy? Walking around in the mud, looking for somewhere to go to the bathroom, trying to keep dry? Uh-uh. Not me. I'm staying at the Marriott." Things like that.

Thomson: Have you had to fundraise for this film like in the old days—a few hundred dollars here, a few thousand there?

Kopple: I got a loan . . . well, it's not a loan anymore; I got some money from a producer who just died recently. And I got a grant from the NEA. That's it, from 1994 to now. The rest has come from me working on whatever films I can to keep it going. It's tearing me apart.

Thomson: In what respect?

Kopple: The film is really wonderful, and the reason people can't come in and say, "Here's the money; go finish it" is they'd have to do a deal with Polygram for the money that Polygram put into it. So that takes forever.

Thomson: Given this constant struggle for cash to support independent documentary, what do you tell young filmmakers who come to you with the question, "Should I go into documentary? What are my future prospects?"

Kopple: I tell them it's something I wouldn't change for anything. That for me, it's one of the most wonderful things I could have done in my life. You really have to struggle and persevere. And you have to go after your own dreams and not be dissuaded, no matter if people don't believe in you. There will be people there who will help you and believe in you. I also tell them to get work with people they respect, and then they'll start to meet a whole community of people who are somewhat like-minded who will help them. If you feel really strongly about it, go for it.

A Conversation With Barbara Kopple

Lisa Dombrowski/2018

Lisa Dombrowski: How did you begin your work in documentary filmmaking? What drew you to this field?

Kopple: I studied clinical psychology at Northeastern University. They gave you a six-month work-study program, and I worked with people who had received lobotomies. I knew I couldn't write about it effectively so that everybody would get a feeling of what I was learning, so I did a little film about it. My professor got really angry and thought I had taken the easy way out. But everything clicked for me, and I just said, "I want to work in film!" I came to New York and I took a class at the New School or the School of Visual Arts in cinéma vérité. And there was a young woman in my class named Angela who was sitting right next to me, and she said, "I'm working for the Maysles Brothers, Albert and David Maysles, and they want to have an intern. Would you be interested?" And I said, "Are you kidding? Absolutely." So I got an internship with them and it was the best thing that could have ever happened to me. Albert and I became lifelong friends. He was my mentor. And that's how it started. When I was there I did all of the things that nobody else wanted to do, like at night, putting the trims away from the assistant editor; reconstituting them because the film was on 16mm; getting coffee; helping the PR person; and, during Gimme Shelter, holding the camera magazines and the seven-inch audio tapes while we were shooting. Albert was on Stan Goldstein's shoulders during Gimme Shelter, and I was the one who held them both up, so I became a part of the human tripod.

Dombrowski: What were some of the things you learned from Albert Maysles?

Kopple: I learned from Albert about inclusiveness. He and David would have meetings at Maysles Films and would include everybody in the meetings, talking about their films or what they were going to do or what we thought about things. Because everybody's

opinion mattered, and that's what I've always tried to do in my work, is emphasize inclusiveness. When we have screenings of rough cuts I make sure that anybody who works with me can come to look at the film. So that was a big thing that they taught me.

Dombrowski: What led you to select *Harlan County, USA* as your first directing project?

Kopple: I was listening to National Public Radio, and they did a news report on the Yablonski murders.[14] I knew that I wanted to do the film because of what I heard there. Arnold Miller was a coal miner who never had any leadership experience but in 1972 was going to run against Tony Boyle who the coal miners at that point didn't feel was really helping them at all. They couldn't even vote on their own contract. I had a $12,000 loan from [the film producer and distributor] Tom Brandon, and I went to film that campaign. And then after the campaign, somebody told me that they're having a union organizing drive in Eastern Kentucky, and so off I went to Harlan County.

Dombrowski: How did you develop trust with the local people, folks who are in the middle of a labor battle, so that you could get the intimate access you had in that film?

Kopple: First of all I grew up in Scarsdale, New York, which is totally different than Eastern Kentucky to say the least. But I also had parents who were the most extraordinary, wonderful people, who were so full of love and so full of devotion that they said, "You can do anything, and if anything ever happens to you, you can always tell us, and we're here for you." So that gave me a huge amount of strength, to have that kind of love and support from them, no matter what. The miners at first didn't trust us in Eastern Kentucky. We stayed at this little motel in Pine Mountain, and at first they said, "Okay, be at the picket line tomorrow at five a.m." And we said, "Okay." It rained and poured coming down Pine Mountain, and the road had no side rails, and another car just went right around us, and we lost control of our station wagon, and it fell down off the side of the road. Everybody was all right but we had to walk to the picket line with all of our equipment. And when they saw that—because in Harlan County, word spreads fast whatever happens—they opened their hearts and their minds to us. They trusted us, and we even lived with one of the miners and his family, Jerry Johnson. I shared a bed with one of his daughters who unfortunately wet her bed, so that wasn't much fun!

Dombrowski: What lessons did you learn about how to develop trust and intimacy with your subjects that you applied to later films?

Kopple:	I think just to be there, and to not do anything that is dishonest, and to be truthful and go through whatever they are going through. To allow them to bloom, and not to put your own ideas into what's happening. To let them be who they are, and do what they are, and have no judgments on it.
Dombrowski:	As I look back over your body of work, one of the things I am struck by is how many of your subjects, often going back decades, continue to be hot button topics today, such as labor and industrial decline, or the role of guns in American culture, or free speech issues. On the one hand that makes your films seem timeless and perpetually relevant.
Kopple:	Thank you. That feels great.
Dombrowski:	On the other hand, I can also imagine that it might be frustrating for you, since as Americans we haven't come up with answers to these important problems. How do you understand the continued relevancy of films like *Harlan County, USA* and *American Dream*, or *Gun Fight*, or *Shut Up & Sing*?
Kopple:	That's a very big question. I certainly don't make films because I think nothing is going to change. I pick films to do because of the story, of what I feel very passionate about at the moment. Whether it's mental illness, or how people deal with who they are. For example, in *Miss Sharon Jones!*, Sharon is one of the most exquisite singers, and she's so positive about everything despite having pancreatic cancer. She taught me positivity, and I never thought in a million years anything would ever happen to her. So it's really about the people, the crisis, or the situation. "Oh Boy, the Dixie Chicks and First Amendment rights!" That's not how I think about my work. I think about it in a very intimate, person-to-person way. And if we're still having these problems, which we are terribly in the US, then it's looking back historically that can help us make the right decisions. There are so many real people in these films that can be spokespeople for what is going on in our lives right now.
Dombrowski:	Do you view yourself as a political filmmaker?
Kopple:	I don't invoke politics in my films. I am a storyteller, and a humanistic filmmaker, and sometimes the projects are very political but it's within the storytelling. I'm not didactic—I would never do anything like that. The people are stronger, and what's really happening to them is stronger than politics. People will really get a sense of what's real if they believe in the work.
Dombrowski:	How did *Shut Up & Sing* come together?
Kopple:	Cecilia Peck and I wanted to do a film on the Dixie Chicks and we went to their manager, Simon Renshaw, and asked him and he said, "Oh no, no, they're not very interesting." And we

said, "Yes, we think they are. They're amazing musicians, they have a really tight, incredible friendship, and we want to get to know them." And then Natalie [Maines, lead vocalist] said her bit about George W. Bush, about being embarrassed that the President of the United States is from Texas and she doesn't want the Iraq war. We went racing back to him and said, "Okay, Simon, we're doing it." And he said, "Okay, you're doing it." So that's how it all started.

Dombrowski: You had very intimate access in *Shut Up & Sing* to the meetings where the Dixie Chicks and their management are discussing strategy and crisis intervention. You see the strength of the friendship between the members of the band. It was impressive to me how much they must have trusted you in order to allow that kind of access.

Kopple: Well I think in every one of my films that access is there, because as a nonfiction filmmaker if you don't have access you can't make a good film. In the courtroom in *Harlan County, USA*, they closed the door to keep us out, and I had already wired Bessie Lou Cornett. When she stood up and said, "Laws aren't made for the working people in this country," I just opened the door to shoot inside. In the jail, they shut the cell when they arrested people for being on the picket line, and I just winked at the jailor and opened the door and in we went. If you don't have that access, you're not going to make a film that is going to be true to who the people are and really get deep inside. That's the secret of documentary filmmaking, the access. Without that you don't have anything.

Dombrowski: Can you describe for us how you convinced Hazel Dickens and David Morris to contribute to the soundtrack for *Harlan County, USA*, which is so integral to providing a sense of the history and culture of the region?

Kopple: Hazel Dickens was performing at the Smithsonian. I was pretty far along in the film, and I had used all of her music, as well as that of Dave Morris. And so I went to the Smithsonian where she was performing, and after she finished I said, "If I pay for you to come to New York, will you look at my film and give me your permission to use your music, and will you write a song for the end of the film?" She looked at me like I was crazy, and then she said yes. She came to New York, saw the film, and loved it. We kept up a really strong relationship until she died. And then I knocked on Dave Morris's door in West Virginia and said, "Hi, I want to use some of your music, and I want you to sing some of the songs that other people have done." And he said, "Oh, I don't work with outsiders. If you're from New York, you don't

know about Appalachia." And then I just really got to know him, and he said "Absolutely!" Then I did another film called *Shelter* which was about homeless vets, and Dave had lived for a while in his car or on people's couches. The film was him going to places to help veterans, and singing, and talking to them about his own experiences, and them talking about their experiences. And I'm just so glad I made it, because we lost him a year ago. People really become so close to you and so much a part of your community. And it's quite remarkable that you keep getting to build your family larger and larger.

Dombrowski: There is a prominent musical thread that runs through your work, all the way back to *Harlan County, USA* and up to *Miss Sharon Jones!*. You have returned again and again to subjects who are in some way involved in the world of music. What kinds of directions do you give to your camera people when you're shooting performances? Are you trying to use the performances to inform the larger story that you are telling?

Kopple: In *Miss Sharon Jones!*, we see Sharon before she went on stage at her first performance at the Beacon Theater. She's backstage waiting to be called and the band is playing a little bit until they introduce her. She's holding a cup in her hand and her whole body is shaking. We are wondering who the new Sharon is after chemo, and then they announce her and out she goes. That makes her performance even more interesting because you know what went on behind the scenes as well.

Dombrowski: What are the challenges of financing documentary films?

Kopple: That's always a problem. If somebody calls you and says, how would you like to do a film about . . . that means they usually have the money, so you're very happy about that as a filmmaker. When you're doing a film on your own it feels so difficult to raise the money, because not only are you figuring out how to make the film, but then you can also run out of money, or not have any money if somebody doesn't believe in you or believe in the work that you're doing. So it's really difficult. Even though companies need a lot of content and it's a golden age of documentary, it's always hard. It doesn't feel good to have to go out and beg for financing to do something.

Dombrowski: In a prior interview I read, you talked about how *American Dream* was a very long production process, and one thing that enabled you to do it was the sources of funding available then.

Kopple: I mostly got money for *American Dream* from foundations, as nobody ever invested in it. I remember I was filming outside, and it was five o'clock in the morning during a Minnesota winter, absolutely freezing, 30 degrees below zero with the wind chill

factor—which was par for the course for that film. I got back to the union hall trying to warm up, and my office called and said, "Barbara, you have $250 left in the bank, what do you want us to do?'" And I went, "I'm freezing, I don't know, I'll call you back. Let me think about it." So two hours later the office called back—it was Esther Cassidy [the coordinating producer]. I didn't want to take the call because I didn't know what to tell her. Somebody said, "No, no, no, you have to get on the phone, it's your office, you have to." So I got on the phone and Esther said, "We just got money from Bruce Springsteen, $25,000." We had been applying to him and applying to him. And I just burst into tears.

Dombrowski: You described this as a golden age for documentary. Why so?

Kopple: People love documentaries. They want to have that sense of truthfulness, of knowing what's happening. And people are making just extraordinary work. Films that make you laugh and cry, and go through all of the different emotions that a good film can prompt. People don't walk away from you anymore when you say, what do you do for a living? Oh, I make documentaries.

Dombrowski: Let's talk a little bit about your fiction projects. You've worked both in television starting with *Homicide: Life on the Street* and *Oz*, and on a narrative feature. What drew you to making the shift from documentary to fiction, and how did your experience in documentary inform your fiction work?

Kopple: You're always looking in fiction for that sense of truth. For *Homicide: Life on the Street*, they gave me an episode called "The Documentary," and I didn't know it was much harder than all of the others because it had all of the characters in it. But it didn't scare me. Andre Braugher [who played Detective Frank Pembleton] said, "Since you're a documentarian, that means you only film something once." And I said, "No, a good documentarian stays there until she gets every single thing she needs. We could stay here for hours." And he said, "Okay, I get it." And during a break when we were setting the lighting, Yaphet Kotto [who played Lieutenant Al Giardello] said, "Oh Barbara, I don't have very many lines so I'm going to go to my Honey Wagon." And I said—and I can't believe I said this—I said, "No Yaphet, you are the head of all of these guys. Even though you don't have many lines, when we put the camera on you, that's the money shot." And he went, "Oh, oh, oh, okay." So you have a lot of nerve, a lot of guts, where other people might not because you've been out there in the real world as a documentary filmmaker. You're not afraid to get what you think you need.

Dombrowski:	Then you directed your feature, *Havoc*. How does working with actors versus working with subjects for a documentary alter your job as a director?
Kopple:	A lot of the same things have to happen. The people all have to have trust in you. Actors have their lines, so you know what the story is and you know what's going to happen, but the wonder of it all is being with them. Anne Hathaway and Bijou Phillips and I, when we were working on *Havoc* on weekends, would go down to East L.A. and hang out so we could really feel what was going on there for a lot of the scenes. We just had a really good time together.
Dombrowski:	Are there any particular projects you feel most connected to or proud of?
Kopple:	I guess *Harlan County, USA* because it was the first that I did by myself, and it taught me so much about what life and death is all about. It was a major film for me. And also showing that I could be really strong, and knowing that there was violence, and having the whole sense of women taking over the picket line and realizing how important music is to film. So I guess for me it was my formative film.
Dombrowski:	Are there any projects you've done that you wish had received greater distribution or recognition?
Kopple:	I think *Miss Sharon Jones!*—I mean, all Sharon wanted in her life was to win a Grammy. She was nominated for a Grammy after I finished my film, and we won some audience awards. I wanted that Grammy so much for her, but it didn't quite happen.
Dombrowski:	Do you see your work as contributing to a certain kind of documentary tradition?
Kopple:	Yes, like the Maysles and D. A. Pennebaker, it's cinéma vérité. That's what I learned from them, and that's what I have done my entire life, cinéma vérité. Allowing characters to breathe, and to film scenes whenever you can. Of course, you do interviews with people, but really it's called storytelling. I mean, whether it's going to be a series, or whether it's going to be a short film, or whatever it is, I just always film it and edit it as if it is one film that is connected all of the time.
Dombrowski:	What aspects of cinéma vérité really appeal to you versus any other approach? Why do you think that is the most valuable approach to documentary?
Kopple:	This is real life and you never know what corner you're going to go around or who people really are or what's going to happen. That's what's so exciting, that you're filming things unfolding and getting to go along with it and watch how people change.

Dombrowski: Have opportunities for women in the film industry changed from when you started to today?

Kopple: Well it's hard for me to judge because I make documentaries, and men don't rule documentaries because there's very little money in it. So people didn't care if you went off and you made a documentary, and I did that for so many years. It wasn't hard at all, and in fact women mostly did documentaries. It was much easier to do it because men were going after the big bucks in fiction. But more and more women are able to do the films they want to do—I mean, look at *Wonder Woman*, which just soared everywhere. So I think we're going to see a lot more women doing fiction films, and doing what they love doing. I think the world is opening up to that.

Notes

1. Lisa Lincoln, "Stand Up and Do Something: Barbara Kopple Speaks With Lisa Lincoln," *Why* (Winter 1998): 4.
2. Barbara Kopple in discussion with the author, March 2018.
3. Ibid.
4. Ibid.
5. Gary Crowdus, "Filming in Harlan: Interview With Barbara Kopple and Hart Perry," *Cineaste*, 8, no. 1 (Summer 1977): 24.
6. Lisa Lincoln, "Stand Up and Do Something: Barbara Kopple Speaks With Lisa Lincoln," *Why* (Winter 1998): 3.
7. Peter Biskind, "*Harlan County, U.S.A.*: The Miners' Struggle," *Jump Cut*, no. 14 (1977): 3.
8. Gary Crowdus and Richard Porton, "*American Dream*: An Interview With Barbara Kopple," *Cineaste*, 18, no. 4 (1991): 38.
9. Stev, "*American Dream* Review," *Variety*, 340, no. 13 (October 8, 1990): 59.
10. Barbara Kopple in discussion with the author, March 2018.
11. Peter Debruge, "*Miss Sharon Jones!* Review," *Variety* (March 18, 2016), https://variety.com/2016/film/reviews/miss-sharon-jones-film-review-1201734092/, accessed on May 30, 2018.
12. L. A. Winokur, "Barbara Kopple," *Progressive*, 56, no. 11 (November 1992), reprinted in Gregory Brown, *Barbara Kopple Interviews* (Jackson: University Press of Mississippi, 2015), 54.
13. Barbara Kopple in discussion with the author, March 2018.
14. Here, Kopple is referring to the December 1969 murders of union representative Joseph Yablonski and his family. Yablonski had challenged Boyle for the presidency of the United Mine Workers of America earlier that month, but lost in a reportedly corrupt election.

13

MARIA MAGGENTI (1962–)

Amy Guth

Filmmaker, screenwriter, and television producer Maria Maggenti's film career, which began as writer and director of the feature films *The Incredibly True Adventures of Two Girls in Love* (1995) and *Puccini For Beginners* (2006), is interwoven with transformation, activism, and justice, the roots of which began long before her work in film. Maggenti says, "I'm very interested in race. I'm very interested in class. I'm very interested in the stories of people who nobody wants to pay attention to, and that is actually kind of a preoccupation of mine in all of the work that I do on my own."[1]

With her mother doing economic development work for the World Bank, Maggenti spent her childhood in Washington, D.C., and Lagos, Nigeria. "She's a really remarkable person who encourage both my sister and I to fight the power, basically, to insist upon the primacy of ourselves," Maggenti says.[2] Maggenti moved to Rome after high school, then to New York, before attending Smith College where she earned an undergraduate degree in Philosophy. "I did all those moves by myself," Maggenti says, proudly, hinting at her contagiously strong sense of self, her independence, and refreshing willingness to be honest and vulnerable. This seems to underscore so much of her work and path, her disarmingly unpretentious survival instinct as an artist coupled with an ability to continually draw context—deep, structural, social context—to nearly everything.[3]

The intersection of Maggenti's disarming authenticity and her creative survival instinct become even clearer when speaking of her transition from activism to film, and from film to television. Indeed, transitions through unknown territory seem to be a significant and quietly powerful place for Maggenti, again and again, a theme that underscores many other eras that proved productive and creatively fulfilling. After graduating from Smith and moving to New York City, Maggenti describes frustration attached to going to the then Lesbian and Gay Community Center—now the Lesbian, Gay, Bisexual, Transgender Community Center[4]—as a

20-something seeking community. "I went to all these different meetings and I was like, 'Oh my God, everyone here is so unattractive and so unhip. They're so old. There's just nothing here for me.'"[5]

After initially struggling to feel connected, one night at a center AIDS lecture, she met Frank Jump, a young, "super-hip guy" who presented a new group forming at the center called ACT UP—AIDS Coalition to Unleash Power. "I was searching desperately for somewhere to put a lot of my kind of political, emotional energy. And, remember, too, I didn't have a good job. I was not career focused. I didn't have any money," she says in a 2003 interview. "And the first thing I thought of was the Unleash Power sounded like a feminist phrase."[6] Feeling connected to the new group's mission, Maggenti became deeply involved with Act Up[7] and their dedication to acts of civil disobedience. Maggenti, in particular, found a place with Act Up members making documentaries, "chronicling everything Act Up was doing as well as creating little activist videos, like 'this is how you shut down your local city hall,' 'here's a PSA about how to stay healthy and have safe sex.'"[8]

It was through her involvement in Act Up's organized effort to chronicle activism and agitprop filmmaking that led Maggenti to apply to NYU, where she earned her MFA in filmmaking. "I loved music, and I was doing documentary work and photography," she recalls of the decision to pull these elements together through film school.[9] Maggenti describes the transition into film school as not what she thought it would be, "I thought it was going to be this really intellectually exciting place, we'd talk about all the greats of cinema, and that's not what it was at all." Nevertheless, the practical training in production shifted her initial disappointment to sharp focus. "Ultimately, it turned out to be the greatest experience of my life. Because it turned out I loved the camera. So, that's where I put all my energy, learning how to use the camera," she says.[10]

Soon after receiving her MFA, she set about making her first film, *The Incredibly True Adventures of Two Girls in Love*, a love story of two high school-aged girls from vastly different backgrounds who fall in love. Maggenti laughs recalling, "I was like, 'You know what? There are no lesbian movies with anyone interesting that are funny and wonderful and so I guess I better do it myself.'" Maggenti emphasizes that her inspiration for the film "kind of came from a political point of view even though I had the artistic impulse and desire and interest."[11]

Filmed in the summer of 1994, the film premiered at the 1995 Sundance Film Festival, and went on to win a GLAAD Media Award for Outstanding Film (Limited Release) in 1996. Of the film, *New York Times* critic Karyn James wrote that the film

> exists in a place where almost everyone is gay or potentially gay, a mirror-world of most mainstream movies. But having established that world, Ms. Maggenti leaves politics behind. With great confidence, wit and charm, she builds a universal story about first love, adolescent rebellion and sexual awakening.[12]

The reprinted interview in this chapter by *The Independent Film & Video Monthly* in 1996 takes place shortly after the release of *The Incredibly True Adventures of Two Girls*

in Love. The conversation focuses on the somewhat guerilla financing of the independent film, which she, and producer Dolly Hall, did in the determined way that threads throughout Maggenti's career.

Despite that determination and integrity, though, there exists nearly a decade gap between her first feature and her second feature *Puccini for Beginners,* a process which made her "feel very demoralized."[13] As she describes, "That was not because I did not have a script; I had a script within three years of *Two Girls.* It took six years for anyone to decide that they'd give me money and I could make it," says Maggenti.[14] She describes how she took numerous jobs that she was "lucky to get" as a writer, but laments how "as time has gone on, and I see male peers and I see male filmmakers that I admire, the thing that makes me enraged is how much work they've been able to get done."[15]

Maggenti's ability to see beyond the circumstantial and connect the dots to the overarching social structures provides context as much to her audience and fans as, perhaps, to herself. She continues, describing having the epiphany while watching Steven Soderbergh discuss his latest project that there is, in fact, no female Soderbergh.

And the reason why is that none of us are—none of us—both on an internal and structural level, are able to do that much work. I feel an incredible amount of rage about it and I think the concomitant conversation is there's also a very well-established construction of male genius in the film world and we can count all the young male filmmakers who go on to be considered geniuses and I do not believe any women would fall into that category. Perhaps Jane Campion.[16]

She pauses, then continues, "So, that also limits one's own sense of what's possible, what's waiting for you, where do you fit." She calls attention to the essay "The Male Glance" from *The Virginia Quarterly Review,*[17] which she states is about "the ways in which male critics don't take female work seriously." She found the article "significant" because it caused her to "recognize[] so profoundly the ways in which women who work in the art of storytelling are not paid attention to, and when you're not paid attention to and when you're not taken seriously, it is harder and harder to get your work done. . . . I mean, sit down, by yourself and [try to] keep going. It is fucking hard."[18]

Maggenti's second film *Puccini for Beginners* explores sexual identity, relationships, and boundaries through the story of an opera-loving writer. "It's hard to analyze your own work because the best part comes from your unconscious," she said in a 2007 interview.[19] "In *Two Girls* I was dealing with first love and what it feels like to say 'I love you' when you feel like it's the last time you're ever going to say it. In *Puccini,* I was more interested in the problem of commitment." After the film's release, she says "basically my career as a director ended," speaking more with matter-of-fact determination than lament. "The film was caught in an interesting moment before we were doing streaming but after films were [only] being released theatrically, so

it never found an audience home." Despite premiering at Sundance and receiving a positive reception, *Puccini* was "considered, by my agent, a failure," Maggenti says.[20]

"Failure" is a word hard to imagine associated with Maggenti, but it was this era that ultimately brought her into television, where she has worked as a writer on "Without A Trace," "90210: The Reboot," and that led her to a current role as Co-Executive Producer for "Supergirl" on the CW. Maggenti says that since her first film, she has found steady work as a writer—rewrites, television, pilots, movies. She states bluntly how this impacts how we view her "work," explaining "the larger context in which we discuss what would be considered, and I put it in quotes, 'my work'. . . . needs to be understood in the context of me taking jobs."[21]

Her ability to transcend the situational and connect to broader, more universal context is interwoven in this narrative. It's not Pollyanna-brand optimism, though; it's Maggenti's unpretentious realism and intellect, grit, and unflinching voice:

> It's very, very hard for women to fail. Meaning: a woman who doesn't succeed at every attempt that she is making is rarely given another chance to make an attempt. Men learn by failing; we all learn by failing and then getting up and trying to do something again. Very few women get that chance because once they have a failure, they are very rarely encouraged, or they're actively discouraged, from trying again.[22]

However, Maggenti is no pessimist. When asked what inspires her and keeps her inspired, she adds, "As tragic as the Trump administration is, as tragic as Trump's election and all of that was for a lot of people, including myself, the fact that every-body now has to stand up is thrilling to me."[23] Although she recognizes that some of the activist conversations are a long time coming (and many were ones that people had several decades ago), she also appreciates that this type of advocacy is finally gaining momentum. She says, "There is a public conversation around stuff that means so much to me as a person, as a citizen, as an artist. There's hope, so that is something that I feel very inspired by."[24]

This chapter includes the 1996 interview with Maggenti from *The Independent Film & Video Monthly*, as well as a current manifesto by Maggenti herself and an interview with Maggenti from 2018.

A Case Study: *The Incredibly True Adventures of Two Girls in Love*

Roberto Q. Dardon/August/September 1996

The Independent Film & Video Monthly

One question inevitably comes up at every filmmaker Q&A and press conference: "What was your budget?" And there's good reason for that. Filmmakers are always in search of a reliable frame of reference when putting together their own produc-tion budgets.

In making *The Incredibly True Adventures of Two Girls in Love*, director Maria Maggenti and producer Dolly Hall were able to get a lot of production mileage from their modest budget. Car shots, public locations, scenes with extras, dolly moves, brand new film stock—in short, a well-crafted and completely art-directed film by a full crew. How did they do it?

Roberto Q. Dardon:	You spent $60,000 to get your film "in the can." How do you define "in the can?"
Maggenti:	"In the can" means ready for editing. For us, that was 16mm dailies and the work print with all the sound transfers to mag stock.
Dardon:	What, if any, deferrals does that figure include?
Maggenti:	Practically nothing was deferred. New York post facility Sound One allowed us to edit on a deferral basis, and, for the amount of money we owed DuArt when we finished with principal photography, it might as well have been a deferral. We didn't finish paying these people off until we got money from the distributor [Fine Line Features, which released the film in June 1995].
Dardon:	How was *Two Girls in Love* financed?
Maggenti:	I took out a personal no-interest two-year loan from a man I knew. He is not in the film business, but he had disposable income—and he disposed some of it my way. That was our seed money: $35,000. The rest came from Dolly Hall, our producer, and a couple of $5,000 investments from women involved in the shooting of the film.
Dardon:	Did you have a completion bond?
Maggenti:	The only guarantee we had was my enthusiastic word that we would make the movie, sell it, and get it into theaters. Our last-minute $5,000 investor gave us the money because she saw how well everything was going. Completion bond . . . *ha!*
Dardon:	How much did you spend on insurance? Who required it?
Maggenti:	We used New York University insurance [for equipment and general liability] for the first half of the shoot, which I had because I maintained matriculation at NYU's graduate school.

Of course, one day a guy who was working for us got bonked on the head with a light—a Junior or a Baby or something. He had to go to the hospital, and our insurance didn't cover any of it! It also didn't cover our wardrobe or props or anything, so people slept in the prop and wardrobe vans overnight on our locations.

[During the second half of production,] Dolly was adamant about having adequate insurance, so she made a deal with some

other production company to use their insurance. [The company said *Two Girls in Love* was being made for them, thereby enabling Maggenti and Hall to obtain production insurance and Workers' Compensation, two other basic types of insurance needed for a shoot.]

Dardon:	How much time was spent on preproduction?
Maggenti:	Close to seven weeks. This is the single most important part of doing a low-budget film. We did the casting, script breakdown, scheduling, and location scouting in that time. Also, I rehearsed for four solid weeks with all actors.
Dardon:	How much of the budget went to preproduction?
Maggenti:	Not much. The office was Dolly Hall's loft. There were production people in there around the clock throughout the whole film. A lot of what they did was find crew who could come in and work for free.
Dardon:	The crew all worked for free?
Maggenti:	It's the only way this film could have been made. People worked on this because they wanted to. It was truly a labor of love. But most people on the film knew that Dolly would get them on a paying gig next, and that's exactly what she did.
Dardon:	What was the crew size?
Maggenti:	This wasn't a fly-by-night, "Hey, let's make a movie, kids!" kind of shoot. Dolly Hall is a professional producer, so we had every department that you'd have on a larger-budget film, except for a second unit crew [associate producer Melissa Painter was the second unit DP].
Dardon:	Did you have to do much in ADR (automatic dialogue replacement)?
Maggenti:	Very little ADR. Randy's voiceover in the beginning, which was written in post and was not part of the original script; a couple of Evie's lines when she's in her car; ambient sound was added for the Evie-comes-to-Randy's-for-dinner scene. All the post was done by Steve Bourne at Planet Ten Post—what an excellent dude! Otherwise, everything's location sound.
Dardon:	Your shooting ratio increased from 2:1 the first five days to 4:1 for the rest of the shoot. Why is that?
Maggenti:	Most of the dolly shots occurred after that. The film was shot pretty much in sequence for dramatic reasons, and the beginning of the film [was conceived] with less camera movement.
Dardon:	Not counting the crew's personal cars, how many production vehicles did you use?
Maggenti:	Four. The "production vehicle" that got Dolly, Tami, and me to the set everyday—and the camera—was also a star in the

Dardon: | movie. There was also a rental van to move the crew around, a van for the art department, and a grip truck. Our grip and lighting package came from an excellent guy in Pittsburgh named Jim Jackson.

Dardon: Finally, the question everybody wants to know: How much was spent on food?

Maggenti: Eight thousand bucks.

Maggenti Manifesto for Female Filmmakers

Maria Maggenti/2018

1. Do your homework.
2. Tell the truth.
3. When making a movie, don't take no for an answer.
4. Always ask how much people are getting paid and always share how much you're getting paid. If you don't, you'll never know if you're getting paid less than your male colleagues.
5. Join the union.
6. No matter what, always ask for more.
7. Friendly is not the same as friend. If you're working in Hollywood, learn the difference.
8. Let every single film with a male protagonist be remade by a female filmmaker with a female protagonist playing the same part.
9. You will meet people with power. Most are entitled, self-absorbed assholes.
10. Do not become an entitled, self-absorbed asshole.
11. Do not think only of yourself. Think of the women coming after you. Clear the path.
12. Screw motherhood.
13. Screw romance.
14. Don't be afraid to be radical, sexual, and single even when you're in your 90s.
15. Cry your guts out, then get back to work.
16. Hire women to head every department.
17. If someone in power is abusing that power, call them out. If someone in power is hurting someone less powerful, call it out.
18. Do not be a coward. This will be hard.
19. Get a therapist. Learn to analyze your behavior and cop to it when you're a jerk.
20. Only create female characters with deep existential problems, the problems of heroes, anti-heroes, crooks, crones, witches, bitches, and sirens. Create female characters who take up space and don't always smile for the camera.
21. We need Black butch dyke movie stars and sissy fag romantic leads. Go for it.
22. Listen.
23. Fight back.
24. Always say thank you.

25. Speak up. Don't whisper.
26. Always put women first.
27. In every movie description or synopsis replace the male lead with a female then read it out loud. Do this for every log line, every pitch and every breakdown. Read it out loud. You will be reminded of how far we have yet to go and you will be inspired to go there.
28. Write parts for older women.
29. Get a sense of humor. Especially about yourself.
30. Try not to give up. It won't be easy. (See all of the above.)

Conversation With Maria Maggenti

Amy Guth/2018

Amy Guth: Looking at the body of work that you have created thus far, what themes emerge that are perhaps sometimes missed by others?

Maria Maggenti: Every single piece of my published or produced works have female characters at the center. All of those women usually have some sort of crisis that is not always linked to who they are in love with.

I'm very interested in race. I'm very interested in class. I'm very interested in the stories of people who nobody wants to pay attention to, and that is actually kind of a preoccupation of mine in all of the work that I do on my own; I am always interested in the stories of people who most people don't care about. I'm very happy, however, that we seem to be in a moment where I'm not alone [in that thinking]. There are many more people who are looking outside of themselves and a lot more people who realize that white men just can't be the standard by which we all gauge our experience, the human experience. And for that I am so incredibly grateful. I also so feel that my activist work and my film work was part of that shift, even though it's taken 20 some odd years.

Guth: What piece of your work created the biggest pivot or turning point for you?

Maggenti: Since *Two Girls*, I've worked consistently as a writer. Some of those jobs have been television, some of them have been re-writes, a number of them have been pilots, a couple have been movies that got made, and I had my second movie. The reason that I say that is because the larger context in which we discuss what would be considered, and I put it in quotes, "my work" . . . needs to be understood in the context of me taking jobs.

Alexander Payne, for instance, who when I was just starting out, I went to a lecture of his and he said, "Don't ever take a job; always

write your own scripts. Always write spec scripts." And I'll never forget thinking, "Only a guy, who doesn't have to worry about money, would say that." I'm not in a position every year to say, "I'm going to take six months by myself and write my own script" and it's very difficult to write your own material when you're on another job. All of that being said, it's still a way to look at everything I've associated myself with or have been interested in that has been kind of linked.

After I made my second film, *Puccini for Beginners*, basically my career as a director ended. And, there's a couple of reasons why. I mean, it kind of makes me want to burst into tears when I say that, but I have to be honest. The film was caught in an interesting moment before we were doing streaming but after films were being released theatrically, so it never found a proper audience home. Therefore, it was considered, by my agent, a failure, and . . . so I had already worked on one television show. There was not in any way the push that there is now to find female directors to direct television, and I pushed and pushed and asked and begged and said, "I've done two features and I'll walk around with a director, which you know, is shadowing, and I'll do anything" and . . . nothing ever came of it.

A couple of things were combined: I was so demoralized by the failure of *Puccini*, which had also, like *Two Girls*, premiered at Sundance, got great press, it was a wonderful audience pleaser, lots of laughs, people loved it, but its identity in the world was . . . it was almost as if I never made it, and that was very demoralizing. That kept me from writing anything of my own. So, I then just started to take as many potential jobs as I could.

It also, unfortunately, coincided with the [Writers Guild] strike that we had in 2007, but when we all got out of that, I went into television because it was a regular paycheck and I had a pitch. I had material that I was desperate to make into a movie. It was called *Before I Fall*, the movie that came out this past year, finally, and I pitched that project to every studio for approximately one year before one studio said, "Yes, we will pay you to write this." That studio was Fox 2000.

However, the space between being paid to write it, writing it, delivering it, and then them finding a director to make it was another seven years. Almost seven years? Six years. I wanted to direct that film, and I wrote it as if I were directing it. However, it was made clear to me I would never be considered as a director [on the project].

That was the big turning point in my career. Here we are a little more than 10 years later, and I still have fans, and I have film-maker colleagues who say, "You should make another movie" and, "Don't give up" but there's a part of me that feels like I just . . . like I started high and had a great beginning of my career and I think what I did was really important and it had meaning to a lot of people, but, yeah. I don't know if I'll get that chance again.

Guth: Will you share a bit about your process of switching the creative medium, whether it's out of inspiration or necessity or a little of both?

Maggenti: It was absolutely necessity. There's no doubt. I'm lucky, as I have been told by directors who don't write—which by the way, it's very hard to find a woman director who doesn't write, certainly, of my generation. As another woman director once made the obser-vation and it is so, so true, she said, "Most pilots are not asked to build the plane before they learn how to fly. But all of us are asked to build our own planes before we get a chance to be a pilot." And, that is very true of being a woman filmmaker.

Now, there are more and more women coming on the scene, who are not necessarily writers of their own material, and I'm thrilled for them. But, for myself, I had no other way in, and I had no other way to stay in, because no one was hiring me as a director. I mean, *Two Girls* came out in 1995, and it took until 2007 for me to make that next movie. We shot it in the summer of 2005, but, look how much time that was. And, that's not atypical.

I was part of that study that was done by [USC professor Stacy] Smith where they interviewed so many different women who had had films at Sundance and I was part of that cohort and all of us, I think the average was seven years between projects. And that was not because I did not have a script; I had a script within three years of *Two Girls*. It took six years for anyone to decide that they'd give me money and I could make it.

The big conversation, the larger conversation, the culture that we're having right now, is that it's very, very hard for women to fail. Meaning: a woman who doesn't succeed at every attempt that she is making is rarely given another chance to make an attempt. Men learn by failing; we all learn by failing and then getting up and trying to do something again. Very few women get that chance because once they have a failure, they are very rarely encouraged, or they're actively discouraged, from trying again. I have so much rage. It's remarkable because I was very lucky in my twenties and I was in the [activist] group Act Up, and I had a place to put all of

my rage about the world and injustice, then I went to film school, and then I made my first movie, and I'm so thrilled with my experience. I was so happy, I was so inspired, and I was awoken to having a voice in a different way that I didn't. . . . I knew there was prejudice, I knew there was sexism, but . . . I wasn't focused on it, at all. All I knew was that I was amazing and I made a movie and I loved it and people loved it and things were going great.

Over time, as it became more and more difficult to make that second movie—and the first one, as I said, was considered a success—I began to feel very demoralized. I took many jobs, and I was lucky to get them, as a writer, which is great so I was actually in the business, making a living; I was in a union, for which I am grateful, but as time has gone on, and I see male peers and I see male filmmakers that I admire, the thing that makes me enraged is how much work they've been able to get done. They just work and work and work, and they have ideas and then they try things.

I just saw a thing with Steven Soderbergh the other day, talking about this new movie that he just directed, and I thought, "Wow, there is no female Steven Soderbergh." And the reason why is that none of us are—none of us—both on an internal and structural level, are able to do that much work. I feel an incredible amount of rage about it and I think the concomitant conversation is there's also a very well-established construction of male genius in the film world and we can count all the young male filmmakers who go on to be considered geniuses and I do not believe any women would fall into that category. Perhaps Jane Campion.

So, that also limits one's own sense of what's possible, what's waiting for you, where do you fit. There is a really remarkable essay that's in *The Virginia Quarterly Review* and it's called, "The Male Glance" and it's the ways in which male critics don't take female work seriously. The reason it's significant is because as I read it, I recognized so profoundly the ways in which women who work in the art of storytelling are not paid attention to, and when you're not paid attention to and when you're not taken seriously, it is harder and harder to get your work done. And I don't just mean because nobody's noticing that you're doing any work. I mean, sit down, by yourself and [try to] keep going. It is fucking hard. In a way, having those paid gigs is great because I kept on writing, but the idea, after *Puccini*, of devoting myself to my own work, and my own ideas? I was like, "No, it'll never happen. I'm too vulnerable. I got raked over the coals. I don't think I have it in me." And, that's really a shame.

And I don't say that like, "Oh, I was a wonderful filmmaker!" I look at it more from a bird's eye view which is, irrespective of me, Maria Maggenti, as an individual, I represent a whole group of individual voices, female voices, of a certain generation in filmmaking. . . . I mean, I find it almost too heartbreaking to try and do my own stuff.

I'm so grateful to talk about it because I do feel as though it requires this conversation which is so much more than it used to be. [Frequent interview questions] like, "Can you talk about being a women filmmaker" and it's like, "Ugh, shit. I don't want to talk about being a woman filmmaker." But I do want to talk about what happens, what is the process—and this is possibly some hindsights now after working as a professional in the business since 1995, and so I do have sense of how it works, and it's not so simple as, "What does it mean to be a woman filmmaker?" It's, "What does it mean to be a woman in society?" It's all connected and when you raise your voice, you're going to have a different kind of experience as a woman than you have if you don't raise your voice, and I happen to be a "raise your voice" type of individual. I probably would have been like that no matter what historical moment I was born in. It's my nature! [Laughs] It's like I was born with "let me tell you my opinion on that!" So. But there's definitely a price.

Guth: It's an interesting point given that conversations have happened in so many industries about getting women to enter a field, yet very little conversation has been devoted to the systemic issues beneath them, or the "death by a thousand cuts" sort of thing—

Maggenti: I think right now is a very interesting and a very inspiring time. I just can't believe that all the stuff that this tiny group of us, pointy-headed intellectual feminists activists, have been talking about for 20 years around race and around class and around sexuality and around recognition and taking down some of these icons and deconstructing the sense of what is universal; this moment is so thrilling, but indeed it's not so simple as "all we need are more women." Politics shows us that that is not the case.

Margaret Thatcher was a woman, and there are quite a few women who are working in Washington, DC right now who . . . I don't care that they're women; they don't stand for any of the values that I think are values that make the world a better place, so it's not really that simple. But, it certainly makes a difference to have more women because [when] you do, then, [you] stop thinking about women as this little unicorn group, you start thinking of them as individuals.

I say that because I went to Smith, and being at a women's college was really interesting because you stop thinking about women, women, women, women. You started thinking, "that women is smart, that one is not smart, that one is interesting, that one is manipulative, that one is somebody I can be friends with, that person's going to be famous." Being in an all-female environment, you create a different universal. So, in that respect it is helpful to have as many women as possible in any particular business or profession or place. Because then you get to really not just be standing for all women but you get to be "she's a woman and she's like that, and I'm a woman and I'm like this" and we just don't happen to be at that moment yet.

Guth: Backing up a bit, what do you think made you a "raise your voice" person, especially early in your life?

Maggenti: I think my mom. I was raised by a single mother who is a very strong, wonderful personality. Far more refined than I am. She's very girly in a lot of ways even though she's a career woman. She took us to Africa as a single woman working for the World Bank doing economic development in the 1970s. She's a really remarkable person who encouraged both my sister and I to fight the power, basically; to insist upon the primacy of ourselves. And, that's tricky business when you're white and you come from a certain background because it's like, "ok, well, that's a function of privilege," you know? And there is certainly an entitlement that can be beneficial, in that respect, and I have benefitted from it. I am a white person who came from an upper-middle class background who went to a Seven Sisters school. I've had lots of advantages. But, all girls need to be encouraged to raise their voices, and not all of them are. My mother definitely encouraged that, so I would say that's where it all started, with my mom.

Guth: At what point did you know the industry you wanted to enter?

Maggenti: I always knew I was going to be a writer. But, I didn't have any ambitions in the film business until. . . . I went to college, I did philosophy and classics, I didn't do anything that had anything to do with getting a proper job, and then I graduated. I moved to Manhattan, and I took every crappy job you could. And, I got involved in the group Act Up, so my whole life became activism. Temp jobs and activism! Then, about two and a half years in, I had been with Act Up since the very beginning, and I lost a lot of friends to AIDS in a very short time frame, and that's when I decided, "You know what? I'm really much better at school than I am in the real world. . . ." So, I thought, "you should just go back to school, Maria. You really suck in the real world and you're always getting fired."

Maria Maggenti (1962–)

I was just the worst! I'd get a temp job and they'd be like, "Hey, are you the girl who's temping today?" and I'd be like, "Yeah! That's me, Maria!" and they'd say, "Great, can you get the coffee going?" and I'd be like, "Are you kidding!? Why? Why can't you get the coffee going? Why do I have to get the coffee going? Because it's a woman thing?" I was impossible! I'm amazed I made it through. I just did not have the capacity to take directions. I wasn't good with authority. So, all of that made me felt like, "You know, maybe you should try going back to school, because you're always really good at school. . . ." And, then I got in and suddenly I was in film school, which was not at all what I thought it was going to be. I thought it was going to be this really intellectually exciting place, we'd talk about all the greats of cinema, and that's not what it was at all. What it is: "here's a camera, here's a boom, here's how you organize a day." It's production oriented. First I was disappointed, but ultimately, it turned out to be the greatest experience of my life. Because it turned out I loved the camera. So, that's where I put all my energy, learning how to use the camera. I didn't even have a writing class until my final year!

That's what started it. But I wasn't one of those, "My family gave me a Super 8 camera when I was 18!" Or, eight years old. Or whatever. I don't know how many women have had that experience, maybe more of them [than not], but I was like, "You know what? There are no lesbian movies with anyone interesting that are funny and wonderful and so I guess I better do it myself." [Laughs] And that's really what got it started. It kind of came from a political point of view even though I had the artistic impulse and desire and interest.

Guth: Can you tell me more about your time with Act Up, and what led you to that organization in particular?

Maggenti: I graduated from Smith and, you know, I was a young lesbian; I'd broken up with my girlfriend, I was like "what is my life going to be?" So, I would go to the Lesbian and Gay Community Center [now the Lesbian, Gay, Bisexual, Transgender Community Center] trying to kind of find a place to fit in.

I went to all these different meetings and I was like, "Oh my god, everyone here is so unattractive and so unhip. They're so old. There's just nothing here for me. What am I doing to do?" It never occurred to me to go to bars because I just wasn't a bar type of person. Then, I was at The Center one night and there was this really cute, young, super-hip guy and he was like, "Hey, we just started this new group. It's called Act Up: a coalition to unleash

power." And I had a t-shirt—and this was from when I was with my girlfriend in undergraduate—and the t-shirt said, "unleash the power of women for a mighty force for revolution." So when he said "Act Up, unleash power" I was like, "Oh my god! That's totally a group I could get with. I want to find out what that group's about." I went to the meeting, and the group was dedicated to civil disobedience.

I brought a lot of different lesbian and female [non-lesbian] friends at the beginning. Every single one of them was like, "There's no way I'm doing this. Not interested; it's all male." I felt like this was a social justice issue, and I hadn't met any women who were as amazing as the men I was meeting. I had no experience with the gay, male community, really. I just didn't know very many gay men. So, I thought it was kind of fascinating and then I got to know some of the women who got involved in the group and then that was it. That was my whole life. . . . And, it was a good life. I loved it. I really, really, really did. And those people from that group, including all my girlfriends, even though I don't even have girlfriends anymore, I have boyfriends, but every single one of those people were the most important people in my life.

Guth: Where did filmmaking and civil disobedience intersect for you?

Maggenti: Act Up was really good at chronicling every single thing that we were doing. We had scores of people filming, and doing documentary, and stuff like that. I got involved with the documentary group and basically what we were doing is chronicling everything Act Up was doing as well as creating little activist videos, like "this is how you shut down your local city hall," "here's a PSA about how to stay healthy and have safe sex" and all of those things were connected.

Act Up was also in that period where there were all these major artists, and Keith Haring was coming [to Act Up events], and it was very connected to the art world. It was only related in that I wanted to use film as a force for social change. But then, my personality is that I like comedy and so it became much more personal than that but I think the first part of it is very much like, "Oh yeah, I want to make the world a better place and I'm going to do that my getting involved in making movies."

Guth: Shifting to the business side of film, when you think of key business lessons or moments through your career so far, what comes up?

Maggenti: There are a couple things. Here's some hindsight: after *Two Girls*, I had more than 15 minutes; I had quite a lot of attention, I was

flown out to L.A., I met everybody. I should have been better at accepting advice and help. I did not know that I needed as much help as I actually needed, and I didn't really know how to ask for it. I didn't have anyone guiding me. I mean, you think that maybe there's somebody who's like, "Ok, Maria, now this is how it works when you go into a meeting" or "these are the things you're going to need to know when you go into a negotiation." But, I didn't have anyone telling me that, so I didn't actually know how it works. I would have been much more actively seeking that from someone who knew more, to help me. I did not do that and I didn't know that I needed that.

I can't really take full credit for this, but one of the best things I ever did which has given my career the kind of range that it's had, is when I said yes to taking a job in television in 2002 when not one filmmaker I knew would do that. I didn't know that was prescient. I didn't take the job because I knew that television was important; I took the job because I'd been trying to make *Puccini*, nobody wanted to make it, 9/11 had happened, I was super fucking depressed, and a friend of mine had a TV show and was like, "Why don't you come to Los Angeles, get away from New York for a little while?" And I thought, "Great!" and I went right there to the bottom as a staff writer on a TV show.

That was one of the best decisions I ever made. That was "Without a Trace." Television is so different from the film business and there's so much I love about it, so probably the best decision I ever made was to say "yes" to a job in television.

Guth: It's an interesting time for filmmakers in the digital space, with so many tools available and the ability to network in such a different way through social media. Some say it's an exciting time because it allows filmmakers to be in control of their fates a bit more, some feel like the stakes are much different. Where do you lean on that?

Maggenti: It's interesting because I've been living in the world of creating pilots for the last—six years, I guess. And, I've been super lucky that I've sold every pilot that I've pitched. I've been very, very lucky. There's definitely a glut in the television market. But, I also feel really optimistic at the same time because I feel like, "Wow, look at some of the really amazing, interesting movies that have happened in the last five years."

I mean, Dee Rees was at the Academy Awards with her movie; she made the movie *Pariah* like five minutes ago! That's incredible. So, that part makes me feel super optimistic.

I do believe there's a lot of cross-pollination between film and television. Just as a brief aside, it's so interesting; one of the people I went to graduate school with was Tamara Jenkins, and we're still friends, and I'll never forget when she was dating this guy, this was 15 years ago or so and he was a cinematographer and he got a job in television and one of the things they [in television] said to him was, "can you please stop making it look like film? You're making everything look like it's a movie." [Laughs] Of course now one of the most wonderful things about television is how cinematic it is. I mean, I just saw Season Two of "The Crown" and was like, "Oh my god! The filmmaking is stunning!" So, there's a lot of me that feels really optimistic. There's a lot of me that wishes I had made *Puccini*, my second film, more in this context because maybe it would have had a better life, but there's no way to know that.

There's a project that I'm writing and my friends are like, "You've got to direct it!" and I think I could direct it but . . . where would it go? How would it work? We're in a weird, interesting moment. Like, Sian Heder did the film *Tallulah*, financed by Netflix, had a very brief theatrical [release] and then it was on Netflix. And, if you come out of my generation where everything was about theatrical [release], part of me is like, "Ugh, I want a real movie. I don't want it to just be on Netflix; I want it to be in the theaters and be seen by many, many people."

Guth: What inspires you right now?
Maggenti: What's really exciting is seeing everyone have to put their money where their mouth is. As tragic as the Trump administration is, as tragic as Trump's election and all of that was for a lot of people, including myself, the fact that everybody now has to stand up is thrilling to me.

So many of the conversations that I hear that are like, "Oh man, we talked about that in 19-fucking-85. But, whatever! I'm glad people are talking about it now. I'm so thrilled when people talk about people of color, and when people talk about women, and when people talk about gay men and lesbians. Lesbians, in particular!" I'm like, "Oh my god. Finally!" There is a public conversation around stuff that means so much to me as a person, as a citizen, as an artist.

At the same time, of course, we're also fighting for our lives, because we really, really are, when it comes to this administration. But, interestingly, I feel really, really inspired. Even these kids, the

anti-gun kids? They did a die-in. The die-in is something that Act Up came up with. We were doing die-ins in 1987, 1988, '89 and '90. And I see them, and they're doing die-ins and I'm like, "Oh my god! It's so great!" There's hope, so that is something that I feel very inspired by.

Notes

1. Maria Maggenti. Interviewed by Amy Guth on March 22, 2018.
2. Ibid.
3. Ibid.
4. The Lesbian, Gay, Bisexual & Transgender Community Center, https://gaycenter.org/, accessed on June 19, 2018.
5. Maria Maggenti. Interviewed by Amy Guth on March 22, 2018.
6. Maria Maggenti. Interviewed by Sarah Schulman, Act Up Oral History Project, The New York Lesbian and Gay Experimental Film Festival, Inc. (January 20, 2003), www. actuporalhistory.org/interviews/images/maggenti.pdf
7. Act Up New York, www.actupny.org/, accessed on June 19, 2018.
8. Maria Maggenti. Interviewed by Amy Guth on March 22, 2018.
9. Ibid.
10. Ibid.
11. Ibid.
12. Caryn James, "FILM REVIEW; Young Love Just Between Friends," *The New York Times* (June 16, 1995), www.nytimes.com/1995/06/16/movies/film-review-young-love-just-between-friends.html
13. Maria Maggenti. Interviewed by Amy Guth on March 22, 2018.
14. Ibid.
15. Ibid.
16. Ibid.
17. Lili Loofbourow, "The Male Glance," *VQR* (Spring 2018), www.vqronline.org/essays-articles/2018/03/male-glance, accessed on June 19, 2018.
18. Maria Maggenti. Interviewed by Amy Guth on March 22, 2018.
19. Lisa Garibay, "Mixed Signals," *Filmmaker Magazine* (Winter 2007), https://filmmaker magazine.com/archives/issues/winter2007/features/mixed_signals.php, accessed on June 19, 2018.
20. Maria Maggenti. Interviewed by Amy Guth on March 22, 2018.
21. Ibid.
22. Ibid.
23. Ibid.
24. Ibid.

14
DEEPA MEHTA (1950–)

Anna Sarkissian

Born in Amritsar, India in 1950, director and screenwriter Deepa Mehta has become Canada's most prominent female narrative filmmaker. Mehta offers a distinct perspective as a transnational filmmaker, portraying complex sociopolitical issues, often related to women's roles, identity, and belonging. Her celebrated Elements trilogy, *Fire* (1996), *Earth* (1998), and *Water* (2005), has been the subject of scholarly debate and received numerous international accolades, including an Oscar nomination for Best Foreign Language Film for *Water*.

Mehta is known for her incredible tenacity, refusing to yield when angry mobs trashed cinemas screening her films and finding new shooting locations when her sets were thrown into the river. The stories that have motivated Mehta have at times attracted controversy: a romantic relationship between two sisters-in-law in *Fire* and the historical treatment of India's widows in *Water*. She had to stop shooting *Water* for security reasons and spent a month living under police protection.[1] Later, production of her 2012 adaptation of Salman Rushdie's novel, *Midnight's Children*, was shut down in Sri Lanka due to the fatwa against Rushdie[2] and a complaint from the Iranian government.[3] Mehta has contended with the burning of effigies and threats against her life, in addition to criticism from Hindu fundamentalists, conservatives, and feminists alike. Despite these obstacles, she is unequivocal in her commitment to carrying on. "It's when we fall down and how we choose to rise that defines our character," she told the graduating class at the University of Toronto in 2011 while receiving an honorary degree. Speaking about the importance of failure, she went on to say that everyone has plans, but plans change. "Some days are going to be filled with despair," she said, "But never mind. Learn from them."[4] Mehta has persevered, writing her own material, adapting screenplays, and directing short films, documentaries, television shows, and 12 narrative features.

As a girl, she didn't dream of being a filmmaker.[5] In fact, she had no plans to pursue film by the time she was studying at the University of Delhi. Mehta's father

was a film distributor and exhibitor, and she grew up surrounded by movies.[6] At a young age, he brought her into the projection booth to hold a piece of celluloid in her hand and then walked her towards the screen so she could touch it. "Somewhere between the projection room and the screen, magic happened," she said.[7] The theater served as her own private screening room and on Sunday mornings, they screened Western films like *Blue Hawaii* (1961) with Elvis Presley, introducing Mehta to Hollywood. "It's a question of being exposed at a very early age to another world," she said. "When I came to Canada, it bewildered me that many people hadn't been exposed to my world."[8]

The extreme highs and lows of box office success dismayed Mehta, who wanted nothing to do with an industry built on so much uncertainty.[9] After graduating, she spent a brief period of time in London before returning to Delhi.[10] She was about to start her masters in Hindu philosophy when a friend told her about a part-time job at a documentary company, Cinema Workshop, where she learned the tools of the trade.[11] She made her first film and was hooked. Soon after, Mehta married Paul Saltzman, a Canadian documentary filmmaker, and moved to Canada in 1973. They founded Sunrise Films with her brother, photojournalist Dilip Mehta, and began making documentaries. Through Saltzman, she met her first Canadian friend, an elderly woman, and captured her life in an acclaimed documentary, *At 99: A Portrait of Louise Tandy Murch* (1976). The short film won a Canadian Film Award (now the Canadian Screen Awards) and elicited 700 glowing letters to the broadcaster, CBC, when it premiered.[12] The *Spread Your Wings* series, made over the course of several years in locations around the world, consisted of films about young people excelling in various crafts, such as photography or shipbuilding.[13] *Travelling Light* (1986), a portrait of her brother, was nominated for three Gemini Awards (equivalent to the Emmy Awards and now called the Canadian Screen Awards) and narrated by Christopher Plummer.

For Mehta's first feature, *Martha, Ruth & Edie* (1988), she shared the director's chair with two collaborators, each directing an adapted short story by Alice Munro, Cynthia Flood, and Betty Lambert.[14] In Mehta's words, it "bombed critically and at the box office."[15] She had more success with her next film, *Sam & Me* (1991), about a young man from India who forms an unlikely bond with an older Jewish man in Canada. The film screened at Cannes and was awarded the Caméra d'Or Special Distinction for a first film, catching the eye of George Lucas. He called Mehta about working on his young Indiana Jones television series for ABC, but she mistook him for a prank caller when he identified himself. "Yeah, and I'm Princess Leia," she said, hanging up the phone. The two laughed about it later. Following TV credits with Lucas, she returned to the big screen with a road movie, *Camilla* (1994), starring Jessica Tandy and Bridget Fonda. Distributed by Miramax and in the hands of Harvey Weinstein, the film was recut and Mehta walked away disheartened.[16] She considered leaving film altogether if her next project did not find an audience.

In 1996, she founded Hamilton-Mehta productions with her second husband and producer, David Hamilton, and together they embarked on the Elements

trilogy. First, there was *Fire*, in which the protagonists Sita and Radha turn away from tradition and towards each other. Following the premiere at the Toronto International Film Festival, *Fire* collected more than a dozen awards on the festival circuit and then screened in India without incident for several weeks in late 1998.[17] It was the first mainstream Indian film to feature a same-sex relationship,[18] and though it was twice-approved by India's Censor Board with no edits, an uproar started. A small group of right-wing Hindu fundamentalists ransacked theaters, assaulted a cinema manager, and disrupted screenings.[19] The film was accused of being "against Indian culture"[20] because there were "no lesbians in India."[21] In response, a candlelight vigil was held outside the Regal Theater in New Delhi with women and young men holding signs saying, "We are Indians, and we are lesbians."[22] Elsewhere, counter-protests helped ensure that the screenings continued, and viewers came in droves.[23] A year later, the controversy had died down and Mehta's next film, *Earth*, was well-received,[24] becoming India's official entry for the 2000 Oscar nominations.[25] Told through the eyes of a young girl, the story focuses on the impact of partition, when the country was violently split into Muslim-majority Pakistan and Hindu-majority India in 1947. Born soon after and growing up within 25 kilometers of the Pakistani border, Mehta was curious to explore how bloodshed pitted neighbors against each other. "I was intrigued by sectarian war," Mehta said. "I'm appalled by it. I was immensely curious about how it affects the everywoman and everyman."[26] The final film in the trilogy, *Water*, was once again a target of Hindu nationalists, who stormed the set and forced Mehta to halt production. It is the story of eight-year-old child bride, Chuyia, whose fate is sealed when her husband dies and she is sent to live among widows by the Ganges. Set in 1938, Hindu widows had been seen as a source of bad luck and were traditionally relegated to communal homes and a life of poverty. According to one theory, groups used the film to stir up nationalist sentiment and strategically presented Mehta as an "outsider" who aimed to insult Hinduism with an unflattering portrayal of widows and the sacred city of Varanasi.[27] Already known for *Fire*, there was a perception that Mehta only made films about "aberrations of Indian culture" and that she was influenced by Western preconceived notions about India.[28] With *Water* on hiatus for several years, Mehta changed pace by writing and directing two light-hearted comedies. *Bollywood/Hollywood* (2002), a parody of Bollywood films set in Canada which won best original screenplay at the Genies[29] (now the Canadian Screen Awards), and *The Republic of Love* (2003), an adaptation of Pulitzer Prize winner Carol Shield's novel, starring Bruce Greenwood and Emilia Fox. *Water* was eventually filmed in Sri Lanka under a false production name, *Full Moon*,[30] and gained worldwide attention when it was nominated for an Oscar in 2007. Mehta was subsequently courted by Hollywood studios but ultimately decided to remain independent.

Her next projects cover a wide range of topics, time periods, and settings. *Let's Talk About It* (2006) is a documentary filmed by Canadian children interviewing their parents about domestic violence. Written by Mehta, *Heaven on Earth* (2008)

is a drama with a similar theme: a young Indian woman leaves her family behind to join her new husband in Canada and is met with abuse. Mehta worked closely with Salman Rushdie on the magical realist *Midnight's Children*, an adaptation of his novel by the same name and then explored Vancouver gangster culture in the action film *Beeba Boys* (2015). Her most recent project, *Anatomy of Violence* (2016), is a fictional account of the lives of the six men who gang-raped a woman on a Delhi bus in 2012.

Mehta has consistently said that she does not believe that films can effect change, but they can start a dialogue.[31] "All art is political. We all know that. And it should be," she said in a National Film Board of Canada video portrait.

> But it has to be about a story. It has to be about real people within that story that are maybe dealing with an issue. It has to be honed in and represented by something that is living, breathing, that talks, that stops, that decides to sit in a corner and weep. Issues are boring. Feelings are important.[32]

Dividing her time between India and Canada, Mehta's hybrid identity has been referred to as unique in Canadian cinema, because of her ability to continue filming in India (despite the protests) and in Canada (despite the funding challenges).[33] "India, the country of my birth, gives me its inspiration for its stories," Mehta said. "But Canada gives me the freedom to tell those stories."[34] Her transnationalism, and by extension her onscreen representation of Indian culture is both admired and heavily critiqued. Opponents have vocally questioned Mehta's "Indian-ness," saying that she is an outsider with an ulterior motive.[35] She has been called a "self-hating Indian"[36] in an Indian feminist journal and been accused by Canadian academics of being a "native informant" who portrays Indian culture as "backward, static, traditional, and timeless" for the consumption of Canadian audiences.[37] Mehta told an interviewer in 1998 that she once felt conflicted about where she belonged but now she disregards labels: "I feel very happy being who I am, Deepa Mehta."[38]

For her body of work and contribution to the performing arts, she received the 2012 Governor General of Canada's award for Lifetime Artistic Achievement,[39] as well as 17 honorary degrees. Other accolades include an award for Outstanding Achievement in International Cinema from the International Indian Film Academy, a Hanging in There Award for Best Persistence from the Alliance of Women Film Journalists,[40] the YWCA Women of Distinction Award, and the Canadian Civil Liberties Association Excellence in the Arts Award.[41] In 2013, she became an Officer of the Order of Canada for her groundbreaking contributions[42] and named to the Order of Ontario for defending human rights and fighting for social justice.[43] She was inducted into Canada's Walk of Fame in 2016 for continually challenging the status quo through her provocative films.[44]

This chapter includes an interview with Mehta from the March 2006 issue of *The Independent Film & Video Monthly* and a conversation with Mehta compiled from several interviews with her in 2018.

Shaking the Tree: When It Comes to Modern Mores, Deepa Mehta Refuses to Stop Asking Why

Sarah Coleman/March 2006

The Independent Film & Video Monthly

Five years ago, when Deepa Mehta was about to start making her film *Water* in the holy city of Varanasi, India, 11 people stood outside the set and threatened to light themselves on fire. Weeks before, protesters had stormed the film's set on the banks of the river Ganges and destroyed it, causing hundreds of thousands of dollars in damage. In one climactic moment, a man rowed himself out to the middle of the river, tied a rock around his waist, and jumped in, yelling that Mehta's film was responsible for his suicide. It didn't matter that the man, who survived, was exposed as a paid professional suicide attempter; by that time, frenzy had hijacked common sense, and the local government shut down the film's production.

Watching this delicate, lyrical film, which was made four years later in Sri Lanka, it's hard to imagine what could have inspired such anger. The film follows a group of marginalized widows living in a run-down building on the banks of the Ganges. It's the 1930s, and the widows' struggle for freedom is set against the backdrop of Mahatma Gandhi's rise to power and the country's larger struggles for independence.

It sounds like a gentle, life-affirming period drama, but in India, where millions of widows are shunned by their families and forced into a life of begging or prostitution, the film hit a nerve. According to Hindu scripture, a widow has three choices: marry her husband's younger brother, burn on her husband's funeral pyre, or live a life of isolation and self-denial. By daring to suggest that widows are worthy of basic human rights, Mehta temporarily made herself public enemy number one for Hindu extremists.

"These people were the self-appointed caretakers of Hinduism, and I was in their way," recalls the filmmaker, reached by phone at her second home in Delhi. "I was a soft target, and an easy one."

It wasn't the first time Mehta found herself at the center of a swirling controversy. Her 1996 film *Fire*, the story of two middle-class Indian sisters-in-law who become lovers, touched off violent protests in India. A movie theater showing the film was ransacked, and the film was withdrawn from distribution. When Mehta appeared to talk about the film at the International Film Festival of India, a man in the audience stood up and announced, "I am going to shoot you, madam!"

One expects, then, that the voice on the other end of the phone might be strident, defensive, perhaps a little bitter. But Mehta is never less than warm and down-to-earth; her laugh is an infectious deep, throaty chuckle. After the aborted Indian production, it took four years for her to film *Water*, she says, because she didn't want the film to come from a place of anger. "Literally, one day I woke up and said, 'Oh my god, I'm not angry anymore,'" she says. "If *Water* had happened out of anger it would have been a different film—and frankly, not one I'd be interested in."

One of several talented female Indian directors working today (the group includes Mira Nair, Gurinder Chadha, and Aparna Sen), Mehta is undoubtedly the most taboo-breaking of the group. Yet despite their controversial themes, her films don't trade on sensationalism. *Fire*, she says, is less a movie about lesbianism than about how traditional, patriarchal Indian society fails women. "[Patriarchy] is a way of life that, like any other, should be questioned," she says. "I think questioning is natural— I've never really deemed that I'm doing something controversial or cheeky."

Listening to Mehta talk about her films, it's hard to imagine she ever wanted to do anything else. Although she grew up steeped in Bollywood culture (her father was a movie distributor and theater owner), she wasn't immediately sold on filmmaking. "On the whole, I thought the [Bollywood] movies were a bit silly," she says. But one film, Asit Sen's 1966 *Mamta*, caught her attention. "It was the first film I'd seen that felt so much more real, emotionally, as opposed to over-the-top melodrama. It moved me greatly, and I realized that there was a kind of cinema that didn't have to be all cheap and shiny."

Still, she resisted—until a friend persuaded her to work for a while in the Cinema Workshop, a government-funded documentary house in Delhi. "It had nothing that was even remotely glamorous, so that felt safe for me," she says, adding, "I didn't realize I'd get hooked."

Her first film, *Vimla*, focused on the hard realities of women's lives. A documentary, it was made for India's Ministry of Family Planning and featured a 13-year-old girl who worked as a house cleaner. "I remember feeling passionately about her as we made the movie, and I was so upset to find out that she died two years later in childbirth," Mehta recalls.

While filming in Delhi, she met a Canadian producer named Paul Saltzman; the two married and Mehta moved in 1973 to Toronto, where a new raft of filmmaking possibilities awaited. Her first two feature films, *Sam & Me* and *Camilla*—pleasant, character-driven dramas—are set in Toronto. In between those two films, Mehta got a call from an unlikely source. "Was I interested in meeting George Lucas and possibly directing an episode of *The Young Indiana Jones Chronicle?*" She laughs. "Yeah, right. George Lucas. I thought it was a joke."

She went on to direct two episodes of the series, one of which was set in Varanasi, which is where Mehta first came across the widows' houses: broken-down buildings filled with destitute women with shaved heads and thin white robes. "I'd seen a lot of widows while growing up, but I'd never seen the institutionalization of widows as an adult," she says. "That was my first exposure, and I said, 'My god, one day I'd really like to do a film about this whole phenomenon.'"

Water and *Fire* are two parts of an ambitious trilogy in which politics intersect with the personal aspects of women's lives. The third film, *Earth*, is set in 1947 in Lahore during the time when India was literally splitting in two. Based on a novel by Pakistani writer Bapsi Sidhwa, the film follows the fortunes of a beautiful Hindu nanny as the British pull out of India and a violent sectarian war erupts.

When she started working on *Earth*, Mehta says, the film seemed especially relevant because the genocide in Rwanda was only a year or two old. "Bapsi said

something intriguing to me, which was that all wars are fought on women's bodies," she says. "I think that's especially true of sectarian war, which is so devastating."

Though each part of the trilogy takes place in a different era, the three films clearly have common themes. Each is about the struggle of a woman—or women—to escape male oppression, but that doesn't mean that all the women in them are angelic. Along with their complex heroines, many of Mehta's films feature powerful matriarchs bent on thwarting the heroine's wishes. "The only people these matriarchs can exercise power over is other women, so they abuse them," says Mehta. "I find that fascinating."

In between *Earth* and *Water*, when she was recovering from the aborted production in Varanasi, Mehta took some time out to make a completely different kind of film. *Bollywood/Hollywood*, which came out in 2002, is a romantic comedy full of snappy dialogue, quirky characters, and joyous song-and-dance numbers. After what had happened in Varanasi, Mehta says, "I felt like doing something irreverent. I think I wrote *Bollywood/Hollywood* in about a month. It was very liberating."

Even at her most frivolous, though, Mehta has a knack for creating intriguing, believable characters. From Rocky, the house servant in *Bollywood/Hollywood* who has a secret double life as a transgender nightclub singer, to Shakuntala, the middle-aged widow in *Water* whose Hindu faith conflicts with her earthly desires, Mehta's characters have rich, fascinating inner lives. Thanks to her ability to write such full characters, Mehta has been able to attract leading Indian actresses like Seema Biswas and Shabana Azmi to the roles.

These days, Mehta divides her time between Toronto and Delhi, spending approximately half the year in each city. Not being fully immersed in either culture "has given me an ability not to look at them through rose-colored glasses," she says. That clear perspective on both countries will come in handy when she films her next project, *Kamagata Maru*, a story of how Canada, fearing a "brown invasion," refused to accept a ship full of Indian immigrants in 1914.

With any luck, the project will be free from controversy—but don't bank on it. Mehta tends to pick subjects that get under people's skins, and *Kamagata Maru* is bound to raise some thorny questions about race and immigration. If it's anything like Mehta's other films, it will be a powerful piece of filmmaking, because it encourages out-of-the-box thinking and ruffles some feathers. "It all starts from curiosity," Mehta says. "Why can't two women make a choice to be together or a widow get married? Why do we have racism and exclusion? That's what it's about—why, why, why?"

A Conversation With Deepa Mehta

Anna Sarkissian/2018

Note: The following Q&A is an edited compilation of three interviews with Deepa Mehta from June and July 2018.

Anna Sarkissian: I am struck by what you've gone through making films. It's difficult to imagine the strain of having your film shut down because

	the police can't guarantee your safety or having a mob burn you in effigy. How did you keep going?
Deepa Mehta:	First of all, I don't think I've endured so much. I would love to feel like a martyr but I really am not. [The controversy] was irritating as hell and got me angry. It taught me a lot of really important lessons. One was when *Water* was shut down. I remember going to the office of the organization, the RSS [Rashtriya Swayamsewak Sangh],[45] which had shut it down, to ask them what they were doing. The head of the RSS at that point looked at me and he said, "Deepa, a good general always knows when to retreat." So, it really gave me perspective on what I was doing and why I was trying to do it when all the odds were against me. Also, I was so angry. I realized that to make a film, to try and remount a film when I was that angry would really make the film not what I wanted it to be in the first place. So, I learned some valuable lessons. But I never ever felt that I had to endure anything really. It was a bit of a pain in the neck, but I didn't feel threatened or that my life was in danger or anything dramatic like that. But maybe that's just me. You know shit happens, and you have to deal with it.
Sarkissian:	It has probably been dramatized more in the media. Is that true?
Mehta:	I don't know, I don't read [about that]. I really don't read that much. What am I going to read about? The way I think or my films being shut down or the way it's been received? It's painful, yes, it is. But there are some aspects of filmmaking that are always painful. If it isn't something like this, there are other things. Crews fall apart, actors walk out, financing drops off. That's the nature of the film business. I think to romanticize it is maybe kind of naive.
Sarkissian:	I wanted to go back to the beginning and talk about how you got into filmmaking, which was almost by accident. Can you talk about how you started making films?
Mehta:	I grew up with films. So, you have to understand that there was nothing about film that I didn't know. I'd been to shootings since I was a little kid. I had movie stars come to our house. I'd been in movie halls. I knew how projectors worked. I knew what happened when films failed in the box office. I knew what happened to actors, what happened to my father—that distributors would have a rough time if a film didn't do well. I knew every aspect of commercial filmmaking. I grew up with it. So, nothing was, "Oh my god, this is such a glamourous industry. I want to be a part of it." Or it wasn't, "It's not a glamorous industry, and I do *not* want to be a part of it." I just was not very impressed with it nor was there any part of it that made me feel that I want to be a filmmaker because there were so many great aspects of it, and

there were equally, sort of, difficult aspects of making films. So, I was doing philosophy and I was just wondering if I should do my master's. I was thinking about it and I was in Delhi. Friends of mine said can you help us out. They had a small company called Cinema Workshop—five people. "We've lost the person who answers the phones, so can you come in and answer the phones for a couple of days?" And I said sure. So, I went there. Making documentary films and the way they made them, it was very different from the Bollywood machine. This was hands on, small, intimate. . . . It seemed that it was worthwhile . . . the subjects that they were dealing with. I had terrible phone manners, so they laughed about it. I was intrigued by editing for example. And so, my friend said, "Why don't you learn how to edit?" So, I learned how to do editing and I learned how to do sound. I was just an intern more than anything else. And I learned how to do second camera. By the time a month went by, they said, "Why don't you do small documentary, two minutes long, on how wheat grows or something like that?" And that's how I got interested in it.

Sarkissian: From there to today, why are you still making films? What is it about the medium that continues to attract you?

Mehta: It's curiosity. For me, the reason I make films is because the subjects that intrigue me actually propel me to feel that I should explore them. This is the medium that interests me the most to explore them. If I wasn't a filmmaker, I'd probably write.

Sarkissian: It sounds like you learned so much about the industry through informal means. I was wondering if there is one person who has taught you the most or is it a collection of experiences that you've had? You didn't go to film school.

Mehta: I'm glad I didn't. I would say my father. At a very young age, he showed me how a projector works and what a film felt like. I'm talking about celluloid now. What happens to a screen. He explained that to me at a very young age. I didn't understand that something that I couldn't touch or feel, how could it evoke laughter in me or make me cry. How did it evoke emotion? He explained that magic of cinema to me. It's my father who did this.

Sarkissian: You recently tweeted an interview you did with the CBC in 1991 about *Sam & Me*. In it, you talked about how it was easier to start off telling a story based on something you are so familiar with, in this case the Indian and Jewish cultures. Has this evolved for you over time?

Mehta: Yes, it has evolved, but the focus has changed. Nothing can take away from the fact that I wasn't born here and didn't grow up here, but I do feel comfortable, now, after many years, with being an Indo-Canadian.

Sarkissian:	What is the focus for you now?
Mehta:	I have to go back to it. It really is what I'm curious about, which I don't know that much about. So, any issue about what's happening politically and with women is something that really intrigues me. . . . Because actually right now, everything seems to be causing some pain, politically that is. What's happening with the world. There are some movements which are happening which are very interesting as well, whether it's Black Lives Matter or an awareness of colonialism, and the fallout of imperialism right now. Anything that is surrounding these subjects that is political and has to do with women is what intrigues me. Whatever intrigues [me] isn't necessarily going to make a good film or even a film that people would want to see, but it's a starting point. But unless I do something that I really wish to grow or get more knowledge about it while I'm doing it or writing it, I don't see the point.
Sarkissian:	*Let's Talk About It, Heaven on Earth,* and *Anatomy of Violence* all address violence against women in various forms. How do you go about translating sensitive and potentially triggering stories for the screen?
Mehta:	We touched on this before, but it's always about me being curious. That's what drives me. I think inequality—being brought up in a patriarchal society, seeing idiots like Trump around—it's always made me aware of inequality and the physical force that men sometimes use, and violence against women. I think what intrigues me most is, what makes monsters? What is our relationship with them in the world? So, I try to look at it from different angles. There's always going to be a fallout. I was talking to a journalist once some time ago and he was asking me a question like this. How do I deal with the sensitivity of the subject and the possibility of it being misinterpreted or hurting people? You can't go around thinking about that because of course you're going to hurt somebody. It's going to happen regardless. Either you're going to make films that bore people to death or they're going to be riled up or they're going to love them. It's going to be a different reaction. The most important thing is to have a dialogue. I'm curious about it, I really am. What causes violence? What makes men rape? And what does economy, what does patriarchy, and what does culture have to do with it?
Sarkissian:	Does it take an emotional toll on you because of how difficult these subjects are?
Mehta:	Not at all. Not at all, no. I don't wring my hands and. . . . That would make it very subjective. I have to be slightly removed from it.

Sarkissian:	Do you mean in order to survive? In order to get through the project?
Mehta:	No, in order to look at it from all angles. I try not to be emotionally involved.
Sarkissian:	I know that your trilogy gets a lot of attention. I wanted to give you an opportunity to talk about another film that you think hasn't gotten enough recognition and that is maybe underappreciated?
Mehta:	One of my favorite films is *Heaven on Earth*. I wish it had gotten more attention. But maybe it will, you never know. It's about displacement. It's about arranged marriages. It's about leaving your home. It's about identity. It's about coping in a different environment. It's about many things that are happening in the world right now. And I think it's really important. I wish we could change a law that any time women migrate to Canada, for example, they get a list of shelters that they can go to. I think something like that is extremely important and I hope a dialogue will start with that. A lot of migrating is happening in the world right now. I think the most vulnerable people are women.
Sarkissian:	Your father used to say that there are two unknowns in life: how a film will do, and when you will die. What does success mean to you?
Mehta:	Success means knowing that your work somehow has made a difference or has started a dialogue. Critical, financial success are all temporary.
Sarkissian:	Speaking of success, the icons of narrative independent cinema in Canada are mostly white men. Aside from you and Sarah Polley, there aren't many contemporary women who have become household names. How do you see yourself fitting into "Canadian cinema" and does this matter to you?
Mehta:	Of course, it matters that there aren't more recognized female directors. Luckily things are changing as we speak. Within the group of younger filmmakers, there are some really talented writer-directors—indigenous, Black, white, and [people of color]—all bringing their stories onto celluloid and enriching Canadian Cinema.
Sarkissian:	Who are some of the directors that are exciting to you?
Mehta:	Charles Officer is very exciting. I think he's really an interesting filmmaker. Alethea Arnaquq-Baril, the young woman who made *Angry Inuk*, which is just fantastic. It's a wonderful film. I think Molly McGlynn is very interesting as well. Federica Foglia is an immigrant filmmaker. She just did a short on the refugee crisis in Italy. Who else? There's Salar [Pashtoonyar] who I think is fabulous. He's an Aghani who did a short film called *Hero*. He's young, he's hungry, and extremely talented. So, there are many of them. I feel very hopeful.

Sarkissian:	Many of your films have been co-productions, with money coming from Canadian government agencies, special funds, and international sources. For those who aren't familiar with Canada's structures, can you explain the advantages and disadvantages of directing films within this system?
Mehta:	It's a huge question that my producer David Hamilton will know how to answer better. I don't know much about it because my producers take care of that. On a creative basis, the funding I did receive has allowed me to tap into Canadian talent which is huge because there are many talented Indo-Canadian actors, editors, cinematographers that don't get much exposure other than politically correct ads.
Sarkissian:	What needs to change for Indo-Canadians or other groups to break into the industry?
Mehta:	The industry has to change. First of all, most films in Canada are funded by the government, and I think it's about time that the government or the Heritage Ministry realize that Canada is a diverse country. That means that people who come here and become Canadian whether they are first generation or second generation, might want to tell stories, their stories, in the language that they feel most comfortable in. You just cannot have it [the funding] limited to French and English and Indigenous languages. I think it all starts with language. Stories start with the language you feel comfortable with. If you have someone from Afghanistan here who has never spoken a word of English and has to do a film in English. That's terrible. The stories get convoluted. The authenticity gets questioned.
Sarkissian:	Do you think that's starting to change with digital?
Mehta:	No. We're talking about movies. You want to see a movie in a movie hall. Where are you going to get the funding from? How limited is it? Sure, you can make a film for $5,000 with your best friends. But what are the chances that it's going to get out there or that it's going to be seen and someone's going to buy it and you'll get some publicity? Very little.
Sarkissian:	Have you come up against challenges because you were a woman, or a woman of color? Do you feel it would have been easier to carve out your path if you were a man?
Mehta:	I personally haven't that experience. Maybe it's because I work in Canada. I was able to create a gangster film without being made to feel like I couldn't do so. Yes, there are preconceived notions that women are not equal to the guys. But Kathryn Bigelow dented the ceiling and so did Patty Jenkins with *Wonder Woman*. I wish I could say [my experience] was negative because that's exactly what you want to hear. But it really isn't. I think I was

just lucky. I came at a time when it wasn't rare. Especially in the arts. I think if I had come to Canada and joined a bank, it would have been very difficult. People were just much more open then. I think it was perhaps a climate that was politically and artistically naive. So, when I made my first film, it was pretty early on. I think the fact that it was successful helped enormously in giving me the freedom to do what I wanted to do. I never felt that on set I was compromised, or that someone came onto me, or that nobody listened to me because I was a woman. I think I'm a strong person, and I don't have a set that screams and shouts. It just didn't happen, sorry to disappoint you.

Sarkissian: I'm not disappointed, I'm thrilled. [*Both laugh*] Do you think if you had moved to the US, you would be telling the same story?

Mehta: I don't know. Had I moved to Timbuktu, would I be telling the same story? I don't know.

Sarkissian: What I mean is, how much of this is a product of the fact that the [Canadian] government provides a lot of the funding?

Mehta: I haven't gotten Canadian funding for most of my films. *Sam & Me* was the most difficult because it was my first film. Telefilm [Canada's main funding body] did not like the script and turned me down. I think we received Ontario funding. Then it got a little easier after that. But when I did *Fire*, there was no government funding. David was the producer on that and it was made mainly through the crew deferring their wages, including mine, and then getting enough money from private sources. *Earth* was done with no government funding. So, I'm not exactly beholden to that.

Sarkissian: During rehearsals, you lead your actors through an extensive workshopping process. I wanted to know more about your own preparation as a director. Whether it's your own script or someone else's, how do you mentally, physically, and emotionally prepare? Do you have any rituals?

Mehta: I go to the gym and get into good physical shape because I think stamina is very important. I do yoga and meditate with more discipline than I usually do. I stop watching other movies and read mindless murder mysteries to clear my mind.

Sarkissian: You mentioned your directing style very briefly, saying you're not the type of person who yells on the set. Can you tell me more about how you like to run your set?

Mehta: Everybody has to be really well prepared as much as they possibly can. I really believe in rehearsals and workshops. I expect actors, when they come on set, to be absolutely as certain as possible. They can't always be 100 percent certain, what their characters are and why they are saying the lines they are. The last rehearsal

they do, I always like to do it on set. I do it with my director of photography and my first AD [assistant director]. We rough it out with the actors—what the movements are going to be. My camera is always motivated by the actors, not the other way around. So, it isn't, that this is the setup and now the actors are going to come in and this is what the actors are going to do because we are going to cover it like this. That's not the way I work. By the time we get to the first day of shooting, we really are pretty much prepped. Shit always happens, but it doesn't faze us.

Sarkissian: Have you felt pressure to "stay in your lane" so to speak, and continue making films like the trilogy, which brought you international attention? Has it been more difficult to branch out into other genres like your gangster film *Beeba Boys* or the Matisse biopic *Masterpiece*? (Is there any news you can share on the Matisse film?)

Mehta: It wasn't difficult. I have done many other films after the trilogy that have been very different: *Midnight's Children, Heaven on Earth, Anatomy of Violence*. But perhaps *Beeba Boys* was the most complicated. Maybe it's as simple as the film did not resonate with people. Or it could be that Indian immigrants are still very wary of being portrayed negatively in a largely white country. What I mean is, if you're an Indian immigrant to Canada, you come into a white society and you want to blend in. You want approval. When people look at Indians they want to think of yoga or Mahatma Gandhi. At least that's what would come to mind some time ago. You know, it's changing now. A lot of Indian immigrants and immigrants [of color] want to fit in and not make any waves or have themselves portrayed in a negative way. And Canadians are largely really polite people and they feel very uncomfortable when they see people [of color] portrayed negatively because it's not "politically correct." There are always different opinions. People like happy films about immigrants or folk dancers. The Matisse film has long been shelved, maybe it'll get revived again. . . . I'll let you know.

Sarkissian: After *Water* was nominated for the Oscar, Hollywood came calling and you received many offers. In the end, you turned them down. Can you tell us about that process and why you ultimately made the decision to stay independent?

Mehta: There were really good offers and though I did think about a couple of them, I realized very soon that there was no way that I could have creative control. And that's the reality of it. I wanted to make my own films on my own terms. It's not a criticism but that's how the system in Hollywood is, maybe it's changing now, I don't know.

Sarkissian: The #MeToo and #TimesUp movements have been dominating the headlines since last fall. I was curious to get your thoughts on the current state of the industry. Will we see genuine change or is this lip service?

Mehta: I certainly hope it's not lip service, and I don't think it is. I hope it has a lasting effect. I think that it's really good that it's happened. There's going to be collateral damage of course, whenever something like this happens. But it's been a long time coming and I hope it sustains itself.

Sarkissian: There is an incredible amount of work that goes into making a film that has nothing to do with directing. The meetings, the pitches, the networking . . . it can take years of prep to get a project off the ground and sometimes it goes nowhere. How much of the business side are you involved with? Can you describe your working relationship with David Hamilton, your producer and partner?

Mehta: I wouldn't have been able to work without David. I think I have close to zero percent business sense. We have one rule: if he makes a suggestion, say for example he says, "We don't really need a crane," I can't reply to him for 24 hours and have to think about it first because usually my initial instinct is to want everything.

Sarkissian: You've worked with the same producer, cinematographer, actors, and even distributor on multiple projects throughout the years. For you, what are the keys to a successful creative collaboration?

Mehta: All of us have to share the same vision, have to have the same take on the script and then because we trust each other they can add their own perceptions to the work. But sometimes it is really nice to work with new people, because it's adventurous.

Sarkissian: If you didn't have to worry about money or logistics, do you have a dream project in mind? Who would you work with and who would you cast?

Mehta: I'd love to work with Cate Blanchett. She's one of the most versatile actors I know. She inhabits every role that she's ever played, whether it's *Elizabeth* (1998) or something as crappy as *Ocean's 8* (2018). She just has such integrity—it's amazing. And I think Chivo [Emmanuel Lubezki] is one of the most brilliant cinematographers ever. *The Revenant* (2015) is stunning.

Sarkissian: What new challenges are you seeking out? And what can we expect from you next?

Mehta: Every project is challenging. A film becomes less challenging only when it's released. We're working on *Funny Boy*, based on the book by Shyam Selvadurai. It's an evocative coming-of-age novel based in Sri Lanka during the Tamil-Sinhalese conflict— one of the country's most turbulent and deadly periods.

Sarkissian: What drew you to this project?

Mehta: These are difficult political times I feel. There is such paranoia about "the other." It struck me that *Funny Boy* which is partly about "the other" as far as sexuality is concerned . . . but the background is civil war in Sri Lanka, which like all civil wars is about fighting "the other" or somebody who is different than you. Of course, it's based on economy and power struggles also. *Funny Boy* seems very important and something that I wanted to explore about what it is that makes us uncomfortable about someone who is different from us.

Notes

1. Deepa Mehta, "Email Exchange With Author" (July 11, 2018).
2. In 1989, the Iranian leader Ayatollah Ruhollah Khomeini declared that Salman Rushdie's novel, *The Satanic Verses* insulted Islam and issued a fatwa, calling for Rushdie's death. Andrew Anthony, "How Salman Rushdie's Satanic Verses Has Shaped Our Society," *The Guardian* (January 11, 2009), sec. Books, www.theguardian.com/books/2009/jan/11/salman-rushdie-satanic-verses
3. Daphne Bramham, "Canadian Director Deepa Mehta Talks About Everything From Film to Food," *Ottawa Citizen* (September 28, 2012), www.ottawacitizen.com/entertainment/movies/canadian-director-deepa-mehta-talks-about-everything-from-film-to-food
4. University of Toronto, "University of Toronto: Deepa Mehta, Convocation 2011 Honorary Degree Recipient" (2011), www.youtube.com/watch?v=xvnAujhqXK8
5. Deepa Mehta. Interviewed by Anna Sarkissian, June 2018.
6. Ibid.
7. Indian Summer Festival Canada, "'I Don't Want To Choose' Deepa Mehta and Jeet Thayil on Identity and Art" (Vancouver, 2013), www.youtube.com/watch?v=hG1xNYt6b3Y
8. Ibid.
9. Nelson Pressley, "The Churning Mind of Deepa Mehta," *The Washington Post* (May 7, 2006), www.washingtonpost.com/wp-dyn/content/article/2006/05/05/AR2006050500405.html
10. Deepa Mehta, "Deepa Mehta Shares Her Journey in Film (Death Threats Included)," *TIFF* (July 30, 2017), www.tiff.net/the-review/deepa-mehta-journey-in-film/index.html
11. Deepa Mehta. Interviewed by Anna Sarkissian, June 2018.
12. George Csaba Koller, "Sunrise Goes East," *Cinema Canada*, no. 21 (September 1975): 29.
13. Gerry Flahive, "Young Hands, Old Skills," *Cinema Canada*, no. 62 (February 1980): 14–17.
14. Patricia Kearns, "Deepa Mehta Saltzman, Norma Bailey and Danièle J. Suissa's Martha Ruth & Edie," *Cinema Canada*, no. 157 (November 1988): 30.
15. Deepa Mehta, "Deepa Mehta Shares Her Journey in Film (Death Threats Included)," *TIFF* (July 30, 2017), www.tiff.net/the-review/deepa-mehta-journey-in-film/index.html
16. Ibid.
17. Dipanita Nath, "Keeping the Flame Alive: What Made Deepa Mehta's Fire Such a Pathbreaking Film," *The Indian Express* (March 20, 2016), https://indianexpress.com/article/entertainment/bollywood/keeping-the-flame-alive-what-made-deepa-mehtas-fire-such-a-pathbreaking-film/
18. Ibid.
19. Women in the World, "Deepa Mehta on India's Reaction to Her Film 'Fire'—YouTube" (November 20, 2015), www.youtube.com/watch?v=1Nv6e4FPeu0

20. Geoffrey Macnab, "Deepa Mehta: A Director in Deep Water—All over Again," *The Independent* (May 19, 2006), www.independent.co.uk/arts-entertainment/films/features/deepa-mehta-a-director-in-deep-water-all-over-again-478731.html

21. Women in the World, "Deepa Mehta on India's Reaction to Her Film 'Fire'—YouTube" (November 20, 2015), www.youtube.com/watch?v=1Nv6e4FPeu0

22. Ibid.

23. Dipanita Nath, "Keeping the Flame Alive: What Made Deepa Mehta's Fire Such a Pathbreaking Film," *The Indian Express* (March 20, 2016), https://indianexpress.com/article/entertainment/bollywood/keeping-the-flame-alive-what-made-deepa-mehtas-fire-such-a-pathbreaking-film/

24. Roger Ebert, "Earth Movie Review & Film Summary (1999)," *RogerEbert.com* (October 15, 1999), www.rogerebert.com/reviews/earth-1999; Stephen Holden, "FILM REVIEW; India Torn Apart, as a Child Sees It," *The New York Times* (September 10, 1999), sec. Movies, www.nytimes.com/1999/09/10/movies/film-review-india-torn-apart-as-a-child-sees-it.html

25. Aseem Chhabra, "Rediff On The Net: What Lies Between 'Earth' And An Oscar," *rediff.com* (December 11, 1999), www.rediff.com/news/1999/dec/11us.htm

26. Bilal Qureshi, "The Discomforting Legacy of Deepa Mehta's Earth," *Film Quarterly* (blog), (June 12, 2017), https://filmquarterly.org/2017/06/12/the-discomforting-legacy-of-deepa-mehtas-earth/

27. Edwina Mason, "The Water Controversy and the Politics of Hindu Nationalism: South Asia," *Journal of South Asian Studies*, 25, no. 3 (2002): 253.

28. Ibid., 258.

29. IMDb, "Deepa Mehta Awards," *IMDb* (2018), www.imdb.com/name/nm0576548/awards.

30. Elisabeth Bumiller, "Film Ignites the Wrath of Hindu Fundamentalists," *The New York Times* (May 3, 2006), www.nytimes.com/2006/05/03/movies/03wate.html

31. Ibid.; Deepa Mehta, "Deepa Mehta Shares Her Journey in Film (Death Threats Included)," *TIFF* (July 30, 2017), www.tiff.net/the-review/deepa-mehta-journey-in-film/index.html

32. Ibid.

33. David L. Pike, *Canadian Cinema Since the 1980s: At the Heart of the World* (Toronto: University of Toronto Press, 2012).

34. Radheyan Simonpillai, "How Deepa Mehta Mastered the Art of Telling Stories Only an Indo-Canadian Could Tell | CBC Arts," *CBC* (September 8, 2017), www.cbc.ca/arts/the-filmmakers/how-deepa-mehta-mastered-the-art-of-telling-stories-only-an-indo-canadian-could-tell-1.4281637

35. Rediff, "The Rediff Interview/S Gurumurthy," *rediff.com* (March 31, 2000), www.rediff.com/news/2000/mar/31inter.htm

36. Madhu Kishwar, "Naive Outpourings of a Self-Hating Indian," *Manushi*, no. 109 (November 1998): 12.

37. Kamal Arora, Saydia Kamal, and Usamah Ahmad, "Water: Drenched in Colonial Benevolence," *Seven Oaks* (October 5, 2005), https://web.archive.org/web/20080516091547/www.sevenoaksmag.com/commentary/81_comm4.html

38. Ibid.

39. Governor General's Performing Arts Awards, "Award Recipients—Governor General's Performing Arts Awards (GGPAA)," *Governor General's Performing Arts Awards* (2012), https://ggpaa.ca/award-recipients/mehta-deepa.aspx

40. Alliance of Women Film Journalists, "AWFJ Announces 2006 EDA Awards Winners," *Alliance of Women Film Journalists* (December 17, 2006), http://awfj.org/blog/2006/12/17/awfj-announces-2006-eda-awards-winners/

41. Governor General's Performing Arts Awards, "Award Recipients—Governor General's Performing Arts Awards (GGPAA)." https://ggpaa.ca/award-recipients/mehta-deepa.aspx

42. The Office of the Secretary to the Governor General, "Governor General Announces 74 New Appointments to the Order of Canada," *The Governor General of Canada* (2013), www.gg.ca/document.aspx?id=15215
43. Ministry of Citizenship and Immigration, "25 Appointees Named to Ontario's Highest Honour," *Government of Ontario* (January 31, 2013), https://news.ontario.ca/mci/en/2013/01/25-appointees-named-to-ontarios-highest-honour.html
44. Canada's Walk of Fame, "2016 Canada's Walk of Fame Inductee: Deepa Mehta," *Canada's Walk of Fame* (2016), www.canadaswalkoffame.com/inductees/2016/deepa-mehta
45. The RSS is a right-wing Hindu organization.

15

TRINH T. MINH-HA (1952–)

Benjamin Schultz-Figueroa and Patricia Alvarez Astacio

In many ways, Trinh T. Minh-ha's work resists the undertaking of this book to present biographical portraits. As readers of the following interviews and essay will see, Minh-ha actively rejects attempts to locate the origins of her films in singular life events. She warns against assuming "that there's such a thing as a 'natural' link between what happened in your individual life and the kind of work you do."[1] This sentiment is consistent with her films, which also upend any neat relationship between filmmaker and filmed subject. They radically disrupt both the impersonal gaze of ethnographic cinema and the self-situating moves of reflexive documentary, claiming neither to voyeuristically reveal truths about an already constituted Other, nor to situate herself as a singular, separate Self. Rather, she describes the process through which her films let "the world come to oneself rather than claiming to 'discover' it" by remaining "attentive to how reality speaks in its infinite manifestations."[2] Within the shifting terrains that comprise each film, she urges viewers to let the work speak for itself and refrain from the temptation to label.

In spite of, or perhaps because of this resistance to categorization, Minh-ha's films have had a massive impact on both the fields of documentary and anthropology. As she problematizes the category of "origins," biographical or other, we will briefly describe her career and vast accomplishments. Aside from completing her Baccalauréats in Saigon, Minh-ha also studied piano and music composition at the National Conservatory of Music and Theater before moving to the US in 1970, where she attended University of Illinois, Urbana-Champaign, specializing in French literature, music, and ethnomusicology. After receiving her Ph.D., she taught in several universities in the US and abroad and is currently Professor of Gender & Women's Studies and Rhetoric at University of California, Berkeley. In addition to her films—which include *Surname Viet, Given Name Nam* (1989), *Shoot for the Contents* (1992), *A Tale of Love* (1995), and most recently *Forgetting Vietnam* (2015; 2016), among others—she has created numerous musical compositions, books of

philosophy, theory, ethnography, and poetry, and has designed several pieces of installation art. Despite broad acclaim, Minh-ha's works, in particular her films, remain controversial. As she described for us, viewers continue to struggle with her films' "refusal to comply with their normative expectations and to turn the mirror around to look at themselves."[3] Throughout her artistic and academic work, Minh-ha's irrepressible interdisciplinarity is clear. She constantly warps the boundaries between specialized forms of knowledge by asking "basic questions that undo constructs taken for granted, make one lose one's bearings, and hence compel one to restart or *re-assemble* anew."[4]

This process can be experienced in viewing her films. Her first film, *Reassemblage* (1982), weaves together fragmented scenes from Senegal and Minh-ha's own ruminations on the nature of documentary encounters. Following the film's release, in an interview for *The Independent Film & Video Monthly*, she lists the many ways it diverges from or subverts the tenants of anthropological filmmaking through the film's structure, which refuses to synthesize singular important events; its framing of subjects, in which "even the wild animals come back and stare at you"; and in its absence of omniscient voiceover, which she describes as the "voice of culture." Perhaps unsurprisingly, anthropologists were resistant to the critiques of anthropological modes of observation and knowledge production posed in Minh-ha's film and written work. As An van Dienderen describes, this disciplinary defense often took the form of either dismissing Minh-ha as simply "an experimental filmmaker" who indulged in purely formalistic flourishes or as an interloping outsider who failed to properly comprehend the history of anthropological self-reflexivity. As Dienderen writes, "the politicization of the aesthetic experience through a critical and often ironic subversion of Western categorization that *Reassemblage* put into practice made it a pioneering work in experimental documentary and post-colonial studies."[5] The "spirit of South-South solidarity" embodied in her films and writing has made her work crucial for intersectional feminism and post-colonial theory.

Reassemblage broadly displays the major tenets of Minh-ha's filmmaking practice, even as her topics and techniques change. In our interview with her, she describes her filmmaking as a process in which the "what" and the "how" of each film feed into one another, where the texture and movements of a depicted event dictate how it is framed by the film. Darkened Burkina Faso homes in *Naked Spaces. Living is Round*; train rides in *The Fourth Dimension* (2001) and *Night Passage* (2004) that transport us through multiple yet simultaneous temporalities and between life and death or the infinite within the finite; and structures of forgetting and remembering in *Forgetting Vietnam* are reproduced in the editing and cinematography of each film. Here, the details of daily experience are multiplied and amplified, plunging audiences into complex musings of seemingly simple occurrences in ways that trouble the distinctions between cinematic subjects, the camera, and the gazes of the filmmaker and film audience.

In our interview, Minh-ha locates the politics of her work in this process. She describes how feminism's politicization of the personal hinges on the ungluing of everyday and mundane events, which elude our attempts to contain or frame them.

As she writes: "It is where the familiar could turn out to be *extra*-ordinary."[6] Her films work to open up this possibility, in which a momentary gesture, the repeated actions of a well-practiced task, or the rituals of daily life, can become catalysts for considering the infinite elements binding and defining each moment, as well as the multiplicity of connections between seemingly different selves, cultures, and communities. Through a reverent attention to the everyday and a multi-faceted tracing of its expansive connections to history, spirituality, and ideology, Minh-ha's films lead audiences into transformative, unexpected, and subversive journeys. As Minh-ha concludes: "Acts of creativity and of transformation maintain our relation to infinity."[7]

This chapter includes an interview with Minh-ha from 1983 and an essay by Minh-ha from 1987 both originally published in *The Independent Film & Video Monthly*, as well as an original interview with Minh-ha from 2018.

Ways of Seeing Senegal: Interview With Trinh T. Minh-ha

Kathleen Hulser/December 1983

The Independent Film & Video Monthly

"Scarcely 20 years were enough for two billion people to define themselves as underdeveloped," says Trinh T. Minh-ha at the outset of *Reassemblage*. From this perspective, she launches her meditation on Senegal and colonialism, creating a film not so much about the reality she encounters as about her perception of that reality. Full of brief but rich images of women at work in villages throughout the length and breadth of Senegal, the film flashes by in rapid edits that replicate the filmmaker's impressions. Her visions range from the gasping emaciated body of a collapsed cow in a dry hollow to the denuded trees in the Sahel plain during a sandstorm to the quiet early morning concentration of a weaver by the riverbank.

Using a hand-rewind Bolex 70D and shooting no synch sound at all, Minh-ha captures a glimpse of beauty and death without wallowing in the scenic exoticism so fatal to the National Geographic format. On the other hand, with her persistent first-person voiceover, the film also distinguishes itself from the explanatory anthropological approach.

When shown last year in various public and social science milieus, *Reassemblage* elicited reactions from walk-outs and denunciations to enthusiasm and praise. For example, at the Women's Film Festival last spring in Washington DC, *Reassemblage* attracted favorable notice. But at the Women's Film Festival in New York this fall, it drew criticism both for saying too little and too much: too little because the filmmaker chose not to translate conversations; too much because Minh-ha's voiceover governed the meaning of the images. Likewise, film professionals attending the summer Flaherty Film Seminar divided between those who decried the lack of clear information and those who delighted in the art.

Minh-ha has fielded the divergent comments in these screenings and discussions with a serene demeanor and an acute articulation of her purposes: to abandon the

slippery empiricism of the "scientific" posture and to begin to see and hear the humanity of her subjects, beyond the stock images of underdevelopment.

Looking at its gorgeous resolution and listening to its fine soundtrack (recorded with a very small Sony TCD 5M), one would hardly suspect that this was her first film. A believer in doing the maximum possible amount of work herself to make the film the product of "one eye," Minh-ha spent four months editing in Oklahoma and, later, Berkeley, CA.

Kathleen Hulser:	What was your relationship to the people you were filming? How much time did you spend in each village, and how did your subjects understand your purpose?
Trinh T. Minh-ha:	I made contacts well before shooting, visiting each village several times. I would stay from three days to a week each time. The film is not about a single village, it's about the whole of Senegal, with maybe a dozen different villages.
Hulser:	Does the film reflect the country's geography? What is your structure?
Minh-ha:	The order is very simple: the order in which I traveled.
Hulser:	So it is the geography.
Minh-ha:	Yes, since my intent is to invite the spectator to travel with me and discover with me, as I discovered it myself. I didn't want to give a synthetic view, nor a reconstruction of what I saw. For example, if you want to show a dance in a village, you come into the village and inquire about it and gradually discover the dance. But films usually lead the spectator to the dance immediately, or show people sculpting masks and then preparing for the dance in a totally reconstructed order.

You can't categorize *Reassemblage* as an art film or experimental film. It's a documentary, but taken to an outer limit. I would like people to understand an action not through verbal explanation, but through a certain continuity. For example, what I first heard when I came into a village was the sound of women pounding corn, so this is what the viewer hears first, before seeing the women. But since you already hear the sound it's not necessary to let it go on till the very moment when you see the grain, so I cut it and let it return later. This makes the viewer actually much more aware of the sound.

Hulser:	Were the people in *Reassemblage* accustomed to being the subject of anthropological research?
Minh-ha:	Yes, especially in northern Senegal. But in some villages you feel the presence of foreigners less, and those were the nicest villages because you wouldn't be accosted by children asking for gifts and expecting a lot of things from tourists and foreigners.

Hulser:	How did you distinguish your purpose from the regular scientific task of the anthropologist?
Minh-ha:	First, I never catch people unawares. When I first arrived my idea was to catch people while they were working or while they were not looking at the camera: a very conventional documentary approach. But I realized that it is almost an illusion, because once I put the camera down, the action would change. So I preferred to stay there for several hours until the people were totally aware of the camera and then start shooting.
Hulser:	So you wanted to avoid the traditional "unselfconscious" performance with people acting as if the camera wasn't there?
Minh-ha:	Yes. In my film people constantly look at the camera, and even animals like the wild boar come back and stare at you.
Hulser:	At one point in the film you said the women washing clothes in the river invited you to film them.
Minh-ha:	I had several invitations. Women would come and lead me to a place where they all gathered.
Hulser:	Did these invitations to film reveal the women's assumptions about what they thought you wanted?
Minh-ha:	I don't think they knew what I wanted as an image but they did know that I was interested in filming women. So they would bring their children over and they'd sit around and just talk and I could film whatever I wished. On the other hand, they also expected that whenever they invited me to film them, they would get photographs afterwards. This is also, perhaps, why they loved to invite me. I sent them the photos, and last summer when I went back those who had received them were very happy. I also noticed that it's much more difficult for men to take pictures of women than it was for me.
Hulser:	When you refer to *Reassemblage* as anti-anthropological what exactly do you mean?
Minh-ha:	The film is an outgrowth of reflections that I've had on anthropology, but the film is not just on anthropology. There is no way that one can approach a complex issue by reducing it to just one film. When I refer to the anthropological context, in what I would call polemical statements, they are not an assertion of a position or a judgment but simply statements that open into questions.

I stayed away from the ethnocentric illusion that objectivity lies in "the other." In order to legitimize what they say, ethnologists and anthropologists usually insert some kind of voice from the person they are filming, to give an inkling of objectivity. This is

not what I was after. The whole film was a reflection, and I tried to speak *as close* to the people as possible. But it's not speaking *for* them or *about* them.

Hulser: So you are saying that your narration explicitly attempts to pose problems—the problems not of the village but of the eye that sees the village.

Minh-ha: Yes. Just reflections—"problems" is probably too strong a word. Let's say that it poses some questions to the person who looks at the culture and the person looking back in the film.

Also, sometimes filmmakers haven't thought enough about how to explain through images, so they need this voice to tell you what happened, because the visual side has not been developed. So another aspect of my film, when compared to anthropological films, is the absence of the omniscient narrative voice, what I call the voice of culture, that one constantly hears in those films at the Margaret Mead Film Festival. That voice gives a very logical explanation, but besides that explanation there is nothing. I don't feel what the narrator feels, I don't know how he discovered the culture, how the people felt about him and so on. It's actually an empty scheme of what the culture might be.

Hulser: It's depersonalized, generalized. Instead of a person talking about how they feel when hoeing yams, you have a generalized statement about the agriculture of yams in this area.

Minh-ha: Exactly.

Hulser: It makes one person stand for the whole of the culture.

Minh-ha: There's no room for me to fit in when I hear those kinds of documentaries.

Hulser: What's the relationship of the soundtrack and the image in your film?

Minh-ha: If I start with the southern part of Senegal, the Casamance, then I have the music of Casamance and the Casamance people at the same time. But afterwards this music can come back when the images are of other parts of Senegal, but this time it refers to myself. For example, the film begins and ends with Jola music. At the beginning, you hear the music of the people you see, but at the end of the film, when I'm in the northern part of Senegal, you hear it again because it has become the music that *I* hear when I work on the images. The music enters me sometimes.

Hulser: So it's a memory of your journey, not what you heard in a specific place?

Minh-ha: Yes. The same thing happens with the second sequence, in Serer country. You hear the voice of the people talking in Serer language. But when afterwards you go to the Manding people, who live in another region, you hear that first voice again. It comes back. So there is one part of the film created by putting things from the same region together, and there is another part which is me, how I hear a voice repeatedly, how it haunts me.

Hulser: You mean like the place where you looped that phrase with the repeated vowels?

Minh-ha: Yes, what strikes me is the sound. This is another way for me to approach documentary: by the auditive side, and the visual side, rather than just verbally.

Hulser: To move on to another topic, one sequence in *Reassemblage* struck me as particularly brutal: the one where there's the woman with the very sunburned little white kid whose skin looks like he's been on fire—it's painful! What do you mean by that sequence? I read it as saying white people are so ill-adapted to the West African climate that they literally burn up.

Minh-ha: It's not a white person; it's an albino. I didn't think at all about what you mention. I took that shot because I was struck by this woman who had her child on her back as she worked all the time. To me it was just the sight of the child on her back. In fact, the nicest thing is that in the villages albinos are, most of the time, considered a godsend.

Hulser: With your colorful images and rather seductive atmosphere and everyone smiling into the camera, the film implies that the people are content, there are no problems, there's no conflict. I thought *Reassemblage* threatened to partake of the romantic exotic, in spite of the inclusion of the big fires, the sandstorm, and the dying animals.

Minh-ha: Happiness *is* there in spite of those aspects (which are not very pleasing for Africans to look at). You have life and death together all the time. If I wanted to be romantic I would have chosen some other kind of music.

Hulser: . . . more soothing?

Minh-ha: Or drums beating constantly, which is the usual kind of romanticism about Africa. But I only use fragments of drums, plus the voices of people—even the scream of a woman. I received a comment which might show you that the film is not so romantic: a Black American woman told me she was very upset because the film didn't glorify Africa enough. To her I was very voyeuristic. But for me simply holding the camera is voyeuristic.

Hulser:	Voyeurism is intrinsic to filmmaking?
Minh-ha:	I emphasized in the film that when we are always stealing images from people, we are in that sense voyeurs. I didn't deny it at all. And I never changed anything in the image, arranging things or taking out things.
Hulser:	Well, then where were the radios or plastic cups?
Minh-ha:	They are there, but because of the way I film, in remote villages, these things are so discrete that one does not notice them. But let's say that the choice to go to those remote villages was probably already made at the beginning.
Hulser:	You are planning to do some other films on Africa dealing with social and spiritual space. Why do you choose Africa?
Minh-ha:	There is one line in the film where I said that I do not feel the need to express myself. The statement was shown with the image of the man weaving. To some people, if you don't feel the need to express yourself anymore, it's a loss. But to me, it's like a constant weaving, it continues, and I do not express myself in this film so much as let myself be impressed by the reality that I confront. This is what I felt most in Africa: this challenge, this interaction between experiencing and impressing things, receiving and projecting things.
Hulser:	So that insofar as this is not an anthropological film, it is also not, at the other pole, an act of claiming your creative "right" to express yourself as an artist?
Minh-ha:	Oh no, it's not that at all. That is a very important point to raise because some people think that because I criticize objectivity, the film is therefore subjective. But in fact for me there is no pure objectivity or subjectivity. The two are always interacting. There is always a tendency to go to a more egocentric or anecdotal kind of film, where you talk about your experiences. But this is not what I wanted to do in the film. What I would like to do is go beyond that cleavage between subject and object, between subjectivity and objectivity, while always emphasizing that reality exists through an eye, that it doesn't exist as an absolute.

Questions of Images and Politics

Trinh T. Minh-ha/May 1987

The Independent Film & Video Monthly

Let me start by asking myself: What do I expect from a film? What I expect is borne out by what I work at bringing forth in my films. The films I make, in other words, are made to contribute to the body of film works I like and would like to see.

Through the way it is made, the way it relates to its subject, as well as through the viewers' receptions, I expect that it solicits my critical abilities and sharpens my awareness of how ideological patriarchy and hegemony work.

The commercial and ideological habits
of our society favor narrative with as
definite a closure as possible once the
narration is consumed one can throw
it away and move on to buy another one
clear linear entirely digestible

There is more and more a need to make film politically (as differentiated from making political films). We are moving here from the making of a genre of film to the making of a wide range of genres of film in which the making itself is political. Since women have for decades worked hard at widening the definition of "political," since there is no subject that is "apolitical" or too narrow, but only narrow, apolitical representations of subjects, a film does not necessarily need to attack governmental institutions and personalities to be "political." Different realms and levels of institutional values govern our daily lives. It is therefore in working at shaking any system of values, starting with the system of cinematic values on which its politics is entirely dependent, that a politically made film takes on its full significance.

never installed within transgression
never dwells elsewhere

Patriarchy and hegemony. Not really two, not one either. My history, my story, is the history of the First World/Third World, dominant/oppressed, man/woman relationship. When speaking about the Master, I am necessarily speaking about both Him and the West. Patriarchy and hegemony. From orthodox to progressive patriarchy, from direct colonization to indirect, subtly pervasive hegemony, things have been much refined, but the road is still long and the fight still goes on.

> *It is thrilling to think—to know that for any act of mine, I shall get twice as much praise or twice as much blame. It is quite exciting to hold the center of the national stage, with the spectators not knowing whether to laugh or to weep.*
> —Zora Neale Hurston

Hegemony is most difficult to deal with because it does not really spare any of us. Hegemony is established to the extent that the worldview of the rulers is also the worldview of the ruled. It calls attention to the routine structures of everyday thought, down to common sense itself. In dealing with hegemony, we are not only challenging the dominance of Western cultures, but also their identities as unified cultures. In other words, we call attention to the fact that there is a Third World in every First World and vice-versa. The Master is made to recognize that his culture is neither homogeneous nor monolithic, that he is just an other among others.

Trinh T. Minh-ha (1952–)

One's sense of self is always mediated by the image one has of the other. (I have asked myself at times whether a superficial knowledge of the other, in terms of some stereotype, is not a way of preserving a superficial image of oneself.)
—Vincent Crapanzano

What every feminist, politically made film unavoidably faces is at once: 1. the position of the filmmaker, 2. the cinematic reality, and 3. the viewers' readings. A film, in other words, is a site that sets into play a number of subjectivities: those of the filmmaker, the filmed subjects, and the viewers (including here those who have the means or are in a position to circulate, expose, and disseminate the films).

The stereotyped quiet, obedient, conforming modes of Japanese behavior clashed with white expectations of being a motivated, independent, ambitious thinker.
When I was with whites, I worried about talking loud enough; when I was with Japanese, I worried about talking too loud.
—Joanne Harumi Sechi

Walking erect and speaking in an inaudible voice, I tried to turn myself American-feminine. Chinese communication was loud, public. Only sick people had to whisper.
—Maxine Hong Kingston

The assumption that the audience already exists, that it is a given, and that the filmmaker has to gear her making towards the so-called needs of this audience is an assumption that seems to ignore that needs are made and audiences are built. What is ideological is often confused with what is natural—or biological, as often implied in women's context. The media system as it exists may be most efficient for reaching the audience desired, but it allows little direct input from the audience into the creative process (critics and citizen groups are not defined as part of the audience, for example).

A responsible work today seems to me above all as one that shows, on the one hand, a political commitment and an ideological lucidity, and is, on the other hand, interrogative by nature, instead of being merely prescriptive. In other words, a work that involves her story in history; a work that acknowledges the difference between lived experience and representation; a work that is careful not to turn a struggle into an object of consumption and requires that responsibility be assumed by the maker as well as by the audience, without whose participation no solution emerges, for no solution exists as a given.

The logic of reaching "everybody" often encourages a leveling of differences—a minimum of elements that might offend the imaginary average viewer, and a standardization of content and expectations.

Apartheid precludes any contact with people of different races which might undermine the assumption of essential difference.
—Vincent Crapanzano

Working against this leveling of differences is, also, resisting that very notion of difference, which defined in the Master's terms, always resorts to the simplicity of essences. Divide and conquer has for centuries been his creed, his formula of success. But a different terrain of consciousness is being explored for some time now. A terrain in which clear-cut divisions and dualistic oppositions such as counter-cinema versus Hollywood, science versus art, documentary versus fiction, objectivity versus subjectivity, masculine versus feminine may serve as departure points for analytical purpose, but are no longer satisfactory, if not entirely untenable to the critical mind.

What does present a challenge is an organization that consists either in close association or in alliance of black, white, Indian and Coloured. Such a body constitutes a negation of the Afrikaans' theory of separateness, their medieval clannishness.

 —Ezekiel Mphahlele

I have often been asked about what some viewers call the "lack of conflicts" in my films. Psychological conflict is often equated with substance and depth. Conflicts in Western contexts often serve to define identities. My suggestion to this so-called lack is: Let difference replace conflict. Difference as understood in many feminist and non-Western contexts, difference as foregrounded in my film work, is not opposed to sameness, nor synonymous with separateness. Difference, in other words, does not necessarily give rise to separatism. There are differences as well as similarities within the concept of difference. One can further say that difference is not what makes conflict. It is beyond and alongside conflict. This is where confusion often arises and where the challenge can be issued. Many of us still hold on to the concept of difference not as a tool of creativity—to question multiple forms of repression and dominance—but as a tool of segregation—to exert power on the basis of racial and sexual essences. The apartheid-type of difference.

difference, yes, but difference
within the border of your homeland, they say
White rule and the policy of ethnic divisions

Let me point to a few examples of practices of such a notion of difference.

The positioning of voices in film. In documentary practice, for example, we are used to hearing either a *unified* voiceover, or a string of *opposing, clashing* views from witnesses which is organized so as to bring out objectively the so-called two sides of an event. So, either in unification or in opposition. In one of my films, *Naked Spaces,* I use three different voices to bring out three modes of informing. The voices are *different,* but *not opposed* to each other, and this is precisely where a number of viewers have reading problems. Some of us tend to consume the three as one because we are trained to not hear how voices are positioned and to not have to deal with difference other than as opposition.

The use of silence. On the one hand, we face the danger of inscribing femininity as absence, as lapse and blank in rejecting the importance of the act of enunciation. On the other hand, we understand the necessity to place women on the side of negativity (Kristeva) and to work in "undertones" (Irigaray) in our attempts at undermining patriarchal systems of values. Silence is so commonly set in opposition with speech. Silence as a will not to say or a will to unsay, a language of its own, has barely been explored.

The Veil. (As I stated elsewhere), if the act of unveiling has a liberating potential, so does the act of veiling. It all depends on the context in which such act is carried out, or more precisely, on how and where women see dominance. Difference should neither be defined by the dominant sex nor by the dominant culture. So that when women decide to lift the veil, one can say that they do so in defiance of their men's oppressive right to their bodies; but when they decide to keep or to put back on the veil they once took off, they may do so to reappropriate their space or to claim anew difference, in defiance of genderless hegemonic standardization. (One can easily apply the metaphor of the veil here to filmmaking.)

Making films from a different stance supposes 1. a re-structuring of experience and a possible rupture with patriarchal filmic codes and conventions; 2. a difference in naming the use of familiar words and images, and of familiar techniques in contexts whose effect is to displace, expand or change their preconceived, hegemonically accepted meanings; 3. a difference in conceiving "depth," "development," or even "process" (processes within processes are, for example, not quite the same as a process or several linear processes); 4. a difference in understanding rhythms and repetitions—repetitions that never reproduce nor lead to the same ("an other among others" as mentioned earlier); 5. a difference in cuts, pauses, pacing, silence; 6. a difference, finally, in defining what is "cinematic" and what is not. The relationship between images and words should render visible and audible the "cracks" (which have always been there; nothing new . . .) of a filmic language that usually works at gluing things together as smoothly as possible, banishing thereby all reflections, supporting an ideology that keeps the workings of its own language as invisible as possible, mystifying hereby filmmaking, stifling criticism, and generating complacency among both makers and viewers.

Working with differences requires that one faces one's own limits so as to avoid indulging in them, taking them for someone else's limits; so as to assume one's capacity and responsibility as subject working at modifying these limits. The patriarchal conception of difference, as we have seen together, relies heavily on biological essences. In refusing such a contextualization of difference, we have to remain aware of the necessary dialectics of closure and openness. If, in breaking with patriarchal closures, feminism leads us to a series of musts and must-nots, then this only leads us to other closures. And these closures will then have to be re-opened again so that we can keep on growing and modifying the limits in which we tend to settle down.

Difference is not otherness. And while otherness has its laws and interdictions, difference always implies the interdependency of these two-sided feminist gestures:

that of affirming "I am like you" while pointing insistently to the difference, and that of reminding "I am different" while unsettling every definition of otherness arrived at.

A Conversation With Trinh Minh-ha

Benjamin Schultz-Figueroa and Patricia Alvarez Astacio/2018

Benjamin Schultz-Figueroa and Patricia Alvarez Astacio: All of your films pose incisive critiques of popular and scientific uses of cinematic language. Since your very first film, Reassemblage, you have consistently deployed a critique of both the ethnographic gaze and its expression through film form. Given this backdrop, can you narrate your decision to become a filmmaker yourself? How did you come to see film as a format from which to theorize and develop a critical engagement with documentary cinema, ethnographic practice, and feminism?

Trinh T. Minh-ha: There was no predetermined decision involved. The way I came to filmmaking happened quite accidentally in 1980, when I just returned to the States from three years of research and teaching music in Senegal. The decision to leave Senegal was most difficult but necessary, for substantial educational reasons that I have already discussed and would not come back to here. I had many friends there and it took a lot to move from a vibrant, collective lifestyle in Dakar to a rather dreadful, isolated and highly individualistic university context in Norman, Oklahoma—where I was marooned after having been promised a job that never came through. Life could be so unpredictable, for it was during this most depressing passage that out of the blue, I began learning the ropes of filmmaking. I befriended a number of artists teaching at the university there, and was introduced to the arts and crafts of cinema through the generous exchanges I had with the filmmaker Deborah Meehan, who now teaches at Pratt in New York. It was with her and her assistant Charlie Woodman that I learnt—literally from A to Z, including the skills of negative cutting and AB rolling—how to make films independently from the mercantile demands of the film industry. Without knowing it at the time, they had awakened in me great interest for a non-conforming, liberating film practice. Just when I felt I had hit rock bottom and was literally groping in the

dark, I also experienced a new, unexpected beginning— through the proverbial light of cinema at the end of the tunnel.

Filmmaking happens to offer a wonderful way to pull together the many interests I have across what is known as the arts, the humanities, and the social sciences. I don't really operate with labels and categories as references. These may come with the need to confine and control, and with the way society compartmentalizes knowledge, but what is most refreshing despite the discomfort gen- erated are the basic questions that undo constructs taken for granted, make one lose one's bearings, and hence compel one to restart or *re-assemble* anew. In non-tech- nical terms, what's a film? A format? What's documen- tary? Ethnographic? Feminist? Is raising such primary questions a way of engaging critically with predominant practices and hence, inevitably with one's own activities?

Criticism is not a mere matter of judging or of pointing, from a safe place, at what is right and what is wrong. The finger pointing out is bound to point back in. In telling, one is told. What one sees in an image is a manifestation of how one sees it. And what one hears through sound could tell of how one receives the universe. The reflexive dimension of my film practice, for example, is extensive and indefinite; it is not a mere matter of self-criticism, for what is at stake could be much larger than the self and the human. In the politics of representation, it is not enough to come up with a narrative of self-location as a solution (by showing oneself on camera or by revealing one's attributes, background, and conditions of research for example), just so as to give oneself the license to go on with the business of representing others as usual. This was how certain cultures' observers conveniently reduce the question of reflexivity—to a question of fieldwork technique and method—in their attempts at "correct- ing" or "improving" their politics.

The necessary play of reflexivity and related display of power relations requires that one remains attentive and alert to all processes of reflection in their interdepen- dent shifts and moves. The critical ear, eye, and voice are vital when one works at shifting viewers' perceptions of reality while expanding the language and experience of

cinema. But what is critical could, should also be inventive; it's much more challenging than simply offering a critique. Making a film that does not conform to the conventions of mainstream commercial cinema requires that one sees anew and makes new uses of the medium or of cinema's tools of creativity, so as to transform it. To use an image I've previously evoked, it is not only the shape or the flowers and fruits of a plant that matter, it's the *sap* that runs through it. This is how "rigor in criticism" could be understood.

Schultz-Figueroa and Astacio:

Almost all of the interviews you did for *The Independent* end with a variation of the question: What is your next project? Your answers don't directly state what will be next, rather you give brief insights about how you approach new work, stating that a new project is: "always an exploration and encounter—with a place, a group of people, a thought process, a force, an energy, for example—that ideas and images take shape." How do you start new projects or how do projects find you?

Minh-ha:

It's very adequate to ask how the projects found me between circumstances, how their current picks me up rather than the other way around as commonly thought. The tendency to inquire about what's next is in itself very telling: the new always seems to be located in this *next*—the future and elsewhere, the *fast* and *more* of consumer society. We barely have time to stay with what we have, and we are always already trying to move away from the here and now for fear of not being able to keep ourselves busy with filling in the blanks ahead of time. No wonder that this here and now so often escapes us.

When I put exploration and encounter as initial motivations for a film project, I am referring to what, in reality, remains infinite within the finite. As in my film *Reassemblage*, the question often asked and the answer given run as follows: "A film about what?"—"A film on Senegal." "But what in Senegal?" Or else, "What kind of film is this? Is it documentary, experimental, educational, musical, narrative, cinéma vérité, essay or art?" My films do not focus on individualistic subjects; in that sense, they radically have no "subject" although they do always offer specific, distinctive characteristics of the moment imaged on screen, the culture and people portrayed, as well as the process of formation at work.

A film attentive to the here and now in its unfolding also speaks accurately of the instance of consumption. Here knowledge is always situated, and the referent is "Us" rather than "Them." The mirror is turned around, so that what is reflected on screen, visually and aurally, points back to the viewers' reactions, their representative position vis-a-vis the materials shown, and the way they consume films in general. Furthermore, as in all encounters, what comes through is neither Self nor Other, but something in between—dispossessed and deterritorialized—which makes classification through film genres and sub-genres hopelessly inadequate. When one faces the multi-faceted wealth of life in daily existence, all this demand for message, "story" or storyline from the film establishment and its funding networks is needlessly reductive and utterly absurd. (Obviously, this doesn't apply to people's storytelling around the world, especially as encountered among indigenous societies, which is very different in nature and which I've discussed at length in my book *Woman, Native, Other.*) By letting the world come to oneself rather than claiming to "discover" it, one remains attentive to how reality speaks in its infinite manifestations.

"No story, no sex, no violence," this was how a film critic from the magazine *Variety* characterized my films and more specifically the feature-length film *Naked Spaces. Living Is Round* when it was premiered at the Toronto International Film Festival. She was concerned about the viability of such a long film [135 minutes] in which she had also identified three substantial *lacks* that would bar it from television and established distribution networks. Although we were heading in opposite directions with her comment, it was great after all, that she did get it! With a focus on every day's processes, what I question in filmmaking and filmviewing, whether meant for theatrical screening or for TV programming, is this tendency to package knowledge: the centralizing story as in predominant narrative mode, and the all-knowing account as in documentary and ethnographic modes.

To refuse the ready-made of packaged, specialized knowledge is to maintain open that relation to infinity within the finite mentioned earlier. Politics is a dimension of one's consciousness in being with non-being.

It permeates our everyday, which turns out to be most difficult to "discover" because it is what we are, what we do, ordinarily. The everyday evades our grasp; we may try to tame it with order and control, and we tend to equate it with habit, but it allows no hold. It is where the familiar could turn out to be *extra*-ordinary. As the feminist struggle used to remind us, the personal is political. Not because everything personal is naturally political but because everything can be politicized down to the smallest details of our daily activities. Each encounter is so utterly bound to the elements that define it, that for me, it is impossible to reproduce, identically, what has been made at different moments of one's itinerary, and with different peoples, circumstances, and locations. The specificity of each encounter would dictate a different itinerary for each film. In other words, each film has its own field of energies, and the unique form it takes on in the process remains nonpredetermined. Form here is a way of tuning in with the formless.

Schultz-Figueroa and Astacio: Can you share with us some early important experiences doing fieldwork that shaped your career and life? What are the filmmaking lessons that you took from this work in the field, and how did you arrive at them?

Minh-ha: Not only while doing fieldwork but while simply living in an unfamiliar context, which Senegal, for example, was for me at the time, and Japan also, years later. There are many transformative experiences that taught me how to rest with uncertainty, and come up with the kind of work I do. But two of them come to mind here. The first one concerns the question of positioning and the second brings up a situation all at once existential, cinematic, and spiritual.

I will skip the long story as to why I went to Senegal for postdoctoral quest and ended up teaching at the National Conservatory of Music, while doing research at the National Archives of Music. At first, I would accept small, temporary secretarial jobs. The day after my arrival, I was already employed by a French administrator who needed quickly someone to type his reports, and what he told me stayed with me for quite some time during my years in West Africa. He said, "I love Asia; I've spent a few years in Cambodia and in Vietnam. I

learned so much during my stay there; but I've been living here in Senegal for 14 years and I'm leaving this place the way I came; I've learned nothing. *Nothing at all!* There's no civilization, no history, no culture, nothing here in Africa." Of course, he meant it as a compliment to my Asian background. But I actually felt it as a full blow on my face. All that I intuitively registered was the utter violence of the remark. How could anyone live in a place for 14 years and yet not learn a single thing? By a strange twist, I felt that what he said was not simply directed towards African peoples and cultures, but towards all colonized peoples.

It was a jarring introduction to the country. I quit that job the very next day. The man's statement might well reflect the general attitude of many European expatriates in Africa, which made all efforts to research the culture via written sources look very bleak at first. But in reverse, it motivated me to inquire further into the maze of power relations as embedded in the position of the researcher, in the very process of gathering data, of classifying, hierarchizing, and making meaning—in brief, into a whole legacy of Western rationalism as related to the very tools that define one's activities. I got little help in the long process of learning, by which I also had to unlearn, unexpectedly and on a daily basis, many rooted assumptions. But once I accepted that I would have to struggle on my own, not relying on any "rare" information from the so-called "experts" and their expertise, or from those "savvy" long-stayers, I found my own way to create and develop connections, and I started tuning into African life. I do a lot of team work with Jean-Paul (Bourdier) who is an architect, visual artist, and photographer. We traveled across West Africa and we lived a lot in the countryside. So the first two years were rather difficult years of awkward adjustment, eye-opening experiences, and profound, destabilizing self-trial.

Such a process of unlearning and of groping in the dark while learning contextually to see and to hear *double*—from the points of view of both the colonizer and the colonized—has enabled me to develop a critical ear and eye for the way both foreign outsiders and urban insiders spoke about their own culture. Most of the time when city dwellers presented their own culture, the cultures of

Senegal, Mali, or Burkina Faso, for example, they abided by the authority of anthropology. The same preoccupations, the same validations, the same codified language and discursive formations as those of anthropologists could strongly be felt in every cultural presentation. I could not help but be disquieted by such a situation, and even more severely vis-à-vis myself, since I certainly recognized the precariousness of my own threshold position as outsider-insider in much of what I found troubling.

Entirely related to this process of going into the dark to do research or to make films is an important fieldwork experience, which I would only briefly go into here. In the many villages of rural West Africa we've been to, more particularly those in Burkina Faso, for example, entrance into a house could be rife with symbolism and carry with it the weight of ancient wisdom and spirituality. When you walk from the outside to the inside of a home, you actually walk from a bright sunlight into a closed, utterly dark inside where you literally go sightless. It takes quite some time for the eyes to get adjusted because there's no "window," no opening in these closed spaces. Aside from the ritualistic implications around the entryway—requiring (as among the Nankana) that one kneels and stoop down before climbing across an entry partition wall—the experience of light and darkness is very radical and it is only by groping into the dark that you could advance.

In Batammaliba's dwellings, the disorientation is intensified further by presences in the dark that you cannot at first identify: I was, for example, wondering what was happening to me when I was licked all over and only realized well after that people kept animals—cows, goats, dogs—in the front room. It was only in the remote recess for the house, mostly in the women's cooking space that you first see a beam of light hitting the hearth from a side opening. This is like magic. These intimate scenes of house interiors are shown in the film *Naked Spaces. Living Is Round* where deeper insights could only be gained at the cost of being deprived of sight. When you're momentarily blind, you fare non-knowingly; you accept to leave your luggage behind in order to make your way toward the unfamiliar. Such an experience of

sightlessness and insight was very powerful for me—
it's altogether physical, mental, ethical, aesthetical, and
spiritual.

Schultz-Figueroa and
Astacio:

While some of your films were shot in or are about
Vietnam, you have also worked in many other countries
and cultural contexts. Your first films were shot in Sen-
egal and West Africa, but you have also worked in China
and Japan. As a female filmmaker of color from Puerto
Rico who has in the past couple of years been work-
ing in Peru, I (Patricia Alvarez) often face the much-
dreaded question: why don't you make films about your
own culture? Another variant of this question is: why
are you interested in a different culture? Could you
talk to us about your experiences working as a woman
of color with/among different communities of color?
Also, migration and immigration are central themes in
your work. Can you reflect on your own experiences of
border-crossing, translation, and relocation, and how these
experiences turn up in your films?

Minh-ha:

When you work in a non-knowing mode, you don't
necessarily begin with what appears most familiar.
On the contrary, it's my commitment to the spirit of
a South-South solidarity, or of a certain Third World
non-alignment, that led me to work at the intersection
of these different places and situations. We are living in
a global age, where conventional boundaries are made
obsolete with the advent of digital technology, but our
mind still dearly hangs on to the provincial. At stake in
the questions raised are, on the one hand, the proverbial
divide-and-conquer mind, and on the other, the reac-
tive territorial mind. These often go together even when
they appear to counter one another.

I have written at length on how in the politics of rep-
resentation, Africanizing the Africans, Orientalizing the
Orientals, or Nativizing the Natives have become the
norm: Asians could give themselves the license to speak
on Asia, Africans on Africa, and Europeans, on . . . the
world! Reclaiming the rights to represent oneself may be
a necessary step, but it would easily lead us to an impasse
if the politics of representation itself is not taken up.

As for migration and immigration, I wouldn't want to
take away the pleasure of reading and viewing from my

audience and readership. Since I have written at some length on the subject, more recently in a book like *Else-where Within Here. Immigration, Refugeeism and The Boundary Event* (2011), and since I have also made a number of films, such as more specifically, the film(s) *Surname Viet Given Name Nam* and *Forgetting Vietnam*, I would refer them directly to these works. Suffice to say that I've been working with a range of figures of otherness such as: Women, the Other of the West, the foreigner, the outsider, the stranger, the wanderer, the One-who-leaves, that is, the exile, the migrant, the immigrant, and the refugee. More recently, in my installation work *L'Autre marche* at the musée du quai Branly in Paris (2006–2009), and in the most recent book, *Lovecidal. Walking with the Disappeared* (2016), I've focused on the figure of the female walker—or on the walk of multiplicity.

Here, I would like to briefly comment on the very nature of a number of your questions. They are "origins" questions that connote a certain desire for explanations derived from tracing the origins of a work, a trajectory, or an event either to a single individual, a single influence, decision, situation, practice, movement; or to a preset film genre, an institutional discipline, and even to a gender category like "woman of color." Although I understand you're working under a set of editorial guidelines, and you have very sensitively geared your questions towards some of the more prominent concepts in my praxis, I find it very problematic to indulge in these questions, not only because they are confining for both interviewers and interviewee, but also because they tend to take for granted that there's such a thing as a "natural" link between what happened in your individual life and the kind of work you do. In that sense they are reiterating what we just discussed—the territorial mind and the naturalized positions of those who claim ownership of certain areas of knowledge through a mere "speaking as." It would be more fruitful to focus on your specific responses to the work.

Schultz-Figueroa and Astacio:

Something that struck us watching your body of work is how each of your films has a recognizable aesthetic and how there is a clear dialogue across the themes and formal language that you create in each one. All of your

films are recognizably the work of Trinh Minh-Ha. But, on the other hand, each film is also unique and distinct from the others. From the quick cutting, repetition, incisive critique of the ethnographic endeavor in *Reassemblage*, the use of re-enactments and a re-thinking of the interview in *Surname Viet Given Name Nam*, the poetics and sense of movement across scales and temporalities in *The Fourth Dimension*, to your foray into fiction with *A Tale of Love*, you explore new territory with each subsequent piece. Can you discuss the relationship between how your films connect to each other while maintaining such uniqueness and difference?

Minh-ha: Such an expansive question offers plenty to explore; I will try to pull out a few threads here. In the vein of your pertinent reading of the films mentioned, I would say that unlike *Reassemblage*, which features the fleeting, the ephemeral, and the fragmentary, *Naked Spaces. Living Is Round* incorporates the movements of traveling and dwelling, or of outsideness and insideness, and the related impact of seeing and integrating "colors" in daily life in West Africa—such as among others, the drawing-in effect of red being intercut with the pulling-out effect of green as in the opening sequence, for example. The film works on duration and explores long takes with unsteady panning that expose the movements of both camera and filmmaker in their mechanical and bodily responses to the filmed subject. Here, to focus on the interrelations of people's architecture, their color symbolism, and their musical universe, is also to feature the elements of cinema in the film's own formation processes.

There's always more than one dimension at work in every film made. The films' present refers simultaneously to the culture and people portrayed, and to cinema, (or video) and its apparatus—i.e., the creative tools, materials, and conditions that go into the making of these works. Red and green are also prominent in *The Fourth Dimension* as time and light events in Japanese culture and in digital video. A film like *Shoot for the Contents* raises further questions of translation as related to interpreters and cultural narratives in China, while offering a critical approach to color and politics. *A Tale of Love*, inspired by the national love poem of Vietnam, "The Tale of Kieu," works with non-naturalistic or

denaturalized acting as well as with primary colors in depicting the state of being in love and its peculiarly heightened sensorial world. Voyeurism, featured in the film, runs through the history of narrative cinema and as a character in the film said, "every story of love is a story of voyeurism." These are all elements one immediately confronts when working in fictional mode with a category like "feature narrative."

Further, the play of visibility and invisibility, or what is seen, what is unseen, not seen or barely seen runs throughout my film work, although it is most intensely dealt with in the more recent digital films. *Forgetting Vietnam* works with memory and forgetfulness and with the marginalized spaces of survival and resistance via old (Hi-8 video) and new (HD) technology. *Night Passage* made in homage to Miyazawa Kenji's classic novel *Night Train to the Stars*, offers an experience of non-illusory, two-dimensional time-space tableaux. The film itself unfolds in the sequential rhythm of a train of window images, and each scene is devised as a gesture of its own. Both in *The Fourth Dimension* and in *Night Passage* the train is, quite literally, the narrative vehicle of the films. In *The Fourth Dimension* it travels between the ancient and the modern; in *Night Passage* the journey takes place between life and death.

Form and content are never separated. How and What always go together (with When and Where as well). The tools of creativity should subtly play a role of their own rather than be used as mere instruments of thought or feeling. As I've implied earlier, structures, processes, and the mechanisms by which meaning is produced or thwarted are an intrinsic part of the materials that go into the making of each work. The thread of Rhythm running across my films—not as a mere aesthetic device, but among others, as a determinant of relationships between people—has been discussed at length in previously published interviews. I am here also offering the thread of Color—again, not as a mere artistic device, but a determinant of how we see (or not see) life and live social multiplicity. These are works that involve the seer (cinematographer, filmmaker, and spectator) in the seen (the people, things, and events filmed), and position the filmmaker, situating the look and the voice in filmmaking as well as the instance of consumption in spectatorship.

There are so many possible ways to approach the films I made and to link them in their differences. Another significant thread would be to look at how the inquiry into "woman," as with the notions of self and other, remains a project with each work. Sometimes she is explicitly and almost exclusively the focus of the camera (as in *Reassemblage, Surname Viet Given Name Nam,* and *A Tale of Love*); other times, she is less prominent in the images but remains the force that drives the film (as in *Shoot for the Contents, The Fourth Dimension,* and *Forgetting Vietnam*). In addition to the intense attention given to the everyday in most films (rather than the mere focus on individual stories), mentioned earlier in relation to feminist politics, I would also add here how the place of the look—both the eye-camera, eye-maker, and the eye-spectator—which defines cinema, is visually and audibly made discernable in each work. Most importantly, rather than merely focusing on women as content (female role-model or strong characters) and going beyond films made by women and on women, these are films made deliberately to address the *feminist viewer*—who can be any gender.

Schultz-Figueroa and Astacio:

In an essay published in *The Independent,* titled "Questions of Images and Politics" published in 1987, you discuss the need to make film politically—which you define as different from making a political film. Drawing from work of earlier feminists to expand the definition of "politics," you write: "Different realms and levels of institutional values govern our daily lives. It is therefore in working at shaking any system of values, starting with the system of cinematic values on which its politics is entirely dependent, that a politically made film takes on its full significance." The politics of representation are as contested now as ever. Since this was written, have you seen more political cinema as you define it? Is there a new way of thinking about how to make film political given the particularities of our contemporary moment?

Minh-ha:

Could we keep that last question alive with each work we conceive rather than respond affirmatively or negatively just so as to give an opinion? Furthermore, why hold on to "politics" in the linear construct of today-versus-past—if your concern is about finding a "new way of thinking"?

Redefining of the "political" independently from the body politic could widen our visionary field and open

251

up to possibilities not previously envisaged. As a pre-
liminary step, one should simply put film, video, art,
and women's daily activities, for example, at the center
of politics, rather than the other way around. Working
with the everyday as I elaborated earlier in relation to
women's struggles is certainly a way of continuing to
shift and to inquire into the political. There's no before
or after. Each project is different and presents a new
challenge. Why would it matter so much whether more
filmmakers and film audiences agree with the stance
I've been taking on making film politically? When you
decide to move, you move. You don't look around to
reassure yourself that other people are moving in your
direction too. The fight is ongoing.

Another example could be found in the writing of my last
book, *Lovecidal. Walking with The Disappeared.* It started
long ago, during the turbulent times. That marked the
so-called end of the war in Iraq, the military surge in
Afghanistan, and the transition from Bush's to Obama's
presidency. One could have thought that the release of
such a book in 2016 might raise questions as to its cur-
rent pertinence. But on the contrary, in the present cli-
mate of unbridled revival of sexism, racism, homophobia,
and xenophobia where America's heartsick society is
suffering a huge throwback, the book turned out to be
even more relevant today. The phenomenon of women's
transgressive, transpolitical marching across nations in
their struggles for justice, which I discuss at some length
in the book, has now gained in scope and amplitude to
become the Women's March built on diverse alliances
around the world. The term "Lovecidal" (the suicide of
love) is a creation I necessarily came up with to encap-
sulate the predicament of our warring time and what we
define as human, in the pair of love and death. The book
could be said to be an elaborate manifestation of that
term through events across geopolitical, ethical, and artis-
tic times, places, and spaces; it sustains the use of "love-
cidal" as a tool for change in its multiplicity. Presented
here as an adjective (rather than as a noun, "lovecide"
like genocide, for example) that grammatically qualifies
nouns and pronouns, it could modify an indefinite range
of events, situations, and contexts. Acts of creativity and
of transformation maintain our relation to infinity.

Notes

1. Trinh T. Minh-ha. Interviewed by Benjamin Schultz-Figueroa and Patricia Alvarez Astacio on January 4, 2018.
2. Ibid.
3. Ibid.
4. Ibid.
5. An van. Dienderen, "Indirect Flow Through Passages: Trinh T. Minh-Ha's Art Practice," *Afterall: A Journal of Art, Context and Enquiry*, no. 23 (2010): 90–97.
6. Trinh T. Minh-ha. Interviewed by Benjamin Schultz-Figueroa and Patricia Alvarez Astacio on January 4, 2018.
7. Ibid.

16

YVONNE RAINER (1934–)

Aviva Dove-Viebahn

Even before she became a filmmaker, Yvonne Rainer challenged conventions around what it means to be a performer, a creator, a writer, and a spectator, blurring the lines between reality and fiction, auteur and amateur aesthetics, and the sublime and the mundane. First a dancer and choreographer, then a filmmaker, and now a choreographer again, Rainer, in her life and work, refused a traditional path while building upon the very same traditions she eschewed in complex and perceptive ways. A childhood punctuated by frequent and influential encounters with classic and avant-garde cinema segued into a young adulthood in which she was an integral player in the flourishing and radical New York art and dance scene of the 1960s. Her films, seven features produced between 1972 and 1996, offer sometimes-political, experimental, provocative, and semi-autobiographical encounters with the vagaries of life, desire, gender, bodies, and cinema.

Born November 24, 1934 in San Francisco to an Italian immigrant father and Jewish mother, Rainer and her older brother Ivan spent a significant portion of their childhood years in a series of private "foster care" facilities where their parents chose to voluntarily board them. Once the siblings returned home permanently in 1941, Rainer remembers a childhood full of tantrums and acts of defiance small and large.[1] She also fell in love with film under the guidance of her father and went to the opera and ballet with her mother during those early years, with Carl Dreyer's *The Passion of Joan of Arc* and Jean Cocteau's *Orpheus* sticking out sharply in her memory alongside the more prosaic offerings of melodrama and film noir endemic to the 1940s and 1950s.[2]

A precocious teen, Rainer read vociferously and thought deeply about life, politics, and love, recording many of her reflections in journals and letters to her family and friends, some of which are reproduced in her 2006 memoir, *Feelings Are Facts*.

In one such journal entry from 1952, she compares herself to her neighbors, who follow the same routine day in and day out:

> Why do I attach a feeling of banality to the aspects of life that pass before us in a steady, perennial procession? Sleeping, awaking, dressing, eating, crapping, working, copulating, bathing? If such things are not a part of living, what is?. . . . I expect more from myself in extracting things from life and in contributing things to life than they do. Things, unknown, vaguely luminous, with shifting hovering shapes. Things that sometimes mock me with their maddening flitting and capricious whims for alighting with a shock of recognition and then as suddenly vanishing into a cloud of forgetfulness, a black, angry blur of frustration.[3]

Rainer's remarkable meditations on the conundrums of daily life and the complexities of how we seek meaning in action and inaction are as starkly rendered in this early missive as they are in her dances and films to come.

After a year in junior college and one week enrolled at the University of California, Berkeley in 1952, Rainer dropped out of school, working in a factory and then as a clerk, attending poetry readings, plays, dance performances, and art exhibitions as often as she could. During this time, she also took a 16mm film production class at the San Francisco Institute of Art and acting classes. At the end of the summer in 1956, she moved to New York City with painter Al Held, eventually beginning dance classes. By 1959, Rainer had separated from Held and was fully immersed in dancing, studying at the Martha Graham School and Ballet Arts, before transitioning to Merce Cunningham's studio. As a dancer and choreographer, she was a member of the revolutionary Judson Dance Theater collective with other notable choreographers, dancers, visual artists, filmmakers, and composers. During this time, she also became involved with artist Robert Morris, with whom she occasionally collaborated and lived.

Throughout the 1960s, Rainer was enmeshed in the intersecting worlds of avant-garde dance and performance art, her style a radical reconceptualization of what constitutes dance and its technique. She employed pedestrian movement and ostensibly simple gestures and forms that would ultimately coalescence into a resonant and intricate whole—much like in her later films. For example, in her solo performance, *Three Satie Spoons*, executed during Robert Dunn's dance workshop in 1961, Rainer recalled people and events she had witnessed in her daily life to inform her choreography. In an essay she submitted for the workshop, she reports influences

> as diverse as the mannerisms of a friend, the facial expression of a woman hallucinating on the subway, the pleasure of an aging ballerina as she demonstrates a classical movement, a pose from an Etruscan mural, a hunchback man with cancer, images suggested by fairy tales, children's play, and of course my own body impulses generated in different situations—a classroom, my own studio, being drunk at a party.[4]

While her famous "no manifesto"—

NO to spectacle no to virtuosity no to transformations and magic and make-believe no to glamour and transcendence of the star image no to the heroic no to the anti-heroic no to trash imagery no to involvement of performer or spectator no to style no to camp no to seduction of the spectator by the wiles of the performer no to eccentricity no to moving or being moved[5]

—points to a similar renouncement of traditional dance conventions in favor of the everyday; Rainer was far from disinterested in questions of aesthetics.

In the years precipitating Rainer's move to filmmaking, she choreographed and performed an evening-length dance work, *The Mind is a Muscle*, of which one of her most famous dances, *Trio A*, was a part. In the 1968 program notes for this piece, Rainer wrote, "If my rage at the impoverishment of ideas, narcissism, and disguised sexual exhibitionism of most dancing can be considered puritan moralizing, it is also true that I love the body—its actual weight, mass, and unenhanced physicality."[6] While later in this program note, Rainer seems to foretell her move to film, she also offers a reproof to herself for her lack of politicality at that moment: "My connection to the world-in-crisis remains tenuous and remote. I can foresee a time when this remoteness must necessarily end, though I cannot foresee exactly when or how the relationship will change."[7] Among other things, filmmaking became one of the ways Rainer found herself able to connect with politics, in both theory and practice, although not always in the ways one might expect.

Economic hardship—later rectified, at least momentarily, by a grant from the National Endowment for the Arts—and depression led Rainer to attempt suicide in the fall of 1971. In the following year, "it was the women's movement itself—coinciding with the devastation of my love life and enraged near demise and recovery—that ultimately catalyzed my transition from moving body to moving image."[8] While she made several minimalist short films in the mid-1960s, including the 1966 *Hand Movie* while she was convalescing from one of a number of hospital stays after surgery to remove intestinal adhesions, Rainer did not begin making films in earnest until she met French cinematographer Babette Mangolte in 1972. Rainer credits her love of "all kinds of film culture," starting in childhood and evidenced in the use of film in some of her dance performances, with setting the stage for her film journey, stating, "Against this multifarious backdrop of Vigo, Renoir, Cocteau, Dreyer, Pabst, 'women's weepies,' and the formal strategies of the avant-garde, I intuited that I was venturing into a mother lode of possibility."[9] Rainer explains in a published 2002 lecture on her work in retrospect, that, "the language of specific emotional experience already familiar outside the avant-garde art world, in drama, novels, cinema, and soap opera, promised all the ambivalent pleasures of the experiences themselves: seduction, passion, rage, betrayal, terror, grief, and joy."[10] Her first feature-length film, the experimental *Lives of Performers* (1972), served as an apt transition in this period, in that it

juxtaposes her "old" dance practice with the new celluloid medium she was just beginning to explore.

In 1962, cultural critic Susan Sontag wrote about New York art "happenings" as sites of "radical juxtaposition,"[11] and Rainer consciously embodies that term in her dance and in her filmmaking practice. A retrospective of Rainer's multimodal oeuvre was even titled *Radical Juxtapositions, 1961–2002*, and she and theorists of her work frequently use the phrase to refer to her methodology, with Rainer contextualizing the term as "usually mean[ing] a less specific kind of contrast, something more akin to ambiguity."[12] The majority of her films explore topics, questions, and ideas—sometimes in opposition, sometimes in collusion—rather than relying on narrative consistency or strictly adhering to a political message. According to Rainer, *Lives* started with an interest in "dance and emotional life."[13] In it, she utilizes stills, intertitles, rehearsal scenes and performances, and real dancers playing fictional roles to explore the relationships between a man and two women he tries to choose between.

In all her films, Rainer uses autobiography as a backdrop—sometimes verbatim passages from her own diaries or recognizable scenes from her youth—but often fictionalized or detached from Rainer herself. "I want my films to reflect whatever complexities I feel about being alive," Rainer explains in an interview with the *Camera Obscura* collective, "and the most I can ask of myself is that I create work that retains a powerful connection to my own experience, whatever distance from literal autobiography it traverses."[14] Distance was especially important in her early work, in which she explored the practice of Bertolt Brecht's theatrical alienation effect:

> I would now embark on bringing a version of [Brechtian] techniques to the representation of episodes of my own checkered past, events that would be fictionalized through narrative fragmentation, text/image combinations, and uninflected delivery of lines designed to invoke but not replicate the familiar rhetoric and role-playing of disaffected love. These were my guidelines when I assayed a first 16mm feature film in 1972.[15]

Nevertheless, it would be misguided to suppose Rainer's first films were devoid of emotion or politics or aesthetics. Rather, she approached these subjects from a provocative position in which she was not subsumed by the assumptions viewers and filmmakers alike often make about how they are meant to invest in visual objects or narrative arcs. In an interview with Scott MacDonald, Rainer discusses how

> filmmakers complained about my films at the beginning because they weren't 'visual'; they didn't play on the retina. My films weren't about making poetic or beautiful images. . . . But my imagery was always at the service of a theatrical, emotional realm; *melodrama* was the perfect form for what I was after: the emotional life lived at an extreme of desperation and conflict.[16]

In the early 1970s, encounters with feminist film theory written by Laura Mulvey, Teresa de Lauretis, and others shaped Rainer's filmic explorations, as well as her personal politics. Still, her propensity for leaving even difficult political and ideological questions open for debate sometimes left her work vulnerable to attack. Her second feature, *Film About a Woman Who . . .* (1974), "became a focal point for more than one brouhaha in the feminist film theory wars of the late seventies and early eighties," Rainer writes in a retrospective essay. "The battles raged over issues of positive versus negative imaging of women, avant-garde versus Hollywood, strategies of distanciation versus traditional tactics of identification, elitism versus populism, documentary versus fiction, accessibility versus obscurity, etc."[17] The film centers on a woman and her sexual satisfaction, but employs myriad techniques of distancing and abstraction, while exploring issues ranging from the male gaze, anger, and desire to the performance of lovers for each other and the audience.

Rainer's *Kristina Talking Pictures* (1976) continues in this vein, employing collage and quotation and abstraction, with actors delivering affectless and fragmentary monologues about language and the environment and performance or engaging in dialogue with each other while their actions or other images on the screen appear completely incongruous. The protagonist is a lion tamer from Budapest who moves to New York to become a choreographer with an on-again-off-again sailor boyfriend. Public and private merge and part ways, are negotiated, and become fraught. Narrative continues to be illusive in this work, although not entirely absent, with different actors sometimes portraying the same character. Rainer states,

> For me the story is an empty frame on which to hang images and thoughts which need support. I feel no obligation to flesh out this armature with credible details of location and time. . . . Where narrative seems to break down in my films is simply where it has been subsumed by other concerns, such as the resonances created by repetition, stillness, allusion, prolonged duration, fragmented speech and framing, "self-conscious" camera movement, etc.[18]

As always, autobiographical dalliances remain, and feminist dilemmas are again taken up without being fully excoriated or championed.

The politics of Rainer's work shifts into a slightly more insistent register in *Journeys From Berlin/1971* (1980), which confronts questions of terrorism and pre-revolutionary Russian history alongside an interrogation and utilization of psychoanalysis. In it, a character recounts her attempted suicide to three versions of her therapist, allowing Rainer another autobiographical, but dissociated, outlet for expression. In an interview with Noel Carroll, she describes how the film "was an opportunity to bring together powerful themes from my youth with my later experience of psychotherapy, and thus establish a point of view—peculiarly but clearly American—from which to look at other—European—components of the film."[19] Moreover, Rainer yet again insists on the dichotomous interplay of her lack of explicit theoretical positioning with an active interrogation of the political in the film:

The film has no theoretical position on politics, feminism, or psychoanaly-sis. Rather than theoretical exposition, *Journeys* offers contrast and contra-diction. . . . I have—realistically, I think—little trust in myself as a political analyst. Like my 15-year-old counterpart in *Journeys*, I have more sympathy with victims than understanding of the uses of power. Partly because of my particular psychological history, partly because of my socialization as a female. It is from the viewpoint of the victim that I became fascinated with the subjects of suicide and assassination, and with the conditions of powerlessness—real and imagined—as something that has so much poten-tial for erupting into violence.[20]

Deftly exploring the role of spaces, politics, history, and experiences of gendered oppression, *Journeys* sets the stage in many ways for Rainer's fifth feature, *The Man Who Envied Women* (1985), while still being strikingly different. This film, which explores the dissolution of a marriage via an embodied male protagonist and the disembodied narration of the female protagonist, is discussed at length in Rainer's own essays from 1986 and 1987 reprinted in this volume.

Rainer's final two films, *Privilege* (1990) and *MURDER and Murder* (1996), begin to slide into a notably more narrative register. The former "evolved initially out of [Rainer's] experience with menopause, and in the process became an investigation into the implications of social privilege in the areas of race and gender."[21] Recog-nizing her position as a white, middle-class feminist, Rainer's decision to tackle race stemmed in part from the "writing on race [that] had been pushing at the limits of feminist film theory" during this era.[22] The film "plays around with documentary," and offers an interrogation of the genre in three ways:

the traditional professional talking head (the doctors who represent author-itative kinds of speech); the so-called 'real' interviews—with their 'sponta-neous' speech—which have been highly selected from hours of material; and the 'fake' documentary in which Yvonne [Washington, Rainer's char-acter of herself] interviews Jenny.[23]

In *Privilege*, Rainer merges this fictionalized documentary-style narrative with the realities of filmmaking practice: at points, the crew and the cast can both be seen, and, at a crucial moment, one of the characters takes over the work behind the cam-era and a stand-in for Rainer-as-director, Yvonne Washington (played by a Black actress), becomes a subject of the film.

By the time Rainer produced *MURDER and Murder*, two crucial events influ-enced both her subject matter and her move to a more explicitly narrative presenta-tion of content. One, she came out as a lesbian, an experience she writes about in a 1991 essay about coming out at age 56:

Fundamentalism and essentialism aside, I therefore call myself a lesbian, present myself as a lesbian, and represent myself as a lesbian. This is not to

say that it is the last word in my self-definition. "Lesbian" defines not only a sexual identity but also the social "calling," or resistance, made necessary by present social inequities. I must keep in mind that "white" and "aging woman," form other parts of this identity, and that my status as aging lesbian, however stigmatized in daily life, is not equivalent to the experience of people of color.[24]

Two, she was diagnosed with breast cancer in 1993, losing her left breast to a mastectomy. Thus, *MURDER* explores the relationship of an aging lesbian couple—one of whom has fallen in love with a woman for the first time—while questioning conventions of desire and heteronormative romance alongside the capricious experience of breast cancer diagnosis and treatment.

It's perhaps fitting that Rainer's last film is arguably her most narrative, suggesting a trajectory in which her storytelling naturally moves from abstraction and distance to attempts at closure and a meditation on the possibilities of a fulfilling relationship. Economic and ideological finality, alongside a sense of having finished a chapter in her life, led Rainer away from filmmaking and back toward choreography at this juncture:

> As I sat in the editing room for six weeks lovingly toiling over my *MUR-DER* footage on the Steenbeck, I sensed it would be the last time I edited a film in this manner, perhaps the last time I would make a feature film. I had received my share of once-in-a-lifetime big grants; the awards program for individual artists formerly administered by the National Endowment for the Arts had been wiped out; and I was in the last group to receive grants from the American Film Institute. . . . [Filmmaker] Peter Wollen once said to me, "They let you make five." Before the whole cultural and economic climate of the US changed for the worse for low-budget narrative filmmakers, "they" let me make seven.[25]

In the few years preceding and after *MURDER*, several retrospectives and choreography workshops began to draw Rainer back into the fold of the dance world. In 1999, Mikhail Baryshnikov asked Rainer to choreograph for his White Oak Dance Project, resulting in her first original piece in 25 years, *After Many a Summer Dies the Swan*. In a 1980 essay on her own practice, Rainer writes,

> Film is the place the (extra)ordinary (im)balances between culture and expression can be most vividly demonstrated and enacted. Film is opaque and convoluted and baffling, never doing what it seems to be doing, never doing what one wants it to do.[26]

And yet, through both film and dance, Rainer showed, and continues to show, the profound power of acknowledging and welcoming the moments of opacity of which film is capable, embracing the ordinary and the extraordinary, and engaging in both aesthetic and political inquiry without foreclosing on the possibilities of either.

This chapter includes essays by Rainer from 1986 and 1987 originally published in *The Independent Film & Video Monthly*.

Some Ruminations Around Cinematic Antidotes to the Oedipal Net(les) While Playing With de Lauraedipus Mulvey, or, He May Be Off Screen, But . . .

Yvonne Rainer/April 1986

The Independent Film & Video Monthly

The Audience is once more perplexed after viewing my last film, *The Man Who Envied Women* (*TMWEW*). Some of them are once again asking, "What does *she* believe? Where in this welter of ideas, aphorisms, opinions, quotations, ironies, rhetoric, collisions, is *her* voice? Are there really no arguments to follow, no resolutions or conclusions to be gleaned from this overload? Are the meanings so embedded in ambiguity that even the most assiduous concentration is unable to dredge them up, with the various discourses eventually neutralizing each other?" (The Audience of my daydreams, like the voices of my films, is very gabby.)

I hope not. I am not an iconoclast bent on destroying all vestiges of "authorial discourse." (As a "lapsed" anarchist, I am only too aware that when it comes to authority our choices are merely better or worse compromises.) On the contrary, I would like to believe that I subject such discourses to pressures and tests, or dislocations, e.g., a removal from their ordinary contexts—the printed page, the classroom, or the formal lecture—to unexpected physical and psychic spaces. The space of real estate profiteering, for instance, or the space of seduction, or the space of sexual (mis)representation.

In many ways, *TMWEW* lies outside traditional narrative cinema. There is no plot, for instance, and although the voice of the (absent) female protagonist can be construed as a narrator, this voice departs from convention by refusing to push a story forward or promote a singular thesis that would tie up the various strands. In the struggle for the film's truth, this equivocal, invisible heroine is not always the victor. Consequently, in relation to the social issues broached within the film, the question of an externally imposed, predetermined and determining coherence looms very large for some. If the process of identification with the trajectory of fictional characters is thwarted, we look for opportunities to identify with an extra-diegetic author or ultimate voice "behind" the film, if not camera. We are still not fluent in reading films that, while seeming to proffer this identification process, undermine it at the same time by setting other processes in motion, processes that involve a more detached kind of recognition and engagement. Rather than repositioning ourselves as spectators in response to cues that indicate we are being multivocally *addressed* and not just worked on by the filmic text, we still attempt to locate a singular author or wait for a conclusive outcome. The Master's Voice Syndrome all over again. And why not? Why else do we go to see narrative cinema than to be confirmed and reinforced in our most atavistic and oedipal mind-sets?

Well, now that I've so precipitously catapulted us into the psychoanalytic soup, I have to admit that I'm not entirely satisfied with the model of spectatorship so flippantly refashioned here. For one thing, who the hell is this "we"? Can this indolent pronoun possibly account for the people who like the movies I myself make? Let's say it includes some or all of us some of the time, or enough of us enough of the time for me to justify, within limits, my own cinematic practice.

But there is another reason for invoking this specter/spectator, and that is to question its *sexual* homogeneity. Over a decade of feminist film theory has taught us the importance of splitting this undifferentiated pronominal mass into two, if not more, component parts. Let us now speak of male and female spectators. The "we" further unravels when "we" think about stories and storytelling. The stories we love the most are those that appeal to our deepest and earliest fears and desires that modulate and determine our placement in society as more, or less, successful adult men and women. The question has come to be asked (and must continue to be asked inasmuch as those with more power and privilege are always inclined to erase both question and answers): within these stories, quoting from Teresa de Lauretis's "Desire in Narrative,"

[W]hose desire is it that speaks, and whom does that desire address? The received interpretations of the Oedipus story, Freud's among others, leave no doubt. The desire is Oedipus's, and though its object may be woman (or truth or knowledge or power), its term of reference and address is man: man as social being and mythical subject, founder of the social, and source of mimetic violence.[27]

. . . . [man as] hero, constructed as human . . . the active principle of culture, the establisher of distinction, the creator of differences. Female is what is not susceptible to transformation, to life or death; she (it) is an element of plot-space . . . a resistance, matrix, and matter.[28]

Monster and landscape, she adds elsewhere, Sphinx, Medusa, ovum, earth, nature, Sleeping Beauty, etc.

I have no doubt that I dutifully identified with the more passive, feminine "desire to be desired," in de Lauretis's words, at other points; in my 1940s oedipal drama. (And, as a story of one woman replacing another, it was quintessentially oedipal, a recapitulation of the classical Freudian account of male normative sexual development, with its demand for successful repression of infantile desire conflated with the mother.) But those were not the scenes that kept me in that theater until they came around again. Auguring calamitous consequences in my adult life, it was the scene of the two women fighting each other that gripped me most, a scene that almost 30 years later would be transformed and played out as a real life melodrama of internalized misogyny in my private life. In patriarchal terms, I was a wash-out. It wasn't that I had refused to be seduced into dancing on the oedipal stage. I had simply gone to sleep and missed all my cues. Even the prince's kiss could not awaken me. I refused to wake up, and that is what nearly did me in. If the Medusa had not been sleeping in

her cave, could Perseus have slain her? Must it always be either the prince or Perseus who gets you in the end?

Here's another story: On October 25, 1896, on the night after the funeral of his father Jakob, Sigmund Freud had a dream. "I found myself in a shop where there was a notice [Tafel, German for tablet (of the law) or table] saying 'You are requested to close the eyes.'" Using Marie Balmary's intricately fashioned key from her *Psychoanalyzing Psychoanalysis*, we can interpret this dream as an "injunction to 'close an eye' to the faults of the deceased." What might these faults have been?

Preceding his father's death, Freud was collecting indisputable evidence that pointed to the father as the cause of hysterical symptoms in the child. His theory of seduction was not well-received by the Viennese medical community. Within 11 months after his father's death, he emerged from depression and mourning only to "close an eye" to his accumulated evidence via the Oedipus complex, his new theory that repudiated his patients' stories by consigning them to the realm of repressed unconscious desire. With his father's death he laid to rest his own unconscious knowledge of his father's unacknowledged past. Rather than two marriages, there had been three. The town records of Freiberg reveal a second marriage to Rebecca, a mystery woman who is unrecognized in official Freud biographies. The fate of this wife and marriage remains undocumented. Balmary speculates that she committed suicide just before or just after Freud's birth.

Oedipus and Freud's theory conjoin as myth to conceal the "hidden fault of the father." Oedipus's father Laius had seduced his (Laius's) half-brother, Chrysippus, who later committed suicide "from shame." Freud's "closing his eyes" to Jakob's part in Rebecca's suicide (seducer and abandoner) is reenacted in his ignoring the part Laius played in the Oedipus myth (first as seducer of Chrysippus and later as violator of the gods' injunction against procreation) and is echoed yet again in the attitude psychoanalysis brings to the afflicted patient: "The fault is *your* desire rather than that of your father." And rather than that of The Fathers, or patriarchal society.[29]

To varying degrees and from early on, all of us can characterize our lives as a struggle between closing and opening our eyes, sleeping and waking, knowing and refusing to know. If, as de Lauretis and Mulvey say, women oscillate between masculine and feminine positions of spectatorship and identification, then it must be said that we also oscillate between knowing and not knowing that this is what we do. It is not the first oscillation that is in itself dangerous, but rather a state of ignorance of that oscillation that will permit Oedipus (used here to stand for the *dominance* of men's faults, fears, and desires) in some form or another to do you in. My archetypal Hollywood Oedipus waited off-screen to claim his true love in what was for my nine-year-old spectator a no-win situation, a rigged game in which the precondition for participation as a female was the willingness to lose. My pleasure was that of a sleepwalker dreaming a dream of perennial tomboyhood. A more bitter reality lurked in the wings: the father I could neither have nor become, already prompting dialogue from the scenario governing the next phase of my feminine life. But this last was a story that no one was telling, therefore one which I could not know.

By now it must be more than clear that one does not have to probe very far into the psychoanalytic uses of Oedipus to find a phallocentric bias in both myth and theory. The terms of the oedipal formation of the human subject and its cultural expressions all seem to come down on one side, whether we're talking about women as signifiers of castration threat, voyeurism, and the controlling gaze, identity and difference, scopic drives, visual pleasure, To Have and Have Not. The problem is that even as we employ these terms for describing and unveiling the workings of patriarchy, we implicate ourselves deeper into those very operations, as into a well-worn track in the forest. The very notion of lack, as proposed by Lacan, mirrors the prevailing cultural bias by privileging the symbolic threat of loss of the penis over the actual loss of the mother's body. Yes, I know that language is an all-important mediating factor and that loss of the breast predates the acquisition of language. Which then means, of course, that the breast is "less" than the penis. And how can this be otherwise when the clitoris is *nonexistent?* Psychoanalytic hierarchies of sexual synecdoche are mind-boggling and, for psychoanalysis, irrevocable. For women, however, psychoanalysis can only define a site of prolonged struggle.

All of this may seem far afield from my starting place, the authorial voice and fictional subject in cinematic practice, which we may now characterize as our (back to the undifferentiated pronominal mass!) desire for Oedipus in all or most of His manifestations. Although I may have to pay the consequences of breaking the Law of the Father in my daily life, there's no reason I can't give it (the Law) a run for its money as a filmmaker. If I'm going to make a movie about Oedipus, i.e., Eddy and Edy Pussy Foot, I'm going to have to subject him to some calculated narrative screw-ups. It's elementary, dear Eddy: play with signifiers of desire. Have two actors play Jack Deller, the male protagonist in *TMWEW.* Remove the physical presence of Trisha, the female protagonist, and reintroduce her as a voice. Create situations that can accommodate both ambiguity and contradiction without eliminating the possibility of taking specific political stands.

Shift de Lauretis's image/ground of narrative movement by frequent changes in the "production value" of the image, e.g., by utilizing refilming techniques, blown-up Super 8, inferior quality video transfers, shooting off of a TV set with bad reception, etc.—not in order to make the usual intra-narrative tropes, however, such as the character's look at a TV show or a shift in meaning of the image to dream, flashback, or inner thoughts of a character. What I'm talking about is a disruption of the glossy, unified surface of professional cinematography by means of optically degenerated shots within an otherwise seamlessly edited narrative sequence.

Play off different, sometimes conflicting, authorial voices. And here I'm not talking about balance or both sides of a question like the nightly news, or about finding a "new language" for women. I'm talking about registers of complicity/protest/acquiescence within a single shot or scene that do not give a message of despair. I'm talking about bad guys making progressive political sense and good girls shooting off their big toe and mouth. I'm talking about uneven development and fit in the departments of consciousness, activism, articulation, and behavior that must be constantly reassessed by the spectator. I'm talking about incongruous juxtapositions

of modes of address: recitation, reading, "real" or spontaneous speech, printed texts, quoted texts, etc., all in the same film. I'm talking about representations of divine couplings and (un)holy triads being rescreened only to be used for target practice. I'm talking about not pretending that a life lived in potholes taking potshots will be easy and without cost, on screen or off.

I'm talking about films where in every scene you have to decide anew the priorities of looking and listening. In *TMWEW* there's a scene in which Jack Deller delivers a rambling lecture to a group of students in what is eventually revealed to be a newly renovated loft-condominium. If one doesn't pay particular attention to the insistent, autonomous tracking of the camera around the space, but puts all of one's efforts into deciphering the spoken text with its ellipses, digressions, and dipping in and out of Foucault, Lacan, Chomsky, Piaget, et al., when Trisha's voice finally begins to talk about the disappeared in Central America and New York, you will have missed the meaning of that space, i.e., an expensive piece of real estate, as a crucial link between the lecture and instances of US international and domestic imperialism. The visual track in this instance anticipates the soundtrack, but also supplies a subtext for the lecture with its retroactive associations of urban university land grabbing.

Later in the film, texts are played off in a different way. In a scene in a narrow corridor between Jack Deller and his ex-lover, Jackie, the main thesis of Foucault's "power-is-everywhere" is intercut with documentary footage of demonstrations of power "somewhere" in particular, "on this side" and "on that side." Jack Deller's recitation of the Foucault material is further juxtaposed with Jackie's recitation of excerpts from an essay by Meaghan Morris in which she criticizes theory itself for having "no teeth."[30]

Other tensions abound here: the anti-monolithic arguments of Foucault colliding with Trisha's invocation of military/police and medical fraternities, and the disparity between doing and speaking, or image and text, as demonstrated in the seductive moves of Jack and Jackie, a disparity that then collides with Foucault's "There is no opposition between what is said and what is done."[31] At another point Morris's description of Lacan's reign at the "costume ball" of feminine writing "not as lawgiver but as queen" is followed by a dream sequence in which a mother and daughter (played by one performer) play a queen of the kitchen who is alternately romanced by her son-in-law and watches him and her daughter in bed, in a short and shifty oedipal extravaganza caustically narrated by the irate daughter. If these scenes are about a conflict between theory and practice, or a contradiction between theory and everyday life, they can also be read in terms of a "return of the repressed," which, operating as more than cheap subversion, constantly pressures theory into re-examining systems of signification, reinventing its own constraints.

Finally, I'm talking about films that allow for periods of poetic ambiguity, only to unexpectedly erupt into rhetoric, outrage, direct political address or analysis, only to return to a new adventure of Eddy Foot or New Perils of Edy Foot. He may still shoot off his big toe while getting or not getting the girl, but he'll also ask a few questions or wait in the wings a little longer to see how the ladies work it out

without him. And this time around she may start to rip off her rival's dress, but then stop to muse, "Hey, we're wearing the same dress aren't we? Why don't we pool our energies and try to figure out what a political myth for socialist feminism might look like?" So they (she and she) make a movie together and. . . .

Thoughts on Women's Cinema: Eating Words, Voicing Struggles

Yvonne Rainer/April 1987

The Independent Film & Video Monthly

Polemics and manifestos having always served as sparkplugs to my energies and imagination, I've been surprised when, following their publication, such statements were taken with what seemed to be excessive seriousness. Thus, in the mid-'60s, when I said "no" to this and "no" to that in dance and theater, I could not foresee that these words would dog my footsteps and beg me to eat them (or at least modify them) for the next 20 years. Such may be the case with my more recent stance toward/against/for narrative conventions in cinema. Raised, as I have been, with this century's Western notions of adversarial aesthetics, I continue to have difficulty in accommodating my latest articulation of the narrative "problem"—i.e., according to Theresa de Lauretis' conflation of narrativity itself with the Oedipus complex, whereby woman's position is constantly reinstated for the consummation or frustration of male desire. The difficulty lies in accommodating this with a conviction that it is of the utmost urgency that women's voices, experience, and consciousness—at whatever stage—be expressed in all their multiplicity and heterogeneity, and in as many formats and styles—narrative or not—from queendom come and throughout the kingdom. In relation to the various notions of an avant-garde, this latter view, in its emphasis on voicing what has previously gone unheard, gives priority to unmasking and reassessing social relations rather than overturning previously validated aesthetic positions. My personal accommodation becomes more feasible when cast in terms of difference rather than opposition and when the question is asked: "Which strategies bring women together in recognition of their common and different economic and sexual oppression, and which strategies do not?" The creation of oppositional categories of women's film or video, or, for starters, film *and* video, begs this question.

For what it's worth, here is a list of useless oppositions. Documentary vs. fiction. Work in which the voices carry a unified truth vs. work in which truth must be wrested from conflicting or conflicted voices. Work that adheres to traditional codes vs. work in which the story is disrupted by stylistic incongruities or digressions (Helke Sanders' *Redupers*, Laura Mulvey and Peter Wollen's *Riddles of the Sphinx*). Work with a beginning, middle, and end vs. work that has a beginning and then turns into something else (Marguerite Duras' *Nathalie Granger*). Work in which the characters run away with the movie vs. work whose characters never get off the ground (Rabina Rose's *Nightshift*). Work in which women *tell* their herstories (Julia

Reichert and Jim Klein's *Union Maids*) vs. work in which they parody them (Ana Carolina's *Hearts and Guts*). Work that delivers information in a straightforward manner (Jackie Ochs' *Secret Agent*) vs. work in which information accrues slowly, elliptically, or poetically (Trinh Minh-ha's *Naked Spaces*). Work in which the heroine acts vs. work in which she does nothing but talk (my *Journeys from Berlin/1971*). Work in which she triumphs vs. work in which she fails (Valie Export's *Invisible Adversaries*). Work in which she is a searcher or dominatrix (Bette Gordon's *Variety*; Monika Treut and Elfi Mikesch's *Seduction: The Cruel Woman*) vs. work in which she is a victim (Lynne Tillman and Sheila McLaughlin's *Committed*). Work whose heroines you like (Connie Field's *Rosie the Riveter*, Julie Dash's *Illusions*) vs. work whose heroines repel you (Doris Dome's *Straight to the Heart*, Chantal Akerman's *je, tu, il, elle*). Work in which you nearly drown in exotic signifiers of femininity (Leslie Thornton's *Adynata*) vs. work whose director can't figure out how to dress the heroine, so removes her altogether (my *The Man Who Envied Women*). *All* these films share a potential for political purpose and historical truth.

I could go on ad infinitum with these divide-and-conquer oppositions. There is one other example I'm not going to give equal footing with the others but will mention in passing only in so far as it bears a deceptive resemblance to the others: Films in which the heroine marries the man vs. films in which she murders him. We have only to look in vain for recent films by women that end in marriage to realize what a long way we've come, give or take the baby. Marriage at the beginning maybe, but at the end, never. I challenge anyone to name one in recent memory. Murder, on the other hand, is a different story. As Joan Braderman pointed out last spring at the Gender and Visual Representation Conference at the University of Massachusetts, in the past 10 years a substantial number of women's films have been produced that focus on a murder of a man by a woman or women. To name a few: Akerman's *Jeanne Dielman*, Marlene Gorris' *A Question of Silence*, Dome's *Straight to the Heart*, Sally Heckel's *A Jury of Her Peers*, Margaretha Von Trotta's *Sheer Madness*.

The phenomenon of man-murder in women's films points to the problematic of representing men. Do we wreak revenge on them (if for no other reason than the cinematic sway they have held over us for so long), turn the tables on them, turn them into celluloid wimps, give them ample screen time in which to speak self-evident macho bullshit, do away with them by murder within the story, or eliminate them *from* the story to begin with? Do we focus on exceptional men who escape the above stereotypes, or do we weave utopian scenarios in which men and women gambol in egalitarian bliss? Lynne Tillman and I pondered the question of whether it is politically useful to allow ourselves to be fascinated with men in our films even as we discussed the strange fascination with the 1986 World Series that had befallen the two of us along with every woman we know.

Following one screening of *The Man Who Envied Women*, a well-known feminist who subscribes to Lacanian psychoanalytic theory asked me why I hadn't made a film about a woman. I was flabbergasted, having been under the impression that I had done just that. But she, taking the title literally and taken in by the prevailing physical presence of the male character, had discounted the pursuing, nagging,

questioning female voice on the soundtrack. By staying out of sight my heroine is never caught with her pants down. Does this mean the film is not *about* her?

It's also been noted that my female characters are not heroines. I would qualify that: My heroines are not heroic. They are deeply skeptical of easy solutions and very self-critical, constantly looking for their own complicity in patriarchal configurations. But neither are they cynical or pessimistic. The moments I like best in my films are those that produce—almost simultaneously—both assertion and question. Early on in *TMWEW*, the assertion that women can't be committed feminists unless they give up men is uttered as part of a conversation, overheard by a man in the foreground, by a woman who is testing her female companion by quoting yet another woman whose relationship to the speaker is not identified and who never appears. The two speakers are also anonymous and are never seen again once this scene is over. I, the director, am not trying in this scene to persuade my audience of the rightness or wrongness of the statement. What is important is that it be given utterance, because in our culture, outside of a convent, giving up men freely and willingly—that is, without the social coercion of aging—is a highly stigmatized act or downright taboo. The linkage of giving up men, in this scene, with commitment as a feminist, however, is distanced and made arguable through the device of having the spectator become an eavesdropper on the conversation along with the foregrounded male character, then distanced once more through quotation. "*She told me*," says this minor, will-o-the-wisp heroine, "that I would never be a committed feminist until I give up men."

Whether an utterance comes across as feminist prescription, call-to-arms, or problem-articulated-ambiguously-to-be-dealt-with-or-not-later-in-the-film is always on my mind in the collecting, mounting, and framing of texts. If the experience of watching certain kinds of social documentaries is like watching the bouncing ball come down at exactly the right moment on the syllables of the familiar song, watching a film of mine may be more akin to "now you see it, now you don't." You never know when you're going to be hit on the head with the ball, and you aren't always sure what to do when the ball disappears for long stretches of time.

Which brings me to what might be called a method of interrogating my characters and myself when I set out to make a film. Thinking about this has been facilitated by rereading Bill Nichols' essay, "The Voice of Documentary," which poses certain questions that are relevant to both fiction and documentary. To what degree are we to believe a given speaker in a film? Do all the speakers convey a unified vision of a given history? Do the speakers emerge as autonomous shapers of a personal destiny or as subjects conditioned by the contradictions and pressures of a particular historical period? To what degree does a given film convey an independent consciousness, a voice of its own, probing, remembering, sustaining, doubting, functioning as a surrogate for our own consciousness? Do the questioning and believing of such a film question its own operations? Does the activity of fixing meaning in such a film refer to relations outside the film—"out there"—or does the film remain stalled in its own reflexivity? Is reflexivity the only alternative to films that simply suppose that things were as the participant-witnesses recall or state them, or as they appear to the spectator, in the case of fiction films?

Yvonne Rainer (1934–)

Finally, should a film whose main project is to restore the voice and subjectivity of a previously ignored or suppressed person or segment of the population, should such a film contain argument, contradiction, or express the director's ambivalence within the film either directly, through language, or indirectly, through stylistic intervention? Obviously, we can't afford to be prescriptive about any of this.

My own solution runs to keeping an extra-diegetic voice, a voice separate from the characters and story, fairly active in every scene. It need not take the form of a narrating voice, although it often does. Sometimes it takes the form of a *Till Eulenspiegel*-like disruption, as when an anonymous woman enters the frame just before a troubling bit of sexual theory is enunciated, peers into the camera lens, and asks all the menstruating women to leave the theater. Sometimes it operates like a kind of seizure, producing odd behavior in a given character, as when the analysand in *Journeys from Berlin* speaks in baby-talk. Often it comes across in reading or recitation, which has the effect of separating the voice of the character from that of the author of his or her words.

At this historical moment, we still need to search out and be reminded of suppressed histories and struggles: prostitutes, housewives, women of color, lesbians, third world people, the aging, working women. The method of representing these histories is a separate and equally important issue. I see no reason why a single film can't use many different methods, which is something I've been saying for years but didn't come close to realizing until *TMWEW*. In this film, fictional, and documentary modes come into play more fully than in any of my previous work, offsetting the calculation of my still-cherished recitations and readings with the immediacy of dramatic and documentary enactment. These last are, admittedly, the strategies that offer the spectator the most powerful sense of the real. But reality, as we so well know, always lies elsewhere, a fact that we nevertheless endlessly seek to disavow and from which we always retreat. I shall continue to remind us of that disavowal by challenging reality's representational proxies with assorted hanky-panky. I hope others continue to do likewise and otherwise.

Notes

1. Yvonne Rainer, *Feelings Are Facts: A Life* (Cambridge, MA: MIT Press, 2006), 32–44.
2. Ibid., 103–104.
3. Ibid., 87–88.
4. Sally Banes, *Democracy's Body: Judson Dance Theater, 1962–1964* (Durham: Duke University Press, 1993), 14.
5. Yvonne Rainer, *Work, 1961–73* (Halifax: Press of the Nova Scotia College of Art and Design, 1974), 51.
6. Ibid., 71.
7. Ibid.
8. Ibid., 385.
9. Yvonne Rainer, *Feelings Are Facts: A Life* (Cambridge, MA: MIT Press, 2006), 383.
10. Susan Sontag, "Skirting and Aging: An Aging Artist's Memoir," in *Yvonne Rainer: Radical Juxtapositions, 1961–2002*, ed. Sid Sachs (Philadelphia: The University of the Arts, 2003), 93.

11. "Happenings: An Art of Radical Juxtaposition," reprinted in Susan Sontag, *Against Interpretation and Other Essays* (London: Penguin Classics, 2009), 263–274.

12. Noel Carroll, "Interview with a Woman Who . . ." in *A Woman Who . . . Essays, Interviews, Scripts* (Baltimore: The Johns Hopkins University Press, 1999), 196.

13. Ibid., 177.

14. Noel Carroll, "Interview by the Camera Obscura Collective," in *A Woman Who . . . Essays, Interviews, Scripts* (Baltimore: The Johns Hopkins University Press, 1999), 163.

15. Susan Sontag, "Skirting and Aging: An Aging Artist's Memoir," in *Yvonne Rainer: Radical Juxtapositions, 1961–2002*, ed. Sid Sachs (Philadelphia: The University of the Arts, 2003), 95.

16. Scott MacDonald, "Yvonne Rainer," in *A Critical Cinema 2: Interviews With Independent Filmmakers* (Berkeley: University of California Press, 1992), 347.

17. Susan Sontag, "Skirting and Aging: An Aging Artist's Memoir," in *Yvonne Rainer: Radical Juxtapositions, 1961–2002*, ed. Sid Sachs (Philadelphia: The University of the Arts, 2003), 96.

18. Noel Carroll, "Interview by the Camera Obscura Collective," in *A Woman Who . . . Essays, Interviews, Scripts* (Baltimore: The Johns Hopkins University Press, 1999), 156.

19. Noel Carroll, "Interview with a Woman Who . . ." in *A Woman Who . . . Essays, Interviews, Scripts* (Baltimore: The Johns Hopkins University Press, 1999), 176.

20. Ibid., 179–180.

21. Susan Sontag, "Skirting and Aging: An Aging Artist's Memoir," in *Yvonne Rainer: Radical Juxtapositions, 1961–2002*, ed. Sid Sachs (Philadelphia: The University of the Arts, 2003), 96.

22. Noel Carroll, "Declaring Stakes: Interview by Kurt Easterwood, Laura Poitras, and Susanne Fairfax," in *A Woman Who . . . Essays, Interviews, Scripts* (Baltimore: The Johns Hopkins University Press, 1999), 231.

23. Ibid., 235.

24. Yvonne Rainer, "Working Round the L-Word," in *A Woman Who . . . Essays, Interviews, Scripts* (Baltimore: The Johns Hopkins University Press, 1999), 113.

25. Yvonne Rainer, *Feelings Are Facts: A Life* (Cambridge, MA: MIT Press, 2006), 460.

26. "Beginning With Some Advertisements for Criticisms of Myself, or Drawing the Dog You May Want to Use to Bite Me With, and then Going on to Other Matters," in *A Woman Who . . . Essays, Interviews, Scripts* (Baltimore: The Johns Hopkins University Press, 1999), 166.

27. Teresa De Lauretis, *Alice Doesn't: Feminism, Semiotics, Cinema* (Bloomington: Indiana University Press, 1984), 112.

28. Ibid., 119.

29. Sigmund Freud, the standard edition of *The Complete Psychological Works of Sigmund Freud*, 13:213, quoted in Marie Balmary, *Psychoanalyzing Psychoanalysis: Freud and the Hidden Fault of the Father* (Baltimore: Johns Hopkins University Press, 1982), 80.

30. Meaghan Morris, "The Pirate's Fiancée," in *Michel Foucault: Power, Truth, Strategy*, eds. Meaghan Morris and Paul Patton (Sydney: Feral Publications, 1979), 159.

31. Rainer notes here that these quotes are derived from a lecture Power and Norm by Michel Foucault.

17

ANNIE SPRINKLE (1954–) AND BETH STEPHENS (1960–)

Linda Williams

It is impossible today to talk about Beth Stephens without also talking about Annie Sprinkle, and vice-versa. Each has had a career of her own, and while I will briefly discuss them separately, the goal of this biography and our interview is to discuss their work together since they became a couple in 2002.

Sprinkle is a tall, buxom woman with long dark hair who is as femme as femme can be. When performing, which is a great deal of the time, she commonly wears what might be called variations on her goddess-slut outfit, designed to display her large breasts (tools of her former trades as a pin-up model, prostitute, and porn star). Her voice is soft, girlish, and seductive. Since the early 1990s she has also been a sex educator, performance artist, and experimental filmmaker. But her art career has never repudiated her porn career. I call this refusal to deny the down and dirty side of the sexual persona she has cultivated the strategy of the "both/and" rather than the "either/or." As *The Independent* profile of her from 2003 shows, her transition to performance artist in the early 1990s took place with her "Public Cervix Announcement," that allowed theater audiences to view her cervix with the aid of a speculum and flashlight, or the 1992 *Sluts and Goddesses Video Workshop—Or How to Be a Sex Goddess in 101 Easy Steps*, where she and her team of "transformation facilitators" demonstrate how to display both sides of this dichotomy. In both, she never eschewed the artist over the whore. Open to sex, open to life's experiences, always learning, never dismissive—note how she turns a near fatal car wreck into romance in the interview which follows—she is an absolute original. There is one other important thing to note about this multi-marrying couple: they laugh a lot. The joy they share spills over into the work. Performance and film work become part of life, and life itself becomes the lifelong work.

Stephens is Sprinkle's physical opposite: short, athletic, vigorous, with a mischievous twinkle in her eye, and as butch as androgynous can be. She is five years younger than Sprinkle and her career attests to the enormous influence Sprinkle has had on

271

the sex-positive, feminist art world, with the singular difference that Stephens did not begin as a sex worker. In recent years, she has gained a little weight and come to resemble a butch version of Sprinkle in ways that become apparent the more they perform, work, and live together. But she is also her own, unique, down-home, West Virginia person. And though it is not evident in her self-presentation, she is an astute academic and is chair of the University of California Santa Cruz Art Department. Stephens began her career as a sculptor and installation artist who was already taking environmental road trips photographing the sky, the mountains, and the water long before teaming up with Sprinkle. Another of her early works, "Lessons in Photography: Who's Zoomin' Who?" features her Harley Davidson 883 on a revolving pedestal surrounded by a dozen large photos of Sprinkle in full porn mode. It makes a big difference, in this spoof on the male gaze, that one of the photos reveals that it is a woman who is "zoomin" Sprinkle and that that woman is Stephens herself in male underwear.

Sprinkle and Stephens' seven-year performance: *The Love Art Laboratory* was the first large-scale art project they did together, and it was "dedicated to exploring and generating love through art." Their friend, Linda M. Montano, who herself does multi-year, endurance, performance works, encouraged others to do so as well, based upon a simple structure; explore one chakra (bodily energy center) each year with its corresponding theme and color. Everything else was up for interpretation.

What Sprinkle and Stephens did with that basic structure is to create the *Love Art Lab*, a series of performance art weddings beginning in 2005. The *Love Art Lab* was nomadic and existed wherever they were. They posted their progress and documentation on their website, loveartlab.org. At first the weddings were conceived as expressions of love to one another, but after two years they opened up to more expansive, perverse, and ecological expressions. They turned an inherently inward-looking spiritual/physical coupling into more outward-looking, political but still sexualized events.

In their first year (the root chakra), the color was red and the themes were security and survival. One of their performances was *Cuddle*, in which a bed was installed in an art gallery or museum and everyone was invited to join the couple under a red "security blanket" to cuddle between them for seven minutes apiece. Another was a series of "extreme kisses," some lasting hours. The most striking of these took place when Sprinkle was undergoing chemotherapy for breast cancer and her hair fell out. In solidarity, Stephens shaved her own head. In their video *Kiss*, these upper-torso framed kisses seem like Martian rituals: two pale, almost identical bald heads thrusting at one another and connecting only at the lips or tongues seem to be one body.[1] The first wedding ceremony itself took place at the old Harmony Burlesque club in Manhattan where Sprinkle first performed her famous Public Cervix Announcement.

A turning point in the weddings came in 2008, in the green heart chakra year, with the theme of compassion, when the couple married the Earth. However, instead of marrying "mother Earth" they married "lover Earth" which was more polymorphously perverse. Instead of expecting the Earth to take care of them like a mother, their desire was to please the Earth, and be in a more romantic, erotic, and reciprocal relationship.

Through a process that Judith Butler calls re-signification (*Gender Trouble* 145), they discovered new things to love in each wedding. The first wedding had begun partly as a protest that a legal marriage was denied them as a "same-sex couple." But repeated iterations yielded a perverted "swerving away" from the presumably original "love object" (man or woman) and "purpose" (procreation) to queer the love. A traditional wedding focuses on a couple's love and commitment to each other. Sprinkle and Stephens' weddings (now numbering over 21) expanded from an esoteric religious practice involving chakras to re-signify the very idea of love and exchanging sexual energies as something necessary for the planet. Soon the two brides were getting invitations from all over the world to create community weddings to various entities.

By 2009 and the Blue Wedding to the Sea (throat chakra, blue, communication) the couple found themselves at Mercia Spain's pavilion of the Venice Biennale, and the sea they married was the Adriatic. Beatrize Preciado (not yet Paul) was the officiant and delivered an eloquent and fierce homily and the two artist-brides explained in a press release:

> The Sea has a fast growing cancer made of islands of plastic the size of Texas. She is suffocating from gasses caused by our pollution. . . . Mercia's Fear Society Pavilion is the perfect place for this wedding. Many of us fear the destruction of our beautiful environment. We want to transform this fear into loving action to care for the sea.

Artists came to perform in the wedding from 19 different countries and marry the Sea along with them. "Anti-priest," Preciado's homily before the couple went out in a gondola to drop wedding rings into the Sea, emphasized the types of connections meant by the union:

> As we marry the sick Sea today, let us get rid of fear of the other, fear of queerness, fear of sickness, fear of ugliness, fear of the grotesque, fear of the virus, fear of death.
>
> As we marry the sick Sea today, let us remember to construct community on "the social and biological vulnerability of the body" rather than on immunity and fear of the other. . . .
>
> I propose that we think of community as water. The most expanded chemical substance of the planet, present in every living being, though never having the same form: the water is changing constantly through a cycle of evaporation, becoming steam, and then becoming liquid, solidifying and becoming ice, the sky being just the sea in an altered form . . .
>
> As we marry the Sea today, we invite you to open your mouth, your hands, your vaginas, urethras, and anuses to non-human love.

In the final year of *The Love Art Laboratory* (2011, white, top of the head chakra), they saw four weddings, including white to the Snow in Ottawa, Canada; black to

273

Coal in Gijon, Spain, silver to the Stones in Barcelona, Spain, and gold to the Sun back home on Bernal Heights hill in San Francisco. By this time, they had incorporated tenants of their *Ecosexual Manifesto* into the ceremonies. What had begun as a protest to gain marriage rights for everyone, had become a fully promiscuous wedding to and with communities in nine different countries with over 3,000 participants—not only a successful piece of performance art, but one with video documentation.

After 21 weddings to various entities such as the Earth, Moon, and Sun and after declaring themselves ecosexuals, Stephens and Sprinkle went on the road to make activist documentaries with an ecosexual twist. We might have expected the films to come from Sprinkle who had been making them for years both in her porn starlet phase and then later as director in her post-porn modernist phase.

Though Stephens was a neophyte, the first film, *Goodbye Gauley Mountain: An Ecosexual Love Story* (2013), was directed by her. Al Gore's *An Inconvenient Truth* it isn't! The film is narrated by Stephens and told as a personal story of a queer child of Appalachia returning home with her oft-wedded wife and ecosexual partner. As might be expected, the couple marries the Appalachian Mountains in a rousing ceremony. But in the context of a documentary chronicling activist civil disobedience, the ceremonies take on a greater purpose. Stephens learns how to tree sit and to lock her arm into a weighted barrel so that to remove her would be to break her arm. We meet photographers who have archived the beauty of the mountains along with their destruction. We hear and see the explosions that blow off mountaintops and learn how it is done: bulldoze off the vegetation, drill holes down into the mountain, fill them with ammonium nitrate and diesel fuel—and bang. Afterwards, a so-called "overburden" of "waste" is bulldozed into the valleys where nothing further will ever grow. Deep mineshaft mining was dangerous to miners' lungs, but this is a rape that leaves no life in its wake. More than 500 mountaintops have been violently removed in this way.

The ecosexuals hug trees, skinny dip in a stream, join demonstrations, and get a tour by a hillbilly poet and seer who calls coal the lungs of the Earth. Stephens not only stares down, but "sings down" a group of cops at an Environmental Protection Agency demonstration by singing multiple verses of the state song of West Virginia. The film is down to earth and heartfelt. Its greatest accomplishment is to marry the performance art of the earlier seven-year project to a more accessible and informative documentary.

Water Makes Us Wet: An Ecosexual Adventure is their second film. It is co-directed by the couple and their most recent major work. It premiered in June 2017 at documenta, but has not yet been widely screened in the US. The topic is water, and the problem is a drought-ridden and then a flooded California. What can the ecosexuals do? One thing they can do is to make a film narrated by the Earth in the resonant voice of pioneer transsexual Sandy Stone. Earth is often exasperated by the ignorance of the ecosexual couple that tries to join other environmentalists but are considered too weird. A clogged toilet in their San Francisco home impels them to take a tour of their local water treatment plant and learn from a friendly expert the

only things that can go down a drain: pee, poop, and paper. "How could they be good lovers to my waters when they didn't know shit about shit!" remarks Earth.

In white lab coats, they pack up their funky Earth Lab Research Unit and head south on a tour of the state's water resources. They walk on the beach, drink recycled water, interview kindred sea lions, and, at the ocean's edge, learn how global warming leads to acidification and loss of marine life. When they reach Sprinkle's birthplace, Los Angeles, she not only tells us of her love of water, she also becomes an aquaphile who shows us just how much water makes her wet. Heading to sprinkle her father's ashes in Lake Tenaya in Yosemite, Sprinkle asks her aged mother where she would like to be sprinkled. "I don't know, surprise me," answers the sprightly older woman.

One of the most powerful sequences occurs in a drought-ridden San Bernardino county when they are led to a so-called "spring" where Nestle claims to bottle fresh "spring water." What we find are a series of pipes that steal the ground water from the mountain and leave many newly endangered species without the water they need to live. In what may be a not so-subtle incitement to action, Stephens speaks to the pipes that mine the water and wishes them to burst. Graphics tell us the many brands that market this Nestle water (Perrier, Vittel, Calistoga, Glacier, S. Pellegrino, etc.).

At a hot spring, they encounter two inspiring young women whose appreciation of water leads to a pool baptism and some rousing choruses of "Wade in the Water." In Yosemite they finally sprinkle Sprinkle's father's ashes wading into Lake Tenaya with a cloth bag of ashes labeled "Dad." The film then seems to pause; where to next? With Sprinkle's family goal accomplished, but Earth's more ecological needs still neglected, they drift on without momentum and are suddenly rear-ended. A ferocious montage conveys the trauma of what was an actual bone-breaking event. Earth narrates the catastrophe and almost relishes it for he/she/it had almost had it with the couple's many ecological sins, including the gas guzzling, fume exhaling van totaled in the accident. We have witnessed some of these other sins: the eating of an annual hamburger, ignorance of what clogs toilets, too many plastic water bottles.

"Five months later," a title informs us, the irrepressible couple are back on their feet; Earth has given them one more chance. As if to make amends, they adopt their local storm drain, and then march in San Francisco's annual Pride Parade where they have assembled and choreographed a strong ecosexual contingent and they find their acceptance among the leather fetishists, drag queens, performance artists, sex workers, and other aquaphiliacs. They launch their march with a ribbon cutting ceremony that marks the moment they add E to the GLBTQI moniker. The Ecosexual Manifesto is read by Guillermo Gomez Pena:

We are aquaphiles, terraphiles, pyrophiles and aerophiles. We are skinny dippers, sun worshippers and stargazers. We are artists, sex workers, sexologists, academics, environmental and peace activists, feminists, eco-immigrants, putos y putas, trans/humanistas. . . . Whether GLBTQI, hetero, asexual or Other, our primary drive and identity is being Ecosexual!

The triumphant costumes and chants of so many celebrants may give the impression that ecosexuality has finally succeeded, at least in San Francisco, and that might seem to be the film's happy ending. But Earth, always more skeptical, puts the question to the audience, "Does water make *you* wet"? There is certainly more work to be done.

This chapter includes an interview with Sprinkle from the March 2003 issue of *The Independent Film & Video Monthly* and an original interview with Sprinkle and Stephens from 2018.

Annie Sprinkle: From Porn to NYC's MOMA and Everywhere in Between

Michaela Grey/March 2003

The Independent Film & Video Monthly

My main interest has never been film. It was never about doing a great drama, or great action, or anything like that. It's always been: How can we really show sex in the best way?

—*Annie Sprinkle*

The inimitable Sprinkle—porn star, performance artist, filmmaker, photographer, author, erotic guru, and all-around *metamorphosexual* (her own term)—has been doing just that for 30 years, using every possible opportunity to create and distribute positive representations of sexuality. How on Earth did Ellen Steinberg, the shy, chunky daughter of staid, suburban Jewish intellectuals, transform herself into exhibitionistic, glamorous alter-ego Annie Sprinkle, whose art/sex films have screened at the museums and galleries around the world, including the Museum of Modern Art?

After a stint at a massage parlor, 18-year-old Steinberg became the mistress of *Deep Throat* director Gerard Damiano, who, she says, "was probably my biggest influence, porn film-wise. He was definitely an artist. He encouraged me to make things personal and intimate . . . to tell stories that were real." Her subsequent apprenticeship on a low-budget porn set made her wonder if she wouldn't have more fun on the other side of the camera; Sprinkle went on to appear in literally hundreds of porn films in the seventies and eighties. While her life's work may not have been clearly defined at that early stage, she was definitely doing what she loved and felt a real sense of purpose in it all. "Actually," she explains, "when I started doing porn in 1973—it seems like another millennium ago—just to do porn at all back then was so stigmatized, no one knew if it was even legal! It's hard to imagine now, but doing those films really felt like it meant something. Just saying 'yeah, pussies are beautiful' was really shocking." Sprinkle pushed the envelope even as a porn star—of her groundbreaking 1981 film *Deep Inside Annie Sprinkle*, in which she talked directly to the camera, she says, "That just wasn't done, but I really wanted to involve the viewer—although it was still formula porn."

Her 1985 appearance in the Franklin Furnace performance *Deep Inside Porn Stars* opened a new realm of possibility for Sprinkle's work. Thus began her revolutionary "crossing of that bridge between art and porn" as Sprinkle's films were shown at the Museum of Modern Art and the New Museum of Contemporary Art (1990). She also memorialized her outrageously popular postfeminist workshop in the classic 1992 video *Sluts and Goddesses*. Birthing such concepts as *edu-porn* (through a female genital massage video co-directed by Joe Kramer) and *docu-porn* (in the 1990 transsexual-themed *Linda, Les, & Annie*), Sprinkle's profound influence on mainstream and alternative porn alike—to say nothing of America's sex-positivity quotient overall—is well documented.

Sprinkle's most recent personal film, 1998's *Herstory of Porn*, is a *Mystery Science Theater*-style commentary on her many years in the industry. She wrote, directed, and edited this one (with a little help from Carol Leigh, a.k.a. Scarlot Harlot). "Whenever I have had a chance to direct, there's always been a great vibe on the set. I always try to make everybody happy and comfortable. I pay people a million compliments and thank them for every little thing and try to create a good atmosphere, so everybody's usually very happy. It's very important to have good food on the set. On any porn movie set, it's the food that people remember, and if it was good, they feel like they were taken care of. I also think it's important to pay people well when you can. I mean, if it's something experimental, that's maybe different. When I made *Herstory of Porn*, which is my porn diary, I had to go into the studio and film on Chroma key. I had about 15 people, and boy, did I spend a fortune on food. But it was worth it—people really appreciated it! Some of them were working for very little money." Of that experience, she learned "never to star in films you direct, produce, and pay for. My acting really suffered. I was so stressed out, and it got really expensive. It was just too much!"

Sprinkle has also moved from posing for porn photography to making her own; her work has appeared in virtually every mainstream and alternative sexually themed publication imaginable, and in spite of a devastating 1999 houseboat fire in which her beloved cats died and most of her archives were destroyed, she still has "articles and piles of photos" from this phase of her work. But her oeuvre is not confined to the visual; Sprinkle is a published author with several titles under her belt, who is often asked to speak to academic audiences, and quoted in "ivory tower" texts. All of this is part of the larger plan for Sprinkle. "I went out to colleges and met people. People got to meet me and see what a real prostitute/porn star was like, in places they didn't necessarily expect," she says. "My books reach students—that book *Angry Women* went to many colleges as a textbook." The academic environment surely had its own influence on Sprinkle: "I did just get my PhD at the Institute for Advanced Study of Human Sexuality, which makes me the first porn star to get a PhD!"

She's currently working on a documentary about orgasms, and asserts: "The best is definitely yet to come, that's all I can say! I've just gotten started. I figure I've got 30 years left before I stop making porn." She also notes, "The sex I'm having now is so far beyond anything I've ever done on film yet. It's so ironic—as people get

older they become so much more vibrant and erotic and skilled as lovers, but society values only youth and inexperience."

Should you wish to follow in the footsteps of this sexual guru, Sprinkle whole-heartedly encourages you, with one caveat: "If you don't like the porn that's out there, make porn that you do like—but you should know that it's harder than it looks!"

A Conversation With Annie Sprinkle and Beth Stephens

Linda Williams/2018

Linda Williams: Let's start with how the two of you arrived at this particular moment of our interview, by which I mean the recent completion in 2017 of *Water Makes Us Wet: An Ecosexual Adventure.* I know that Annie came to art through sex, and I wonder if you, Beth, came to sex through art.

Beth Stephens: Well, no, I grew up spending a lot of time on my grandparent's farm—and farms just have sex everywhere. That's how I learned about sex. I've always really enjoyed sex. I was never really taught that sex was shameful. Then I became a lesbian, and I discovered feminism, so I started making work about lesbian feminist sex early in my career.

I met Annie when I curated some of her tit prints into an art show I was involved in in the '90s at Rutgers. And then I wanted more of her! So I got her to model for me for my master's thesis exhibition.

Annie Sprinkle: Beth also did some sculpture installations with squirting specu-lums. And she did performance art naked in a bathtub with dead fish in it.

Stephens: Yes, so I had already been doing work about sex.

Sprinkle: Her master's exhibit was a sexy photoshoot with me and her pos-ing together on her Harley with an "On Our Backs" magazine flavor—in huge glossy color prints.

Stephens: I was studying with people like Martha Rosler, and Lauren Ewing. I was very interested in the sex thing in New York in the early '90s and Annie was a part of that scene. But I was also engaged in sculp-ture and performance about gender and sex before I met Annie, so it's a little messier than your neater package.

Sprinkle: Beth studied with Fluxus artist Geoffrey Hendricks, and I was living with Willem DeRidder, who was European chairman of Fluxus, so we were both well versed in Fluxus, and we both love experimental and conceptual art.

Stephens: I wanted to fluxus Annie.

Sprinkle: Fluxus was pretty sexy with the vagina painting (Shigeko Kubota) and the topless cello playing (Charlotte Moorman).

278

Stephens:	Oh my god, and Yoko Ono's *Bottoms* film.
Sprinkle:	Yes, we were both Fluxus fans. So I did Beth's photoshoot in '92 and then we stayed in touch a little bit as colleagues for a decade or so. Before we ever became lovers, I went to her art openings. She also did a great piece that was a take off on Judy Chicago's Dinner Party.
Stephens:	Yeah, it was called *Dinner Party for Two*. It was a table with two chairs that had vibrators embedded in them, and I had two monitors in the table that had just flat-up pussy shots. Actually, I laid between people's legs and shot up, so it was like these sort of downward hanging pussy shots. The chairs had these big red soft cushions that were very very comfy, but as you were watching these beautiful pussy shots, the chairs were vibrating and the pussies had text scrolling over them. I invited all the women that Judy Chicago didn't invite to my dinner party, like Lucille Ball, who was blacklisted as a communist by McCarthy. And Valerie Solanas who wrote the SCUM Manifesto. . . . We had this sweet, fuddy-duddy dean when I first got to UC Santa Cruz, and when he sat down on the vibrating chair, he wouldn't get up! [They laugh] I really thought that sex, fun, and art were all just one big, fabulous ball of worms.
Williams:	So that pretty much puts you two on the same trajectory.
Stephens:	Yeah, well I was six years younger and I wasn't as well known, but we were working along the same trajectory until we collided.
Sprinkle:	Beth also had written a piece about lesbian desire for Deborah Bright's book, *The Passionate Camera*. She was exploring "the female gaze." At one point she invited me to be a visiting artist in her class, and I demonstrated a breath and energy orgasm.
Stephens:	You should've seen my little sculpture students' jaws drop.
	I love sculpture, I love the physicality of sculpture. Like Joseph Beuys' notion of "social sculpture," I also feel that society is a sculpture that can be shaped and shifted, just like material sculpture.
Sprinkle:	Sometimes I wonder if I've become a bit of a prude, as lately I'm more into the conceptual than the physical.
Williams:	Do you two ever argue?
Stephens:	Oh, yeah. We're co-authoring a book right now. We get into it about the book sometimes.
Williams:	OK, because seeing you in the film, and here tonight, you're so nice to each other. You always have fun!
Sprinkle:	Yes. Because we're really crazy about each other. For example, we might get into an argument about a title for a film or an exhibit, and I'll tell her that I don't really like her idea, and then she gets her feelings hurt, and then she criticizes my idea. We get all intense

	and combustible, then finally we have an aha moment, and scream "yeah, that's it!" Sex and creativity are one and the same really.
Stephens:	We get a kick out of each other's working process.
Sprinkle:	We do butch/femme right down the line.
Williams:	So let's talk about *Water Makes Us Wet*.
Stephens:	It's about our road trip where we explore the pleasures and politics of water through our ecosexual gaze.
Sprinkle:	It just premiered in documenta 14, which was a huge honor for us. We were one of 180 official documenta 14 artists. documenta is an avant-garde exhibit of international contemporary art. It happens just once every five years, in Kassel, Germany. A million people go to it over nine months, it had about a 40 million euro budget. documenta 14 brought us twice to Athens, Greece and twice to Kassel to do art projects; visual art, performance art, theater and to show the film. We had a blast. We had multiple artgasms.
Stephens:	There was so much going on. It was huge. We loved the exhibition. It was powerful.
Sprinkle:	For our movie premiere, we requested a blue (river) carpet to walk down in front of the theater, and we asked them to create a special water bar, where people could drink all kinds of water with lemon, cucumber, cherries. . . . Our film got a great reception. The Gloria Theater was this beautiful plush green velvet 1960s era theater. We were in heaven.
Stephens:	We were the hillbilly and the porn star!
Williams:	What I've always loved about Annie, and I now love about the both of you, is that you don't make either/or distinctions: between say sluts or goddesses. There's this quote from Annie that I've always loved in which you say, "my mother thought I would grow up to be a whore or an artist, and she was right." You don't say, "and I grew up to be an artist." You don't choose one or the other. Instead, you take dichotomies and destroy them. documenta is probably the most rarefied and radical of art exhibits, but you don't treat it that way. It's a way of being agreeable but it is so much more. It's also a way of refusing, or not preferring the high, academic, route.
Sprinkle:	Once we got a San Francisco Arts Commission grant because the peer review panel liked that we had done a performance in the Venice Bienale, and then we came back and put our all energy into a visual art show at Good Vibrations sex toy shop.
Williams:	What's the book you are currently writing called?
Sprinkle:	*Assuming the Ecosexual Position*, for University of Minnesota Press. It's about the environmental art projects we have done together, and sharing what we have developed around ecosexuality. That's one thing we fight about. How "academic" to be in this book versus how funny and playful.

Williams: But it's very important you don't become too academic . . .

Sprinkle: Actually, Beth is doing the reverse. She's a full professor getting down and dirty while in academia. She's the wildest thing they've got going. She's teaching an Ars Erotica class right now, and showing a lot of sexually explicit films. It's a great class, but pushes some buttons.

Stephens: We're in the process of producing a symposium about soil, called "Seedbed," riffing on Vito Acconci's famous 1972 performance piece in which, hidden under a specially built ramp in an art gallery, he masturbated to the movements of the audience, voicing his sexual fantasies via a loudspeaker. Our soil symposium will be like no other, with dirt-y dancing, mud wrestling, oh, and there's a woman artist who works with donkeys who believes humans developed as they did because of their association with animals. She wants to bring a donkey to the school and we're going to have an "Ass Kissing Workshop" where we will actually kiss the ass to exchange some microbial friends.

Williams: Even I will draw the line. . . . Because you know where we can go from there? Where are you gonna get the ass?

Stephens: A friend of mine just wrote to say he had a donkey. But the donkey had become sick of people and was kicking them.

Sprinkle: I worry about Beth being too wild . . . and jeopardizing her job. She doesn't seem to have as much fear of that as I do.

Williams: That's your fear for her. You were fearless in your own way and are still fearless. I think if you start to worry too much, then you lose it. And the fact that you're willing to risk that academic position and bring an ass to school is amazing.

Sprinkle: Wait until the right wingers get a load of that.

Williams: Well, it's a pun made literal.

Sprinkle: That's the problem. The right wing takes our work literally. They think we are actually fucking trees. You should read our hate mail. They say Beth is going to hell. . . . and I'm going to the gas chamber.

Williams: So let's talk about environmentalism and ecology and ecosexuality and your recent films. Why did you make them?

Stephens: I really wanted to make *Goodbye Gauley Mountain* because I'm from West Virginia and I was so enraged at what the coal companies were doing with mountaintop removal coal mining. West Virginia has become a sacrifice zone. At first Annie wasn't happy about it, because she knew how expensive it would end up being, and how much time and work it would take. It was my first feature film. But she of course jumped in and helped.

Around when we married the Earth in 2008, I had been working with environmental artists Helen and Newton Harrison. They

281

said, "you must go to the mountains." So I went off on this Don Quixote expedition. I had some colleagues who were writing grants and doing trilogies, so I thought let's make a film trilogy. Of course they were making short film trilogies. *Water Makes Us Wet* is the second of our trilogy of feature environmental films.

Williams: What's the third?

Stephens: Something like *Compost is Hot* about soil. I love filmmaking. It's really fun for me.

Sprinkle: She was getting her Ph.D. and when your life partner goes off to get their Ph.D., they're on their own trajectory, and so she became focused on doing something on West Virginia and coal mining. I hadn't made a film since my *Amazing World of Orgasm* (2007), which she helped me produce.

She took the ball and ran with it and learned the latest video technology. I mean I brought some filmmaking skills and experience to it, but it was her baby. So then the film turned out so nice and we had fun working on it, so we decided to do a film about water. I've always been an aquaphiliac at heart.

Stephens: It was sort of first West Virginia and then California.

Williams: Each of your homes . . .

Sprinkle: We like to think of the environmental issues we explore in the two films as microcosms for the bigger picture, the horrible destructive greedy things happening just about everywhere.

Sprinkle: The water film was a 50–50 thing, and soil is really more Beth's thing. . . .

Stephens: But I'll convince her to get into it.

Sprinkle: I don't like bugs.

Before we started the features, we produced and edited a bunch of our own performance documentation and did some video installations. *Extreme Kiss* is a piece that is an hour long, all one shot, of us kissing for an hour, when we were completely bald headed. We looped it. It was shown in a Russian museum on nine monitors, like a wall of kisses. We always hired several videographers to shoot footage of each of our ecosexual weddings, where we married various nature entities, as art events.

Stephens: Our Venice Biennale wedding was organized by Paul Preciado in conjunction with curator Jota Castro and the Mercia, Spain pavilion [the Bienale has national and regional pavilions]. They didn't seem to have very much money at all. We just sent out a call for collaborators and people from 19 countries came on their own dime to Venice to join us and it was just beautiful. . . . That one was really a ritual for artists by artists.

Sprinkle:	It was in public space.
Stephens:	And it was so hot. All of our makeup was melting off. And the police came and questioned us three times just because we were doing weird performance art, in colorful costumes and there was some nudity. Paul talked them into letting us continue each time. We don't know what he said!
Williams:	The conditions under which you've done these things . . .
Stephens:	Are crazy. And the last official wedding of the series was up here on Bernal Hill in San Francisco, and we married the Sun at sunrise.
Williams:	Did the Sun do a good job?
Sprinkle:	The Moon was shy when we married it, but the Sun was totally into it.

Because I was a city girl, and I felt disconnected from these things, the weddings made me feel more connected to "nature." When I realized the Earth did not have to be my "mother," which it is, it could be my lover . . .

Williams:	Here we go with the both/and—
Sprinkle:	Right. The idea of Earth as lover for me was great, and it also helped me expand my concept of what sex is, to universal proportions.
Stephens:	We made a 10-minute video, *Ecosexual Weddings* (2014), about seven of our more elaborate eco-weddings. We've shown it in a bunch of galleries, and at documenta 14.
Sprinkle:	Beth also sculpted a special metal box with a metal speculum that you can peek into and watch some video of me showing my cervix on stage, doing my *Public Cervix Announcement*. The speculum has an iPod inside it. We also did a video installation for a show in France, called *We Made Love with Marcel Duhamp*. It's a door with a peephole in it, and you can watch a video of us lying in grass by a river with our legs spread holding a lantern. It's a feminist wink and a nod to Duchamps' *Étant donnés*.
Williams:	*Water Makes Us Wet* has this lovely, very California progression. First the house toilet gets clogged . . . then we need to learn about water and waste. How did the two of you conceive that?
Stephens:	Well, we love road trips first of all. And I have this wacky knack of buying old vehicles and fixing them up. So we conceived of making this film about water and I had also just discovered the UC reserves, which are these nature sanctuaries that the University of California has, and we wanted to go camping, and we were so busy that we forgot you have to get a reservation a year ahead. But at the reserves, you write a proposal saying you were doing a scientific project and if it is accepted, you can stay there—at Big Sur and Yosemite, and it's better than any camp site in the world. We started

	going around interviewing people about water and having water adventures and . . .
Sprinkle:	It was an editing nightmare.
Stephens:	We had part A done and then we had that awful accident. . . .
Williams:	Which is horrifically portrayed. . . . And then silence. . . . Long, long silence.
Stephens:	We have an amazing editor who is also an artist, director, and cinematographer.
Sprinkle:	Keith Wilson. He lives up the street. He's really great. We also love to work with Jordan Freeman who is a hardcore environmental activist and he stealthily shot all our drone footage.
Stephens:	The idea for the hallucination was mine—I think. Because we had all this footage we wanted to use in the film, and we couldn't use it all. But you asked about the toilet scene. We went on a tour of the waste water plant in San Francisco and John Smith, a wonderful African American guy gave us a great tour.
Williams:	Yes, he was in tune with you guys.
Stephens:	We just fell in love with him. But I had to put all my UC credentials on the line: "I'm a UC professor, and I'm gonna show this to my students," which I am, and "you must let us have a private tour, and we must film it!" They were a little resistant, but we got this footage and it was just perfect. We mapped our desired routes and then took this circular road trip of California.
Williams:	It seems like the accident happens at the end of the road trip. Was that actually the case?
Stephens:	No, actually we probably filmed three quarters of the film after the accident. It made us realize we had better get our shit together. We had been procrastinating or too busy and we realized we could get killed before the film was finished. So the accident really inspired us.
Williams:	In the era of Trump, is there any sense that what you're doing with ecosexuality is especially urgent?
Stephens:	Well for years now our goals have been to make environmentalism more sexy, fun, and diverse, to entice more people to take more action and that was an urgency that was there before Trump. The environmental movement sometimes looks like a real estate convention, where you have a lot of white guys whose intentions are, I think, good, but the movement is very monocultural. And we feel that the Earth doesn't really belong to anyone, but it's all of ours, so we want make environmentalism more inclusive. Human beings are no better than anything else, and maybe worse, since we are the ones who've caused the problems. Clearly Trump is unleashing more corporate greed and is getting rid of regulations

	and encouraging extraction at a scale that has never been attempted before. Resistance is important.
Sprinkle:	We're trying to build up untapped audiences. People who don't fit in. I don't fit in to a lot of environmental groups. I can't fully be myself in the Sierra Club.
Stephens:	They are very Protestant.
Sprinkle:	So we decided to start our own branch of the movement where we felt very comfortable, and all the outsiders, the punk rockers, the performance artists, the sex workers, the strippers, had a place where they can do their thing, because lots of them do care about the environment. So for example we did the Gay Pride Parade where we produced an ecosexual contingent all about water.
Williams:	It's like the collaboration thing you were talking about in the marriage ceremonies. You got a whole contingent of people there, who were going to be the cheerleaders for what you were for. . . . but who made the slogans, like "Blood, pee, cum, sweat/ Water really makes us wet"?
Sprinkle:	That was our friend Dragonfly, also known as Justice Jestor. She's a great artist-activist. She works with Reverend Billy and the Church of Stop Shopping Choir. Everybody pitched in on the chants. "H2 Oh! H2 Oh! We're gonna save water and drink it slooww." We had chants in Spanish too.
Stephens:	"One, two, three, four, I'm an ecosexual whore. Five, six, seven, eight, ecosex is really great!" and "Hey hey, ho ho, I'm a ho' that likes to hoe." It's kind of like "Green Acres" meets the happy hooker meets social movements. We have a lot of fun.
	We also engage what Argentinian artist and activist, Roberto Jacoby called "strategies of joy." Ecosexuality can give us hope in the face of all the despair that Trump has unleashed.
Williams:	It seems to me especially that younger people are devastated because they're not used to losing elections the way my generation is.
Stephens:	I guess crooks have always run for office, but this jackass Don Blankenship from West Virginia (who is the villain in our film *Goodbye Gauley Mountain*) is responsible for the deaths of many many miners. He's running for senator of West Virginia. And there're a few more convicted felons, nationally convicted felons, who are emboldened by this, and running too, so I think ecosexuality and our absurdist theater reflects back on who these people are.
Sprinkle:	I compare what we're doing with the ecosexual movement to the sex-positive feminist movement. At first people kind of rolled their eyes and didn't get it, but then it builds steam, and a little group of people can change the world. It was a handful

of sex-positive feminists, and now there're all these great femi-
nist pornographers. Now there is a "porn studies," in academia
thanks to you Linda. A lot of people roll their eyes at ecosex but
then it's really catching on.

Stephens: We like to pollinate ideas. Our film company is called Pollination
Productions.

Williams: I love the moment in the film when Beth talks to two young women
and they are reflecting back to you what they think your ecosexual
desire is. And you ask what they think the purpose of water is and
one of them says something like, "it lubricates my insides." My guess
is, if you hadn't asked that question, you wouldn't have gotten that.
So in a way, you're an evangelist going to them, but the best part of
it is how they reflect back to you what they think you are doing.

So this is kind of obvious, but Sandy Stone, a pioneer transsexual,
elder plays Earth. Why Sandy Stone?

Stephens: Well, we imagine the Earth as trans. And the Earth is often gen-
dered as female, but we really think it's all genders in one, which is
probably not a good definition of trans, but it transcends gender.

Williams: She has such a resonant voice.

Sprinkle: She's also an amazing performer. And she's a little snarky too. She
has an edge. The Earth can be a cruel mistress. She's not all sun-
shine and daffodils.

Stephens: Sandy had a recording studio at her house, and she records the
tracks herself. She also recorded my friend Xandra Coe singing
the theme song that she wrote. Xandra had never professionally
recorded a song in her life, but Sandy made her sound like Patti
Smith!

Williams: I've been reading Paul Preciado's manifesto, *A Trans Man's Manifesto*.
Among other things, it's a discussion of the #MeToo movement. I
knew him when he was Beatriz. She invited me to talk about por-
nography in Barcelona.

Sprinkle: Right! We've done let me count . . . eight different projects, con-
ferences, events in five different countries with Paul. He's been so
supportive .and generous to us. He always says that he was very
influenced by the post-porn work I had been doing. After doing
a lot of mainstream porn, I started making some sexually explicit
films that were political, humorous, feminist, experimental, gender-
queer, critical, artsy.

Stephens: I would say that Annie is responsible for post-porn here in the US,
but the European post-porn people really took off with it due to
Paul's influence.

Sprinkle: Yes, they totally out post-porned me! Like that great, new Spanish
film, *Yes We Fuck!*, [Antonio Centeno] is post-post-porn, they've

| | taken that ball and run it way forward. Paul had been raised as a good catholic boy, went to Jesuit schools as a kid. Then he put together a conference on pornography and brought me to MACBA in Barcelona where he worked. I did my *Herstory Of Porn* film clips thing. He then went on to produce several more conferences about post-porn, and inspired lots of creative people to make porn outside the box. |

Williams: In English the manifesto is called "Letter from a Trans Man to the Old Sexual Regime." It's a response to the French women's response to the American #MeToo movement. It argues that "necropolitical heterosexuality" is the unwritten law governing the old sex/gender system that gives men the power of death and women the lesser reproductive power of life. The French aesthetic of seduction is based on a domination that eroticizes the power differential between men and women and thus also perpetuates it. Preciado argues that Queer Feminism first believed that epistemological transformation was a condition of social change. But now he argues libidinal change may be just as important. It's a powerful manifesto that speaks from the position of a trans man who disidentifies with the "necropolitics" of male heterosexuality that coerces women. Speaking to the French women who want to preserve the "importuning" men, he says that doesn't turn him on anymore. Anyway, these questions come to me because I have a friend who's writing about Shulamith Firestone, and asking "where is our Shulamith Firestone today?" Paul Preciado is our Firestone and more!

Sprinkle: Some say that Paul is the Foucault of today. . . .

Paul just told us he wants to curate a show with us next year in Barcelona. He was the curator of public events for documenta 14 and created the most amazing gatherings like four and five nights a week for a year! He called the series the "Parliament of Bodies" and they were very non-hierarchal, with such interesting topics, from the Code Noir to shipping container culture, to strategies of joy, to refugee crises, to tantric massage.

Stephens: Well, he did it in the face of very serious criticism, too, because there are fascist undercurrents in Europe right now, and in Greece, where half of documenta 14 took place. Greek people are extremely angry at Germany, as they should be, for the austerity programs. documenta 14 appeared to be just another colonialist insult, coming from Germany. But Paul was fiercely critiquing capitalism, neoliberalism, and fascism. I was worried about his safety.

Williams: And in his manifesto, he has a list of artists, and you're among them. . . .

Stephens: He's a great supporter of us. We both have a huge crush on him. He had everybody swooning. We sort of watched Paul grow up.

So next we're going to make a film about soil, and we're super excited to do that. It will involve a road trip around the USA.

Williams: Maybe you can get an electric vehicle. Tesla—

Stephens: I already tried to get Tesla. I sold my old BMW motorcycle to a Tesla engineer, and he said, "Tesla is never gonna . . ." But maybe we should! Because I'm decking our camper out with all the solar stuff, so maybe Tesla would have a better solar situation.

Williams: Precisely because Earth complained about your "ecological sins."

Stephens: Earth almost killed us.

Williams: What exactly happened?

Sprinkle: I fractured my sternum.

Stephens: We both had serious concussions.

Sprinkle: I had to get staples in my head and stitches in my hand.

Stephens: The sternum thing was serious, and we did not realize the severity of the accident or of our injuries. Even as I was having to unleash her from the seatbelt that was choking her.

Sprinkle: We landed on our side. We flipped over three times. It's a miracle that we didn't die.

Stephens: We went through the median into oncoming traffic. That's all I remember—a semi-tractor trailer lights coming towards us. I carried her out of the van.

Sprinkle: I said, "honey, find the computer, we might make our gig . . ." We were driving to LA to do a talk and we needed the computer. For the talk.

Williams: The show must go on!

Sprinkle: It was a bad accident, but also fuckin' romantic and exciting. We were so happy to be alive!

Stephens: And we made art out of it. It's a good scene in the movie.

Williams: By the way, I wanted to ask you, have you seen the HBO series *The Deuce*?

Sprinkle: I'm a paid "consultant" but I have not watched it yet.

Williams: Is Candida Royalle the basis for the Maggie Gyllenhaal character? I just wrote a review about it and so far I think it's doing pretty well. It's taking it's time to develop the background to the porn industry.

Sprinkle: I talked to Maggie Gyllenhaal a few times and took some phone calls from some other folks, but I didn't do that much. But they just asked me to be a consultant again for season two. I've heard that Maggie's character is a compilation of characters. . . . But Maggie said I was the most helpful of the people she talked to, because I told her, "Maggie, you either get in it for the sex, the drugs, to piss off your parents or heal yourself from past abuse,

or for the creative impulse." I was there for the creative impulse. She said that helped her. Some of us were really there to make films and be creative and express ourselves and explore through creativity. And I guess Maggie's character does some of that. . . . I'm feeling a little hesitant about watching the show, because my own experiences in Times Square were so good, I don't want to ruin my good memories. But I do want to see it. If I had more time I would.

Williams: Yeah, well they're really hard on the Times Square prostitution. . . . There's a prostitute who is pushed out the window and dies just because a John doesn't like the fact that she's Black and over-weight. And the pimps are getting sidelined.

Sprinkle: I really liked the pimps I had met back then. I thought they were great performance artists. They were so theatrical and glamorous. Being with a pimp was a kind of BDSM sexual fantasy back then. . . . A fetish. . . . But of course I had the luxury and privilege of it being a fantasy, not a reality.

Stephens: Pimps sure don't want to be attracting that type of attention today, especially with the police we have now.

Williams: I went to one of your early weddings. I think it was orange. At that time you were just re-marrying one another.

Stephens: We got bored with that. It felt self-indulgent. And so then we decided, "oh, we have to marry the Earth." This is more interesting.

Sprinkle: You were at the wedding where we married our community, and we made 100 vows to 100 people. And then we went beyond our community, beyond humans, to the whole ecosystem.

Williams: Adopting the storm drain was lovely. How is that storm drain doing?

Stephens: Well, yesterday I saw a guy pour a beer down it.

Sprinkle: Over two thousand people in the Bay Area have adopted storm drains through the Adopt a Drain website.

Williams: Oh, it wasn't a ritual just for the movie? Your own whimsy?

Stephens: It's a real city program! Our neighbor Thomas keeps an eye on our drain. We co-parent. His buddy poured the beer down our drain, but maybe the sewage system needs a beer once in a while. . . .

Sprinkle: So Beth and I have now been together 17 years. . . . And it's a freakin' miracle, and we've done everything together.

Stephens: I said to my therapist the other day: "I think we're codependent," and she says, "You know if one of you was codependent, and the other was a jerk. . . . That'd be a problem. But you're both equally codependent, so—"

Sprinkle: We're "co-co's." We did get each other through several surgeries, and we made it fun. All the hard stuff we make into art, and make it fun. I found a great partner for that, and when I'm on my death-bed, dammit, we're gonna make it a fun art project.

Stephens: I think I'll go first actually.

Sprinkle: We'll get a puppy. And a crystal chandelier to hang above my deathbed.

Stephens: You know, I saw *Thelma and Louise* this summer. That was a great fucking idea, you know, just go together. We practiced with the wreck. We've already had our dress rehearsal.

Sprinkle: It was my worst fear, or one of them, being in a really bad car wreck. . . . But it wasn't that bad. I mean we were lucky we didn't lose an eye, and our necks didn't get broken.

Stephens: It became a real bonding thing. . . . And then finding our dog. That was a miracle.

Sprinkle: And if we separate, we're gonna try to make it hella fun. It will hurt like hell, but we'll make art of it. I think it'll be an amazing adventure if we do, but I hope we don't.

Stephens: We'll have multiple divorces.

Williams: I think we should end this before you get carried away!

Note

1. A 10-minute portion of this kiss can be viewed on the permanent archive of the entire seven-year project at https://loveartlab.ucsc.edu/2016/06/04/extreme-kiss/

INDEX

Index